2004

ARCHAEOLOGICAL RESEARCHES AT TEOTIHUACAN, MEXICO

ARCHAEOLOGICAL RESEARCHES AT TEOTIHUACAN, MEXICO

Sigvald Linné

Foreword by Staffan Brunius
Introduction by George L. Cowgill

THE UNIVERSITY OF ALABAMA PRESS
Tuscaloosa and London

Originally published in 1934 by The Ethnographical Museum of Sweden

Typeface is AGaramond

∞

The paper on which this book is printed meets the minimum requirements of American National
Standard for Information Science–Permanence of Paper for Printed Library Materials, ANSI
Z39.48–1984.

Library of Congress Cataloging-in-Publication Data

Linné, Sigvald, 1899–
Archaeological researches at Teotihuacan, Mexico / Sigvald Linné ; foreword by Staffan
Brunius ; introduction by George L. Cowgill.
p. cm.
Originally published: Stockholm : V. Petterson, 1934.
Includes bibliographical references and index.
ISBN 0-8173-1293-5 (cloth : alk. paper) — ISBN 0-8173-5005-5 (paper : alk. paper)
1. Teotihuacán Site (San Juan Teotihuacân, Mexico) I. Title.

F1219.1.T27L55 2003
972'.52—dc21

2002041617

British Library Cataloguing-in-Publication Data available

CONTENTS

FOREWORD
The Early Swedish Americanist Tradition and the Contributions of Sigvald Linné (1899–1986)

Staffan Brunius

In the 1920s the university and the ethnographical museum of Gothenburg (Göteborg), the busy seaport city, were the institutions to attend for an academically competent and internationally well respected Swedish education in American Indian cultures. This high quality ethnographical-anthropological training was the result of one man's extraordinary achievements—those of baron Erland Nordenskiöld (1877–1932), the prominent Swedish americanist. Since the end of the 1890s Erland Nordenskiöld had devoted his life to South America, first as a zoologist but soon turning to ethnography, archaeology, and (ethno-)history. His extensive fieldwork, his productive authorship, his devotion to students, and his professional museum experience made him a respected and beloved teacher and supervisor.

Many of Erland Nordenskiöld's students would, indeed, over time make acclaimed americanist contributions of their own. These students included Sven Lovén (1875–1948), Karl Gustav Izikowitz (1903–1984), Gösta Montell (1899–1975), Gustaf Bolinder (1888–1957), Alfred Metraux (1902–1963), Stig Rydén (1908–1965), Henry S. Wassén (1908–1996), and Sigvald Linné.

Through their teacher they would not only receive theoretical and, in most cases, fieldwork training, they would also be familiar with archival research and museum work. Following the example of Erland Nordenskiöld, most of these students would as americanists concentrate almost exclusively on South America, except for Sigvald Linné who primarily, but certainly not exclusively, focused his research work on Lower Central America and Mesoamerica.

Erland Nordenskiöld's importance to the high standing of Swedish americanist research during the first half of the 1900s can not be underestimated. However, it must be emphasized that Nordenskiöld was not the first Swede to study the American Indian.

If we expand the meaning of the "americanist" concept, we find that such interest in Sweden traces its roots to the New Sweden colony (1638–1655) that covered approximately the present state of Delaware. From the colony derive documents with ethnographical

This foreword is reprinted in the companion volume by Sigvald Linné, *Mexican Highland Cultures: Archaeological Researches at Teotihuacan, Calpulalpan and Chalchicomula in 1934–35*.

information, (ethno-)historical sources that have proved to be important for the study of the Lenape (Delaware) Indians. In Sweden this early interest was, not surprisingly, mostly limited to the absolute upper echelon of the Swedish society and often manifested in the time typical of *Kunst und Wunderkammer* (Art and miracle chambers) established in the castles and mansions of the royalty and aristocracy. The very earliest American Indian collections in Sweden were, indeed, "curiosities" from this very period—a fact that would catch the attention of the broadly oriented Sigvald Linné later in his career (see, for example, his articles *Drei alte Waffen aus Nordamerika im Staatlichen Ethnographischen Museum in Stockholm* [1955] and *Three North American Indian Weapons in the Ethnographical Museum of Sweden* [1958]).

From the 1700s and onward, ethnographical and Precolumbian collections from the Americas were increasingly gathered and systematically organized at universities and various cabinets of naturalia, such as at the Royal Swedish Academy of Sciences founded in 1739.

In the 1800s Swedish travelers visited the New World in greater numbers and sometimes described in accounts their meetings with Indians. One of those travelers was Fredrika Bremer (1801–1865) in the early 1850s. Then in the latter part of the 1800s true americanist efforts with published results were made by Swedish natural scientists, early archaeologists, and ethnographers, including such people as Carl Bovallius (1849–1907), working primarily in Costa Rica and Nicaragua in the 1880s and later in northern South America; Eric Boman (1867–1925), working in Argentina and adjacent areas; Gustaf Nordenskiöld (1868–1895), the elder brother of Erland Nordenskiöld, working in the early 1890s in Mesa Verde in the southwestern United States; Axel Klinckowström (1867–1933), working in the early 1890s in northeastern South America; and Carl V. Hartman, working in the 1890s in northern Mexico, Costa Rica, and El Salvador. Instrumental for Carl V. Hartman's pioneering archaeological work in Costa Rica was Hjalmar Stolpe (1841–1905). Stolpe was himself a natural scientist, archaeologist, and an americanist, and he had researched American Indian ornamental art as well as the archaeology of Peru during the Swedish Vanadis-expedition that circumnavigated the world from 1883 to 1885.

Erland Nordenskiöld had an important influence on Linné, but Hjalmar Stolpe's influence can not be underestimated either. Influenced by currents abroad, Hjalmar Stolpe in the early 1870s helped promote the founding of a Swedish anthropological society, later The Swedish Society for Anthropology and Geography. Its prestigious journal *Ymer* became attractive for the early americanists in Sweden. Furthermore, impressed by what he had seen in Copenhagen, Hjalmar Stolpe was instrumental in the founding of an ethnographical museum in Stockholm, which traces its roots via the Museum of Natural History to the previously mentioned cabinet of naturalia of The Royal Academy of Sciences. Hjalmar Stolpe became the first director of this ethnographical museum in 1900, which today is The National Museum of Ethnography (Etnografiska Museet). It was at this very museum that Linné began his work in 1929 and for which he was the director from 1954 to 1966.

Through the museum, he would publish his major works, and many of his shorter articles appeared in its journal *Ethnos,* first published in 1936.

Linné recognized the importance of history—the history of learning, the history of ethnography-anthropology, and particularly the history of americanist research, especially as it had developed in Sweden. He had detailed knowledge about the *Kunst und Wunderkammer* and cabinet of naturalia periods, about his americanist predecessors, about Hjalmar Stolpe's ambitious ethnographical exhibition venture in Stockholm from 1878 to 1879, about the contents of the Swedish contributions to and the network of contacts that developed at the American-Historical Exhibition in Madrid 1892, and about the organization of and contributions at the International Congress of Americanists held in Stockholm in 1894 and in Gothenburg (together with Haag) in 1924.

This historical knowledge was probably an expression of a sincere intellectual curiosity; however, the academic training under Erland Nordenskiöld also emphasized the importance of using (ethno-)historical sources in archaeological and ethnographical research. One of Linné's major publications, *El Valle y La Ciudad de Mexico en 1550* (1948), which discussed the oldest preserved map of Mexico City kept at Uppsala University library, certainly reflects his interest in history. Already in 1939 Linné had presented his initial research about the contents and the background of the map at International Congress of Americanists held in Mexico City, one of the many international congresses and conferences in which he participated.

When Linné approached Erland Nordenskiöld in Gothenburg in the mid-1920s he had already left behind studies in the natural sciences (chemistry). Obviously Nordenskiöld made a deep impression, because from then on Linné changed his focus of study to archaeology and ethnography of the Americas. Nevertheless, he always recognized the importance of the natural sciences, and his first major graduate work, *The Technique of South American Ceramics* (1925), included microscopic analysis. It received fine reviews from Alfred Kroeber in *American Anthropologist,* and much later, in 1965, it was praised as a "major pioneer work" in a volume from the "Ceramics and Man" symposium held in 1961 at Burg Wartenstein.

The following major work as a student for Erland Nordenskiöld was his dissertation, *Darien in the Past: The Archaeology of Eastern Panama and Northwestern Colombia* (1929), based on fieldwork during Erland Nordenskiöld's last expedition in 1927 to Colombia and Panama. Again reviews in *American Anthropologist* praised the work: Alfred Kroeber wrote that "the Göteborg technique and standard of scholarship are thoroughly upheld." Interestingly enough, the great authority Doris Stone maintained as late as 1984 that Linné's work from 1929 was still the best for that particular area.

In 1929 Linné moved from the west coast of Sweden back to his native Stockholm, having received a position at the ethnographical museum. The previous director of the museum, Costa Rica expert Carl V. Hartman, had retired, and the africanist Gerhard Lindblom was the recently appointed new director. Much work was needed to organize the

museum after the move from central Stockholm to a new location at an adjacent recreational area. But Linné also worked with Precolumbian/archaeological collections from Lower Central America purchased earlier by Carl V. Hartman. Besides studying the rich collections at the museum, he would throughout the years study Precolumbian collections in Europe during his vacations. Over time his knowledge about Precolumbian art and the acquisitions contexts of such collections grew to become, simply expressed, immense.

One reason why Linné began to look toward Mesoamerica was that the museum had fine Precolumbian collections, specifically, the Edvin Paulson collection, from this culture area. No Swede had previously done serious field archaeology in Mesoamerica. The fact that Sweden had excellent diplomatic relations with Mexico and that Swedish business interests were well established in Mexico had significant implications for Linné's archaeological research at Teotihuacan in 1932. He received support from Swedish diplomats and from such firms as The Mexican Match Company and the L. M. Ericsson Telephone Company as well as from the Royal Swedish Academy of Sciences and the J. A. Wahlberg Foundation/The Swedish Society for Anthropology and Geography. Several important professional colleagues also gave him advice and assistance, including Manuel Gamio, Ignacio Marquina, Eduardo Noguera, Sylvanus Morley, Gustav Stromsvik, Frans Blom, and George C. Vaillant, who Linné especially held in high esteem. This support was important, particularly during his travels to numerous sites outside the Valley of Mexico, such as to the Yucatán Peninsula. Considering that his actual excavations of the large Xolalpan public structure at Teotihuacan lasted only about four months, the results were impressive. Two years later, in 1934, Linné's report, *Archaeological Researches at Teotihuacan, Mexico,* was published through the museum with funding from the Humanistic Foundation in Stockholm and from the previously mentioned Swedish-American businessman Edvin Paulson. In 1935 George C. Vaillant in *American Anthropologist* praised Linné for "the presentation of a technical field excavation in such terms that anyone can follow his text and see the relationship between details of position of specimens and the larger problems of history and anthropology."

The expedition of 1932 proved so successful and promising that a new Teotihuacan venture was soon under way. The following individuals and groups were again instrumental for the realization of Linné's new project: the Swedish diplomatic representation in Mexico under C. G. G. Anderberg; the courtesy of Mexican authorities; the business firms Compañía Mexicana de Cerillos y Fósforos, South America; and Empresa de Teléfonos Ericsson, South America. Important support also came from The Vega Foundation/The Swedish Society for Anthropology and Geography and the Swedish-Mexican Society in Stockholm as well as from private persons such as the previously mentioned A. E. Paulson. Again, the intention was to excavate at Teotihuacan but also at other places in and around the Valley of Mexico. Furthermore, the project included ethnographical explorations that were the particular concern of Gösta Montell, a fellow student under Erland Nordenskiöld in Gothenburg and later a colleague at the museum in Stockholm.

The excavations primarily involved the large Tlamimilolpan public structure, similar in

type to the Xolalpan house ruin, which further indicated the former true urban character of that huge archaeological site from mainly the Classic period. In 1942 the museum published Linné's report *Mexican Highland Cultures. Archaeological Researches at Teotihuacan, Calpulalpan and Chalchicomula in 1934/35*. In 1950 Richard Woodbury concluded in *American Antiquity* that "this report is a 'must' for all who are interested in Americas high cultures." Gösta Montell also published the results—a book about Mexico and its native peoples and cultures, written for the Swedish general public.

The Mexican authorities permitted Linné to bring the vast majority of the archaeological finds from both expeditions to Sweden, where they were carefully cataloged. (These finds also characterize the ethnographical collections.) His Teotihuacan finds have been represented in various exhibitions, including the important "Teotihuacan: City of the Gods" exhibition in 1993 in San Francisco. The detailed reports and the correctly cataloged collections still provide a rich data base for new research and interpretations, like the recently published work from 2001 on the Teotihuacan figurines by Sue Scott.

Linné's *Zapotecan Antiquities and the Paulson Collection in the Ethnographical Museum of Sweden* (1938) published by the museum is another major work that again demonstrates his interest in Precolumbian art. This research on identifying the iconography of Zapotecan funerary urns seems not as well known as his Teotihuacan reports. It nevertheless received fine comments by the acclaimed archaeologists Alfonso Caso and Ignacio Bernal in their important work *Urnas de Oaxaca* (1952).

The Teotihuacan excavations in the 1930s was the last of Linné's big fieldwork projects; however, Linné made some later field visits in 1947–48 to Guerrero, which at that time was little known archaeologically. Interestingly enough, as mentioned in his article *Archaeological Problems in Guerrero,* published in the museum journal *Ethnos* (1952), he saw a connection with the Olmec culture, which was increasingly beginning to be archaeologically identified.

Over the years Linné published numerous scientific and popular articles but also books for the general public, particularly those about the Precolumbian cultures of Mesoamerica. He gave, of course, public lectures at the museum. As associate professor and later professor of general and comparative ethnography, a position that went with the museum directorship, he had many students; however, only a few would pursue his Mesoamericanist interest, such as Anna-Britta Hellbom, the former curator of the Americas at the ethnographical museum in Stockholm. Linné made formal complaints about the impossible workload that included administration, teaching, and supervising students, in addition to being the museum director. After his final retirement in 1969 the museum directorship was indeed officially separated from university positions.

The contributions of Linné resulted not only in fine reviews but also in various marks of distinction, including the Anders Retzius medal in 1937 in Sweden, the Loubat prize in 1943, and the Sparrman medal in 1972. In 1951 he was awarded an honorary doctorate in Mexico, and in 1957 he received The Huxley Memorial Medal in England.

In 1994 the 48th International Congress of Americanists was held in Stockholm and

Uppsala. During a session about Swedish americanists, arranged by The Swedish Americanist Society and led by Åke Hultkrantz who is a famous expert on North American Indian religions and shamanism, the contributions of Linné were of course emphasized. Sigvald Linné had the academic integrity and good judgement not to generalize far from the basic findings, even when it was from archaeology, ethnography, or (ethno-)history. Linné is foremost remembered as an archaeologist, but he also mastered the broad cultural background for his conclusions, whether the data came from excavations, ethnography, archives, or the libraries. For us of a younger generation who had the great privilege to meet Linné as retired, living in Helsingborg in the very southern part of Sweden, he was a living encyclopedia with a great sense of humor and generosity. It is no wonder that he had been popular among his crew members from the contemporary local population during the Teotihuacan excavations, and his contributions to this day are remembered and valued.

For a Sigvald Linné bibliography, please see Staffan Brunius, Not Only From Darien to Teotihuacan—the Americanist Contributions of Sigvald Linné, *Acta Americana [Journal of the Swedish Americanist Society]* 1, no. 1 (1993).

INTRODUCTION TO
THE 2003 EDITION
Xolalpan after Seventy Years

George L. Cowgill

B etween 26 April and 29 July of 1932, Swedish anthropologist/archaeologist Sigvald Linné, accompanied by his wife and with the aid of a crew varying from four to nine, excavated in the house lot called Xolalpan, within the village of San Francisco Mazapan, part of the municipality of San Juan Teotihuacán, finding remains of the ancient Teotihuacan* civilization, as well as later materials above the floors of the Teotihuacan structure. He also worked briefly at the site called "Las Palmas," about 150 to 200 meters to the south, site 14:N3E2 of the Teotihuacan map (Millon, Drewitt, and Cowgill 1973:46), where George C. Vaillant had excavated earlier, and he reported briefly on finds at a third site about 100 meters south of Xolalpan (pp. 90–91 and 104–105), probably site 33:N4E3. Xolalpan itself is site 2:N4E2.

Both Kent Flannery and René Millon have observed, verbally if not in print, that our ideas have finite lifetimes, but good data are good forever. Even if there is no such thing as "pure" data free of any interpretive presuppositions, this insight is basically true. The present volume and Linné's later report on his 1934–35 work at Tlamimilolpa (1:N4E4) are cases in point. Linné made excellent use of the literature available to him, and most of his ideas were well-reasoned and often quite astute, given the knowledge and intellectual climate of the time. But he emphasized that the archaeology of Mesoamerica was barely beginning and that it was to be expected that there would be vast changes in our understandings of the pre-Conquest past. He would surely have been very disappointed if many of his ideas and interpretations had not been superseded. This has indeed been the case. Today they have an honorable place in the history of archaeological thought, but on their account alone, there would be little reason for republication of his reports, long out of print. His data are another story. To be sure, there is no evidence that he ever used screens, and he paid little attention to potsherds or other artifacts that were not part of grave offerings or of exceptional interest as individual objects. His field methods fell considerably short of today's

* In referring to the modern municipality, I stress the final syllable; but in referring to the ancient city, I follow Nahuatl usage in stressing the next-to-last syllable. Of course, because we do not yet know the principal language of Teotihuacan, we do not know what the ancient inhabitants called their city.

standards, but they compare favorably with other field practices of the time and, for that matter, those of many more recent projects. He published plans of the excavated part of Xolalpan (pp. 40, 42) and a few informative (though small and not very detailed) stratigraphic sections and plans of some features (pp. 43–45 and 216), but these include drawings of only one of the seven graves he encountered. Linné (p. 47) identified six construction stages. It is instructive to compare his stratigraphic information with the profiles of a number of deep but areally limited test excavations published by Millon (1992). Linné published almost no physical anthropological data. Contextual data on finds not associated with graves are often rather vague. I suspect that an attempt to construct a Harris diagram for Xolalpan would confront one with a number of irresolvable ambiguities, but the effort would be instructive.

We need not belabor the quantities and kinds of data that Linné did not report, although it is worth mentioning that if had felt obliged to publish according to modern standards, he surely would not have published so promptly. The fact is that what he *did* report is of exceptional and lasting importance. His discussions of the things that interested him are keenly observed, well illustrated, and highly informative. After an extensive review of data on Teotihuacan grave lots, Sempowski (1994:27) says Linné's "reports on and illustrations of the artifactual offerings associated with particular burials are unparalleled in their systematic presentation." Even today, with all the advances since 1932, very few Teotihuacan apartment compounds have been excavated as extensively as Xolalpan and also had the results published as fully as Linné did. Manzanilla (1993) is a major exception, although full reports of some other meticulous excavations of relatively large parts of compounds are in various stages of preparation. Thus, a great deal of the information in this book is of permanent interest, especially for Teotihuacan specialists but also for all other Mesoamericanists and for scholars interested in comparative studies of early complex societies.

It is useful to set Linné's volume in the context of research since the 1930s. This is not the place for a general review of current knowledge about Teotihuacan. For that, see Cowgill (2000), Millon (1992), and the numerous publications cited therein. Here, I summarize information that pertains specifically to the sites of Xolalpan and Las Palmas, gathered since Linné wrote.

During the course of the Teotihuacan Mapping Project (Millon 1973; Millon et al. 1973) Xolalpan was revisited on 22 July 1966 by a team led by Pedro Baños C., long-term mainstay of the Mapping Project and now senior technician of the Teotihuacan Archaeological Research Institute managed by Arizona State University. Baños made notes on the site and interviewed Porfirio Reyes, landowner and assistant to Linné in 1932, still hale and active at the time (one of his sons, Alfredo Reyes, and a daughter, María Reyes, worked as laboratory assistants on the Mapping Project). Baños and his field assistant (Silvestre Sánchez) made a surface collection of ceramics and other artifacts. Some time later the site was visited by Millon, Drewitt, and Cowgill, who also interviewed Reyes and examined visible traces of architectural features.

Perhaps the most important finding by the Mapping Project is good evidence that the

apartment compound extends beyond the limits shown in Linné's plans. Linné is explicit that the eastern portion is unknown. Much lies beneath Sr. Reyes's house and other outbuildings (including a *temascal;* these are shown in outline on Linné's plan, p. 42). However, it is somewhat doubtful that the outermost limits were reached on the northern side, and possibly they were not reached on the western. For one thing, Teotihuacan apartment compounds are usually surrounded by thick outer walls, and Linné does not mention any walls of unusual thickness. More important, Baños recorded his doubts about whether the outer limit had been reached on the north. It is especially unlikely that the outer limit was reached on the southern side, where comparison with Mapping Project interpretations of nearby sites (Millon et al. 1973:32) suggests that the limit was about ten meters south of the southern edge of Linné's plan. I have not located notes (if I made any) from my visit in the late 1960s, but my recollection is that we observed traces of Teotihuacan walls extending beyond the limits shown by Linné, at least on the south side. If the southern outer limit had been where Linné shows it, it would mean that there was no room south of the platform on the southern side of the central patio, which would be unusual for a Teotihuacan apartment compound. Millon (1976) follows Linné's plan and interprets Xolalpan as about 50 m east-west by ca. 30 m north-south, i.e., an area of ca. 1,500 m². I suspect that its north-south extension is actually closer to 40 m, implying an area of ca. 2,000 m². This would still make its area somewhat below the median area of Teotihuacan apartment compounds.

There are a few other puzzles and improbabilities in Linné's plan. None of the four platforms (often called "temples" in later literature) surrounding the central plaza connects with rooms behind them, leading me to wonder if Linné missed some doorways. This would not be too surprising, since he reports that architectural remains, at least near the ground surface, were in poor condition, an observation that suggests caution in accepting all his statements about which objects definitely came from below the uppermost floor. Also, although his plan shows small doorways near the southwest and northwest corners, accessibility from outside the compound seems unusually limited, and I suspect that Linné may have missed other doorways as well. The overall layout of Linné's plan makes sense, but its details should be treated with caution.

Millon (1976:218–220) argues that Teotihuacan apartment compounds, including Xolalpan and Tlamimilolpa, were laid out from their beginnings (generally in the Tlamimilolpa* phase) according to overall plans that were not changed drastically in subsequent rebuildings, although he sees fragmentary evidence for accommodation of increased size in domestic groups by subdividing existing apartments or individual rooms at Xolalpan

* For better or worse, both the Xolalpan and Tlamimilolpa apartment compounds have been used as names of phases in the Teotihuacan ceramic sequence. In this introduction I use the terms in both senses. I believe the context always makes it clear which sense I mean.

(Millon 1976:224). However, Linné repeatedly expresses his belief that Xolalpan was substantially enlarged and changed over time (pp. 39–40, 46–47, and 159), and he gives some reasons in support of this belief. Nevertheless, he laments that he did not have time to explore earlier construction stages very much. The same was true later at Tlamimilolpa, and the cases for significant changes over time in the layouts of these structures remain inconclusive. Angulo (1987) argues plausibly but not conclusively for changes in the layout of the Tetitla apartment compound (1:N2W2). At Tlajinga 33 (33:S3W1), Widmer (1987) shows clear evidence for major changes over time in its layout. Tlajinga 33 may be an atypical case, but at present the degree to which most Teotihuacan apartment compounds approximated their present layouts from the beginning remains an open question. We are still very short of excavations of Teotihuacan apartment compounds in which large areas are excavated down to subsoil with rigorous attention to discerning the entire construction sequence.

Another important Mapping Project finding was the proportions of sherds and other artifacts of various types and periods found on the surfaces of these sites, as determined by the ca. 266 rim and feature sherds from the 1966 surface collection at Xolalpan and the ca. 1,010 from Las Palmas. This information goes some way toward making up for the absence of this kind of data from the stratigraphically distinct layers excavated by Linné—the more so since the extensive recycling of earlier material in later building fill at Teotihuacan means that sherds from the earliest occupations in the vicinity are well-represented in surface collections. Chronological assignments of these ceramics differ only slightly between those made in 1966 and a subsequent reanalysis in the 1980s that used approximately the phasing criteria described by Rattray (2001). In round numbers, the percentages of phased sherds are as follows:

	Xolalpan	Las Palmas
pre-Patlachique	none	none
Patlachique (ca. 100–1 B.C.)	trace (1 sherd)	trace (2 sherds)
Tzacualli (ca. A.D. 1–125)	4%	3%
Miccaotli (ca. A.D. 125–200)	6%	6%
Tlamimilolpa (ca. A.D. 200–350)	16%	9%
Xolalpan (ca. A.D. 350–550)	13%	13%
Metepec (ca. A.D. 550–650)	3%	3%
Coyotlatelco (ca. A.D. 650–850)	12%	7%
Mazapan (ca. A.D. 850–1050)	34%	49%
Aztec (ca. A.D. 1050–1600)	12%	10%

Linné, with a few exceptions, correctly attributed ceramics to three main periods, Teotihuacan, Mazapan, and Aztec. At the time, he had no basis for identifying phases within the Teotihuacan Period. It is curious that he did not recognize any Coyotlatelco ceramics, because they are fairly well represented in the Mapping Project surface collec-

tions and because he was aware of Tozzer's (1921) publication on Azcapotzalco, which illustrates a good deal of Coyotlatelco material. On p. 96 he mentions but does not describe some sherds "of the Matlatzinca type" in his discussion of foreign ceramics, and it is possible that he was referring to Coyotlatelco ceramics. This reluctance to see Coyotlatelco ceramics as local, a point clearly established by neutron activation analysis (Crider 2002), persists in Linné's later volume (1942:178). In the 1942 volume, he notes that Coyotlatelco is present at Tlamimilolpa, and some fragments are nearly identical to that found by Tozzer at Azcapotzalco; however, he considers them foreign.

To judge from the Mapping Project evidence, it is doubtful whether there was any significant Patlachique phase occupation in the vicinity of either Xolalpan or Las Palmas. There was probably some Tzacualli and Miccaotli phase occupation at or near both sites although, judging from absence of structural remains datable to these phases at other excavated Teotihuacan apartment compounds, it is likely that these sherds were incorporated as part of the fill of Tlamimilolpa phase and later structures. The proportion of Tlamimilolpa phase sherds collected at Xolalpan suggests that the earliest layers reported by Linné there may well date to that phase, although quite possibly the Late Tlamimilolpa subphase, notwithstanding that the earliest burial Linné discovered is probably Early Xolalpan. A somewhat higher proportion of sherds were identified as Tlamimilolpa phase at Xolalpan than at Las Palmas, but more notable is the low proportion of sherds identified as Metepec at both sites. This finding suggests a substantial population decline, but possibly it only reflects difficulties in distinguishing Metepec phase from Late Xolalpan ceramics.

Not surprisingly, given Linné's emphasis on Mazapan ceramics above the floors at Xolalpan, ceramics of that phase are well represented in the Mapping Project surface collection from that site. The surface collection from Las Palmas is unusually large, and, in both absolute and relative terms, the amount of Mazapan ceramics is exceptionally high. It was with good reason that Vaillant named this ceramic style after the town of San Francisco Mazapan. The still unpublished Mapping Project map of Mazapan ceramic densities shows that Las Palmas is part of a concentration of Mazapan phase ceramics that covers around 25–50 ha, centered in the northwestern part of map square N3E3 and extending into adjoining squares. Xolalpan is toward the northwestern fringe of this area. There are less pronounced Mazapan concentrations elsewhere (e.g., in the southeastern part of square N5W3), but it is fairly certain that the concentration that includes Las Palmas was the principal Mazapan phase settlement within the ruins of the Teotihuacan Period city. There are also above average densities of ceramics of the Coyotlatelco and Aztec periods in square N3E3, but the concentrations are not as pronounced as for the Mazapan phase, and the highest ceramic densities for these periods are elsewhere.

Among much sound analysis, Linné made a few mistakes about ceramic phasing. On p. 81 he misattributes a Teotihuacan Period *tapaplato* ("handled cover") to the Mazapan phase, and on p. 111 he identifies as Teotihuacan a surely post-Teotihuacan tripod bowl censer. Fig. 124A on p. 93 is printed upside down, probably through no fault of Linné's. Incidentally, the feathered rattlesnake on the vessel shown there is reminiscent of one recently

found on a vessel in a cache, together with many female and infant figurines, in site 11:N1E6, near the eastern margins of the city (Rodríguez and Delgado 1997); however, that vessel, a cylinder vase with nubbin supports and outcurved rim, looks earlier than any of the Xolalpan grave lots. It is more like some of the vessels in Burial 1 at Tlamimilolpa described by Linné (1942).

In 1934 it was obvious to Linné that Thin Orange Ware, which he called the "yellowish-red" ware, came from outside Teotihuacan, and he thought its source might be in the region of Chalchicomula (Ciudad Serdán). However, his 1934–35 work in that region showed that this was not the case (Linné 1942). A source in southern Puebla has long been suspected, and Rattray (1990a) confirms this.

Some of the most valuable aspects of Linné's volumes are their relatively full discussions of grave lots and the high-quality illustrations of many of the finds. On p. 54 Linné attributes Grave 1 to the fourth of his six construction stages, Graves 2 and 3 to stage five, and Graves 5–7 to stage six. Recent publications on Teotihuacan grave lots (Rattray 1992; Sempowski 1994) agree with one another in assigning Xolalpan Graves 1 and 2 to the Early Xolalpan phase and Graves 3 and 4 to Late Xolalpan. Sempowski assigns Graves 5, 6, and 7 to the Metepec phase; Rattray more cautiously places them somewhere in the Late Xolalpan—Metepec interval. Proportions of graves per period are not particularly close to the phased sherd proportions in the surface collection, but there is no reason why these seven graves, surely representing a tiny proportion of all the people who were ever associated with the Xolalpan compound, should be a representative sample. If none of the seven graves pertains to Linné's first three construction stages, it is quite reasonable to assume, as suggested by the Mapping Project surface collection, that the earliest stage is likely in the Tlamimilolpa phase. Nevertheless, readers should be aware that the Teotihuacan ceramic chronology is still subject to refinement and that neither Sempowski nor Rattray have made the basis for their chronological assignments explicit. It is desirable to do a systematic and intensive seriation analysis of the several hundred Teotihuacan grave lots now available for study. For example, the high proportions of one-chambered *candeleros,* relative to those with two chambers, in Graves 2 and 4 are somewhat unexpected in Xolalpan phase contexts.

Linné (pp. 96–99 and Figures 127–130) correctly recognized that several sherds with deeply incised decoration (it would probably now be called "carved") found in the fill below floors at Xolalpan, probably of nonlocal origin, had Maya motifs, but he did not note that two of the plano-relief cylinder tripods in Grave 2 (p. 60, Figures 28, 28A, and 29) also have distinctively Maya figures. To judge by the illustrations, the two vessels in Grave 2 may be of local manufacture, but the shapes are taller in proportion to width and more straight-sided than most local products. Also, the rattlesnake tail supports, which are quite a common motif in Teotihuacan sculpture, are unusual as ceramic vessel supports. INAA and other compositional studies of these vessels are desirable to determine their sources. For a recent discussion of these Maya-related vessels see Taube (2003).

Linné was struck by the apparent scarcity of utilitarian ceramics and other evidence of

food preparation at Xolalpan (pp. 45, 110, and 130). This is probably one of the reasons why so many scholars could think of Teotihuacan as an "empty" ceremonial city with little permanent population, even through the 1950s. However, the Mapping Project surface collection revealed that about one-fourth of the Teotihuacan Period sherds from Xolalpan were from burnished ollas and another 5 percent from utilitarian San Martín Orange craters. It is somewhat hard to understand why such a large discrepancy in these findings exists. The best explanation I can think of is that Linné's workmen were under the impression that plain unslipped sherds were of no interest, and Linné failed to note in the field that they were not being collected. More recent excavations in Teotihuacan apartment compounds have found ample evidence of domestic activities. Taken together with the Mapping Project surface collections, there is no reasonable doubt that Xolalpan had a sizable number of residents who carried out a full range of domestic activities there.

Clearly the occupants of Xolalpan were somewhere in the broad middle range of Teotihuacan socioeconomic statuses—neither near the top nor near the bottom. Linné found traces of red paint on white plastered wall surfaces (Appendix 11), but he does not mention any evidence of polychrome murals. Millon (1976:227) states that various lines of evidence suggest that the occupants of Xolalpan were toward the lower end of this intermediate range. I do not know whether the Maya connection in Grave 2 implies any special status. Imported Maya sherds are widely scattered in small quantities at Teotihuacan, and nothing known of Xolalpan is comparable to the strong Maya elements in murals at Tetitla (Taube 2003) or to the concentrations of sherds of Gulf and Maya origin at the "Merchants'" enclave, not far south of Tlamimilolpa (Rattray 1990b).

A great deal more could be done with Linné's collections from Xolalpan and Las Palmas. Most of the material is at the National Museum of Ethnography in Stockholm, whereas some of the finer pieces are in Mexico at the Museo Nacional de Antropología or at the Teotihuacan site museum. Scott's (1993, 2001) studies of figurines and the large (1.14 m) "Xipe Totec" ceramic statue found broken above the floors at Xolalpan are impressive examples of what can be done with these materials.

There are also recent publications that show some of Linné's finds in greater detail or in different aspects. A notable example is the catalog of the 1993 show at the DeYoung Museum in San Francisco (Berrin and Pasztory 1993). Obsidian objects from Xolalpan Grave 1 are shown on p. 119 and discussed on p. 269. A tripod cylinder vase from Grave 1 (p. 55, this volume) is shown on p. 249, another from Grave 4 (p. 70, this volume) on p. 250, and another from Grave 2 (p. 60, this volume) also on p. 250. A so-called "plastersmoother"* of the same general type as on p. 135 (this volume) is shown on p. 123 and is attributed ambiguously to the Stockholm museum but is in all probability from one of Linné's excavations.

* These stone objects doubtless played some role in fashioning the plastered surfaces of walls and floors, but their vesicular texture makes them ill-suited for finishing and polishing and better suited to some abrading operation. Just how they were used remains a puzzle.

ACKNOWLEDGMENTS

The University of Alabama Press is to be congratulated on making Linné's valuable books widely available again.

LITERATURE CITED

Angulo V., Jorge
 1987 Nuevas consideraciones sobre los llamados conjuntos departamentales, especialmente Tetitla. In *Teotihuacan: Nuevos Datos, Nuevas Síntesis, Nuevos Problemas,* edited by E. McClung de Tapia and E. C. Rattray, pp. 275–315. Instituto de Investigaciones Antropológicas, Universidad Nacional Autónoma de México, Mexico City.
Berrin, Kathleen, and Esther Pasztory (editors)
 1993 *Teotihuacan: Art from the City of the Gods.* Thames and Hudson, New York.
Cowgill, George L.
 2000 The Central Mexican Highlands from the Rise of Teotihuacan to the Decline of Tula. In *The Cambridge History of the Native Peoples of the Americas, Volume II: Mesoamerica, Part 1,* edited by R. E. Adams and M. J. MacLeod, pp. 250–317. Cambridge University Press, Cambridge.
Crider, Destiny
 2002 *Coyotlatelco Phase Community Structure at Teotihuacan.* Manuscript on file, Department of Anthropology, Arizona State University, Tempe, Arizona.
Linné, Sigvald
 1942 *Mexican Highland Cultures: Archaeological Researches at Teotihuacan, Calpulalpan, and Chalchicomula in 1934–35.* The Ethnographical Museum of Sweden, Stockholm.
Manzanilla, Linda (editor)
 1993 *Anatomía de un Conjunto Residencial Teotihuacano en Oztoyahualco.* Instituto de Investigaciones Antropológicas, Universidad Nacional Autónoma de México, Mexico City.
Millon, René
 1973 *The Teotihuacan Map. Part One: Text.* University of Texas Press, Austin.
 1976 Social Relations in Ancient Teotihuacan. In *The Valley of Mexico: Studies in Pre-Hispanic Ecology and Society,* edited by Eric R. Wolf, pp. 205–248. University of New Mexico Press, Albuquerque.
 1992 Teotihuacan Studies: From 1950 to 1990 and Beyond. In *Art, Ideology, and the City of Teotihuacan,* edited by J. C. Berlo, pp. 339–429. Dumbarton Oaks, Washington, D.C.
Millon, René, R. Bruce Drewitt, and George L. Cowgill
 1973 *The Teotihuacan Map. Part Two: Maps.* University of Texas Press, Austin.

Rattray, Evelyn C.

1990a New Findings on the Origins of Thin Orange Ceramics. *Ancient Mesoamerica* 1(2):181–195.

1990b The Identification of Ethnic Affiliation at the Merchants' Barrio, Teotihuacan. In *Etnoarqueología: Primer Coloquio Bosch-Gimpera*, edited by Y. Sugiura and M.-C. Serra, pp. 113–138. Instituto de Investigaciones Antropológicas, Universidad Nacional Autónoma de México, Mexico City.

1992 *The Teotihuacan Burials and Offerings: A Commentary and Inventory.* Vanderbilt University Publications in Anthropology, No. 42, Nashville, Tennessee.

2001 *Teotihuacan: Ceramics, Chronology, and Cultural Trends.* Instituto Nacional de Antropología e Historia and University of Pittsburgh, Mexico City and Pittsburgh.

Rodríguez Sánchez, Ernesto A., and Jaime Delgado Rubio

1997 Una ofrenda cerámica al este de la ciudad de Teotihuacan. *Arqueología* 18:17–22.

Scott, Sue

1993 *Teotihuacan Mazapan Figurines and the Xipe Totec Statue: A Link Between the Basin of Mexico and the Valley of Oaxaca.* Vanderbilt University Publications in Anthropology, No. 44, Nashville, Tennessee.

2001 *The Corpus of Terracotta Figurines from Sigvald Linné's Excavations at Teotihuacan, Mexico (1932 & 1934–35) and Comparative Material.* The National Museum of Ethnography, Monograph Series 18, Stockholm.

Sempowski, Martha L.

1994 Mortuary Practices at Teotihuacan. In *Mortuary Practices and Skeletal Remains at Teotihuacan,* by Martha L. Sempowski, Michael W. Spence, and Rebecca Storey, pp. 1–314. University of Utah Press, Salt Lake City.

Taube, Karl A.

2003 Tetitla and the Maya Presence at Teotihuacan. In *The Maya and Teotihuacan: Reinterpreting Early Classic Interaction,* edited by Geoffrey E. Braswell. University of Texas Press, Austin.

Tozzer, Alfred M.

1921 *Excavation of a Site at Santiago Ahuitzotla, D. F., Mexico.* Smithsonian Institution, Washington, D.C.

Widmer, Randolph J.

1987 The Evolution of Form and Function in a Teotihuacan Apartment Compound: The Case of Tlajinga 33. In *Teotihuacan: Nuevos Datos, Nuevas Síntesis, Nuevos Problemas,* edited by E. McClung de Tapia and E. C. Rattray, pp. 317–368. Instituto de Investigaciones Antropológicas, Universidad Nacional Autónoma de México, Mexico City.

ARCHAEOLOGICAL RESEARCHES AT TEOTIHUACAN, MEXICO

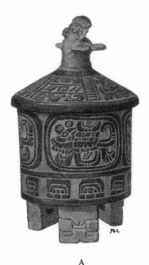

A

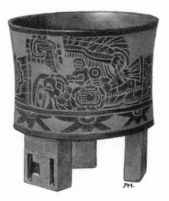

B

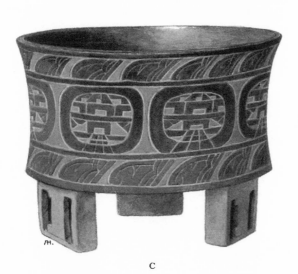

C

A. Tripod vessel with lid, found in Grave 2. (2/5) 3988. Cf. p. 62.

B. Clay vessel found in Grave 2. (2/5) 3985. Cf. p. 61.

C. Clay vessel found in Grave 4. (2/5) 4274. Cf. p. 68.

C O N T E N T S

7

P R E F A C E

Of the journey of archaeological study and research, the more important results of which are dealt with in the following, the initiative was taken by Sweden's envoy to Mexico, Minister C. G. G. Anderberg. By the Royal Swedish Academy of Science I was granted, for the purpose of carrying out this expedition, leave of absence for eight months, as from January 15th, 1932. Minister Anderberg also succeeded in interesting the two most important Swedish industrial concerns in Mexico, The Mexican Match Company Ltd. (Compania Mexicana de Cerillos y Fosforos, S. A.) and the L. M. Ericsson Telephone Company Ltd. (Empresa de Teléfonos Ericsson, S. A.), who generously placed funds at my disposal. The then directors of these firms, Mr. Holger Graffman and Mr. C. E. Lindeberg, subsequently lent their valuable support to the work in many ways. The original working plan did not include any independent excavation operations on an extensive scale. Before long, however, it became apparent that the most important result of the expedition would accrue from the carrying out of a comparatively costly excavation project. This was made possible by a grant from the J. A. Wahlberg Foundation, awarded me by The Swedish Society for Anthropology and Geography. By donations from Dr. Sven Hedin and Dr. Gösta Montell a first-class photographic equipment was secured. This included, as a present from Dr. Hedin, a standard guage film camera with the requisite film material. Thanks to the kind courtesy of Mr. Ch. Strand, of Oslo, Director of the Wilhelmsen Mexico Line, we obtained a substantial rebate on the ocean fares in the ships in which we travelled both out and back.

To all those who made my expedition possible and lent me their support I herewith wish to express my hearty and respectful thanks.

While waiting to receive my excavation licence, I began by making excursions to interesting ruin sites in the Valley of Mexico. Then, as well as later, great kindness was shown me by Dr. Manuel Gamio. Thereupon I went to Yucatan, by way of the air-line from Tejeria to Mérida. From Mérida I made trips of study to Chichén Itzá, where I had the pleasure and privilege of enjoying the generous hospitality of the research station of the Carnegie Institution. To its director, Dr. S. G. Morley, to Mr. Gustav Stromsvik, as well as to the other members of the Institution, I owe a heavy debt of gratitude.

9

I was also given an opportunity of visiting the ruin cities of Labná, Kabáh and Zayí, having been invited by Sr. Eduardo Martínez Canton, Inspector of the Ancient Monuments of Yucatan, and Sr. Emilio Cuevas, architect to the Dirección de Monumentos Prehispanicos, to accompany them on a tour of inspection. Lastly I had the privilege of studying the vast deserted city of Uxmal in the company of Dr. Frans Blom, head of the Department of Middle American Research at the Tulane University of Louisiana, New Orleans.

On my return to the capital I received, through the kind offices of Sr. José Reygadas Vértiz, director of Dirección de Monumentos Prehispanicos, permission to engage in archaeological excavation at Teotihuacan. Under supervision by him, as well as by Sr. Ignacio Marquina and Sr. Eduardo Noguera, the excavation work was in course of time carried out. In the middle of April my wife and I — she having at her own expense travelled out from Sweden, and arrived a few days earlier — began our work at Teotihuacan. In this connection it is with great pleasure I feel it laid upon me to give expression to my gratitude to Dr. George C. Vaillant, of the American Museum of Natural History, New York, for all the advice and guidance he unstintingly gave me. It may not be saying too much that it is largely due to him that my field work turned out so successful. He not only turned my attention to Teotihuacan, but our initial digging operations were in direct continuation of his own work.

By July we had finished our digging at Teotihuacan, and on August 2 the clearingup-work — packing up the collections, etc. — was completed. By way of much-needed intermission in the excavation work we had made minor excursions to ruin sites in the Valley of Mexico. We also visited other archaeologically important places, such as Xochicalco and Teopanzolco in the State of Morelos, Calixtlahuaca in Tuluca, and Tula in Hidalgo. As however our vessel for Sweden was belated and only sailed on August 26, we made use of the extended time for visiting Oaxaca. En route to that place we studied the excavations that had been carried out in the great temple pyramid at Cholula, and in Oaxaca we visited the ancient cities of Mitla and Monte Alban.

For our stay at Teotihuacan the Dirección de Monumentos Prehispanicos most kindly placed at our disposal quarters in the administration building. The local superintendent, Sr. José Perez, afforded us every facility for carrying on our work.

Lastly, I also wish to give my thanks to my assistants in the practical work of excavation at Teotihuacan: Porfirio and Viviano Reyes, Joaquin Oliva and Tomas Mendoza. Through their diligence, methodicalness and active interest it was possible to carry the extensive work to completion within the short time allotted to us, and with the limited financial means at our disposal.

Both the people of the country and the Swedes in Mexico always showed us the greatest kindness, so that thanking them all individually would be equivalent to thanking everyone with whom we came into contact.

Mr. Gustav Algård, Mexican Consul at Stockholm, has defrayed the cost of translation etc. The printing cost has mainly been met by a subsidy granted by the Humanistic

Foundation (Humanistiska Fonden), Stockholm, but as this cost, owing to the swelling out of the manuscript, proved in excess of the estimate, the balance was met by Mr. Edvin Paulson, of New York, for many years a friend and patron of the Museum.

Dr. Gunnar Beskow of the Geological Survey of Sweden with whom on earlier occasions I have had the advantage of collaborating — when he broke new trails for the examination of prehistoric ceramics — has also this time assisted me in the solving of highly important problems. The microscopic sections were, by kind permission of Prof. E. Stensiö of the Paleozoological Department of the Museum of Natural History, Stockholm, prepared by Mr. G. Rettig.

To Prof. J. P. Holmquist I remain greatly indebted for analyses of wall samples; Dr. Nils Odhner has also on the present occasion zoologically determined the mollusk material collected in the excavations, and Dr. Nils Zenzén has determined the stone objects from a mineralogical point of view. Miss Astrid Laquist has assisted me with advice on technical questions as regards textiles, and Mr. Stig Rydén with data from the Ethnographical Department of the Gothenburg Museum.

The drawings and water colours of the objects have been executed by Mr. Axel Hjelm, of Gothenburg, who with photographic exactitude — but with a keener eye for essentials than the camera — has reproduced his models. The fair-copying of my sketches and plans has been done by Mr. Torsten Sjöbohm, of Stockholm.

The translation of my manuscript into English has been carried out by my friend Magnus Leijer, of Gothenburg.

INTRODUCTORY NOTES

To South American ethnography and archaeology interest has in the last decades been devoted by not a few Swedish explorers, the foremost of whom was Professor Baron Erland Nordenskiöld. By him was at the Gothenburg Museum created its ethnographical department, which, in regard to South America, is counted among the most important in the world. Through the work of Nordenskiöld, and that of his pupils and other Swedes, Sweden has come to occupy a prominent place in Americanistic research. The Swedish sphere of interest, however, only extended so far as to include the Isthmus of Panama and the West Indies.

In the early 1880's Carl Bovallius carried out ethnographical and archaeological researches in Costa Rica and Nicaragua, and about the turn of the century C. V. Hartman did very important excavations in the firstmentioned republic, and pursued ethnographical studies in Salvador. In 1881 Gustaf Nordenskiöld, a brother of Erland Nordenskiöld, did some archaeological pioneering work of generally acknowledged value in Colorado in the American Southwest.

The ancient cultures of Mexico, as grandly imposing as they are fascinating, have practically only by our expedition been made subjects of scientific research carried out from Sweden. The present work, in which account is given of our archaeological researches at the famous ruin city of Teotihuacan, not far from the capital of the country, is, by reason of its being the first treatise published in Sweden on Mexican antiquity based on field work, of a somewhat heterogeneous character. It is divided in three main sections, viz. a brief synopsis of the pre-Spanish history of Mexico, and description of Teotihuacan with an account of the excavations at that place and their results, and, lastly an appendix of somewhat detached contents.

The introductory chapters, which deal with material well known to the specialist, are primarily intended for such readers as, although not Americanists, nevertheless may be interested in Mexican antiquity. The principal part of this work, i. e. where the results of the excavations are dealt with, is, on the other hand, written more for specialists. In the last section the geographical distribution of certain culture elements is, inter alia, dealt with. They have been brought together in one place so as to avoid weighting down and interrupting more than is necessary the account of the finds by passages of explanation and discussion. Without pretending to completeness, this

concluding section has purposely been made fairly full, particularly with account taken of Swedish students of cultural history who may be interested in ascertaining the distribution of certain culture elements, etc., as seen from an American point of view. The Humanistic Foundation (Humanistiska Fonden), Stockholm, whence the greater part of the printing costs has been defrayed, has a right to expect that the present work be not exclusively addressed to oversea specialists and a small number of Swedish Americanists.

<div align="center">*</div>

In the text below the figures the fractional number within brackets denotes the scale. »M» means that the object has been surrendered to Mexico. The numerals refer to the Museum catalogue, with omission made of its numbers for year and collection, 32.8. because — with only two exceptions — no objects from any extraneous collections are here depicted. All numbers below 3460 denote that the object was recovered at Las Palmas, while higher numbers indicate that Xolalpan was the locality of the find. »R. M.» stands for the Royal Ethnographical Museum of Stockholm, and »G. M.» for the Gothenburg Museum.

PART I

EXCURSIONS INTO MEXICAN ANTIQUITY

We do not with certainty know when, where, or how the first discoverers of America reached the New World. If we could answer the question why that continent first became the object of emigration, these problems would be easier of solution. It appears strange that the inhospitable — and nowadays sparsely populated — regions of northeastern Asia, which after the last glacial period cannot be supposed to have afforded particularly favourable natural conditions to man, could have played the part of a human reservoir for extensive waves of emigration. There cannot be much doubt, howevre, of the earliest emigrants having crossed from northeastern Asia via Bering Strait. That this might have taken place during the interglacial epoch, when climatic conditions with certainty were considerably more favourable, has a priori been rejected. The German geographer Albrecht Penck, however, has lately entered the lists in favour of the theory that America was populated prior to the last glacial epoch.[1] He maintains that it would have taken the immigrants a longer time than that which elapsed since the termination of the last glacial epoch to cover the distance from the extreme north of North America to the southernmost part of South America, and subsequently to adapt themselves so exceedingly well to the different natural surroundings. The basis of his argument is that the immigrants must, again and again, have had to remodel their culture, in accordance with fresh climatic conditions. Nordenskiöld, on the other hand, is of opinion that the move from Bering Strait to Tierra del Fuego might have been accomplished in only »a few years».[2]

If the »cradle of mankind» be assigned to Central Asia, and no emigration to America took place in that far remotely distant age before the last glacial epoch — which seems extremely unlikely that it did — the problem assumes a somewhat different aspect.[3] When some 200,000 years ago the great glacial period broke over the earth, Central Asia would seem to have been one of the climatically most favoured regions outside the tropics. Along the valleys of Kunlun, glaciers of extended length reached down from the Tibetan plateau, but otherwise the country was free from ice. There prevailed a climate much milder than at present. The rainfall was heavier, the rivers were

[1] Penck 1930:23 seq. [2] Nordenskiöld 1930:128. [3] For the data which here follow I am indebted to Dr. Erik Norin, a member of the Hedin Expedition to Central Asia.

14

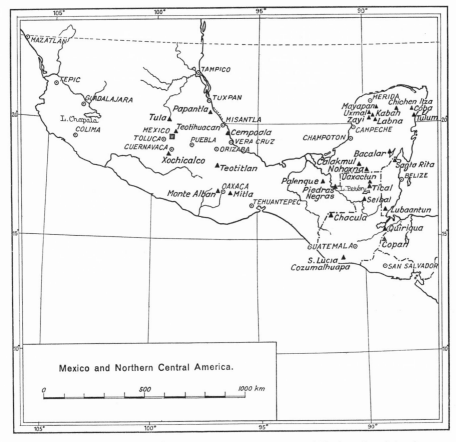

Fig. 1. Map showing important ruin places in Southern Mexico and Northern Central America.

flowing with much water, the boundless plains of the Gobi desert all the way to the lowlands of China were covered with grass and brushwood, affording abundant sustenance to masses of game, as well as to man and his domestic cattle. Nowhere else have the people of the earlier stone age left such abundant traces as in the Gobi desert, where the surface of the ground is strewn with implements from the different periods of the stone age. These bear witness to a population of hunters having in great numbers roamed over these expanses which now are nothing but sterile desert. But the periods of ice and cold came to an end. A milder climate melted away the masses of ice, and new possibilities offered themselves to the hunter peoples of Central Asia to seek fresh ground. Then the drying-up process of the land began. The rivers gradually ran dry, the lakes also began to dry up, and their water turned salty. Vegetation and animal life, including man, had to recede, and extensive emigration took

15

place eastwards as well as northwards. It is not improbable that this emigration, driven on by necessity, provided the very reason for the great migration via Bering Strait into America.

If we suppose that mankind only entered America after the termination of the glacial epoch, such an immigration could at the very earliest have taken place 25,000 or 20,000 years ago.[1] Immigration must subsequently have continued for long periods of time, and the immigrants must have belonged to a variety of races. Only thereby can be explained the wide anthropological divergences found among the Indians, and the circumstance that in America upward of 150 different languages were spoken. These immigrants were possibly related to the north-Asiatic peoples, or they may have constituted a branch of some originally central Asiatic race. Still more probable it may perhaps be that several races were represented among the groups of migrants that in the course of hundreds or thousands of years made their way into the New World, and across the bleak regions trekked southwards to more hospitable zones. By degrees these races intermingled, and thus gave rise to the strangely heterogeneous population of America. The possibility of the aboriginal population of America having obtained a comparatively slight addition of Melanesian or Malayo-Polynesian blood cannot, perhaps, be entirely disregarded.

At Folsom in New Mexico, Gypsum Cave in southern Nevada, as well as in Nebraska and Kansas, there have in latter years been discovered bones of extinct animal species in association with traces of human civilization. The era of »the Folsom man» has by Harrington been dated to 15,000—13,000 B. C., and the earliest occupants of the Gypsum Cave are estimated to have flourished there in 9,000—8,000 B. C.[2]

They were primitive people, those earliest known Americans, who subsisted on what wild fruits and roots that they could gather, and on hunting and fishing. Some impulse now and then they presumably received from outside in the course of time, and minor inventions and improving modifications were no doubt made, but development progressed but slowly during the first thousands of years. Erland Nordenskiöld has in one of his last works pointed out that the culture of the Indians is principally based on their own inventions, and that they have invented or discovered over fifty culture elements that were unknown to the Old World.[3] At a comparatively late period Asiatic culture elements penetrated into America, but these elements were in the main part of arctic origin, and in no case reached very far south. Such fundamental culture elements of the Old World as cultivated cereals, and the wheel, were only introduced after Columbus.

[1] N. C. Nelson (probably the leading authority on early man in America) has lately with extreme exactness collocated all data concerning the age of man in America. In summing up he, inter alia, says: »However, taking into consideration all facts set forth, the only conclusion that now seems warranted is that man did not reach the American continent until some time after, but probably incidental to, the general disruption caused by the last ice-retreat, and that he came as bearer of the partially developed Neolithic culture, somewhere between 5,000 and 10,000 years ago. If, on palaeontological grounds, more time than this must be granted . . . But even this admission still leaves the antiquity of man in America as essentially post-glacial» (Nelson 1933:130).

[2] Harrington 1933:188 seq.　[3] Nordenskiöld 1930.

16

In the Old World the distributing centres of civilization, such as Egypt, northwestern India, and the Euphrates and Tigris districts were situated in comparatively dry regions but never in forest tracts. The same applies to America. The homes of the high cultures were found in the almost desert-like Peruvian coastland and the central parts of Mexico. The sphere of the Maya Indians partly belongs to the tropical low country, but it is probable that their culture began and was developed in other regions. Of all the variegated cultures of America, perhaps there is none that in later years has been subjected to such intensive study as that of the Mayas. In the developed form in which we know it, it forms a comparatively young branch of that tree of development of which the roots maybe are to seek in the highlands of central Mexico.

An extensive literature dealing with the earlier history of Mexico is already in existence, and it is being added to at a fast increasing rate. We possess no mean knowledge of the distribution of the various peoples, their ways and customs, their social fabrics and their religious life at the time of the arrival of the Spaniards. This may above all be said of the Aztecs, who were then at the height of their importance. This picture is supplemented by extensive ancient monuments and a multitude of detached finds. Literary sources from pre-Spanish times are few in number, and only supply exceedingly meagre and vague informations as to earlier times. After the Conquest the representatives of the state and the church united in their endeavour to obliterate all associations with the past, with a view to consolidating the Spanish dominion. The notes that then were taken down by men who, in their inquiring zeal, conscientiousness, and scientific tolerance were centuries ahead of their times, e. g. the Franciscan monk Bernardino de Sahagun, are from natural reasons only able to supply vague information about times that were far removed from those of their informants. If we only go back a couple of centuries prior to the arrival of the Spaniards, we are already, so far as the Valley of Mexico concerned, in »pre-historic» times. The actually historical data of the Aztecs, it should be noted, begin in the latter half of the 14th century. The Mayas possessed a very accurate calendar and a comparatively highly developed art of writing. Their history is so far only little known, except for its most salient features, and conceptions of the correlation between their, and the Christian, chronology are extremely at variance.[1] According to the correlation most generally accepted it appears that the earliest dates on monuments at the ruin city of Uaxactun refer back to the close of the first century. Already at that time their culture seems, in its main features, fully developed, but where this had been accomplished, and how long time it had taken, as to this we are still in the dark.

Archaeological researches into the earliest history of the Valley of Mexico began with the first systematic stratigraphical investigations that were carried out in several places by Gamio, Spinden and Tozzer. These works were only commenced after the year 1910. But already at an earlier date attention had been drawn by Zelia Nuttall to clay figures of archaic appearance which had been found underneath the lava

[1] Computations as to this correlation differ in their extremes by not less than 520 years.

flow, or Pedregal, in the southernmost part of the Valley of Mexico. At the abovementioned excavations, which, so to speak, inaugurated a new archaeological era in Mexico, it was found that artifacts of the Aztec period were located above an archaeological stratum carrying relics of some earlier culture, the so-called Toltec, or Teotihuacan, culture. At a still lower level there were again discovered objects dating from an earlier population. While the firstmentioned layer was fairly thin, objects of Teotihuacan type were found in a somewhat thicker zone, but nevertheless it was at a fairly slight depth that the more primitive objects were present. The latter then continued down to a depth, in certain places, of ca. 6 m. The boundaries between the relics of these different cultures were fairly distinct, and the divergences between the respective artifacts were, largely speaking, exceedingly pronounced. A stratigraphical section of this kind constitutes, as it were, a book below the surface of the ground, and one that the archaeologist has to try to read if he wishes to bring to light the history of earliest Mexico. At the best, his researches will carry him right down to the far distant time when the population of the valley became settled there. A great deal of the work has been expended on gaining knowledge to this with certainty very lengthy history, but there is an immense task still remaining to be done. Systematic field work appears to provide the only path that leads to certain knowledge.

The Early culture — or the »Archaic culture», as it is usually less aptly called — is far from being homogenous. The North American scientist, Dr. G. C. Vaillant, has in latter years carried out exceedingly important, and extremely accurate, investigations at a number of places in the Valley of Mexico, and thereby been able to point out several consecutive cultures belonging to this earliest known epoch. He has for one thing succeeded in linking these cultures together in sequence, and for another in connecting them laterally. But the foundation from which they have developed has not yet been possible of determination.[1]

Prior to this, before Vaillant on the basis of the work of Gamio and other pioneers had built up his exact and entirely unromantic chronological table — as yet one cannot aspire to anything beyond a relative chronology — Spinden has tried to outline the development of Mexican civilization. He has also ventured upon a hypothetical fixing of data, an interesting enterprise, but one which, at the present stage of research, is somewhat hazardous. The first emigration is supposed to have been brought to a close before the domestic plants of the Old World began to be cultivated, or else the immigrants came from a region where no agriculture existed, seeing that none of the Old World's utility plants was known in America in pre-Spanish times. The coco palm and the banana plant, the former of which is certainly late, may possibly form exceptions. Against this may with good reason be objected that it is not so absolutely certain that the immigrants, even if they had previously been agriculturists, would have carried with them seeds on that long journey during which food supplies frequently enough may have been reduced to a minimum. At this time maize was still unknown

[1] Vaillant 1930; 1931; 1931 a; 1932; 1934.

18

in its wild state. Opinions as to its origin do not agree. Earlier suppositions were to the effect that maize had been developed out of a species of grass, teocentli (Euchlaena mexicana), growing in the Mexican highland. Maize, however, was probably not developed just by accident, but by purposeful labour.[1] It has lately, however, been pointed out by Sapper that the only plant which is botanically closely related to maize (Euchlaena luxurians), is found in the elevated parts of Mexico, Guatemala, and down to Nicaragua.[2] By this, the question as to the home of maize is answered. That it had been cultivated for a great length of time is evident from the fact that, at the time of the discovery, it occurred under most variegated climate conditions, from humid to such as periodically were very dry, i. e., from the lowlands and up to an altitude of 4,000 m. Of varieties and sub-varieties over 300 are known, and it has been pointed out that the most important ones had been developed already before the discovery of America. The cultivation of maize is the most important step in the path of development that ever in ancient or modern times — was taken by the peoples of America. In his »Diagram of American Chronology», Spinden, in his — in spite of a number of imperfections and errors — most excellent handbook on the ancient civilizations of Mexico and Central America, dates maize cultivation, and with that the origin of agriculture in America, to about 4,000 B. C. This dating is extremely uncertain, and Spinden himself says that »no one on the basis of present knowledge can offer more than an opinion concerning the data of the invention of agriculture in the New World»[3]. It is hardly capable of proof that maize was the first utility plant to be cultivated, but it is at all events beyond compare the most important. It may with good reason be said that the history of the American cultivated plants is that of American civilizations.

Spinden has quite rightly pointed out that the conditions of settled abode associated with maize cultivation has given rise to pottery-making. The conditions of settled life may certainly be said have provided both the impulse to, and the possibilities of, a new era, i. e., the dawn of civilization. Necessity may perhaps in our times occasionally be the mother of invention, but this rule did certainly not always hold good in ancient times. On the contrary, when the ever-present question as to the daily bread at least at times could be put aside, people were given a chance to devote time and thought to other problems. People could live in association in greater numbers, and this resulted in specialization, one of the royal roads to inventions. In the religious domain a radical change also came to pass. A new religion came into being, with a new, specialized pantheon. The rhythmical phenomena of celestial space, and their influence on earthly life, were given closer study and meditation. Out of practical observations astronomy was developed, as well as chronology and mathematics — ancient Mexico's proudest conquests in the realm of spiritual culture.

At the quarry of Copilco, at San Angel, a southern suburb of the City of Mexico, both human skeletons and artifacts have been discovered below a deep stratum of

[1] Cf. Nuttall 1930. [2] Sapper 1934:41. [3] Spinden 1928:53.

lava — in fact, a primitive American Pompeii.[1] The origin of the lava flow was the peak known as Xitli, and the eruption has approximately been dated to the latter half of the second millennium our era of chronology. But as regards this dating, opinions are far from unanimous. Thompson, for example, writes: »This lava flow can not be dated with any certainty, but it would appear to be quite late — perhaps not over 1500 years old.»[2] But it is not impossible that he underestimates the age of the lava flow. The finds below the lava at Copilco are of a comparatively high development, which agrees well with Spinden's datings referred to above.

In Sweden, as in many other places, the geologist is in a position to extend a helping hand to the archaeologist, thanks to geochronology, Gerard De Geer's genial studies of stratigraphied clays. Exact dating methods of this kind cannot however be employed in the Valley of Mexico. Neither can there be applied dendrochronology, Andrew Ellicott Douglass' wonderful dating method by the study of the yearly growth-rings of trees, which in the Southwest has given such splendid results in the way of dating.[3]

The only practicable method, it seems, will be the one employed by Vaillant, Lothrop and Noguera, i. e. by exact stratigraphical cuttings. In his so far published field-work results, Vaillant had been able to divide the Early, or Archaic, culture in several main periods. This chain will no doubt be added to by continued work. Progressive development can be followed, and it is not improbable that the earliest epochs of the history of the Teotihuacan culture are contemporaneous with the latest in the Archaic sequence. In this way Vaillant sees a chronological connection between the Early culture and that of Teotihuacan, but going back in time there is a great gap. For even the earliest of the periods presents every sign of being a highly developed culture. Vaillant therefore appears to have very valid reasons for his suggestion that the appellation »Archaic» be exchanged for »Middle» cultures.[4] Apart from the above-mentioned finds at Folsom and in the Gypsum Cave, the earliest culture period in the Southwest region consists of the so-called Basket Maker period. Its beginning — the first farmers of southwestern U. S. A. — may be placed at ca. 2,000 B. C.[5] They have been given the name of Basket Makers because of the exquisiteness of the basketry, while pottery-making appears at a later date. If we suppose that this took place in the third, and last, epoch of the Basket Maker culture, ca. 1,000 B. C., it follows that the inhabitants of the home country of maize would have made a start at pottery-making at a still earlier date. As Vaillant dates his earliest period to ca. A. D. 100,[6] there must in consequence exist relics of many and varied cultures still awaiting discovery. Co-ordination of cultures of which no ceramic remains are left behind, into a scheme of progressive development, does not appear very feasible.

In the work he has most recently published, Vaillant gives in tabular form »the

[1] Beyer 1917; Gamio 1920, 1929; Kroeber 1925; Nuttall 1926. [2] Thompson 1933:12.
[3] Huldt De Geer 1931; the most important works of these authors will be found in the bibliography.
[4] Vaillant 1930a:74 seq. [5] Kidder 1924:119. [6] According to a letter to the author.

sequence of cultures in Central Mexico, according to the archaeological evidence of 1932». In a simplified form it will appear as under, with seven main periods[1]:—

VII. Period of Aztec domination.
VI. Late Migration Period.
V. Teotihuacan Period.
IV. Late Period of Early Cultures (Archaic).
III. Middle Period of Early Cultures (Archaic).
II. Early Period of Early Cultures (Archaic).
I. Undiscovered formative stages equivalent to Basket Maker I through Pueblo III.

The above periods he has divided up according to the different cultures represented at the localities he has examined. Thus in the Teotihuacan period he differentiates between consecutive epochs. The Mazapan culture, referred to below, falls within the Late migration period.

Although he considers that he has chronologically connected the Archaic cultures with the Teotihuacan culture, the history of the latter cannot by far be said to be known. Vaillant also says: »The salient results of the season (1931—32) may be said to consist of ... establishing the fact that the Teotihuacan culture was not derived from Valley groups of the Early periods.»[2] It is probable that the development took place outside the Valley of Mexico proper, e. g., in Teotihuacan, and that it only later, and in more developed form, reached the localities where the stratigraphical investigations were made. As to the date of the flourishing and dying out of this civilization, the opinions of the different scientists vary most considerably.

While Vaillant is inclined to assign no very great age to the Teotihuacan culture, Walter Lehmann is of an entirely opposite opinion. Enumeration of the authoritative material, etc., cited by the two scientists would carry us too far. Vaillant makes the first of the epochs in which he divides this period begin at the close of the 8th century, and opines that the part of the Teotihuacan period was played out by the end of the 10th century. As perhaps already during the last epoch amalgamation with certain inhabitants of the Valley of Mexico, or with the bearers of the Mazapan culture, or possibly with both, had taken place, such a supposition would date the breaking up in question to the 12th century.[3]

Lehmann who unquestioningly may be placed at the head of modern experts on the earliest literature concerning Mexico, has, partly on the basis of other — and in certain cases unfortunately not yet published — sources arrived at entirely divergent results. A summary of his chronological table would have the following appearance:[4]—

1325—1519 Period of the Aztec domination.
1193—1325 The Pre-Aztec period, in part legendary.

[1] Vaillant 1934:127. [2] Vaillant 1932:489. [3] According to a letter to the author. [4] Lehmann 1921; 1922; 1933, and according to letters to the author.

1068—1193 The Colhua epoch, with Colhuacan for its culture centre.
726—1064 The later Teotihuacan culture (Jung-Toltekische Kultur).
600— 726 Interregnum.
500 B. C.—A. D. 600 The First Teotihuacan epoch. Extinguished in A. D. 571,
 according to Sahagun.

Although ceramics and other artifacts particularly during the later Archaic period point to a high degree of development, the building remains are of poor quality when compared with the magnificent architectural works of Teotihuacan. The origin and development of the Teotihuacan culture, at any rate that of the First epoch, can hardly be said to have been elucidated. In some degree hyperbolizing, but nevertheless not without justification, it might be said that suddenly — just as the tropical night after a brief dawn changes into brilliant day — the Archaic civilizations were succeeded by the highly developed Teotihuacan culture.

THE ARCHAEOLOGICAL CITY OF TEOTIHUACAN

Teotihuacan, one of the largest, and in many respects the most important of the cities of ancient America, is situated in the north-eastern part of the Valley of Mexico. It lies some 50 kilometres from the capital. In spite of the mighty dimensions of this monument of antiquity, and notwithstanding its being situated not very far from the Mexican capital, and moreover in a region of old traversed by particularly important highways leading to the Valley, it is only in later times that Teotihuacan seems to have aroused interest to any considerable extent. One of the reasons for this may well be that the city had probably been abandoned prior to the time of the conquest, and that the main portions of the architectural structures had fallen into ruins and perhaps even been buried under tumble-down wall-sections, sand and vegetation.

The Spanish conquerors thus make no mention of the place, and yet Cortés' defeated troops passed close by the spot after having been driven out of Tenochtitlan. At Otumba, a very short distance to the east of Teotihuacan, the Spaniards not long afterwards found an opportunity of revenging themselves for »la noche triste». On Alonso de Santa Cruz' map, which is preserved in Uppsala University, Sweden — the earliest known map of the Mexico valley from Spanish times and probably compiled before 1553 — in a spot roughly corresponding to that of Teotihuacan may be seen two figures.[1] Each of these resembles three boxes of diminishing size piled one on top of the other. On the other hand fairly detailed mention is made of Teotihuacan in the reports that in 1580 were dispatched to »His Majesty, Philip II, and the Council of the Indies» concerning conditions in this section of the Mexico valley. In these reports we read: »In the language of the Indians the name of the town of

[1] Dahlgren 1889; Eriksson 1919.

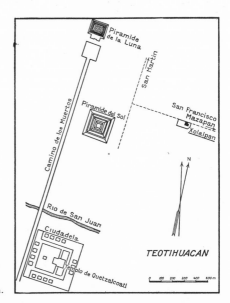

Fig. 2. Sketch map of Teotihuacan.

San Juan is Teotihuacan, meaning 'temple of gods', because in this town there was the oracle where the Indians of Mexico and those of all other surrounding towns idolatrized.»[1] On the map appended to the reports the pyramids of Teotihuacan are also set down. They resemble the figures drawn by Alonzo de Santa Cruz, but, in accordance with reality, are placed at an angle with each other and are surrounded by smaller conical figures. Of the place it is further stated, inter alia: »In the said town there was a very high pyramid temple which had (stairs with) three landing places (terraces) by means of which one ascended to the summit. On its summit was an idol they named Tonacatecuhlli, made of a very hard, rough stone all of one piece ... A little farther to the North was another (pyramid) temple slightly smaller than the first, which was called 'the Hill of the Moon', on the top of which was another great idol ... Surrounding this (pyramid) temple were many others, in the largest of which were six other idols called 'the Brethren of the Moon', to all of which the priests of Montezuma, the lord of Mexico, with the said Montezuma came to offer sacrifices, every twenty days.»[2] This description of the pyramids is rather at variance with actual facts, as will be apparent from information cited below. This naturally impugns the statement that every twenty days Montezuma made a journey of, there and back, 100 km. for the purpose of offering sacrifices. If such in reality was the case it does of course not necessarily mean that Teotihuacan at that time was not a ruined city. To this day sacrifices are being offered, e. g., by certain Maya Indians to their ancient gods, at badly ruined temples that were deserted centuries ago.

[1] Nuttall 1926:62. [2] Nuttall 1926:68.

23

Certain of the early chroniclers, such as Bernardino de Sahagun, Jerónimo de Mendieta, Toribio de Benavente Motolonía, and Juan de Torquemada, occupy themselves, however, with Teotihuacan. The last-mentioned supplies the following important information: »These Indians of New Spain had two Temples of great elevation and grandeur; erected six leagues from this city near San Juan Teotihuacan northwards from this city, dedicated to the Sun and the Moon ... and round them there are others exceeding two thousand in number; on account of which the place was called Teotihuacan, which means place of the Gods.»[1] The name is more likely to mean »the place where godship is attained».

But even in other, still earlier, writers this ancient city occasionally glimpses, although under a different name, to which I shall recur in the following. Then there again occurs a blank interval where no historical sources are available.

The great scientist Alexander von Humboldt, who not unjustifiably has been called »America's second discoverer», and, keenly observant of the wonders of nature and the works of man, made researches in Mexico during 1803—04, only refers to Teotihuacan thus: »The only ancient monuments that may attract attention in the Valley of Mexico are the remains of the pyramids of San Juan Teotihuacan.»

A comparatively voluminous literature directly dealing with Teotihuacan has sprung up during the last decades. Leopoldo Batres has written a good many minor essays, in which also his own work is given account of.[2] Unfortunately his writings are badly lacking in pregnancy and exactness, and, like his field work, are apparently not in every detail quite reliable. Peñafiel's work, on the other hand, is a monograph exceedingly good for its period.[3] Eduard Seler, the grand old man of Mexican research from Europe, is the author of an excellent treatise in which he above all deals with the movable finds and makes comparative studies.[4] The most all round elucidation of Teotihuacan in ancient and modern times, as well as of local conditions, is found in the monumental work »La población del valle de Teotihuacán», published by Dirección de Antropología under the editorship of Manuel Gamio and in collaboration with a number of eminent specialists.[5] It contains, inter alia, an account of the excavations on a grand scale that were carried out in the years 1918—22. Detailed study is devoted to the ancient monuments and the movable finds, in addition to which the present population of the valley is subjected to careful investigation. Gamio has also published its introduction which forms a recapitulation, in English, of the most important of the research results.[6] Interesting observations and exquisitely beautiful illustrations are found in Ignacio Marquina's monumental comparative studies of the architecture of the archaeological monuments of Mexico.[7] During his journey in Mexico in 1925—26, Walter Lehmann also carried out studies in Teotihuacan, and part of his observations have recently been published.[8]

While referring to the above-mentioned important and exhaustive descriptions

[1] Peñafiel 1900:29. [2] Batres 1889, 1906, 1906 a, 1908. [3] Peñafiel 1900. [4] Seler 1915. [5] Gamio 1922.
[6] Gamio 1922 a. [7] Marquina 1928. [8] Lehmann 1933:63 seq.

of Teotihuacan I propose here to give only a brief general survey and description of the most important of the architectural works. Otherwise, without some sort of introduction to local conditions, the account of our excavation work and its results is apt to hang in the air. Part of the buildings of Teotihuacan are mentioned in connection with the excavation of the ruin at Xolalpan, and different problems attached to the city will be taken up for renewed discussion in the comparative studies. Account has in the foregoing been given of the most widely divergent opinions that have been expressed as to the age of the city, and the variegated conceptions of the identity of the people that erected such a magnificent monument of its culture. With an assurance equalling that of certain students who maintain that the ancient inhabitants of Teotihuacan were Toltecs, others have denied that any Toltecs ever existed.[1] The most impartial way is therefore to name this ancient civilization by its most eminent locale. In the following the apellation of »Toltec» will therefore be discarded, and the culture connected with Teotihuacan will be referred to as the »Teotihuacan culture».

The district surrounding Teotihuacan is, in the dry season at all events, exceedingly arid. Arboreal vegetation is sparse, but, as is largely the case in the mountain plateau, also here extensive agave plantations occupy considerable areas of the arable ground. The surrounding mountains are almost bare of forest vegetation, probably the results of haphazard and wholesale timber-cutting during the colonial period. This circumstance no doubt largely contributes to the rapid drying-up during the dry season, but it is probable that the water question was a troublesome problem even in ancient times. In the reports above referred to the following passage occurs: »In the territory of the subordinate towns there is a lack of water, and the natives drink stored rainwater.»[2] These territories of the subordinate towns also include the ruined city of Teotihuacan. At the place now known as San Juan Teotihuacan there are bounteous springs, which naturally would have served to see the population of the ancient city through the worst period of the annual drought.

For the last fifty years, with intervals of longer or shorter duration, there has been carried on excavation work at a very heavy cost and involving an immense amount of labour, but so far practically only the more monumental of the buildings, and certain ruins of minor importance as regards size, have been laid bare and more or less restored. But even with a very large labouring force and modern technical resources the digging out of the entire city would require several decades of continuous work. For centuries the building complexes have been left to decay. Collapsed, broken-up and disintegrated structural remains, together with wind-drifted sand and soil, have piled themselves on the top of and around the more solid portions of architecture, which while still unexcavated mostly have an appearance of earth mounds.

It is difficult to determine Teotihuacan's original extension. The so-called archaeological zone covers 200 hectares and is surrounded by a fence. But far outside this area — within which the great ruins are situated — one finds remains of buildings

[1] Brinton 1890:83 seq. [2] Nuttall 1926:54.

that in all probability were included in the building plan of the city. They belong in any case to the same period. Quite close to the Teotihuacan railway station lies Teopancaxco, »Casa de Barrios», about 500 m. south of the southern limit of the archaeological zone. This little ruin is above all noted for its frescoes, whose figures in point of style are closely allied to decorations found on certain clay vessels typical of the Teotihuacan culture. The building works besides agree very closely, inter alia as regards planning, with the ruin at Xolalpan that we excavated. The last-mentioned spot lies about 600 m. east of the Sun Pyramid, but still farther away in the same direction, remains of ancient buildings are discernible. Equally distant to the west of the western limit of the zone there are badly dilapidated architectural relics to be found. A large proportion of the ground below the site of the village of San Martin, north of Xolalpan, is occupied by extensive remains of houses, many of which most certainly will be found in as good a state of preservation as the ruins below the maize field of Xolalpan. Important finds are likely to be brought to light by future excavation at San Martin. It therefore does not seem improbable that the dimensions usually given as the maximum extension of Teotihuacan — 6 km. in length by 3 km. in width — will be found correct.

The architectural remains largely consist of temples — or more correctly foundations of temples, seeing that the shrines themselves have everywhere completely vanished — and remains of houses containing apartments. What purposes the latter may have served is difficult to determine, but naturally at least part of them will have been dwelling rooms. A typical feature of all Teotihuacan buildings is their unsubstantial construction. Hewn stone occurs exceedingly sparsely. Pyramids, foundations of temples, etc., even ordinary apartment walls, are built of adobe — unburnt brick dried in the sun — or small undressed stones. Round these fragile building details, which were not joined together with mortar but occasionally with clay, a usually fairly thick and continuous course was laid on. This course, or layer, consists of clay mixed with broken-up stones of volcanic origin, »tezontle», and plastered over, not with ordinary mortar — lime and sand — but with lime only, cf. fig. 15. Herein lies the cause of the Teotihuacan buildings having in such a high degree perished. As soon as the stucco coating had disintegrated, the buildings not only lost their distinctive shape, but vegetation, rain, wind and injurious action committed by men or animals readily achieved their complete destruction. The roofs were probably more or less flat and supported by wooden beams, but it has been impossible to obtain any certain evidence as to this construction owing to the wall remains rarely being above one metre in height. The doorways were rectangular and in certain cases possibly lined with wood, or only at the top edged with a horizontal beam of wood or stone. Window openings were probably unknown, and to this day buildings of a plainer category, such as the huts of the common people, lack daylight ingresses, the doorways excepted.

The most important, or at any rate the most remarkable in point of size, of the build-

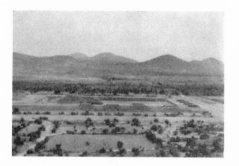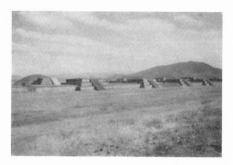

Fig. 3. Ciudadela. Left: view from the top of the Sun Pyramid. Right: the western embankment wall.

ings are two great pyramids, the Sun Pyramid and the Moon Pyramid, and an extensive lay-out, the so-called Ciudadela, cf. plan, fig. 2.

According to legend, the gods had once assembled at Teotihuacan, and thereupon the sun and the moon had begun travelling along their newly appointed courses. This is supposedly the origin of the ancient tradition that assigns to these two great pyramids their pertinence to the sun and the moon, respectively. Whether this actually is an unbroken tradition from the era of the pyramids, or whether this significance has been given to the building works in question by a later population, is naturally impossible of determination.

La Ciudadela, or the temple of Quetzalcoatl as the building complex nowadays is generally called, largely speaking consists of a spreading establishment surrounded by broad embankment walls. The entirely misleading appellation of Ciudadela, »the citadel», had come into being prior to the large-scale excavations that were begun in 1917, and, carried out with extraordinary energy, in the main were completed in 1922. Formerly these walls were supposed to form part of some sort of fortification, but La Ciudadela was in all probability a temple place, where ceremonies, sacrifices and other religious actions could be performed by a large concourse of celebrants. There were in ancient times a good many open places or court-yards, surrounded by buildings erected on foundations of pyramidal form. Low platforms connected these constructions, which frequently were symmetrically arranged. Thus Ciudadela does not stand in a special category of its own, but is merely the largest and best preserved structural complex of its kind.

The building complex is nearly quadratic in shape, cf. diagram fig. 2, its side measuring over 400 m., whilst the width amounts not less than 80 m. The western embankment wall, fig. 3, over which the court-yard is reached by means of two stairways 30 m. wide, measures only about half the height and width of its fellows. It consists of only one »storey» while others have two, the upper being narrower. Each embankment wall is surmounted by four platforms with quadratic base, with exception of the eastern with only three such platforms. The platforms of the western wall,

27

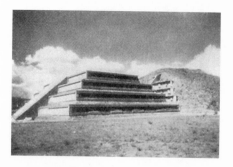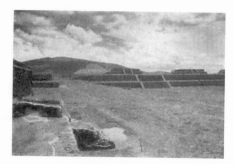

Fig. 4. Ciudadela. Left: the temple of Quetzalcoatl. Behind it the excavated portion of the older pyramid. Right: the western part, in the background the Sun Pyramid and Cerro Gordo.

which is the front or entrance side, are directly accessible from the outside by means of stairways, but are not otherwise communicating with the building. The rest of the platforms, on the other hand, are only mountable from the embankments by means of stairs on the sides facing on to the court-yard, that correspond to stairways leading from the court-yard to the top of the embankments. The different approaches, from the outside, or the inside, to these small platforms were probably associated with certain long ago forgotten customs of ritual import.

On the middle line of the court-yard there is a low, square platform with steps on either side. The eastern portion of the court-yard lies on a somewhat higher level than the rest, with which it is connected by two wide stairways. It is possible that this raised portion was forbidden to the common people — perhaps the whole area within the embankment walls was exclusively set apart for ritual performances — as there have been discovered remains of extensive foundations of buildings that possibly were dwellings for the priests charged with the care and use of the temple. One of these compounds forms a square, the middle portion of which consists of a slightly sunk court-yard with apartments symmetrically grouped around it. Those which are next to the court-yard are provided with antechambers opening on to it. The general building plan at this place shows an unmistakeable correspondence with the ruin that we excavated at Xolalpan. Similar house remains are, however, to be seen even in the north-eastern corner of the western, and larger, portion of the court-yard.

On the line dividing the court-yard into an eastern and a western portion there elevates itself an only partly excavated mound which represents the remains of the central temple of this cult place. Excavation revealed that the mound contained two temple pyramids, an earlier one as well as one of later date, the latter built in front, and partly on top, of the former, fig. 4. In order to uncover the earlier façade, the immediately adjoining portion of the later one was cut away. The façades of both are facing west, i. e. towards the larger of the court-yards. The pyramids are of step construction, that is to say they consist of platforms erected one on top of the other,

28

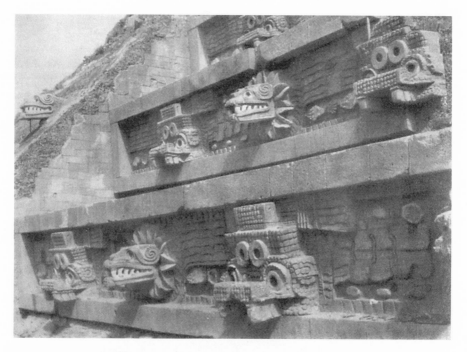

Fig. 5. Ciudadela, temple of Quetzalcoatl. Part of the façade of the older building.

of decreasing size and with vertical sides. The earlier one consists of six platforms of this kind, and of the later four have been preserved. The building material consists of »rubble», which in the earlier building is coated with stones, and in the later for the most part covered over with plaster. Of the shrines that may have crowned these step-pyramids nothing whatever has survived. This is also as a rule the case with regard to the temple ruins of the high country, whilst in the Mayan ruined cities the shrines surmounting the pyramids, resembling gigantic altars, are well preserved.

The front face of the earlier pyramid, which was partly hidden below the later building had at the time suffered remarkably slight damage. By reason of having been protected from destructive forces thanks to the later pyramid, these structural parts appeared in an exceedingly good state of preservation. The remaining three sides, which had probably been decorated in the same way, are on the other hand badly dilapidated. The stone coating has been removed and used in the building of churches and houses in neighbouring villages. The preserved, western façade is built of stone and conforms in style to the frontal faces of Ciudadela's embankment walls and platforms. This profile, which is characteristic of Teotihuacan, also recurred in the house ruin that we excavated, cf. fig. 15. It is richly decorated with sculptured figures

29

and reliefs. The former represent »The Obsidian Butterfly», which apparently was an important deity, probably the rain god, and »The Feathered Serpent», the symbol of Quetzalcoatl, the mythical hero of the inhabitants of ancient Teotihuacan. The writhing bodies of the feathered serpents and rattlesnakes are chiselled in relief and form a background for the heads that project from the façade. In the free spaces about the snake bodies, sea shells are chiselled in relief. Even on the balustrade of the broad stairway that led up to the top of the step-pyramid, the same kind of massive forbiddingly grinning serpents' heads have been placed, fig. 5. This dramatic decoration was further enhanced by paint. The teeth of the serpents' heads were painted white, as were the eyes of the rain god, which in addition were fitted with pupils of polished round disks of obsidian. As the predominant decorative motif consists of representations of Quetzalcoatl, Ciudadela — and this structure in particular — has been given the name of Quetzalcoatl's temple. Quetzalcoatl, being the god of the winds, was closely allied to the rain god, and it is interesting to note the predominance at this place of these to agriculture so important spiritual potentates. The preserved façade was decorated with altogether 66 heads of both types. As the lengths of the remaining sides are known, as well as the dimensions of the heads and the intervals between them, the heads once decorating each of the sides must have numbered 96. This makes a total of 354, to which should be added the twelve that were mounted on the parts forming insets in the stairway, or 366 in all. It is not impossible that in these numbers, as well as in others that may be revealed in similar studies of the decorative details of the pyramid, there may be hidden numbers connected with the calendar. The great pyramid of Chichén Itzá, partly reconstructed by Mexican archaeologists, may doubtlessly be looked upon as a key, in stone, to the Mayan calendar.

The later pyramid, fig. 4, is devoid of any such decorations, and conforms as to style with the remaining portions of the settlement. Whether it was fully completed only at the same time as the earlier temple pyramid was discarded and built over, is uncertain. Remarkably enough this development is of a retrograde nature, as it makes for simplification. To people of our time, who have learnt to appreciate the beauty of the severe and clear-cut style, La Ciudadela however stands out as perhaps the finest architectural work of ancient Mexico.

Exceedingly interesting information is found in »Historia de los Reynos de Colhuacan y de Mexico», the history of the kingdoms of Colhuacan and Mexico. A certain Quetzalcoatl, a priest-king of the Toltecs, lived from A. D. 843 to 895. It is related of him that he never showed himself to the people but dwelt in the innermost retreats of his house, and that heralds on the wall tops guarded his safety. This account fits in very well with the Ciudadela settlement at Teotihuacan.[1]

From Ciudadela a broad and in parts cemented road leads in a northerly direction and past the Sun Pyramid to the about 1700 m. distant Moon Pyramid. As the ground rises towards the north, this road is here and there interrupted by steps. The road,

[1] Lehmann 1933:69.

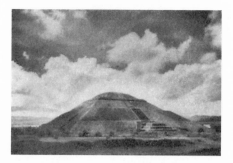

Fig. 6. The Sun Pyramid. Left: the northwestern corner. Right: the pyramid seen from the west.

which constitutes the main axis of the city plan, is bordered with mounds that formerly were supposed to be graves, and was for that reason called »Camino de los muertos» — the Road of the Dead. More correctly perhaps would be »Via sacra», the sacred road. For it has since been shown that some of these mounds contain remains or foundations of houses and others consist of small pyramids, while no graves have been discovered in them. The temples, now vanished away, that once stood on those little pyramids were probably shrines for sacrifices to less important members of the somewhat crowded pantheon of ancient Mexico.

The work of excavating Camino de los muertos, and the building remains along it, is uninterruptedly being pursued. So far the only section laid open and examined is the part bordering on Rio San Juan. On the western side of the road and near the river bank there is an interesting complex known as »Los subterráneos», or more correctly »Los edificios superpuestos», the Superimposed buildings. This consists of earlier building remains which have been filled in and afterwards built over with later structures. Of the earlier remains hitherto excavated the chief interest centres on a small temple with, among other things, simple frescoes. The floor of the earlier buildings are on about the same level as Camino de los muertos. In one of these rooms is found a 10 m. deep well containing good drinking water.

On the opposite side of the road there is a fairly spreading complex, The Temple of Tlaloc, the god of rain, which has been uncovered in the last years. It derives its name from the circumstance that there were found large clay plaques with emblems that seem to refer to the rain god. In this spot, too, there are later buildings on top of those of an earlier period.

Next after the badly ruined pyramid of Cholula, the Sun Pyramid, Pirámide del Sol, is doubtlessly in point of volume the mightiest building work of ancient Mexico. During the years 1905—10 excavation was completed of this pyramid, which through the agencies of rain, vegetation and decay from weather, in the course of time had lost its characteristic contours and almost deteriorated into a mere mound. The work was directed by Leopoldo Batres, the man at whose initiative it was undertaken, who

31

however in all probability carried it out with a far too heavy hand, and all the more so in the restoration that followed. Below the side surfaces that originally had been stone-plated, he found at a depth of 4—6 m. a second stonecasing enveloping the pyramid proper, which was constructed of adobe and stones. By removing this outer envelope, which had been transformed into a shapeless mass, he obtained — with more or less accuracy — the original shape of the pyramid, albeit reduced in size. The surface that had thus been laid bare soon, however, began to disintegrate on account of the rains because the stones were only bound together by clay. In order to stop further damage, Batres had the joints between the stones filled with cement. Thus the shape possibly remains true, but the surface presents an alien, modern appearance.

The sides of the pyramid are not smooth, but pointed and apparently methodically placed stones project from them, probably for the purpose of providing hold for the original casing. On the southern, eastern — and to some extent also the northern — side of the first and second terraces there remain walls of buttress character, forming angles with the sides, that also had for their object the retention of the outer layer.

As seen in the pictures, fig. 6, the pyramid consists of five architectural blocks in the form of truncated pyramids. The base surface of each is slightly smaller than the top surface of the one next below. The sides of the topmost but one begin by rising almost vertically, but later assume the same angle as the outer sides of the rest of the platforms. Of the temple that crowned the erection no remains whatever are preserved. On the western side, in front of the stairs leading to the top, is erected a structure consisting of three platforms of decreasing sizes placed one on top of the other. It is probable that here, as well as on the topmost terrace of the pyramid, one or more images of gods were once set up. The present measurements of the pyramid are: the western, eastern, southern and northern sides are at their bases, respectively, 211, 207, 215 and 209 m. long, the base area thus being over 46,000 sq. m. The height is 64.5 m., and the sides of the topmost terrace are about 40 m. in length. The cubic measurement has been computed at ca. 993,000 c. m., and the weight at ca. 2,980, 000 tons. Originally, that is to say before the removal of the outer layer, the length of each side would probably have been about 220 m.

As will be seen from the plan, fig. 2, the base lines of the pyramid are orientated by the four cardinal points. It is a remarkable circumstance that this pyramid, as well as the Moon Pyramid, Ciudadela, the Road of the Dead, etc., is not orientated according to the astronomical north, but that its north axis has a strong easterly deviation. The ancient inhabitants of Teotihuacan consequently did not use the Pole star for ascertaining the astronomical north, but the directional planning of the buildings was due to other, as yet unknown, observations. It would however not seem impossible that a professional astronomer might be able to solve this problem. Still I consider the following facts worth mentioning. The peak of Cerro Gordo, the highest mountain of the region is to be seen in the prolongation of the Road of the Dead. A line from the

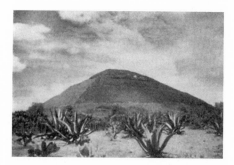

Fig. 7. The Moon Pyramid. Left: as viewed from the southeast. Right: northern view.

Moon Pyramid to the top of the Sun Pyramid meets if lengthened the crest of Cerro Patlachique. Further Cerro Cuauhtlatzingo is situated straight east of the Sun Pyramid.

Even the interior of the Sun Pyramid is partly capable of being studied. In the middle of its eastern side a horizontal tunnel has been bored right into its centre. Its width is one metre, its height nearly twice as much, and its length 110 metres. As has been mentioned, the building material consists of adobe, and in this clay are found pottery fragments, broken-up clay figures, etc., which therefore originate from an earlier period than that of the pyramid. So far as I have been able to find, these ceramics are not assignable to any of the earlier cultures that are hitherto known. Once this is done it will be possible to determine the maximum age of the pyramid, that is to say it must belong to period subsequent to that in which the ceramics present in the adobe were manufactured.

The Sun Pyramid is situated on a carefully levelled piece of ground framed in by a wide platform whose sides are parallel to the side of the pyramid and open to the west. Between its western side — the step façade — and the Road of the Dead there are eight small pyramids, collected in two groups. This platform once formed the support of buildings of which any considerable remains are only found in the south-western corner. Round a low pyramid are located rows of apartments and a couple of small court-yards. This lay-out has been given the name of »Casa de los Sacerdotes», the house of the priests.

The Moon Pyramid is of more modest dimensions, although this building work, by itself considered, is quite imposing. Its basal area is not square like that of the Sun Pyramid, but rectangular. Thus the south and north sides each measure 150 m., the other two 120 m. Its height amounts to 42 m., but the rising of the ground makes the upper surface of the top platform reach a level equal to that of the Sun Pyramid. As regards planning and mode of construction, the two buildings, on the other hand, present close correspondence. Thus the shape of the Moon Pyramid is that of five truncated cones placed one on top of the other, the topmost but one being considerably

lower than the rest, cf. fig. 7. Also here the top is reached by means of a large stair-case at one of the sides. Contrary to the general rule, however, these steps are situated on the southern side, i. e. towards the Road of the Dead. According to the architectural rule of the mountain districts, all stairways should have a western orientation. The lower part of the stairway consists, among other things, of an elevated, strongly projecting platform. Once upon a time the sides of the pyramids were undoubtedly smoothly plane, besides being plastered and painted. Unlike its fellow, the Moon Pyramid has only to a very small extent been excavated and restored. Undoubtedly future work at its pre-servation will be less roughly carried out than was the case with the Sun Pyramid.

At the south face of the Moon Pyramid the Road of the Dead terminates in an open square, The Plaza of the Pyramid of the Moon, once defined and surrounded by various kinds of buildings. Near this square and on the western side of the road are situated the remains of an interesting building. The excavation of these remains was begun as early as 1886, by Leopoldo Batres, who here recovered frescoes which in part were well preserved, and the establishment was therefore named »Casa de los frescos», the House of the Frescoes. It is also occasionally known as »The temple of Agriculture», because, according to Batres, one of the frescoes shows the apportioning, and the offering to certain deities, of agricultural products. Another of these frescoes, which by this time have largely perished, carries two consecutively superimposed paintings on top of the original decoration. Only a small portion of this building complex has so far been excavated.

In the south-western corner of the square, and fronting the Moon Pyramid, there was discovered an enormous stone figure carved out of a single block, the so-called »Diosa del agua», the Water Goddess. The figure undoubtedly represents a woman, but what particular deity it refers to might well be more than hazardous to determine. The statue in question is 3.19 m. high, and its weight is estimated at more than 22,000 kg. The ancient Teotihuacan people must — not least when it is remembered that the wheel was unknown in these parts in pre-Spanish times — in their own way also have been wonderful mechanical engineers, in that they were able to handle blocks of that size. That in the shaping of large stone figures, as well as in the working out of intricate details, their only tools were of stone and extremely simple, must arouse our admiration. With much labour and great trouble the Diosa del agua was in 1889 transported to Museo Nacional, Mexico City, a piece of work that required nine months. Not far from Diosa del agua was also discovered a second colossal statue, which however was badly damaged. Also this one represents a female deity. The spot where these figures originally stood is impossible of determination. That they might have been carried up the pyramids does not appear very probable, and if such had been the case, how is it that they were discovered so far away from them? On the breast of each figure is a circular depression. In this may possibly have been fixed a stone disk, let-in, thus providing the figure with a »heart», in other words, made it a living thing. Tradition has it that the god image on the Sun Pyramid carried on its breast a golden shield of

circular shape. This, to say the least of it, is improbable, especially as gold has never been discovered in Teotihuacan. Altogether impossible might perhaps not be that this image's heart was of obsidian, and that this obsidian disk in course of time was transformed by popular imagination into a golden disk.

As already mentioned, the Teotihuacan ruin complex occupies a considerable area. Walter Lehmann has in his above cited new work pointed out that the flat ground on account of its lack of natural limitations, in which respect it is the opposite of, e. g., Monte Alban, Xochicalco, and other mountain cities, invited to spacious planning. Hence there lies upon this ancient city an air of rare grandeur and sublime repose. There is an admirable blending of nature with culture in that the pyramids spontaneously and naturally fit in with the perspective of the landscape. Cerro Gordo, the great mountain north of the city, completes the panorama viewed from the south in such a way as if the mountain itself were a creation of man, or as if its soft and serene contours had served as a model for the pyramids.

PART II

ARCHAEOLOGICAL EXCAVATION WORK AT
TEOTIHUACAN IN 1932

After having travelled for purposes of study through, among other places, Yucatan, visited various spots of archaeological interest in the Valley of Mexico and adjacent districts, and finally conferred with different archaeologists, I came to the conclusion that Teotihuacan was likely to offer the best chances of successful field work. Dr. George C. Vaillant, who during the winter months had been carrying out stratigraphic excavations in different spots in Teotihuacan, assisted me in a most unselfish way by word and deed in the planning of my work. One of Dr. Vaillant's principal objects during the excavation season, i. e. the dry season 1931—32, was the finding of points of contact between the »Archaic» periods and the Teotihuacan civilization. At these researches at Teotihuacan he had discovered ceramics of a type hitherto unknown. It seemed to belong to a period earlier than the Aztec era, but later than that of Teotihuacan. As the spot where he had made this discovery would be likely to furnish further valuable results, Dr. Vaillant advised me to start in there until a suitable, fresh field for my work could be found. By kind courtesy a licence to carry on excavation work was eventually issued to me by the Department of Archaeology of the Ministry of Public Education of the Mexican Government (Dirección de Monumentos Prehispanicos, Secretaría de Educación Pública). On April 20 my wife and I moved out to Teotihuacan. An apartment in the Administration building and a section of the Museum store-house were placed at our disposal. It goes without saying that thereby our work was facilitated to an exceedingly high degree, and for all their kindness to us we are deeply indebted to the Mexican authorities concerned, above all to the Director of the Department, Sr. José Reygadas Vértiz.

Las Palmas.

Excavation work was begun on April 21 in a maize field situated about 200 metres south of Xolalpan. Regarding the naming of the site there was some difference of opinion. The landowner considered »Las Palmas» most appropriate, and as it was necessary to distinguish in some way between the two sites, this was the name we

adopted. Whether correct or not, is a matter of no practical importance. Our working staff consisted, apart from the landowner, Tomas Mendoza, of five men who had previously been working for Dr. Vaillant.

As I have already made grateful mention of, this site was recommended to me by Dr. Vaillant, who had here earlier — during the excavation season, the dry season, of 1931-32 — done some extensive work. Like Xolalpan, Las Palmas is situated in San Francisco Mazapan.[1] The type of pottery which here predominates, to which until then no particular attention had been paid, and which differs both from the Teotihuacan culture and the Aztec period, was by Dr. Vaillant given the name of Mazapan. It dates from a period lying between the two cultures just referred to. What people those potters belonged to may perhaps never be revealed, and, analogous to precedents, this newly discovered culture may suitably, at any rate for the time being, be described as the Mazapan culture. Dr. Vaillant's collection from this site being more important than that obtained by us, and as he is going to publish his researches, I have thought it more suitable to report on Mazapan finds from our second working place, viz. Xolalpan. These are however supplemented with a number of finds from Mendoza's field. This also applies to the groups of objects collocated under Part VI, the material of which mainly originates from Xolalpan.

Cuttings were made in different portions of the field, with varying results. In the course of these were discovered six graves containing fairly rich sets of ceramics. The principal interest centred however on the discovery of a natural cave, the descent of which bad been situated within a house. In digging at a spot 20 m. due west of the present dwelling house was revealed the presence of large, mainly rectangular, stones disposed in rows. This arrangement was strongly suggestive of a foundation for a wood-built house. Within these rows, which will be seen to form a rectangle, there were at a depth of 1.4 m. found a number of large stone flags placed together in a row. These formed the roof of the descent of the beforementioned natural cave, which was fairly roomy. On the stone flags was found a figure of stone, fig. 267, with fragments of typical Mazapan pottery lying around it. The cave contained nothing beyond two exceptionally large and undecorated vessels, one of which is reproduced in fig. 96 and they appear to have done service as storage jars. The above constitutes the only actual dwelling house remains that were discovered from the Mazapan culture. Of the finds an account will be given in the following, Part IV.

Xolalpan.

During our work at Las Palmas we were now and again obliged to interrupt excavation operations in order to get time for putting our fast-growing collections into some sort of order. It was my wife's principal task to sort, label and catalogue the

[1] Plancarte (1911:87) states that according to Pomar the signification of Mazapan is the deers' water, »agua de venado».

material, as well as doing the mending work that was necessary. If a vessel was re-covered all in fragments, it might very easily happen that in a soil in which potsherds so profusely were embedded, some individual fragment or other might be overlooked. On days when excavation work was thus suspended I also reconnoitred the ground north of the road that leads, roughly, from the north-eastern corner of the Pyramid of the Sun to the church of San Francisco Mazapan. So far as I was able to ascertain, the profane settlement in Teotihuacan's era of greatness must to a certain extent have been concentrated to these parts and to the present-day village of San Martin. In many instances it seems that the present roads have been laid out across ground containing the remains of houses. Below the stone walls that largely fence in the roads — the latter having through the ages been worn down below the level of the surrounding ground — may be seen the lighter-coloured streaks of lime-plastered ancient floors. Traces of ancient houses were, besides, also found near Las Palmas.

After careful consideration, and having made arrangements with the owner of the ground, I selected for a fresh working place a maize field bordering on the southern side of the road just referred to, cf. fig. 2. Its distance from Las Palmas was only about 150 m. in a northerly direction. This plot, which was rectangular, was on all sides defined by roads, and from three directions it was possible to make out remains of floors. The name of the place was Xolalpan, or Xolalpa,[1] and the name of its owner was Porfirio Reyes. This man and his brother Viviano, and a third Teotihuacanian by the name of Joaquin Oliva — who had previously taken part in the excavation of Ciudadela — were engaged as my assistants.

While the work at Las Palmas was still going on, test-diggings were on April 26 started in the maize field of Xolalpan. While the brothers began trenching near the dwelling-house — where they had previously come across hewn stones and ceramics — Joaquin Oliva was set to digging test-trenches in the north-western portion of the field. Already on the first day he came upon, at a depth of 1,50 m., the remains of a floor, and on the day following we were able to ascertain that ceramic finds above the floor-level were of Mazapan type, while on the other hand the artifacts below the floor were of Teotihuacan type. At the same time the brothers had unearthed, at very slight depth, a floor and the remains of a wall quite near their small hut which was situated in the north-eastern portion of the field. On the next day and onwards the whole working party was concentrated upon this spot, with the exception of Thomas Mendoza, who was to clear up the work he was engaged upon in his own field. Pro-ceeding from the wall that formed the initial find, cuttings were made, one parallel to the direction of the wall, and another at right angles to it. The object of this was to ascertain, if possible, the size of the house ruin, in case it was the ruins of a house.

[1] In La Población del Valle de Teotihuacan (Gamio 1922), Tomo II, p.669, the following explanation is given as to the name of Xolalpa: »De xolal, carril o camino que se hace entre los campos, y la terminación paopan, en o sobre: solar que está sobre el carril. Este nombre se refiere a un solar de San Martín de las Pirámides que viene a ser la porción pequeña que resulta de dividir un solar cuadrangular con una callejuela oblicua, que es el carril o xolal que sirve de raíz a la palabra.»

Very soon we clearly saw that we had been lucky enough to come upon the ruins of a building complex of fairly considerable extension. Thus the building remains occupied a large area, and everything pointed to conditions here being analogous to those prevailing in the north-western portion of the field, that is to say the remains belonged to the Teotihuacan civilization. Unfortunately the two working gangs fell out with one another. At first those with a priority of engagement, the men that had been transferred from Las Palmas, were put to making test-diggings outside the pegged-out ruin area, but eventually they had to be discharged. With the assistance of only four men, the brothers Reyes, Joaquin Oliva and Tomas Mendoza, the work was carried on, and was completed July 29. Day by day fresh portions of the building complex were brought to light, and when the work was finished the whole lay-out had been examined with the exception of certain of its eastern portions which were situated below the modern dwelling-house, the steam-bath house, and the cactus plantation surrounding them. Much then still remained to be done, but my leave of absence was restricted to nine months, and by the Swedish, or Norwegian, shipping lines sailings as a rule only occur once a month between Mexico and Scandinavian ports. Time did not allow of any delay with the dividing up of our collections between Mexico and Sweden, and their subsequent packing and dispatching to Vera Cruz for forwarding on to our home country. During the remaining days of our stay at Teotihuacan, the brothers Reyes were, at my expense and in accordance with our agreement, put on to restoring as far as possible the maize field to its original condition.

However tempting it might have been to uncover the ruins in their entirety, we were compelled to excavate the place section by section, and then as a rule the removed soil had to be thrown into the portions that had previously been cleared. The photographs that were taken of all the excavated sections and more important details therefore carry little interest beyond that of being a check on the accuracy of the diagrams. As however they would be of little or no use to anyone that did not take part in the work, I have deemed it unnecessary to devote any space here to those photographs. In the course of the work special drawings were made of all important details: stairs, doorways, etc., of the rooms, of larger sections cleared at the same time, and as the ruined site more and more was revealed it was simultaneously recorded on a general ground-plan. On account of the relatively large scale that was used, the measurements suffered to some slight extent in exactness, but the deviations that resulted were corrected by means of the detailed diagrams when working out the complete plan. As fixed points to which all measurements were correlated served the northwestern corner of the apartment first excavated (No. I on the plan), and the southwestern, northwestern and southeastern corners of the ruin.

The ancient building site showed, in the state in which we found it, that it had been added to and extended again and again, and therefore represented the final stage of a lenghty course of development. Time unfortunately did not allow of a thorough

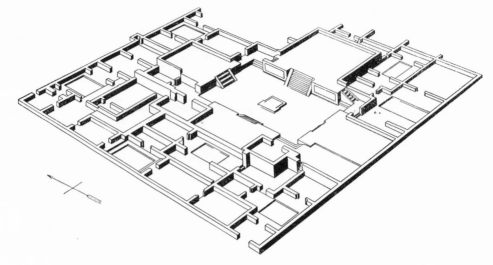

Fig. 8. Xolalplan. Bird's-eye view of the ruin.

examination of its earlier portions. For this reason my account of the work has to be given in reversed order, that is to say beginning with the later, and going back to the earlier, period.

The Xolalpan House ruin.

As will be apparent from the plans and sections, figs. 8—10, the establishment is grouped round a central court-yard. In its midst there is a low platform which in the following will be shown to have, in all probability, constituted the establishment's central sacrificial altar. The court-yard is surrounded by four platforms which are orientated by the four cardinal points.[1] By a stairway leading from the middle of each side these platforms communicate with the court-yard. The eastern platform is longer and higher than the rest, and therefrom lead also stairs to lower platforms, connecting it with the southern and northern ones. The upper parts of these structures were badly dilapidated, but what remained was however sufficient for determining their height and other dimensions. As will be seen from a comparison of figs. 8 and 15 with figs. 3—7, the façades of the platforms correspond with those of the Quetzal-coatl temple, and they are of exactly the same construction and style as the façades of the platforms skirting the lower portion of the Road of the Dead that so far have been cleared, the platforms in front of the Sun and Moon Pyramids and other minor

[1] The North/South line does not, however, coincide with the astronomical North/South, but here, as in the larger buildings of Teotihuacan, cf. fig. 2, there is an easterly variation of 6—7°.

structures that have been excavated. One of the proofs that this house ruin dates from the Teotihuacan time of prosperity lies in its conformance to the profiles that are so characteristic of the monumental edifices of that city. So far as I have been able to find, this style has not been found to have existed outside of Teotihuacan. It is true that certain points of resemblance are apparent in architectural profiles from Tula that are reproduced by Charnay.[1] No modern pictures of this place are known to me, nor have I personally been able to identify these buildings, besides which Charnay strikes me as not particularly reliable also on other points.

The apartments built around the central area are arranged in four separate groups. Of these the two western ones have been thoroughly explored, the south-eastern only partly so, while of the north-eastern only three or four apartments were possible of excavation, for reasons already mentioned. How far eastwards the establishment extended was not possible of determination. Certain it is, however, that that portion of the establishment was more extensive than the western one. On the road that formed the eastern boundary of Reyes' farm it was possible to discern faint traces of floors that had been cut through. The eastern portion may be supposed to date from a comparatively late period, that is to say to belong to the later building eras, whilst underneath the western one were found earlier architectural remains, of which detailed account will be given in the following.

In the court-yard are three »floors», one immediately above the other. Of these the earliest possibly extends below the platforms. As within the latter no earlier building remains were found, it appears as if the court-yard at that time was not enclosed with platforms. The latter were in all probability erected at the same time as the greater part of the entire establishment, i. e. the western, the farthest north, and the eastern portions. In addition a new »floor» was laid on the court-yard, and on this the altar was set up. The spaces on either side of the southern platform were then left open, but were subsequently filled in with the lower communicating platforms, in connection with which the court-yard was given its uppermost floor. This is, among other things, evident from the fact that there are no drains contemporary with the middle floor which, like the other two, has a southward slope. It must have been a matter of necessity to provide for an effective draining off of storm water from such a large surface as that of the court-yard. The large rain-water drain issuing from the south-western corner was constructed simultaneously with the latest of the floors, and it is only then that the communicating platforms can have been constructed.

After this only very few structural changes appear to have been made as regards the central portions. In the northeastern corner there was originally a staircase erected from the middle floor. It was however built over with the communicating platform which belongs to the same period as the other two. The small staircase just north of the eastern platform thus replaced the one that was built over. It had its direct counterpart on the southern side which was however built over when the small stairs

[1] Charnay 1885:70.

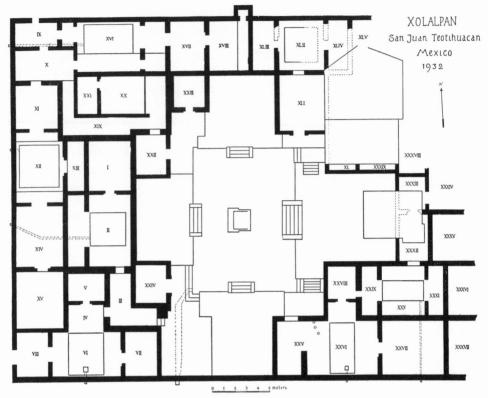

Fig. 9. Xolalpan. Plan of the ruin.

that lead down from the eastern platform were constructed. These latter stairs thus date from a still later time. Communication between the south-eastern group of apartments was therefore in the last period only by way of the eastern platform.

The four groups of apartments communicated with the court-yard each by its own doorway, and it also appears that each group had an outer door. Whether the eastern apartments had been provided with any especially noteworthy entrance arrangements was not possible of determination for reasons above referred to. It also appears as if facilities had been afforded outsiders to enter the court-yard by a more direct route. For through a considerable portion of the north-western group leads a corridor which otherwise would hardly have possessed any particular raison d'être. Only two rooms do not belong to any »suite», but only communicate with the court-yard.

Rather curious is the gap between the western and northern platforms, seeing that the remainder of the intervening corner spaces are filled up with lower platforms. As already has been mentioned, the latter were however constructed at a later date than the larger platforms, and did moreover not involve any very extensive

42

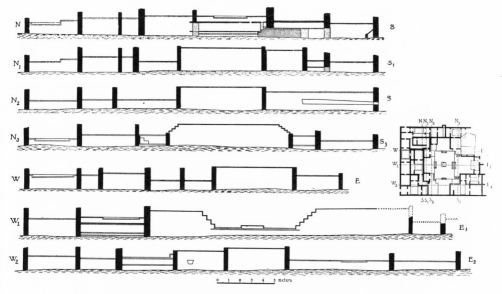

Fig. 10. Xolalpan. Sections of the ruin. On the right a plan showing the section lines.

structural alterations except as far as Room XXIV is concerned, this being contrived partly at the cost of Room III, and then raised to a level with the communicating platforms.

Below the communicating platform in the south-western corner and the floors of Rooms VII, XV, and XVI graves were discovered. The grave below the above mentioned platform is therefore of later date than the grave below the floor of Room VII, because the latter must have been laid at the same time as the floor of Rom III. The graves below the floors of Rooms XV and XVI are no doubt of the same period, with their date lying between that of the beforementioned graves. This must be so, because all of the western room suite are of later date than Rooms III—VII, and because the rooms in the north-western corner and on the north side were almost to a certainty built at the same time as those of the western portion. They are, however, older than the communicating platforms. If this had not been so, the symmetry-loving architects of Xolalpan would no doubt have placed a low platform in the north-western corner. The rooms within it being already completed, such a platform would, however, have involved inconvenient consequences, among other things a modification of Rooms XXII and XXIII.

As will be apparent from the plan, several of the rooms were provided with forecourts, corresponding to the atria of classical antiquity. As the rooms — like all true Mexican houses — were devoid of windows, it was left to the doorways to provide what spare light there could be obtained. To this day only very few native huts in

43

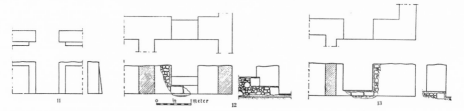

Figs. 11-13. Xolalpan. Architectural details of the ruin. Fig. 11, doorway of room XXIII. Fig. 12, doorway with stairs between room II and III. Fig. 13, doorway between room III and IV.

Teotihuacan are provided with openings for windows. In an extensive establishment like the present one, with a large number of rooms, one behind the other, it became necessary to multiply the doorways that could let in light. This was accomplished by the erection, here and there, of fore-courts. The roofs were presumably flat, and in some cases possibly sloped towards these tiny fore-courts, although as a rule they probably sloped to the outer walls. All the fore-courts were provided with well-made drains consisting of cemented conduits, built below the floors and piercing the house walls. By means of stone gutters the water was led some distance away from the outer wall. The great drain conduit leading from the central court-yard, which strangely enough narrows towards either end, was very well-built. In order to sustain the very considerable weight of the platform it was topped with flat stone slabs laid closely together and resting on ledges made in the sides of the culvert, and covered with a heavy coating of plaster.

In Room XXVI was built a small water-collecting well in the south end of the fore-court, fig. 14. What purpose was meant to be served by this apparently unnecessary arrangement is difficult of explanation.

The doorways have as a rule been made by square-cutting the walls, but in certain cases, as seen in fig. 11, a recess has been made on the wall's outer side. This only occurs in rooms with only one door. The object of this recess is to facilitate the closing up of the doorway, e. g., by some sort of curtain suspended in front of it. Judging by the plaster it would seem as if door-posts were not used.

The walls were as a rule vertical. Exceptions to this are in certain cases found in walls with doorways provided with the abovementioned recesses. Here the walls are of greater thickness in the lower part, the outer face then leaning inwards but after reaching a height of about one metre again rising vertically. The recess at that height disappears, and is thus only found in the lower part of the doorway. The floors consist of a 5—10 cm. thick layer of clay and crushed-up stone, which is coated with lime plaster. For ballast often serves a course of stones placed closely together. Certain smaller part are built of adobe, and in some few cases — corner portions in particular — roughly hewn stone was used. The plaster continues from the floors up the walls, round corners, and so on. The angles between the floors and the walls are never sharply defined, but instead softly rounded. This is probably the result of

44

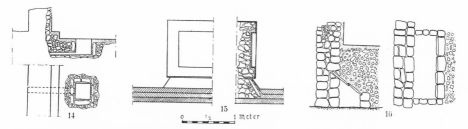

Figs. 14-16. Xolalpan. Architectural details of the ruin. Fig. 14, the drain in room XXVI. Fig. 15, the western corner of the northern platform. Fig. 16, Grave 1.

large, round stones having been used in the plastering of these details. For plastering plane surfaces special flat plastering stones were employed. For further particulars see under the heading *Masonry implements*.

What purpose this building complex served in its time is a question not easy to give a definite answer to. Without a doubt it was a dwelling place, but whether its occupants were priests, men of learning, or artists — more or less directly employed in the service of religion — or whether it was an entirely profane establishment is hardly possible of determination. The altar arrangement in the central court-yard may point to the first alternative being the correct one, but even chiefs, at any rate in Aztec times, had to perform ritual acts. From the contents of the graves discovered below the floor-levels of the ruin — graves which undoubtedly originate from the inhabitants of the dwelling place — no information is either to be gained. It is true that in one grave were found a large spear head and a heavy blade, both made of obsidian. But it does not follow that these objects necessarily formed part of a warrior's equipment, as they may have been used in some rites and eventually deposited with a servant of the religion in his grave. It is worthy of note that no fireplaces were discovered, and that ceramics for purely utilitarian purposes were of extremely rare occurence.

As regards its architecture this building complex is entirely in accordance with the main part of the Teotihuacan building remains. This applies both as to plan, style of architecture, structural details and technical execution. The finds of artifacts below the floors, i. e. those which with certainty are contemporaneous with the building, are likewise typical of the Teotihuacan culture. Beyond any kind of doubt this ruin dates from the high civilization era of Teotihuacan. Although being of more modest dimensions it nevertheless presents a good picture of the better class of »utility architecture» during that period of Mexican history.

The earliest portions of the ruin.

In the course of the work at excavating the different portions of the ruin, the floors were dug into in a number of places. Then were discovered the graves that have

been mentioned in the foregoing, account of which will be given later, as well as a good many of the stray finds. In most cases the floors were either laid not far above the »bed rock», el tepetate, or they rested on a more or less thick layer of fillings consisting of stones, earth, potsherds, and such like. Conditions below the floors, the depth to the bed rock, etc., were not always exactly recorded, and therefore these portions of the sections, fig. 10, are not perfectly reliable. It was only below certain areas west of the central court-yard that remains dating from earlier building periods were revealed. Unfortunately it was not possible from the start to devote sufficient attention to these portions, which in the most part lay below Rooms I and II. This was because the rainy season, which this year fell later than usual, might begin at any time and thus put a stop to all sorts of excavation work. The most urgent thing was therefore to clear as much as possible of the remains of the later stages of construction before the older portions could be made subjects of examination. When, however, it subsequently became apparent that exactly these portions of the house were of paramount interest, time unfortunately did not allow of their being thoroughly examined. The work that was done in that line was also made more difficult through the excavated soil having been transferred to the abovementioned apartments. The following results were however arrived at:

Rooms I and II were contemporaneous and dating from the same building period as the western, and consequently also as the northern, suites of apartments. This supplemental building stage proved to be the sixth and last with the exception of the most recent modifications of the portions surrounding the central court-yard, cf. figs. 10 and 339. Below the floors of Rooms I and II, at a depth of half-a-metre, there was a second floor — dating from the fifth period — which was contemporary with the floors of Rooms III—VII and on the same level with them. The walls between I and II, and between II and III, were then already built up, and had doorways in the same places as after the raising of the floors. In the doorway between II and III steps were however built, and the walls given a fresh, thin coating on the top of the old plaster.

This second floor below Room II had been provided with six holes with a diameter of about 25 cm. When the floor was filled in, these holes had been covered with flat stones. It is not impossible that these holes, which were arranged by twos, and in which probably at one time wooden posts were placed, have a number of counterparts farther north. Of these details there was only time to give closer examination to those next to the wall between Rooms I and II.

It was also found that the floors of the fifth period, as far as Rooms I and II are concerned, were laid directly on top of an earlier floor which close to the southern wall of Room II ended up with a plastered, descending wall. In the middle of this wall there were steps, whereby this portion — dating from the fourth period — was given the appearance of a platform. The westernmost portion of this floor projected farther, on the same level as the southern wall of Room II. The western part of the

floor terminated against a wall on which the western wall of Room II had been built, this latter wall by that time being an outer wall. Below the steps the fourth period floor then continued below Room V. The southern wall of Room II was built on this floor, and originated, as mentioned, from the fifth period.

The stairs were built in between two square wall piers, which were hollow. Two of the round holes in the floor of the fifth period here continued downwards, and the remainder were again found in the floor of the earlier period. These piers dated from a still earlier era, viz. period three.

The remains from period three consisted, beside the piers just referred to, of the floors and two walls. Of the latter, one formed the foundation of the wall of the fifth period between Rooms I and II, and of the wall towards the western suite of apartments. The other was partly over-built with the eastern wall of Rooms I and II. From period three also dates a floor below Room V, directly underneath the floor of period four, and also a floor below Rooms I and II, situated 0.75 m. below the floors of period four.

However, 0.2 m. below the floor of Room II of this period were found remains of yet another floor. This was laid almost directly on the bed rock, el tepetate, and terminated at a contemporary wall, the earliest one below the fifth-period wall between Rooms I and II. These scanty remains represent period two.

The earliest building remains of all were however found below the wall between Rooms II and III, and Room V. They consist of a low platform with one stair-step on its northern side. Six building periods are therefore distinguishable, of which however only the latest one is more particularly known.

The floor of the third period, that is to say the southern and more elevated portion of it, lies roughly on a level with the lower floor of the central court-yard. Without wishing to draw any far-reaching conclusions from this circumstance, I may however point out that conditions are identical as regards »the Superimposed Buildings» at the Road of the Dead. The earlier architectural remains, on which later buildings have been superimposed, are on a level with Camino de los muertos, and the façades of the later buildings giving on the Road of the Dead are of a construction similar to that of the façades of the Xolalpan platforms. These date, as mentioned in the foregoing, from the same period as the latest, uppermost, building remains in this section of the house ruin.

The altar of the central court.

As seen from the plan, in the middle of the central court-yard there is a low, square platform, figs. 8—10, which was originally erected on the middle floor. In its earliest form it was therefore somewhat higher, but when the uppermost floor was laid, it was — as it would seem — reduced in height. This altar was built up of smallish

stones loosely bound together by a relatively meagre quantity of clay, but it was coated with a thick layer of plaster, and painted red. Its unsubstantial construction however resulted in the little platform being badly damaged in the destruction of the building. It will be noticed that the western side is the broadest, and, parallel to all but the eastern side, grooves had been made in the plane top surface. These grooves, about 2 cm. wide and 10 cm. deep, decline inwards at an angle of about 60°. The inner portion of the top surface was damaged to such a degree that it was impossible to determine whether the middle portion had been higher than, or level with, the outer edges. It is not improbable that a wooden sheltering roof, of pyramidal shape and open to the east, had once rested in the grooves. That this little platform had served as an altar is evident from the finds made in this spot.

In these central parts which were almost entirely demolished, a large number of objects were recovered, consisting among other things of a large cylinder, ornamented plaques, circular ornaments and such like, and a large figured face. There can be no doubt whatever that these objects formed parts of an incense burner of a type of which intact specimens only have been recovered at Azcapotzalco, fig. 149. On closer examination it appears that the fragments originate from at least two incense burners of this type. Fragments of elaborately executed pieces of this kind occur not only in the collections from Las Palmas and Xolalpan but also in other Teotihuacan collections. As, however, it proved impossible to reconstruct the incense burner belonging to this altar, I have supplemented the details here depicted with an intact specimen recovered at Azcapotzalco and preserved in Museo Nacional, Mexico. Both the face and certain of the fragments show traces of red and green paint. There is no doubt that Tozzer is correct when he writes that »this type of brasero and its ornaments belong to the Toltec culture», but the find shows that the continuation of the passage requires revision: »and seems to be typical only in this vicinity (Azcapotzalco)».[1] In association with fragments of the incense burner were found two small, highly polished plaques of greyish-green rock, rectangular in shape, one of which was intact while the other was in pieces, fig. 277. Each has a hole pierced through it, pointing to their having been used as hanging ornaments. The intact one has however a sharp edge, which may perhaps be considered as indicating their use as knives, e. g., for ceremonial purposes.

Between the altar and the stairs of the eastern platform were discovered fragments of a »brasier» (Feuerbecken) made of volcanic rock. Owing to lack of time, as already mentioned in the resumé of the excavation work, preventing the site from being cleared in its entirety, we had no opportunity to search for further fragments of the brasier. Judging from the position of the fragments that were recovered, it would probably have been placed either on top, or immediately to the east, of the altar. The fragments were too large and heavy, and not of especially fine appearance, and were therefore left behind. They were however compared with objects in the Teotihuacan museum,

[1] Tozzer 1921:44.

and with accessible illustrations of earlier finds of this kind, and were found to be fragments of the »Old Fire God», of the Mexicans, Ueueteotl, in sitting posture and with a low-rimmed cylindrical bowl on his head. The fragments recovered consisted of the right leg, the left arm with the shoulder region, and parts of the bowl. These pieces are very typical of Teotihuacan, and generally — as is also the case with the one in question — made of light grey and very brittle lava. As to form and decoration they are very consistent. The deeply lined face marks the deity down as an old man, and in the corners of his mouth a tooth projects on either side. The bowl, which probably was originally conceived as a crown, is decorated with stylized eyes and groups of vertical ridges. In this case the eyes probably suggest the fire in the brasier. At Xolalpan were frequently discovered more or less complete miniatures in clay which in a very high degree correspond with the full-size stone brasiers, fig. 147.

As to the method of their employment we have no detailed information. How very important was the part played by incense-burning in ancient Mexico is, inter alia, apparent from the representations of priests holding incense burners that so frequently occur in the codices. Of interest is the following information which particularly refers to Teotihuacan and neighbouring places of the Mexico valley.

In the official reports that different communities in the Valley of Mexico rendered in the year 1580 to the Council of the Indies in Spain in reply to various enquiries, information was also supplied as to native religious conditions. In these reports it was pointed out that in earlier times the chiefs burnt incense every twentieth day in special edifices erected for that purpose. The vassals performed the ceremony in their houses daily[1]. — The house whose ruins we are here concerned with dates, it is true, from an earlier period, but both the objects discovered in association with the platform, and the incense burners as well as fragments of such utensils from other parts of the complex, show that this ceremony, of such importance to the people, was of great antiquity.

[1] Nuttall 1926:66.

4

PART III

THE FINDS

The inventory, or list, which was compiled in the cataloguing and sorting of the collections at Teotihuacan comprised 6783 numbers. The parts of the collections that were added during the last weeks of the excavation operations were somewhat summarily catalogued, and occasionally several minor objects were then grouped under one and the same number. Out of the great mass of pottery fragments that we brought away, we were in many cases after our home-coming successful in building up more or less complete vessels. A number of restorations have been made, and in some cases even reconstructions. It is on this account that the complete and final catalogue compiled at the Ethnographical Museum, Stockholm — in spite of the collection that the Mexican archaeologists selected for retention by the Mexican state — comprised 6588 numbers.

The material is naturally far too extensive to allow of an account being given of every separate object. For reasons already explained in the foregoing, exclusion has almost wholly been made of the finds from Las Palmas, with the exception of the artifacts that supplement the Xolalpan collections. Of the finds from that place description and illustrations will here only be given of those which from different viewpoints are most important. For various reasons the grouping has been arranged as follows:

Part III The earliest artifacts and the graves at Xolalpan.

Part IV Finds from the Mazapan culture.

Part V Finds from the Aztec culture.

Part VI Various classes of clay objects.

Part VII Objects of bone, obsidian, stone, etc.

In order not to burden the letter-press more than is necessary, and with a view to clearness, it has been considered expedient to place comparative studies and special investigations in Appendix 1—12.

ARCHAEOLOGICAL FINDS OF THE TEOTIHUACAN CULTURE

In connection with the description of the Xolalpan ruin mention was made of the graves discovered below certain floors. Through a study of the architecture, and above all through determination of the successive building periods, it is possible to fix the relative dates of the graves. Of these, account will be given in chronological order. First of all it should however be emphasized that the ruin dates from the period of the Teotihuacan culture, and that consequently all finds made below the intact floors of the house ruin are attributable to that culture. That this was sharply defined as against the later cultures is evident from the fact that no traces whatever of the latter were discovered in association with the artifacts that originate from the builders of the house. The few finds that belonged to the Aztec period were located quite near the surface. Between the ground level and the floor of the ruin, and only in a few cases in contact with the remains of the building, were situated graves from the so-called Mazapan culture, which in point of time falls between the Aztec period and the classical era of Teotihuacan prosperity. Of any earlier culture, with artifacts of a more primitive type, such as W. Lehmann states he has found at Teopancaxco near the railway station of Teotihuacan, no remains were found.[1] Heads and portions of clay figures of archaic type were found, it is true, but they were discovered both below and above the floor level.

Any difference of age between the objects recovered from a grave dating from the Teotihuacan culture in the ruin at Xolalpan and the objects that were found in the immediate vicinity of the grave could hardly be expected. This of course only provided the covering floor was intact. A comparison between stray finds of this kind and the grave material shows that no divergencies of importance exist. Among the stray finds there are, it is true, some that are not found in the graves, e. g., ceramics of especially utilitarian character, stone implements, and the like, while all of the clay-vessel types that were represented in the graves were also found among the mass of fragments recovered from the fillings of the floors. These finds originate from fillings under floors dating from building periods 4—6, with exception of the earliest artifacts. The building periods not being, as already mentioned, separated by any considerable spaces of time, the stray finds have been collocated in groups according to the nature of the material and not according to locality where discovered.

The earliest artifacts.

It has already in the foregoing been pointed out that time unfortunately did not allow of a thorough examination of such earlier portions of the ruin as were hidden below the sections that had been added during later building periods. A certain amount of interesting material was however collected.

[1] Lehmann 1921:17.

51

Before entering upon an account of the finds, I think a description might appropriately be given of the type of pottery which is characteristic of Teotihuacan, viz. the Teotihuacan tripod ceramics. The clay vessels that belong to this group consist of cylindrical vases with sides generally slightly concave, a flat bottom, and three feet which are either cylindrical, or tall and hollow and of rectangular section. When cylindrical, the feet are at the bottom either open, closed or rounded. Those which are rectangular are, on the other hand, often open on the outer side but closed at the bottom, and in such case there are generally two openings, one being a vertical rectangular aperture and the other a T-shaped ditto with the »T» given a quarter-turn to one side. Occasionally there are two T-shaped apertures. Rectangular feet may also be solid and provided with decoration in relief. The material is comparatively thin, of considerable hardness, and in colour ranging from grey-yellowish brown to brownish-red. The decoration, which is always applied to the outer sides of the vessels, is executed by a special method: After the firing of the vessel, often previously lightly tinted with brown or brownish-red colour and then polished, part of the surface was scraped away with some sharp instrument. An obsidian knife would do very well for this. In this operation the pattern is left out, and the removed portions instead painted in a red colour of a vivid cinnabar, as proved by chemical examination. Occasionally the vessels are ornamented with a border running round the lower edge, consisting of small heads or geometrical figures which have been shaped in a mould and then attached to the vessel before the latter has quite dried. These vessels are so typical of the Teotihuacan culture that they may be regarded as »type fossils», so to speak.

Below the floors of the second period in Room II were discovered a number of objects which thus belong to the same era as the very earliest portions of the house. The majority of the artifacts, which proportionately to the slender bulk of the filling were exceedingly numerous, consisted of potsherds which in the main were fragments of the special Teotihuacan type. Among them were some which originated from a Teotihuacan tripod vessel which either had not been treated to »spared-out» decoration or else this had been very lightly put on. The main part of its brownish-black and polished surface had however been removed and replaced with cinnabar. Another vessel, which it was possible to restore completely, fig. 19, is altogether devoid of decoration, nor did it ever possess any, as the slightly glossy, yellowish-brown surface had not undergone any treatment after the firing.

Two more vessels were possible of reconstruction with exception of the feet. That these were of rectangular shape is evident from their points of attachment. One of these vessels, fig. 17, is decorated with large, plain figures consisting of flowers alternating with leaves. They are designed to fit in between two borders ornamented with plain incised lines. The flowers are four-petalled with an L-shaped figure in each petal, these four L-shaped figures together forming a swastika.

The decoration of the second vessel is more complicated, fig. 18. It is likewise

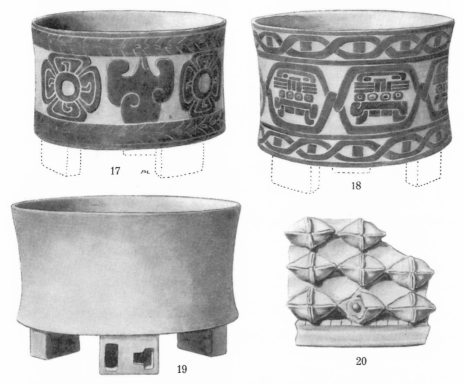

Figs. 17-20. Clay vessels and potsherd found below the floor of Room II. (1/3) 17: 6665, 18: 6666, 19: 6664, (1/2) 20: 6694.

provided with borders, chiefly consisting of two intertwined fillets. The main decoration, which consists of identical complicated figures probably representing strongly stylized faces, suggestive of Tlaloc, the Aztec rain god, forms a design inside the loops of two intertwined fillets.

In the filling between the floors of periods 3 and 4 only few artifacts were found. Of a very interesting vessel unfortunately only a single fragment was recovered, fig. 20. It consists of the lower portion of the wall of a Teotihuacan tripod vessel. There is no doubt that it was cylindrical and had a flat bottom. It is of a material which is somewhat lighter and yellower than usual. Its decoration consists, as will be apparent from the illustration, of small hollow bags suggestive of seed pods. These have been manufactured one by one, by folding over a thin sheet of clay, and then fixed into a depression in the wall of the vessel. This was naturally accomplished before the vessel had dried. They each contain small loose clay pellets which rattle when the vessel is shaken. With exception only for its shape, this vessel must have differed from the

ordinary Teotihuacan ceramics to such a high degree that it seems doubtful whether it was of local manufacture or an importation. It is not altogether impossible that this vessel belongs to the yellowish-red pottery that may possible have been imported from the Chalchicomula district in the state of Puebla, account of which will be given below.

The graves.

The most important finds from the time of the house-builders consist of seven graves with rich and interesting grave furniture. The artifacts, with few exceptions, consist of clay vessels. These are naturally to some extent different from each other as to size, etc., but common to them all, except in the case of the three last graves, is a predominance of Teotihuacan tripod ceramics. In studying the building history of the house it became evident, as already has been mentioned, that the graves differ as to age. The difference in time cannot, however, be very considerable: Grave 1 is contemporary with Room VII, that is to say it dates from the fourth period (cf. fig. 339), graves 2 and 3 below Rooms XV and XVI originate from the fifth, and the last discovered graves, Nos. 5, 6 and 7, which were located below the uppermost floor of Room II, date from the sixth period. Artifacts, too, bear witness of a certain difference in age by showing that in the later graves fresh types of ceramics have made their appearance.

Grave 1.

In digging through the floor of Room VII we found that, in order to attain the level of the rooms adjoining it to the north, it had been overlaid with filling to a depth of 1 m. This filling consisted of rubble, sand, earth, and divers artifacts consisting of objects which were broken, worn out, or for other reasons discarded as valueless. Close by the southern outer wall, on the east side of the wall which partitioned off this room from its fore-court, a grave was discovered, fig. 16. This was the only one of the graves that had been especially built up. In other cases, so far as could be seen, space had only been provided for the dead in the filling that already served as underlay for the floor that was laid down at subsequent extensions or superimposed building works. Because in no case was any difference whatever, in appearance, discernible between the floor of a room looked upon as a whole, and the portion of it that covered a grave. As of course an entire floor would not, on the occasion of a burial, first have been removed without a trace and subsequently re-laid, it follows that after each burial were started building operations on a more or less extensive scale.

The grave below the floor of Room VII, here indicated as Grave 1, is of rectangular shape and built up of two layers of fairly smoothly dressed stones, laid one on top of the other. As will be seen from fig. 16, the outer wall of the room forms one of the

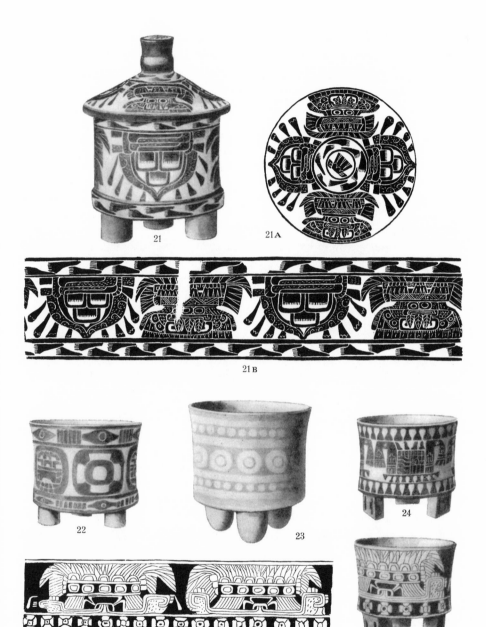

Figs. 21-25. Clay vessels found in Grave 1. (1/4) 21: 4195, 22: M, (1/3) 23: 4201, 24: 4200, 25: 4198.

grave's long sides. The height of the rest of the sides is barely 30 cm., but in order to obtain increased space the roof had been given an acute pitch. The roof, which consisted of two rows of thin, rectangular stone slabs, was constructed in a rather ingenious fashion. The lower row of the stone slabs rested in a step cut out in the upper stone layer of the longer side. This lower row of slabs was supported by the upper one, which was wedged fast into the wall. This construction plainly shows that the grave came into existence at the same time as this portion of the building. As this belongs to the fifth building period it follows that the grave — the dead and the grave furniture — belongs to the fourth. Hence there are very good reasons to suppose that this grave is the earliest of the seven that were discovered below the floors of the ruin.

The contents of Grave 1 consisted of skeletal remains, earthenware vessels, objects of obsidian and one stone axe.

The skeletal remains were exceedingly friable. A sudden shower of rain (the grave was opened in June 2) ruined them almost completely. Judging from the teeth, the entombed appears to have been an adult person, and the few remaining bone fragments further indicate old age. The corpse had been placed with the head towards the east.

The clay vessels were — apart from some small clay dishes — as regards form of a uniform type, viz. exclusively tripod ceramics of the type peculiar to the Teotihuacan culture. Two of these have purely linear patterns, while the rest have a richer and more complicated decoration. As to technique, the decoration is executed by the usual method of scraping away certain portions of the surface skin. The firstmentioned are decorated by the process known as negative painting. They are the only exponents of this process found in the collections. The technique and geographical distribution of negative painting will fully be dealt in the Appendix 1.

The vessel with the plainest decoration is reproduced in fig. 22. The feet, of simple construction and somewhat crudely made, are cylindrical, at the terminals closed with thin sheets of clay, and fixed to the bottom of the vessel by means of rings of clay. The decoration consists, apart from an upper and a lower border of plain execution, of large figures of two different kinds. Seler and Lehmann consider figures of this sort to be symbolic hieroglyphics, and the former has devoted much work to their interpretation. When unsupported by any documentary source whatsoever, interpretation of this kind must necessarily remain merely subjective. The large figure on the right in fig. 22 may with all justification be supposed to represent a stylized, four-petalled flower. The same motive also occurs in small clay disks attached to large incense-burners, in the head ornaments and earplugs of certain small clay figurines, etc. It is not improbable that this flower-suggesting figure also was a symbol of the planet Venus, whose cruciform hieroglyphic[1] would assume a similar appearance if its limbs were rounded off. The left figure, on the other hand, which also occurs in vessels from Graves 2 and 3, is in part found on a vessel depicted by Seler.[2] He

[1] Seler 1915:428. [2] Seler 1915:fig. 163.

explains it as hieroglyphics for »Sun», or »Year». It is remarkable that this motive was found in Graves 1, 3 and 4, seeing that these graves, as mentioned, are of different periods. This circumstance appears to lend colour to Seler's theory that certain figures found in Teotihuacan ceramics are conventional signs carrying significance as symbolic hieroglyphics.

Of the two vessels reproduced in figs. 24 and 25, duplicates were recovered. Their correspondence covers both shape, size and decoration, and they are only to be told apart by minor divergencies as to detail. As seen from fig. 25, the decoration of this vessel consists of a lower border formed by flower-shaped figures set in a connected row. The rest of the surface is occupied by two large and complicated figures. A not inconsiderable resemblance to one of the paintings in Casa de los Frescos is indisputably recognizable.[1] The painting is executed in several colours, while the potter only had two at his disposal, viz. the dark-brown, gleaming surface of the vessel, and the vermilion paint with which he filled in the abraded portions of the »skin». With Seler's interpretation of the fresco, the two figures of the vessel may be thus described: At the top a semilunar expanse of quetzal feathers is held together by a band of gem tablets (the band set with five rounded figures each enclosing a similarly shaped ring is in the fresco corresponded to by green tablets with red centres, that is, symbols of precious stones, e. g. turquoises). Below this is seen a flower of which the fourth petal is hidden behind fillets which, issuing from the centre of the flower, extend to either side and have their ends recurved. These fillets correspond to the conventional lines that run above the upper lip in the Tlaloc face. In form, this flower corresponds with the sign for the planet Venus. Thus we here find no less than three or four details that are symbols possessing mythological or astronomical significance, and there seems reason for agreeing with Seler's assertion: »Das ganze Ornament . . . spricht von stark entwickeltem Konventionalismus, ist ein Beweis, dass diese Völker schon sehr weit auf dem Wege vorgeschritten waren, der von dem Objekte zur Vorstellung, von dem Bilde zur Hieroglyphe führt.»[2]

As regards the ornament on the vessel in fig. 24, certain details typical of the decorative style of Teotihuacan are recognizable. The top and bottom borders seem to consist of drops, probably symbolizing rain. The drop border which support the main ornament also contains other symbols of water, namely the numerous small lines or dots that are seen in the fields surrounding the drops. The quadratic centre portion of the large ornament is flanked by recurved fillets, decorated with stars and terminating in feather brushes. It does not appear improbable that the decoration bears reference to magical conceptions of water, in particular to rain, which among natural phenomena was perhaps of paramount importance to Teotihuacan.

The most pretentious of the clay vessels originating from this grave is however the tripod reproduced in fig. 21. Although the legs and the knob of the lid are rather on the large side, and the diameter of the lid considerably overlapping that of the

[1] Gamio 1922: Tomo I, vol. 1, pl. 27. [2] Seler 1915:428.

vessel, the piece as a whole impresses one favourably. The decoration, it will be noted, is very rich. The outside of the vessel is decorated with four large figures of two different kinds, fitted in between a top and a bottom border. These latter consist of figures, placed the one after the other, in some measure suggestive of foot-prints. The same motive is also found on the lid, round the base of the handle knob. One of the large figures represents the face of Tlaloc in front view. He is provided with a large head ornament consisting of big plumes. The face runs into one with the body, the eyes are encircled by large rings, and above the mouth is found the typical straight line with upturned ends. From the mouth depend three leaf-like objects, and behind them there is a glimpse of the large canine teeth. What the second figure is supposed to represent is not easy to say with any certainty. It may perhaps not be impossible that it is meant to symbolize rain clouds. The design by which it is framed in, and which at the bottom terminates in a point, is provided with small lines and dots, thus corresponding with the fluid-representing signs found in the frescoes of Teopancaxco. The drop-shaped objects issuing from the figure might possibly represent rain. In favour of this supposition speaks the alternating representation of Tlaloc, the rain god, and the vessel may be supposed to have been employed in rites connected with rain.

Close by the western of the shorter sides of the grave was recovered a finely shaped spear-head, fig. 309, and a symmetrically shaped and entirely intact blade, fig. 297. Both are made of obsidian, and are good exponents of highly developed skill in the art of working up stone, especially when the brittle nature of the material is taken into consideration. That the stone point cannot have been used as an arrow-head is, among other things, apparent from the fact that it weighs no less than 58,1 grammes. Near the middle of the grave, and close by one of its longer sides, was discovered the stone axe reproduced in fig. 255. Stone axes are comparatively rarely found at Teotihuacan. This is very remarkable, especially as the country at that time was undoubtedly far more abounding in trees than in our days. As far as vegetation is concerned, the wholesale cutting down of forest trees in colonial times has created a new aspect of the countryside. In spite of an »obsidian mine« being in existence not far from Teotihuacan, it seems uncertain whether stone suitable for axes or ornaments was obtained otherwise than by trading. Close collaboration between archaeologists and mineralogists should prove of value in throwing light on trade routes and cultural intercourse.

Below the head of the interred were discovered three small, flat figures of obsidian, figs. 315—317. They were found near the middle of the grave, and it is not impossible that they had originally rested on the chest of the dead. What object these figures may have served does not appear possible of determination. But seeing that they, although of a very defined type, present no features characteristic of any deity representation, and as they cannot have been toys — the dead being as already mentioned of advanced age — they may no doubt be set down as ornaments or charms, cf. p. 152. A remarkable thing is that objects of this kind have hitherto — so far as I am aware

— only been discovered in British Honduras. Certain pottery fragments that were found in the filling below the floors of Rooms VII and XV also present distinctly Maya features, cf. p. 96.

Grave 1 contained an additional number of clay vessels. The most noteworthy of these is fig. 23 which, as mentioned, is decorated by the negative painting method. The light colour that was used for decorating it is not of a permanent kind, and therefore the pattern has already in a high degree faded away. Originally there were two almost identical vessels, but one of them, like the »twins» of figs. 24 and 25, was incorporated with the collection picked out by the Mexican archaeologists.

The remainder of the vessels are entirely lacking decoration. The method by which the feet have been affixed is worthy of remark. They were made separately and, before drying, stuck fast on the vessel while the latter, too, was still soft. Round the edge of the place of contact were then placed rings of clay which were joined on to the material both of the feet and of the vessel. The feet were thus, so to speak, »glued on». This manner of proceeding seems to have been universal with regard to all Teotihuacan tripod vessels.

A footless cylindrical vessel is noteworthy inasmuch as its smooth, grey surface has been covered with a thin black coating which has been made fairly glossy, probably by polishing. The smallest of the bowls, which is provided with small, almost rudimentary, feet, is interesting in so far as it is closely allied to the type of bowl which is dominating in Graves 5—7. The smallest of the ceramic finds, a little dish, has its entire upper side coated with red paint of the kind that was used in the decoration of the richly ornamented tripod vessels. The coat is so thick, and comes away so easily, that it is doubtful whether the bowl was actually fired after the application of the paint. It may not be impossible that it was used as a colour-saucer for mixing that vermilion paint which was so popular.

Grave 2.

This grave was discovered in Room XV, close by the eastern wall, and about 1 m. below the badly damaged floor of this room; its outer portions were all in a much dilapidated state on account of the inconsiderable thickness of the covering earth stratum. Contrary to Grave 1, no protective arrangements whatever had here been made, Grave 1 being in that respect exceptional. No skeletal parts could be found, only a few teeth which also were much decayed. The only evidence that they afforded was that they had belonged to an adult person. The most important of the objects found in the grave are seen in figs. 26—29 and evidently of pure Teotihuacan type. In connection with the arrangement of the vessels a peculiar circumstance might be mentioned. In the bottom of fig. 26 had been placed a »candelero», fig. 164, mouth upwards, and on top of the latter was set an undecorated and footless cylindrical vessel, also mouth upwards. Of the remainder of the vessels, three small dishes were

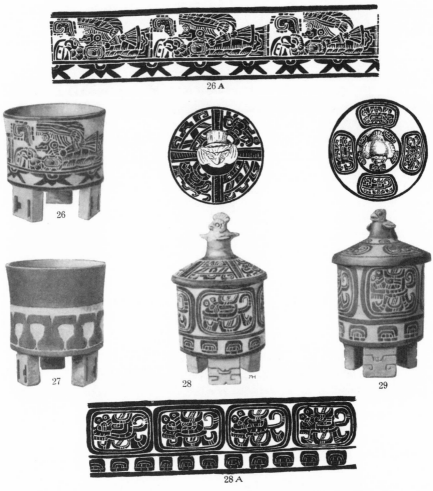

Figs. 26-29. Clay vessels found in Grave 2. (1/3) 26: 3985, 27: M, 28: 3988, 29: M.

placed one inside the other. The whole of the grave goods formed a crammed and untidy accumulation.

Figs. 28 and 29 are good representatives of the typical Teotihuacan ceramics. With the exception of two cylindrical vessels which are devoid of ornaments, decoration has been produced in the usual way, i. e. all such portions of the darker, and polished, surface skin as to not form part of the figures have been removed after the firing. The portions scraped off have been filled in with vermilion, which in part is well preserved, cf. frontispiece.

Fig. 27 is ornamented with plain, drop-like figures and a horizontal border, abraded, and filled in with red paint, traces of which are still remaining. Very remarkable is the strict adherence to tradition which is characteristic of the Teotihuacan ceramics. Even this exceedingly meagre ornamentation of a vessel, otherwise well made, has been gathered into a frieze running near its bottom edge. Similar friezes, consisting of small faces, and the like, fashioned in moulds and then stuck on, were much in vogue, cf. fig. 122. The remainder of the decorated vessels, on the other hand, form part of the best productions hitherto known of the art of the ancient potters of Teotihuacan. Technically they are of high quality, both as regards material, shape and decoration. The tall legs, which are not over firmly attached, and the acute angle between the plane bottom and the sides, naturally tend to make them fragile. Neither is it to be supposed that they were put to any very extensive practical use. They are not designed as utility ceramics, but were probably intended for ceremonial purposes.

In particular fig. 26 is of plain, severe, although harmonious form, and its decoration is beautifully composed. The figure of human shape three times recurring round the vessel, is probably a representation of the rain god, Tlaloc, with rings round the eyes, and above the mouth the typical figure with ends of an upward curve. It is also provided with a richly developed head ornament, probably largely consisting of feathers. On its left arm it carries a shield of oval shape, behind which is discernible a throwing spear or some ceremonial implement. The shield is decorated with spikes or acutely pointed triangles, surrounding a left hand depicted in the centre. In front of the face is seen a spiral-formed figure which, according to Seler, signifies speech or song. In its centre portion are small dots, possibly meant to symbolize water. Round the spiral figure are placed 12 small squares, divided into four groups of equal size. This shows affinity to the frescoes on the ruin at Teopancaxco. Those figures have five-pointed stars for patterns in their dresses, stars which also recur in the paintings in Casa de los Frescos, and the frieze below the figures likewise consists of five-pointed stars. In front of the figure is seen a bird's head, probably representing an eagle, at the open beak of which a square figure is placed. Near the bird's head are seen, beside the square figure, some lines which might represent a simplified variant of the sign that Seler considers to be the hieroglyphic for the sun or the year. The right-hand portion of the figure seems to consist of feathers, presumably the bird's body. There is also a glimpse of something suggestive of the Mayan sign for the planet Venus, surrounded by hand-like figures which perhaps signify the bird's tail feathers. Similar figures are, however, also found on the dresses of the so-called pulque priests at Teopancaxco. Unfortunately we do not possess any certain starting-points for the interpretation of these designs, which probably are of a symbolic nature. If we had, it is probable that a great deal of the world of conception of the ancient Teotihuacan people would be revealed. The rain god, in combination with symbols for speech or song, possibly referring to life-giving water, and in combination with the figure of an eagle, with the symbol of the planet Venus, in addition to stars, the symbol of

»sun», or »year», the numerical combination 3×4, possibly $3 \times 4 + 1 = 13$, and this group of figures repeated three times above a border consisting of 7 stars, may reasonably be expected to contain, in the concentrated form of picture-writing, a great deal about rain magic and astronomical conceptions.

Figs. 28 and 29 are, as will be noticed, very similar. Both the border and the large figures on the sides of the vessels are, respectively, almost identical. Only the lids differ. The handles are in both cases bird-shaped, but the birds are of different kinds. The incised decoration of one of the lids corresponds with the large figures on the sides of the vessel, whilst that of the other lid seems to have been composed of sections of the vessel's decoration. These figures, which are repeated four times, are almost identical, but it is difficult to say what they represent. Possibly a highly stylized animal figure, of which, with the exercise of some imagination, the head can be made out to the left, the tail to the right, and the legs below. Rather remarkable is the extreme length to which the stylization of the incised figures has been carried — these supposedly being intended to represent a living being of some kind — and the very realistic bird representation. Perhaps it may be possible to determine the latter zoologically. If one of them is a night-bird — the one in fig. 28 resembles an owl — and again the other a day-bird, a certain ceremonial import may perhaps attach to these almost twin-vessels. The lids are fairly well-fitting, and were intact. The vessels contained nothing.

Of interest, too, is the small clay figurine, fig. 30, found in the grave. A few complete clay figures of different kinds, as well as a large number of fragments, were recovered at the excavations, but only three of the former belonged to graves. Besides the abovementioned, there were two moulded twin figurines recovered in a child-grave belonging to the Mazapan culture above the floor of Room III. It being inconsistent with conceptions of a more primitive kind to deposit in a grave any representation of a living being — and as a deity must be considered very much alive — these figurines must be supposed to be of a different character. As in the firstmentioned grave a child had been interred, the figures were most probably toys. But on the other hand, a dead child is not anything like so dangerous to the living as a grown person, and there are many instances of children having been buried in a different manner and with less complicated ceremonies. Graves 6 and 7 contained remains of children, and they are to a certain extent urn-graves. Grave 2 on the other hand contained, as mentioned, the remains of an adult person, and therefore the figure must have had some other significance. It is balanced in such a way that it can stand by itself. In its right hand it originally held some object, and the gripping pose of the hand shows that it must have been something cylindrical. As it lacks a head, but is otherwise well modelled, it is not impossible that it was only the framework of a figure to which was added dress, head, etc., of some more perishable material.

The remainder of the objects consisted of three small saucers, two vases with constricted mouths, three miniature vases with wide mouths, and three one-chambered,

and one two-chambered, candeleros. The largest of the dishes is without decoration, but in its bottom are seen some curving marks, possibly produced with the potter's tool after the surface had been smoothed. The dish next in size is entirely coated with a dark-red paint, iron oxide, which contains finely powdered hematite. As regards the smallest dish, it is quite devoid of decoration, made of a lighter-coloured clay, and provided with three small feet. The vases are all rather indifferently shaped and imperfectly smoothed, and in the larger ones the material is of exaggerated thickness. The one-chambered candeleros are of the prevalent Xolalpan form. As to their employment, etc., cf. p. 113.

Fig. 30. Clay figurine found in Grave 2.
(1/2) 3997 a.

Grave 3.

This grave was situated under the southeastern corner of Room XVI, 1.45 m. below the floor. Portions of the northern side of the house had been very badly damaged, probably in later times and by the present-day population. For dressed stone is, and presumably also formerly was, a desirable building material, and it is probable that dressed stone originating from the ruin and come upon, say in preparing a cactus plantation, has provided inducement for further digging. In the walls of many houses in Teotihuacan may be seen architecural details from ancient buildings, the ruins of which are situated below the modern settlement, underneath houses, cactus gardens and maize fields.

About one-half of the grave was intact, and the clay vessels in that portion were therefore almost undamaged. In the other portion the ceramics were not only broken up, but even parts of them were missing. As, however, the floor about the grave had been demolished, this damage may, as mentioned, have taken place in later times. That it might have occurred prior to, or simultaneously with, the erection of the portions of the house that were on top of the grave, is not very probable. Exceedingly few skeletal remains could be discovered, and the state of those which were found was such that they crumbled away as soon as touched. Neither skulls nor teeth were found. There was some charcoal intermingled with the skeletal remains, and it is therefore not impossible — although not very probable — that the dead had been incinerated, and that the ashes and some of the charcoal had been deposited in the grave.

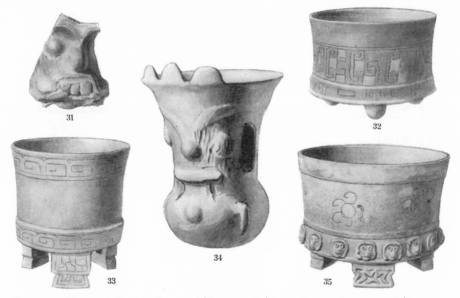

Figs. 31-35. Clay vessels found in Grave 3. (1/3) 31: 5239, (1/4) 32: 5260, 33: 5264, 34: 5227, (1/3) 35: 5259.

This grave, which from technical reasons was connected with the building appears to date from about the same period as Grave 2, differs in point of contents considerably from the rest. Part of the grave goods will be seen in figs. 31 —39. The vessels are of several kinds: the usual Teotihuacan types, rudely fashioned anthropomorphic vases, a partly painted vessel, vases decorated by in-fresco technique, bowls of ordinary types as well as of »importation goods», miniature vessels and candeleros.

The vessels belonging to the group »in-fresco painted ware» were all very badly damaged. One of them, fig. 36, which originally had a lid, is unfortunately very incomplete, and of the decoration on the fragments that were recovered only a few portions are preserved. In two of the remainder, figs. 33 and 35, where the damage is not so extensive and which have been restored, nothing beyond traces are discernible of the ground-colour on which the decoration was painted. In form, they are of pure Teotihuacan type. The vase with a lid has fairly strongly curved sides with the bottom portion slightly projecting. The feet, and the handle of the lid, were cylindrical. The lid is of a somewhat original shape, as, although this is conical, its upper side is concave. It is entirely devoid of incised decoration. The other two vases have straighter walls, which however are projecting at the bottom, and in one of them the rim of the mouth is somewhat thickened. The surface has been purposely roughened over with scratches in order to provide a better hold for the paint. The incised decoration is plain, but the lastmentioned vessel is ornamented with a frieze of small and thin faces, all made in one mould.

64

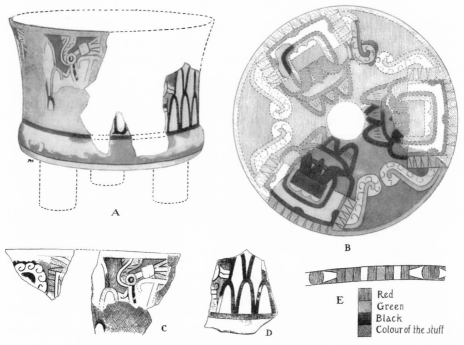

Fig. 36. In-fresco painted tripod vessel found in Grave 3. (1/3) 5258.

Of the in-fresco technique and its geographical distribution account is given in Appendix 2. As the lidded vase retains some considerable portions of its decoration, it deserves a more detailed description.

The material of the vase is of grey colour and of very even and homogeneous structure. The inner side is covered with a dirty brown coat of paint, worked up to a glossy surface by polishing. The outside of the vessel, which has not been so carefully smoothed as the inside, was originally painted red. The roughness of the surface has purposely been left unsmoothed, which has made the paint stick on better. Whether the whole surface, or only portions of it, was painted red, and whether on this as a groundwork painted decoration was applied, is impossible of determination. The red paint has subsequently been coated with a layer of white and finely washed clay. It is not quite certain that the lid was originally made for the vase. In any case it shows no trace of any original red paint, but only of a white coating. Its diameter is, moreover, considerably larger than that of the mouth of the vessel. The white coating of the lid as well as of the vessel is of somewhat varying thickness, generally less than $\frac{1}{2}$ mm. On this layer the decoration proper has been painted. The contour lines of the figures are drawn in black, and of a width of about $\frac{1}{2}$—$\frac{2}{3}$ mm. In order to make them more

marked, and also that they should better serve their purpose of separating in a purely mechanical way the different colour fields, these boundary lines were first incised with some pointed instrument and then filled in with black paint. The colours used in the decoration consist, apart from the white ground-colour and the black contour lines, of bright red and turquoise green. Generally the colours have only slightly penetrated into the white grounding, but in certain places the paint coating itself is fairly thick.

In fig. 36 are reproduced: A, a reconstruction of the vessel with the greater part of the recovered fragments (except the bottom, which is complete) fitted into their places; B, a reconstruction of the decoration of the lid; C, two rim fragments of the vessel (top left in A); D, a piece of the wall (to the right in A), and E, a portion of the rim of the lid. For denoting the different colours, the hatching system of heraldry has been employed. While in A only the relative values are marked, the hatchings represent in C, D and E the actual colours. In the reconstruction made of the lid, both systems have been used. Thus the preserved portion is water-colour washed, while the reconstructions are hatched. It may be mentioned that the lid is almost complete, although the decorations are only preserved on a smaller part of the surface.

What the decoration is intended to represent appears to me uncertain. Some points of resemblance are discernible with the vessel preserved in Museo Nacional, Mexico, found in the vicinity of the Moon Pyramide. The decoration of the latter has been analyzed by Seler.[1] The picture reproduced by him, after Peñafiel, is however incorrect as regards its shape. Lehmann[2] however publishes a photograph of this highly interesting and well preserved vessel. Certain details correspond with fig. 36 A, altough no far-reaching conclusions can therefrom be drawn. Certain ornaments appear however to be referable to the butterfly motive of common occurrence in Teotihuacan art.

Six of the vessels discovered in this grave are of the common cylindrical tripod type. Four of them are undecorated. One is of the classical Teotihuacan-type, fig. 38, while another, fig. 39, forms an exception in one remarkable respect. In form it corresponds with the majority of the vessels discovered at Xolalpan, but as regards decoration it occupies an entirely exceptional place. The lower half of the outer side is painted red, and the paint has been given a faint lustre. The classical vase, on the other hand, fig. 38, which is provided with a cover, is of dark material and decorated with a broad border consisting of large figures of almost identical appearance. They have been produced by the usual method of sparing out the surface layer and filling the removed portions with red paint. The figures bear close resemblance to those ornamenting the large vessel of Grave 4. Seler has explained a similar figure as the symbolic sign for »sun» or »year».[3]

Of quite a different type is however fig. 34. Fragments of similar vessels were recovered from room XVI, but only in Grave 4 a second one which was complete, although badly damaged. Strangely enough there was in this grave found one frag-

[1] Seler 1915:525 seq. [2] Lehmann 1933:65. [3] Seler 1915:511.

ment of a vessel of the same type, but no further portions could be discovered. As has been mentioned, one section of the grave was however not intact. The form of the vessel can hardly be said to be typical of Teotihuacan, and neither do any points of agreement exist between its crude and clumsy and badly finished modelling and the meticulously exact decoration on the typical tripods. Seler, however, reproduces clay vessels from Tlaxcala and San Francisco Chalchicomula,[1] and Charnay[2] some others from Nahualac and Tenenepanco on the slopes of Ixtaccihuatl and Popocate- petl, presenting certain points of relationship with figs. 31 and 34. By topping the tall and wide neck of the vessel with clay, a stylized face has been modelled into being, while the roundedly compressed lower part suggests its body. Three upstanding pointed projections on the rim of the vessel form a stylized representation of a head ornament. Figures of this kind are by Seler connected with the rain god, Tlaloc. At least fig. 31 represents the face of this deity, and the same may probably be said of the still more summarily executed fig. 34. There is great probability that vessels of this type were imported ware. Whether their origin was Tlaxcala or Chalchi- comula cannot be determined with certainty. It is not impossible that yet another locality was their centre of dissemination. It is also of interest to note that the rain god of the Aztecs belonged to the »Toltec» mythology and was subsequently incor- porated with the pantheon of the warrior people.

There are, however, two vessels which as regards form to some extent agree with these anthropomorphic vases. They are entirely devoid of decoration, the material is coarse and of a dark grey colour, and in this respect they show relationship with the flat-bottomed bowls that often are provided with three small feet. This type of vessel, too, is of less common occurrence at Teotihuacan. The grave further contains a cylindrical vessel shaped like the tripods, although it had never been provided with feet. A saucer of light-coloured material, with a flat bottom and three feet, had a counter- part in Grave 2. The remainder of the bowls — except two which almost resemble dishes, one of which is coated with dark-red paint (iron oxide, mixed with finely pow- dered hematite) — are of dark material, and one of them is painted black. Two of them are provided with rudimentary feet. Although smaller, and of softer outline, they nevertheless bear a measure of resemblance to a very common type of bowl which, however, so far as the graves are concerned, is only represented in Graves 6 and 7. Two candeleros and two miniature vessels have their near counterparts in Grave 2. Five bowls, all of them damaged, belong to the group of vessels which is stated to be importation goods, and of this group account will be given below, p. 101. Strangely enough, there is a bowl of similar form but of a different, and coarser, material. It appears as if an attempt had been made at copying the — probably po- pular — imported ceramics, although the result can hardly be called a success.

[1] Seler 1915: figs. 197, 198, and pl. 72. [2] Charnay 1885:64, 140.

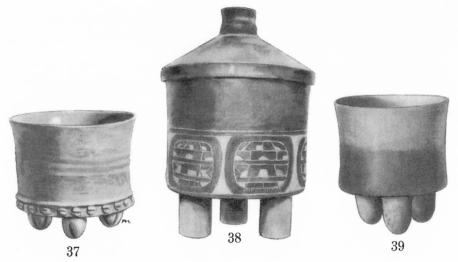

37 38 39

Figs. 37-39. Clay vessels found in Grave 3. (1/3) 37: 5782, 38: M, 39: 5262.

Grave 4.

This grave was situated between the eastern wall of Room VII and the large drain conduit which, issuing from the southwestern corner of the central court-yard, passed underneath the communicating platform and debouched outside the southern outer wall, cf. fig. 9. The grave lay at a depth of about 1 m., and must have been made simultaneously with the platform. Seeing that the latter, as already has been pointed out, dates from the very last stages of the building history of the establishment, this grave must be later than Nos. 1—3. As regards ceramics it corresponds, with a few exceptions, with Grave 3. From the weight of the platform all of the larger vessels had been crushed. Of the dead exceedingly few remains could be discovered, practically nothing else than almost disintegrated bones and a few teeth.

In point of quantity the grave was very rich, but it cannot, however, as regards quality in any way compare with the graves already described. The clay vessels numbered no less than 45, to which should be added 7 candeleros. Not only had the vessels been crowded closely together, but also on top of each other. Excavation therefore presented certain difficulties, as through the weight of the platform the vessels had partly been telescoped into one another. In one of the tripods four candeleros had been placed, after which the vessel had been covered with a bowl, bottom upwards. In another of the tripods was found a small and low cylindrical vessel, and some mica plates, small and round.

Only one of the vessels belonged to the Teotihuacan type with abraded decoration, namely a very large tripod, fig. 41 and frontispiece. The large figures — eight in

number and almost identical — which form the broad middle border are already known to us from finds described in the foregoing. A vessel decorated with closely similar symbolic hieroglyphics was recovered in Grave 3, fig. 38, and the same motive is found in fig. 22, Grave 1. Seler, as already mentioned, has explained this kind of figures as symbols of the year, or of the sun.

The small tripod, fig. 48, is remarkable inasmuch as, of all the vessels belonging to the graves, it is the only one decorated with nothing but incised lines. This process was carried out while the vessel was still soft, the instrument used being somewhat blunt and provided with a fine-toothed edge. The width of this tool corresponds to the incised lines. In the feet, which are hollow, are placed some loose objects serving as »rattles» when the vessel is shaken. As regards form, the vessel conforms to the ordinary Teotihuacan type of tripods, but the colour of its material is darker than usual. This circumstance, together with its peculiar decoration whose style does not harmonize with that usually connected with Teotihuacan, justifies the suspicion that it was manufactured at some other place.

Of classical type, although entirely lacking decoration, were the remainder of the cylindrical vessels, six in number. With the exception of one which only bore traces of three small feet, probably not hollow, they were all provided with cylindrical feet of the usual kind with rounded terminations. It may be worthy of mention that all of these vases, excepting the firstmentioned, are of precisely equal capacity.

The anthropomorphic vase, fig. 40, corresponds in a high degree with fig. 34 of Grave 3. Although the attributes characteristic of Tlaloc in this case are absent, it is however not impossible than even here a representation of the rain god is intended.

While all the vessels recovered at Xolalpan that so far have here been dealt with are flat-bottomed, in Grave 4 were found two with rounded bottoms. One of these, fig. 47, has a wide mouth and exceedingly plain decoration, merely consisting of vertical lines of considerable width, and fairly deeply incised. This vase has a utilitarian appearance, and may well have been employed as a household utensil. Vases provided with feet are designed for placing on some plane and firm kind of pedestal, while those with a rounded bottom, which either require props or some yielding underlay capable of being hollowed for their support, probably have formed part of the kitchen equipment. For in those days, as now, cooking pots were no doubt placed in the middle of the fire, or next to it, or on the live cinders. A flat-bottomed vessel is, for various reasons, hardly practicable as a cooking pot.

The second round-bottomed vessel, fig. 42, does however not seem likely to have been used as a cooking vessel. Both in type and, to some extent, because of its light-coloured material, it is alien to Teotihuacan. Its ball-shaped feet, directed outwards, are un-typical and generally found in association with the so-called »glazed» ceramics.

As regards both form and ornamentation, and, above all, the character of the material, the ten bowls fitted with annular feet — four of them reproduced on figs. 43-46 — diverge, however, from the style typical of Teotihuacan ceramics. They occur in

69

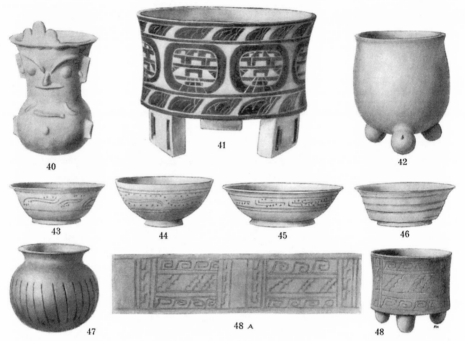

Figs. 40-48. Clay vessels found in Grave 4. (1/4) 40:4238, 41:4274, 42:4227, (1/3) 43:4427, 44:4426, 45:4207, 46:4208, (1/5) 47:4228, (1/4) 48:4316.

Grave 3, but not in the first two graves. At the same time they were abundantly present below the floors of the westernmost file of rooms. The material is very thin, hard, and of colours ranging from yellowish-red to a light yellowish-brown. It differs in a very high degree from the material of the classical Teotihuacan tripods. The largest of these vessels, originating from Grave 4, which unfortunately could not be restored, has a diameter of 26 cm., and is the largest bowl of this kind in the collections. Its decoration consists of incised lines and impressed dots. Contrary to what is the case with the beforementioned tripods, the decoration had been applied prior to the firing. The motives are simple: horizontal lines running round the bowl, recumbent S-formed lines, and, generally grouped around the latter, impressed dots of more or less circular shape. It is beyond all doubt that these bowls were imported, see further p. 101.

The grave goods includes some additional pottery. Among this are three small and plain dishes of dark-coloured material, and the same number of smaller dishes of lighter-coloured, yellowish-grey material. These ceramics, as well as two flat-bottomed bowls with tall and out-turned rims — the larger of dark material and well polished, the smaller of light-coloured, yellowish-red, material — belong to types

70

known from the graves dealt with in the foregoing. The one-chambered cande-leros, which evidently are intimately connected with the classical tripods, are re-presented by eight examples. As in Grave 2, also here occurs a candelero with two cylindrical cavities, each provided with two ventholes. It agrees with the one-cham-bered ones in so far as its upper side is decorated with round impressions. These are circular, and have been made by means of some hollow object. Somewhat odd is the small collection of miniature vessels, almost identically alike, viz. seven small dishes with a rounded elevation in the bottom, and eight small vases with wide mouths. In addition there is a small cylindrical vessel with very thick walls and with faint traces of red paint, and a small round object, resembling a dish, of the same type as the moulded ornaments on the large incense-brasiers, cf. fig. 149.

What purposes all these miniature vessels once served is a question which obviously cannot be answered. To me, they are however suggestive of the »dispensaries» kept by certain medicine-men among the Cuna Indians — »licensed practioners», as it were, in their own way — whom I met in the course of the late Baron Erland Nordenskiöld's expedition of 1927. Those medicine-men possessed large collections of all sorts of medicines, both real and fancy, and preserved them either well concealed from the eyes of the profane, or else daintily exposed in storing vessels of different kinds. That the house at Xolalpan had not been occupied by common people would seem quite obvious, and seeing that weapons — which moreover could not have possessed any-thing beyond a purely ceremonial import — were only found in one grave, it is not impossible that the dead interred in the graves so far reported on were priests or medicine-men.

Grave 5.

Graves 5-7 originate from the people that occupied the house at the time of its latest building period, as all of them were situated below the topmost floor of Room II, in the space between it and the floor next below. The depth of this stratum was 0.4 m. Grave 5 was found roughly in the middle of the oblong chamber to the west of the fore-court, and immediately north of the culvert drain which, starting from the fore-court, at this spot ran at a very shallow depth below the floor. The dead had been laid down at full length, with the body, as in Grave 1, orientated west to east, its head pointing in the latter direction. Unlike the graves already described, the contents were poor from a ceramic point of view, and the clay vessels only be-longed to three different types. The skeleton was recovered, although in parts rather badly damaged. It was that of a middle-aged person, probably a man. The skull was of brachycephalic type, and showed a slight deformation, which possibly had been artificially produced. This agrees with the results of Hrdlička's examinations of anthropological material from Teotihuacan. He has placed it on record that the ancient inhabitants of Teotihuacan were brachycephalic, and practiced skull-de-

formation. In this they differed from the Aztecs and the Otomí Indians, who were dolichocephalic and did not artificially deform the skull. On the other hand they appear to have been related to the population of the Gulf coast at the time of the Conquest.[1]

The ceramics only consist of eight pieces. Six of these were bowls with flat bottoms and out-curving brims, and of dark-coloured material. Similar vessels were also found in all the other graves, although in Nos. 1 to 4 they were of smaller proportions. With one exception they conform to figs. 50 and 53, although naturally with minor individual divergencies. As to this, one of the bowls is made of material of a lighter colour, and has its outer side painted with two oppositely placed ornaments at the bottom edge. These consist of fields which are rounded at the top and encircled by arched lines. The paint is of the usual deep-red variety, with an intermixture of finely powdered hematite particles. The remainder of the vessels consist of an undecorated bowl of the beforementioned hard and redish-yellow material, and of a small miniature vessel with a tall and wide mouth, of the kind especially mentioned in the description of the next foregoing grave. The ceramics belonging to this grave have not been illustrated here because pictures are given of the contents of other graves where similar and better representatives of these types of vessels are found.

Graves 6 and 7.

Graves 6 and 7 were situated close together next to the eastern wall of Room II. These graves, unlike the foregoing five, were child-graves. Judging from the skeletal remains, the children must have been new-born or of very tender age.

Grave 6 consisted of a largish bowl, with a flat bottom and of truncated cone shape. In this bowl the child corpse had been placed, together with a small vase, fig. 49 A. On top of the bowl, and perhaps supported by some perishable material, had been placed a somewhat flatter bowl, upside down. Immediately adjoining the grave there was yet another bowl, in the same way covered over with a similar vessel. This bowl contained nothing but a third, and smaller, bowl of the same type, figs. 50 and 53. As was mentioned in connection with the preceeding grave, this type is one of common occurrence, although in earlier graves it occupied a less prominent position. In the later graves, however, bowls of this type play a similarly dominant part as the tripods in Graves 1—4. In Graves 5—7, on the other hand, Teotihuacan tripods are entirely absent. This type of bowl is very little varied. Some bowls of this kind have been manufactured with great care, like those here depicted, while on others — although these are very much in the minority — less work has been expended. To the latter category belongs the covering bowl of this grave. Characteristic of this type is: firstly, a flat bottom and out-curving rim; secondly, almost rudimentary feet, and, thirdly,

[1] Seler 1915:442; Hrdlička 1899:104.

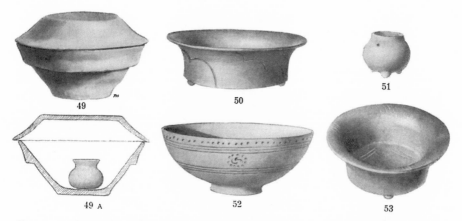

Figs. 49-53. Clay vessels found in Grave 6 (figs. 49, 50, 53), and Grave 7 (figs. 51-52). (1/5) 49: 3584-86, 50: 3586 a, (1/3) 51: 3655, (1/4) 52: 3656, (1/3) 53: 6705.

external decoration consisting of incised arched lines. Occasionally also the inside of the rim, as well as the bottom, may be decorated in the same way, or with groups of straight lines. The colour of the material is dark, occasionally the vessels are coated with a layer of paint — likewise dark-coloured — and in certain cases the marks left by the tool used in the smoothing of the vessel's surface are conspicuously heavy. As a rule they are carefully smoothed, and not seldom beautifully polished. Only one bowl of this kind in Grave 5, and another in Grave 7, bore painted decoration. Technically, the flat bottom is a weak point, but esthetically these bowls often attain a high level.

The last of the graves dating from the time of the house-builders consisted of a large bowl of the type stated as importation ware. It is a good exponent of this class of ceramics, and, as is only fitting, is provided with an annular foot and incised decoration, besides being made of yellowish-red material, fig. 52. The child corpse had been placed in this bowl together with the small vase, fig. 51, and invertedly placed above it were no less than three bowls of the same type as fig. 50, one on top of the other. One of these bowls had a yellowish-brown surface, a red border along the bottom edge of the outside, and three almost rudimentary feet. The remainder of the bowls had neither feet nor any sort of decoration. The largest vessel of the collections, as regards vessels of this category, was the topmost of these bowls. It measured 28.2 cm. in diameter. As the corpse of the child, both here and in Grave 6, is likely to have been deposited in some sort of sitting posture, the bowls must have been propped up by supports of some perishable material. An alternative possibility must in both these cases be taken into consideration, viz. that of secondary burial, that is to say that the children had first been buried elsewhere, and their bones subsequently deposited in these sepulchral urns. As these fragile bones were badly

decayed, their position did not supply any guidance for or against any supposition as to this. I do not, however, incline to the belief that secondary burial in this case was practiced.

As already has been mentioned, it is remarkable that no Teotihuacan vessels occur in the last three graves, nor in the filling below the floor in which they were embedded. The vessels of the types here predominant — as also the flat-bottomed bowls recovered from Graves 1-4 — are however undoubtedly products of the Teotihuacan culture. Judging exclusively by the material here presented, one may be tempted to accept, as regards the bowls in question, an evenly progressing line of development from the earliest to the latest of these graves. For in the earliest graves the bowls are unpretentious in regard to form, practically innocent of decoration, and were evidently objects to which no great interest was given. For reasons unknown, tripod vessels do not occur in the latest graves, but special care has been devoted to providing a decent show of bowls, and these are frequently very well made. That the manufacture of tripod vessels had been discontinued may be regarded as most unlikely. Probably the different character of the grave furniture may be put down to priests or other notables having been interred in Graves 1—4, while a person of some different social rank was buried in No. 5. If this theory is correct, it tends to show that tripod vessels constituted a privilege pertaining to a certain social position. In that case it would only be natural that they were not allotted to child-graves. That during this period, when it attained its maximum extent and in point of architecture showed no changes from the past, the establishment might have been occupied by aliens — and that the absence of tripod vessels would thereby by explained — seems out of the question.

PART IV

ARCHAEOLOGICAL FINDS OF THE MAZAPAN CULTURE

In the foregoing it has already been mentioned that Vaillant at Las Palmas discovered remains of a culture that previously had escaped attention, and that the considered himself justified in dating it between the Aztec and Teotihuacan cultures.[1] There has also been given a brief account of the work carried out by us at this place. At Xolalpan we acquired a considerable quantity of material belonging to this newly discovered culture, the Mazapan culture, which has derived its name from this particular section of Teotihuacan: San Francisco Mazapan. Between the ground surface and the floor of the ruin there was a considerable number of graves. Their positions in relation to the ruins of the building prove that the inhabitants of the latter had practically no knowledge of the ruin. After the demolition of the house, collapsed walls and such like, together with debris piled up by strong winds, had formed a low mound, on top of which the later occupants may be presumed to have built their huts, and buried their dead beneath the floors, a custom of fairly common prevalence in America. It is remarkable that no part of the ruin appears to have been made use of by the people of the Mazapan culture. The floors of the hut occupied by the present owners of the place derives, on the other hand, from the ruin. Judging by the relics of the Mazapan culture, one receives the impression that this period was one of comparatively brief duration. The Mazapan ceramics do not seem to have adopted any elements of the Teotihuacan culture. As has been pointed out in the foregoing, p. 71, the dead of either epoch present clear evidence of definite divergencies, one from the other, as regards cranial shape. One of the most important results of the researches carried out at Xolalpan is no doubt the establishment of the fact that the two cultures in question are absolutely bordered-off one from the other. In the groups of objects that are dealt with in Part VI there appear, it is true, elements which occur both in the Teotihuacan and Mazapan cultures, but in certain cases they also date considerably farther back — or forward — in time, and for that reason cannot be said to form any connection, properly speaking, between the firstmentioned two civilizations. Of Aztec artifacts there were, however, none recovered in direct association with any of Mazapan type. Points of connection between the ceramic

[1] Vaillant 1932:489.

75

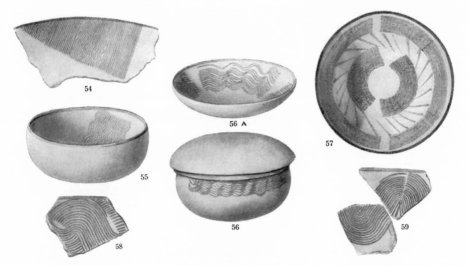

Figs. 54-59. Clay bowls and sherds of Mazapan type. Fig. 56, funeral furniture from a grave found in Room II, fig. 56 A, one of the two covers. (1/3) 54: 3913, (1/5) 55: 6363, 56: 3587-89, 57: 3910, (1/3) 58: 5407, 59: 3912.

material of the Mazapan and the Aztec cultures appear, besides, to be fairly negligible.

So far as I am aware, no evidence has been adduced as to the presence of Mazapan artifacts outside the Valley of Mexico. Sporadic fragments have been found at San Juanico, near the capital, and in Museo Nacional are preserved bowls from Popocatepetl, decorated with S-shaped figures, of which analogies are found an Mazapan vessels. Near Texcoco have been recovered ceramics from this culture of the same kind as in Teotihuacan.[1]

For future research work is left the important problem of determining the distribution of the Mazapan culture, and, if possible, also its origin. By way of suggestion, Vaillant advanced the theory that the bearers of the Mazapan culture were Acolhuas, or the later Chichimecs. He supposes this period to have been contemporaneous with the second period at Tenayuca and the last at El Arbolillo and Gualupita. Chronologically, it is suggested that it might fall between A. D. 1,200 and 1,300.[2]

Mazapan pottery types.

The most important type of Mazapan pottery, the »zonal fossil» of that culture, consists of bowls with peculiar decoration. While some of these bowls are flattish, occasionally almost plane, there are others which are fairly deep, so that the diameter of the mouth may fall below the greatest width of the vessel, fig. 55. Only vessels of

[1] The collection of Mr. R. Weitlaner, Mexico D. F. [2] According to a letter to the author.

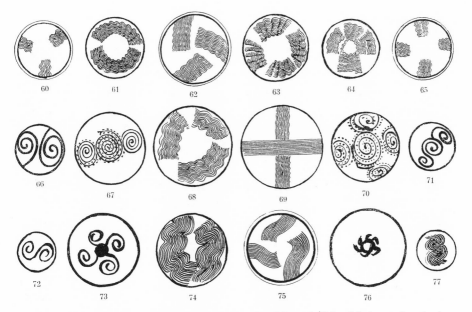

Figs. 60-77. Painted ornaments on Mazapan bowls found at Las Palmas (1/8) 60:2628, 61:115, 62:2363, 63:70, 64:7, 65:14, 66:174, 67:112, 68:118, 69:208, 70:2629, 71:175, 72:171, 73:2092, 74:5155, 75:158, 76:1994, 77:123.

the lastmentioned kind are provided with outside decoration, which is always applied near the rim, fig. 56. The decoration, always painted — in red paint — occurs in two types: 1. narrow wave-lines or straight lines, always parallel and in groups, and, 2. heavier lines, circular or voluted. These simple ornaments vary in numberless ways, as is best seen from figs. 60—94A. The decoration of the former kind often possesses a captivating and dashing elegance, combined with accuracy of delineation. The most highly developed exponent of this is found in a large, partly reconstructed dish, fig. 57, which undeniably comes up to no mean esthetic standard. But even more simple decoration, such as on the sherds, figs. 58—59, bear evidence not only of sureness of hand but also of a good eye for producing artistic effect with means of the plainest kind. The class of decoration coming under the second category, voluted lines, S-shaped figures, etc., is on the other hand of a particularly inferior quality. The vessels, too, appear as a rule less well made, and consist without exception of shallow bowls. The material is also different, being darker and coarser, and, contrary to the other category of vessels, in which the surface is smooth, on their outer walls are often seen heavy marks from the shaping and finishing. Numerically it is also far inferior to the firstmentioned type. Vessels decorated with ornaments of both these types are found in association, but, as will be apparent from the illustrations, both styles are never present on one and the same vessel.

77

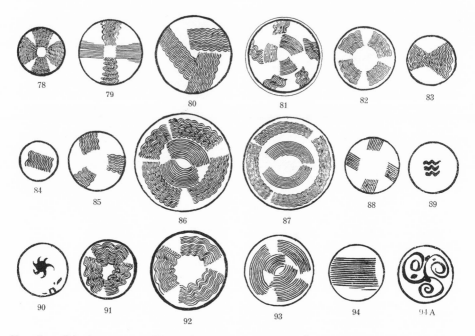

Figs. 78-94. Painted ornaments on Mazapan bowls found at Xolalpan. (1/8) 78:4434, 79:6166, 80:6259, 81:6361, 82:4624, 83:5278, 84:3467, 85:5771, 86:6362, 87:3466, 88:3688, 89:5158, 90:3468, 91:6169, 92:3715, 93:5156, 94:6168, 94A:5482.

Figs. 95—111 represent Mazapan ceramics, in form and decoration differing from the bowls. Of a peculiar character is the tripod vessel seen in fig. 97. Fragments of vessels of this kind were recovered in both of the archaeological sites. Earthenware vessels decorated with spiky projections are not uncommon in Middle America. Examples exist from the Matlatzinca, from Oaxaca, Yucatan, Copan, Coban,[1] Amatitlan[2] and Atitlan[3], and very extensively in Costa Rica. In the Maya codices representations of similar vessels are also found.[4] While Dieseldorff connects the spikes with the sun,[5] Schellhas advances the opinion that they have come into being from some spiky fruit as their prototype.

Of great importance seem to be the tripod vessels that occur in graves in association with ordinary bowls. To a certain degree they form a link of connection between Mazapan and Aztec pottery. In the main they belong to two types, fig. 104 and figs. 108, 111. The latter have big, conical feet, the outer sides of which, as well as the inside of the vessel excepting the bottom, are coated with red paint ranging in tint from the same light shade as in the ordinary bowls, to brownish-red. But red paint with a somewhat glossy surface also occurs. Some of these tripods have served as molcajetes,

[1] Schellhas 1926: figs. 3—4. [2] Röck 1929:373. [3] Lothrop 1933:89. [4] Schellhas 1926:6. [5] Dieseldorff 1926: pl. 34.

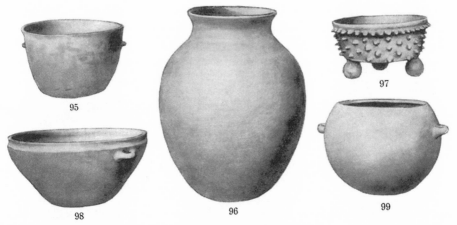

Figs. 95-99. Mazapan ceramic ware of unconventional shapes. (1/10) 95:6179, 96:3441, 97:M, 98:6181, 99:6741.

grinding-pans, a type of vessel not present in earlier cultures. The second type is manufactured of a material of light colour, usually yellowish. A tripod of this class carries a simple decoration of the kind occurring on the »true» Mazapan bowls, fig. 89. It was found in association with bowls decorated in the usual way. In shape, it corresponds in some degree with the dark-coloured and polished bowls of the Teotihuacan culture, cf. fig. 50.

In test-digging on the far side of the road bordering on the north side of the Xolalpan field, the two vessels depicted in figs. 99 and 106 were found quite near the ground surface. Although sherds of typical Mazapan pottery were found in their close proximity, nothing showing any correspondence with them is found among the rest of the finds, and they approach more nearly to modern ceramics. That they actually might belong to the Mazapan period therefore appears doubtful.

Rather peculiar are small lidded vases, four of which were recovered in pairs in two graves at Las Palmas, one at Xolalpan, and three in a grave above Room XXVIII in the lastmentioned locality. Except for a vase with a narrow mouth, fig. 100, they do not present much variation as to form and size. Also excepting the firstmentioned, they have two or three handles near the mouth. In the firstmentioned case two handles are placed near the neck, while the third is found near the bottom. In this respect it resembles fig. 126. The covers are always more or less convex, and are provided with handles either in the form of a plain knob, or a loop. As a rule there are three such handles, which are disposed as in fig. 101, which however represents a vessel of comparatively large dimensions. These three little handles can also do duty as feet if the cover be placed upside down and used as a saucer. Seler depicts vessels in some degree similar, from Santa Cruz, Baja Vera Paz, Guatemala.[1]

[1] Seler 1908:618.

79

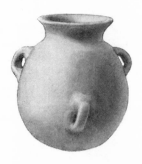

Fig. 100. Clay vessel with
three handles. (1/2) 5287.

While purely utilitarian pottery was almost entirely absent among the finds that were made below the floors of the ruin, it appears that almost all of the vessels just described have served some practical purpose or other, e. g. for serving up food. There are also numerous fragments of storage vessels. These were generally of ovoidal shape, with a relatively narrow mouth, and from many of the fragments it is evident that the vessels often were of considerable size. In the cave that was discovered at Las Palmas were found two intact clay vessels, which are probably the largest that have been recovered at Teotihuacan. The smaller of these is reproduced in fig. 96. The larger, which was left behind in Mexico, has a height of 71.2 cm. Of cooking pots in the proper sense, strangely enough finds were very rare, while on the other hand roasting dishes appear to have been very extensively used.

Graves.

A certain proportion of the material dealt with in Part VI belongs to the Mazapan culture. Of the pottery a brief account has been given in the foregoing. The most important of it was recovered in graves, and as the grave furniture, apart from typical clay vessels, also consisted of others of divergent form, it was by this circumstance possible to connect the latter with the Mazapan culture.

At Las Palmas six graves were discovered. The dead had been placed extended on their backs, but in no case appeared orientated to any particular point of the compass. No special arrangements had been made, and of mortuary offerings only ceramics and obsidian objects were preserved. The offerings consisted of bowls, more or less flat, as a rule covered with one or more upturned dishes. These bowls only contained earth — possibly decayed food — occasionally some smaller vessel, and in addition usually an obsidian knife of the type seen in figs. 286—288. The edges were faultless, and even fairly powerful magnification could reveal no flaked-off chips. It may be regarded as quite certain that they had never been used. In one of the graves there had been arranged in a line, behind the head of the dead, four groups of bowls consisting of 1, 2, 3, and 4, respectively, in one another and with their mouths upwards.

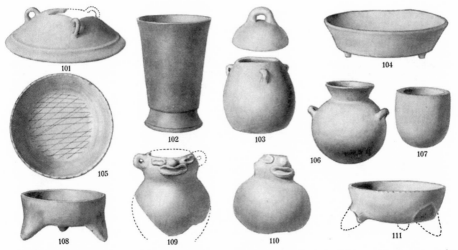

Figs. 101-111. Mazapan ceramic ware of unconventional shapes. (1/6) 101:6262, (1/4) 102: M, 103:5285, (1/6) 104:6177, 105:2633, 106:6742, 107:3177, 108:5274, (1/3) 109:6484, 110:6483, (1/6) 111:2633.

Two graves were furnished, apart from the usual ceramics, each with two vases of the type seen in fig. 103, and in one case with a cup, fig. 102. The furniture of one of the graves was of a highly divergent character. At the back of the occupant's head had been placed a large tripod vessel, fig. 97, provided with irregularly shaped, spherical, feet, with a flat bottom, and straight walls with a re-inforced rim. Its decoration consists of attached clay cones, and the vessel showed heavy traces of white paint. An upturned, very large bowl had been placed over the head of the dead person, of a type similar to fig. 98. By the side of the dead was set a Mazapan bowl, covered with a dish and containing an obsidian knife.

In the course of the test-diggings that preceded the excavation work proper — viz. the clearing of the ruin — both graves and detached finds of the Mazapan culture were discovered. The graves numbered sixteen. All of them present the characteristic pottery, but in addition there are considerable divergencies. A grave located above Room III was furnished with two large bowls, one turned over on top of the other, the latter containing four small saucers and an obsidian knife. Form as well as material were of the usual type, but none of the vessels bore any decoration. One grave, situated about 25 metres west of the ruin complex, was quite near the ground surface. The skeleton had almost completely perished, but the rich grave furniture was well preserved. It consisted of a large vase, resembling a flower-pot, fig. 95. Inside this were two small Mazapan bowls, one of them decorated with groups of wavy lines, the other with heavier lines, a flat bottomed bowl with three small feet, fig. 104, and a tripod vessel from which the feet had been broken off, very similar to fig. 111. By the side of the large vessel was placed an undecorated bowl of pure Mazapan type

6

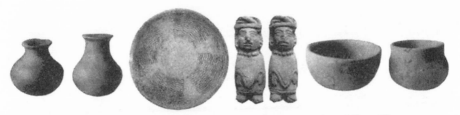

Fig. 112. Clay pots and figurines found in a grave above the floor of Room III.
(1/3) 4626, 4627, 4624, M, 4631, 4628, 4625.

and a red-painted tripod bowl. With exception of the firstmentioned tripod, they were made of the same yellowish-brown material.

A contrast to this is presented by the grave discovered in the north wall of Room XXIV. It only consisted of a flat bowl, placed over the skull of a child. Of the skeleton no traces were discernible. The same peculiarity characterized three more graves. The custom of only, for some reason, burying the head and covering it with a bowl is also known from Oaxaca and Yucatan.[1] That graves of this kind might constitute offerings, possibly in connection with the Xipe cult, is not inconceivable, but would no doubt be difficult to prove. Strangely enough, we never came upon any skulls in clay bowls covered with other clay bowls, while Vaillant discovered nine graves of this very remarkable type.[2] Exceedingly interesting is the circumstance that part of a wall had been removed to make place for this diminutive grave. The walls in question are not, it is true, capable of offering any greater degree of resistance, but if the people of the Mazapan culture had possessed any more intimate knowledge of the ruin, they might have saved themselves the trouble of removing a portion of the wall. By the south wall of Room II there was another grave. The dead lay extended in an almost east-to-west direction, and, in order to obtain necessary space, about half the width of the wall had been removed for a stretch of more than 1 ½ m. The grave offerings are reproduced in fig. 56. Two flat bowls were placed over a third, and deeper, one, and one of the former is also separately depicted. Still more conspicuous was the case of a grave situated above the wall between Rooms XVI and XVII. Also here the dead had been orientated east-to-west, and in constructing the grave a portion of the wall corresponding to the width of the grave had been cut away to a depth of about one-half metre. The grave furniture consisted of a tripod vessel, fig. 108, and an ordinary Mazapan bowl, the latter placed upside down on top of the former. A similar set of pottery was found in yet another grave. Four of the remaining graves contained more or less decayed, though complete, skeletons, and in the case of the rest it was in certain instances impossible to determine whether or not skulls had been included.

Only one grave contained other things in addition to clay vessels, although whether objects of perishable material had been included naturally cannot be determined.

[1] Saville 1899:358. [2] Vaillant 1932:488.

It was situated in Room III, only about 20 cm. above the floor. The grave furniture is reproduced in fig. 112. Of the dead only the teeth remained, and they indicated that their owner had been a child. They were all milk teeth, and the age of the child cannot have exceeded 11 years. The grave furniture is remarkable in two respects. Only one clay bowl is of the traditional type. The remainder, as will be seen, are two bowls of somewhat different types, and two small narrow-mouthed vases. The material is of a divergent structure and colour, and the form almost unique. In addition there were two clay figurines. They had been made in the same mould, and only differ in that the face of one of them is painted red, while that of the other is decorated with blue paint. This was the only grave in which clay figures had been deposited.

A fairly richly furnished grave was found above Room XXVIII. The furniture consisted of 6 bowls, four of which had, by twos, served as covers. With one exception they were decorated with groups of wave lines. One of them was decorated similarly to fig. 63, and one like fig. 78. Another carried a plain, outside, decoration, and the pattern on yet another is reproduced in fig. 88. Further, there was in addition a tripod vessel resembling fig. 104, but painted red, and of material similar to the rest. There was also included a small bowl, quite plain, of thin material. On its outer sides were traces of glossy red paint. In some degree it has the character of imported ware. Lastly, directly connected with the foregoing, there were three vases with covers, one of which is depicted in fig. 103. At a depth slightly less than this grave, and immediately to south of it, fragments of a large figure, representing Xipe Totec, were recovered. Of this find an account is given below.

The Xipe Totec figure.

The incomparably most showy, important and interesting object recovered at Xolalpan from the Mazapan culture consists of a clay figure representing the god Xipe Totec, »Our Lord the Flayed One». The locality of the find was Room XXVI at a spot a little to east of the doorway leading to the platform. The figure, which was hollow, had been smashed up literally into a thousand pieces, and these were scattered over an area of about 6 sq. m. The majority, and largest, of them lay in a pile with the legs underneath and the head uppermost. The head, which was lying face down, was intact except for the brittle head-dress and one ear-lobe, the latter being found nearly 2 m. away. No fragments were in contact with the floor of the room, from which they were separated by a mean distance of roughly 0.4 m. Obviously the figure had not been purposely buried either in pieces, or whole and subsequently crushed, e. g. through pressure of the soil. It must have been standing in the open, or inside some apartment, and had probably been knocked over by a blow on its chest. This seems likely because the centre portion of the breast was shivered into such a large number of splinters that it

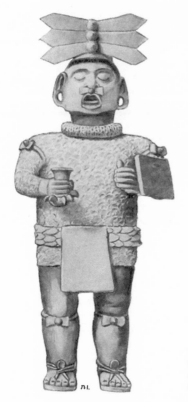

Fig. 113. Xipe Totec. Partly reconstructed clay figure found between the surface and the floor of Room XXVI. (1/9) M.

was not possible to put it together again. If the figure, when subjected to this violent treatment, had been standing with its back against a wall it might well have collapsed in a heap, with the head on top of it, and face down. That the figure dates from the period of the Mazapan culture is beyond doubt. Its location alone proves this, besides which fragments of typical Mazapan vessels were found in association with the broken bits of the figure. At a slightly greater depth, roughly at the entrance of Room XXVIII, was besides located a Mazapan grave: typical bowls, small lidded urns, and minor human skeletal fragments.

As mentioned, the figure was very badly damaged, and it took several weeks of work to put the fragments togheter into a whole. The brownish material was fragile, a circumstance which enhanced the difficulty of the mending operations. Fig. 113 gives a somewhat made-up picture of the statuette, and for the purpose of comparison — and in order to show the shape of the head, the hair and the head-dress — a photograph in profile is also reproduced, fig. 114.

The statuette consists of three parts, independently built up. The legs and the lower part of the body, including the girdle, form one. The rest of the body and the arms form the second section. This is joined to the lower section by having along its lower rim an internal flange by means of which the upper section can be inserted into the lower, where it rests upon a solid, horizontally running shelf inside the girdle. The latter, which is represented as a wreath of narrow, longitudinally arranged leaves partly overlapping each other, showed traces of blueish-green paint. A similar girdle is also worn by the god in pictures that occur in some of the codices. As will be seen, he also wears a kind of breech-cloth, maxtlatl, which passes between his legs and hangs down in broad flaps in front and behind. The head has been given a short neck which is thinner than the high collar, which makes the lower part of the head rest upon the latter. The height of the statuette is 114 cm.

Xipe Totec was the god of sowing and reaping, and to him were sacrificed men who were flayed. Of the ceremonies, etc., that appertained to him account is given in Appendix 3. He is always represented in the same form as certain of the functionaries that took part in the rites of his cult, who appeared dressed in the skin of a sacrificed human being. In the statuette the skin that he has invested himself with is made recognizable by the garment, resembling a corrugated shirt, which covers the trunk and the arms, and is lying in a roll round the neck. These parts of the figure showed traces of red paint. For the removal of the skin of the victim a cut was made along his back, and there are pictures where it can be seen how this interstice was laced up. Our figure, however, has the same appearance back and front. Neither is the skin of the hands represented like, e. g., in the pictures found in the codices, where it is frequently seen hanging down at the wrists. After the skin had become dry it was naturally impossible for its wearer to insert his hands into those grisly gloves.

The face, too, is covered by a mask consisting of the face-skin of the sacrificed victim. Behind its wide-open mouth can be discerned the lips of the wearer, while his eyes are covered by the limply depending eyelids of the mask. Of the rest of the attributes of the deity — his crown, the rattle-staff, etc. — account is given in the hymns recorded by Bernardino de Sahagun, cf. Appendix 3.

In the pictures appearing in the manuscripts the god is wearing a conical cap, Yopitzontli, in front decorated with a rosette in the shape of an horizontal X, the ends of which are cut in swallow-tail fashion.

As can be seen from figs. 113 and 114, the head ornament consists of a screen-like arrangement in three sections placed one above the other, with triangularly pointed ends. From the centre of each section projects a large cone-shaped boss. At the knees and the upper arms are fixed small rosettes, each provided with a similar, though smaller, boss. The rosettes had originally been tied on with string. For a nose ornament the figure is wearing yet another rosette of the same kind, and these may be looked upon as miniatures of Yopitzontli. Especially this kind of nose ornaments frequently occur in the representations of the god that are contained in the codices. Among

other divergencies from traditional representations is the shape of his shield, which otherwise is generally circular. In its right hand the statuette ought to have held a staff fitted with a rattle instead of, as here is the case, a clay vessel. Its left hand, however, originally grasped a cylindrical object which probably once was that very attribute of Xipe's. The cup that is held in the figure's right hand is of a type particularly characteristic of Oaxaca, cf. fig. 338. Several fragments of cups of this kind, as well as a nearly undamaged incense burner, together with fragments of a number of the latter kind of vessels, which also must be connected with Oaxaca, were found in association with artifacts from the Mazapan culture, as well as in association with objects from the Teotihuacan culture, cf. fig. 148. This circumstance points to the god Xipe and the cult connected with him having been imported from Oaxaca, and agrees with Sahagun's definite statement that Xipe in particular was a Zapotec god. The statuette itself was beyond doubt manufactured at Teotihuacan or its neighbourhood, because its material seems to be identical with that of the Mazapan ceramics. A very similar statuette of Xipe is preserved in Museum of Natural History, New York.[1] It was recovered near the town of Texcoco, and in that neighbourhood ceramics of pure Mazapan type have also been found.[2] From the distinguished historian and archaeologist, Mrs. Zelia Nuttall, who deceased last year, I received the small Xipe head from Goajimalpa seen in fig. 337.

[1] Saville 1897: pl. 23. [2] The collection of Mr. R. Weitlaner, Mexico D. F.

Fig. 114. Xipe Totec. Upper part of figure shown in fig. 113.

PART V

FINDS OF THE AZTEC CULTURE

The Aztec empire was a young organization, which had not long been established by an exceedingly expansive and warlike race. When the Spaniards arrived in 1519 the Aztec sphere of dominion extended across the modern republic of Mexico from sea to sea. Certain districts, however, retained their independence. The Aztec expansion began in the latter half of the 14th century, but it was only in 1429 that Teotihuacan with surrounding districts was conquered. At that time this place had long since lost its importance, and therefore it is only as might be expected that, at this place, the finds dateable of the Aztec era are rather scanty compared with those of the Teotihuacan culture.[1] This is apparent, inter alia, from the stratigraphical examinations that have been carried out in different spots within the area of this ancient city site. A great deal of interesting information as to the spiritual and material culture of these parts is obtainable from reports to the Spanish king and »the Council of the Indies», for the year 1580.[2]

Ceramics of characteristically Aztec type were recovered at both of these archaeological sites. They were never proved to occur in contact with artifacts from the Mazapan culture, and were always found near the ground surface. This is however of minor significance, seeing that both of the archaeological sites were tilled fields, which probably had been under cultivation for great lengths of time. Considerable modifications as to the level of the ground may thereby have been effected. It would seem that the maize-field at Xolalpan in earlier times was of a more broken character. Beside the ruin we examined there are remains of a second house in the northwestern corner of the field. After the breaking up of the buildings, on their sites mounds had been formed by wall fragments and the like, as well as by dust piled up by the winds. In the cultivation of the land a more or less unintentional levelling was carried out, helped on by weather and rainflow, so that by now the field is practically level, only with a slight southward slope. In this way the Mazapan graves have more and more been brought near the surface. As the western portion of the field was being ploughed up at the time of our stay, we had opportunity of observing how in this section Mazapan graves, that unfortunately we had no time to examine, were laid bare and destroyed.

The finds of Aztec times that were collected by us are of comparatively minor

[1] Gamio 1922: Tomo I, vol. I, 225 seq. [2] Nuttall 1926.

importance. At Xolalpan the Aztec potsherds do not even amount to 0.5 per cent. They principally belong to the second and third development periods of the Aztec ceramic art. Clay heads, spindle-whorls, and the like, of Aztec type are in relation to potsherds somewhat in preponderance. The material is however too slender to make it worth while treating it separately, as has been done with the finds of the Teotihuacan and Mazapan cultures. It will therefore be included with the groups of the chapter next following. For the sake of uniformity, however, the finds of the Aztec culture have been mentioned in a special section.

PART VI

MISCELLANEOUS POTTERY FINDS FROM VARIOUS SITES AND OF VARIOUS CULTURES

For practical reasons the detached finds have been collocated in groups according to the class of the objects, and not divided up according to the respective archaeological sites. Whenever possible, in each of these sections mention has been made as to the culture, or cultures, to which the different objects belong. Some of them are restricted to a single epoch, while others occur from the earliest periods up to the arrival of the Spaniards.

Very far from all floors in the house ruin were found intact, a circumstance which in itself is often apt to make determination of the finds difficult. At Las Palmas it would seem that — merely on the basis of circumstances associated with the discovery — only graves of the Mazapan culture are dateable with certainty. By points of correspondence between finds recovered beneath intact floors and others that could not be dated by their surroundings, it has however been possible to refer a proportion of the latter category to the Teotihuacan culture.

With exception of the grave vessels, the ceramics recovered below the floors of the ruin mainly consisted of potsherds, fragments of clay figures, stone objects, etc. The filling, which was principally stone rubble and soil, was richly mixed with artifacts of the kinds referred to. Mostly it appeared as if this had been the place for the dumping of general domestic refuse, but on the other hand were here recovered also slightly damaged vases, and even a number of intact, smaller vessels. Of others that were broken, practically all the parts were present, and in many cases they could be reconstructed. It gives one the impression that they had been crushed in the place where their fragments were discovered. This brings to mind the chroniclers' account of how the Aztecs considered the last five days of the year unlucky, and how the people then smashed up and threw away, e. g., incense burners, god images, and domestic utensils. For the new year they thereupon provided themselves with fresh equipment. It might therefore be supposed that successive enlargements of the house took place at fixed intervals of time, and that on such occasions it was customary to make hay of one's household paraphernalia. Otherwise the presence of intact vessels, stamps, stone axes, arrowpoints, etc., is difficult to explain.

Fig. 115. Clay urn of polished black-brown ware. (1/3) 58.

THE ARCHAEOLOGICAL SITE BETWEEN XOLALPAN AND LAS PALMAS

While working in his fields at a spot about 100 metres south of Xolalpan, a landholder came across certain pieces of pottery which he subsequently offered for sale. It was found that he had come upon, and dug through, an ancient floor situated at a depth of about 1.25 m. Examination of the earth layer above it resulted in finds of Mazapan ceramics of the ordinary type. Not very far from the hole that had been dug were, however, recovered a bowl containing an obsidian knife, and a second bowl which was smaller and almost flat. On top of the former had been set an inverted, flatter bowl, to serve as a cover. All three bowls were decorated with typical Mazapan patterns. The finds that were offered for sale originated, however, from a grave below the floor which unfortunately had been destroyed, the skeletal fragments thrown away, and part of the vessels that had got broken in the process of digging-out had not either been thought worth collecting.

The finds were purchased by us, and of them two clay vessels are reproduced in figs. 115 and 136. The former, as will be seen, is a beautifully formed urn of particularly well balanced proportions, and decorated with vertical, incised lines issuing from a horizontal one above them. To one side of the urn had been attached two clay knobs, and on the opposite side, almost down at the bottom, a third knob. This arrangement calls to mind the peculiar three-handled vase, fig. 126. The vessel in question is coated with dark-brown paint and well polished. The other of the vessels here reproduced is painted all over red, with a bright polish. The remainder of the finds consisted of one intact bowl, and seven that were fragmentary, all of them painted red, and polished. Two of them are fairly flat, while the rest are very similar to fig. 139, although considerably smaller. There is also a number of small vases with rounded, compressed body and wide mouth, and some small saucers, all of exactly the same type as those found in Graves 1—4.

Both the fact of the objects having been discovered beneath a floor, and that parts of the ceramics conform to the graves below the floors in Xolalpan, are manifest evidence that the objects belong to the Teotihuacan culture. Time, however, did not allow of any special examination of this interesting — and presumably also archaeologically rich — site.

STRAY FINDS OF TEOTIHUACAN POTTERY BELOW THE FLOORS AT XOLALPAN

Qualitatively and quantitatively, the most important finds at Las Palmas consisted of Mazapan ceramics, the finds dating from the Teotihuacan period being on the other hand not very remarkable. In the fillings below the floors at Xolalpan there were discovered, apart form the graves, a quantity of detached finds, the majority of which consisted of fragments of vessels. Of those belonging to different categories, account is given in the groups of classified objects dealt with in the following. Although Teotihuacan ceramic art is strictly bound by tradition both as regards form and ornamentation, the grave furniture in no way presents a complete picture of it. Considerations of space unfortunately do not permit of any detailed account being given of the voluminous material.

In point of numbers, fragments of the typical tripod vessels with scraped-out ornaments unquestioningly predominate. A proportion of them are exceedingly well made, and both the technique of their decoration and their general beauty bear witness to their superiority even to the best of those found in the graves. Strangely enough, in many of them there are heavy layers of cinnabar remaining in the scraped-out portions. A four-petalled flower is a frequently recurring element, but details of, e. g., Tlaloc faces and butterfly motives of a high class also occur. Very popular appear to have been bottom border friezes with moulded decorations. Only one motive is ever found on any one vessel. In some cases the decorative details, which on different vessels may vary considerably as to size, are placed closely together, while in others they are more spaciously planted out along the perimeter of the vessel. Most frequently occurring are representations of heads, among which faces resembling Tlaloc and the Fat God are distinguishable. Simpler ornaments also occur, such as cruciform figures, often of a flowerlike character, and circular plaques with a straight, transverse incision, semispherical knobs, etc. The dimensions of the vessels vary considerably. Only in exceptional cases does the diameter fall below 10 cm. Fig. 117 shows a large fragment of a vessel whose diameter was about 35 cm., but there are fragments of what appears to have been an undecorated cylindrical tripod vessel with a diameter of between 55 and 60 cm. The thickness of the material varies between 1.2 and 1.5 cm., and the cylindrical feet measure up to 11.5 cm. in section. Many fragments are provided with mending holes, and one of these — with very indifferently executed decorations —

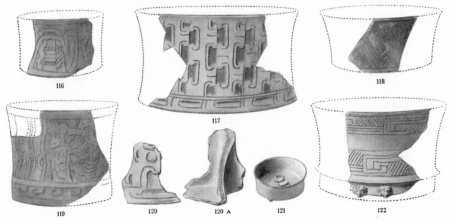

Figs. 116-122. Parts of Teotihuacan vessels of various shapes. (1/3) 116:4747, (1/6) 117:5193, (1/3) 118:4992, 119:4283, 120:5723, (1/6) 121:6744, (1/3) 122:4309.

shows that the original vase had been subjected to very extensive and painstaking mending operations, cf. Appendix 10.

Of the cylindrical tripod vessels, and the dark-coloured, polished bowls with flat bottom, a fairly detailed account has been given in connection with the graves, and in the chapters next following, certain ceramics, partly recovered below the floors of the ruin, will be dealt with. In addition, mention however ought to be made of certain methods of decoration, and types of vessels, which do not occur in the graves.

Fig. 117 is manufactured of light-coloured, yellowish clay, and the ornaments, which are fairly deeply incised, were applied before the firing. Its feet were rectangular, hollow, and very strongly made. Seler publishes a vessel with similar ornaments, and points out that it shows relationship with the Totonac style.[1] Microscopic investigation of the clay has shown that this tripod cannot be of Teotihuacan make, cf. Appendix 12. In fig. 120 a strange-looking fragment is depicted, viewed from two sides. The decoration is not particularly expressive, but this is partly owing to its having been cut out in the still damp vessel, which was subsequently handled so that the ornaments became somewhat blurred. This vessel had a rounded, niche-shaped recess within which the bottom had been removed. Of this type I know of no complete example.

In fig. 119 is reproduced a fragment which also is made of fairly light-coloured clay. The decoration, which is executed in very faint relief, appears, inter alia, to include a figure possibly representing Tlaloc. Tripods with incised linear ornamentation are to a certainty of comparatively rare occurrence. One of these was found in Grave 4, which as regards form does not differ from the ordinary type, but in which the orna-

[1] Seler 1915:519.

92

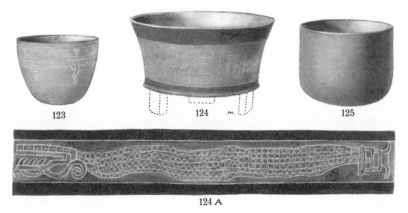

123 124 125

124 A

Figs. 123-125. Black ware Teotihuacan vessels of different types. (1/3) 123: 6552, 124: 6629, (1/4) 125: 5410.

mentation presents a foreign appearance, fig. 48. While the material of the fragment depicted in fig. 118 conforms to the usual Teotihuacan type, that of fig. 116 is browner than is usual. The diagonally disposed ornamentation, divided in fields by plain bands, in the former case is also more easily brought within the range of patterns typical of these ceramics, while the severe decoration consisting of lines and meander figures seen in fig. 122 conveys a somewhat foreign impression. Its shape, and not least the heads on the bottom frieze, are on the other hand especially typical. What is meant to be represented by the figures drawn in exceedingly fine lines on fig. 116 appears very uncertain. It is possible that the roundedly truncated conical figure is surrounded by the leaves of the four-petalled open flower of such frequent occurrence. This, and other ornaments corresponding with those depicted by Seler, which occur on hard, red-polished potsherds from San Miguel Amantla,[1] are not too infrequently occurring in our collections. A type of which there are but few representatives is decorated with impressions of grater-like sharpness, set closely together. While its shape conforms to type, its material is of such light colour that importation may well be suspected.

As imported ware should also be classed the vessels shown in figs. 123—125. Fig. 124 has, it is true, a shape of but slight divergence from that of the classical tripods, while the rounded bottom in the other two places them decidedly apart from the ordinary types of Teotihuacan pottery. In fig. 123 the material is light yellow, while the surface is greyish-black. Its decoration has been done after the firing, and its lines stand out against the light-coloured material. The little bowl with thin walls, fig. 125, which has been in parts reconstructed, has a dark surface but lighter coloured material. To a considerable extent reconstructed is also the vessel reproduced in fig. 124. Contrary to the remainder, it was not recovered underneath the floors of the ruin. As will be seen, a rather badly designed serpent figure runs round the vessel, apparently meant to

[1] Seler 1915: pl. 60.

93

represent a rattle snake. The body of the serpent is provided with circular impressions produced with some very sharp implement.

Another restored object is seen in the small, cylindrical bowl, fig. 121. It has in its bottom been provided with two objects, each separately formed and then attached to the vessel, one being slightly bowl-shaped and the other rectangular. This extremely extraordinary arrangement is not particularly rare, and always occurs in vessels of this description. Boas reproduces a similar bowl in which the round object has the form of a tall, conical vase, and the rectangular one is provided with a round perforation.[1] The surface of the latter is blackened by fire.[2] It may not be unreasonable to suppose that these vessels were ritually used.

A numerically somewhat insignificant group is that of large bowl with thick walls. The bottom is rounded, and the three sturdy feet are cylindrical in section. The inner side is usually undecorated, while the polished outer side is of light yellowish-brown colour and decorated with large, plain figures in red. These are frequently partitioned off by incised lines. Seler makes mention of fragments of similar vessels from Cerro de Iztapalapa and from the shores of Lakes Chalco and Xochimilco.[3] Closely related to these vessels would appear a pottery type recovered by Vaillant at Zacatenco and Ticoman, which belongs to the Late Period[4] in the case of the former locality, while that of Ticoman is of the Early Period.[5]

Numerically of greater importance are the miniature vessels. Where to draw the dividing line between these and ordinary vessels may often be a matter of opinion. They may suitably be divided in two classes: those intended for some practical use, such as colour-cups and saucers, and those which have served no practical purpose. The latter, which as a rule are miniature replicas of ordinarily-sized vessels, may conceivably have been votive vessels or toys. Possibly the latter alternative should be given preference. Occasionally they are badly made, and, judging from certain impressions on them, appear to have been formed by the fingers of small children. Their types vary from small vases with rounded or flat bottom, and bowls, to flat dishes. Some have the appearance of being miniature candeleros.

Of an exceedingly interesting vessel such a large number of fragments were found, below the floor of Room XII, that with some slight reconstruction it was possible to restore it to completeness, fig. 126. The loose material, which partly gives an impression of being »decomposed«, quite certainly originated elsewhere than at Teotihuacan. Microscopic examination has established that the locality of its manufacture is more to seek within the same region as the yellowish-red pottery which is referred to below. Strangely enough there were no fragments of its mouth — or, possibly, neck — by reason of which it is not inconceivable that the vessel has been in use even after the destruction of its upper part. Its shape is foreign, and so is its decoration, which consists of broad bands of a light brown-red tint. Most remarkable however are the positions of the three, fairly strongly made, handles. The two upper ones are somewhat

[1] Boas 1911—1912: pl. 58. [2] Gamio 1921:40. [3] Seler 1915:497. [4] Vaillant 1930:96—97. [5] Vaillant 1931:374—375.

Fig. 126. Three-handled clay
jar of foreign type. (1/6) 5165.

obliquely placed, the lower one, on the other hand, being vertical. This arrangement
may have been made for the purpose of making it easier to carry the vessel on a person's
back with the aid of a strap or rope passing through the three handles. The Incan
aryballes have two handles and a projection, an arrangement made to facilitate trans-
portation.[1] In this case, however, the projection is placed higher up than the handles.
A similar vessel has been recovered at San Andrés Chalchicomula, which, however,
has a flat bottom and a high, slightly conical, neck.[2] Strangely enough, microscopical
examination points in the same direction.

FOREIGN ELEMENTS AMONG THE CERAMIC FINDS

Both the cylindrical tripod vase — that most popular type of earthenware vessels of
the Teotihuacan culture — and the bowls of the Mazapan period, decorated with
wave-line groups, present a singular degree of consistency. In size and decoration
a certain degree of variation exists, but, with a very few exceptions, within extremely
narrow limits. The leading stylistic types, and the almost inflexible pattern-laws,
constitute these vessel-types »zonal fossils», so to speak, and are in South America
paralleled by the aryballe, which, with exceedingly slight variations, is found throughout
the immense Incan Empire.

A good many fragments, and also a few more complete vessels, contrast with the rest
and bear irrefutable evidence of mercantile connections, which in part were very far-
reaching. Careful microscopic examination by experts, of ceramics totally divergent
from the Teotihuacan types would no doubt give good results. But if thereby problems
of a larger scope are to be solved, it would be necessary to examine an extensive range of
material from different parts of the country, preferably from the centres of pottery
manufacture, and that the result be published in a satisfactory manner. Only by such

[1] von Rosen 1919:345, [2] Gamio 1922: Tomo I, vol. I, pl. 128.

95

a procedure no latitude would be available for subjective opinions, and the marshalling of material into ready-made systems, in evidence for or against conventional theories. In collaboration with Gunnar Beskow of the Geological Survey of Sweden who carried out the analyses of microscopical sections of pottery, I inaugurated this scientific and exact research method in regard to material from Panama.[1] The valuable results that have been attained should serve by way of an example. Here lies a field which most certainly will be cultivated by future research-students.

A detailed account of all clay-vessel fragments in my collections of such divergence that they ought to, or might, be classed as imports would carry us too far. It may however be mentioned that in the collections some sherds of the Matlatzinca type are to be found. Under the heading of this chapter I have, however, ranged two groups of numerical importance.

Vessels decorated with figures in relief, »Maya style».

Below the floors of Rooms VI, VII and XV were discovered sherds of vessels of a very superior make, figs. 127—130. The material varies as to colour, from brownish-red to yellowish-grey, it is of very fine quality, and the decoration technique is the same throughout. It consists of ornamentation deeply incised while the vessels still remained in a soft state, i. e. prior to the firing. The ornamentation that is typical of Teotihuacan ceramics was, as already mentioned, applied subsequent to the firing by scraping away certain portions of the surface, which often was well polished.

Fig. 130 shows rim fragments of a bowl with rounded bottom. These fragments, six in number, form, when pieced together, a connected area whereby the nature of the decoration and the shape of the bowl at least to some extent become apparent. On the left is seen an upturned face. The nose is large and projecting, the eye small and elongated, and the lower jaw angular. Under the nose is a somewhat irregularly shaped design resembling a moustache. The face bears some degree of resemblance to certain Maya hieroglyphics, e. g. some of the head-variant numerals, and, possibly, to the glyph *kin*, the sun sign. It is surrounded by curling fillets, twining into each other. It is even possible that the face is placed within the wide-open jaws of a serpent, as is the case with similar faces in an instance related below. The right-hand portion of the vessel-fragment is occupied by vertical bands between which are inserted compositions of ornaments differing from each other, but nevertheless of a certain common style, bearing the stamp of hieroglyphics resolved into ornaments. Certain points of resemblance between these and ornaments from the Totonac district are also apparent. Whether any special importance attaches to this circumstance is hard to say. Knowledge of hieroglyphics was reserved for the priests and the higher classes, and the potters had to content themselves with reproducing the signs as best they

[1] Linné 1929: Appendix 2.

could. In certain of the hieroglyph-ornamented vessels it is possible to identify the signs, but often they seem to be meaningless, and only serving decorative purposes while resolving themselves into mere ornaments.

In Museum of the American Indian, Heye Foundation, New York, is preserved a vase from San Agustín Acasaguastlán in the western part of the Department of Zacapa, central Guatemala. The modern population is Spanish-speaking, but in ancient times the country was occupied by Maya Indians. This vessel is an exceedingly handsome piece, and the Museum has devoted to it a special publication with magnificent illustrations. Similarly to fig. 130, it is covered with figures incised with exquisite sureness of hand, all but the smooth edge of the rim. The only divergence as to shape is that the Guatemalan vessel is more spherical. There are many points of resemblance, even identical ones, between these two vessels: form, size, and the colour of the material, also the style of the decoration and the technique employed in its execution, as well as certain details of the decoration. Mere fragments of a clay vessel cannot of course do it full justice, but it would be an excess of »local patriotism» to claim that, from an esthetic point of view, fig. 130 could ever have been seriously compared with the Guatemalan vase. For this is what Saville says of it: »The vase is without question the most beautiful example of earthenware ever found in either North or South America, and it is in a class by itself as a triumph of Indian art.»[1]

The many points of correspondence between the fragments from Teotihuacan and the vessel from San Agustín Acasaguastlán cannot be put down to mere accident. Saville says of the latter that »this type of decoration is excessively rare in the pottery of Mexico and Central America». Among the ceramics of Teotihuacan it is a foreigner both as to form and technique of decoration.

Both fig. 130 and the San Agustín vessel present, on the other hand, as regards ornamentation undoubtedly considerable correspondence with the gigantic monolithic stone sculpture of Quirigua, which is known as »The Turtle»,[2] and that city of ruins is situated only 80 km. from the firstmentioned place. Saville also emphasizes that many points of resemblance exist with »the stucco reliefs of the ruins of Palenque and the beautiful carved wooden lintels and altar plates of the ruins of Tikal. These examples, and the vase, belong to the best period of Mayan art.» The dated monuments of Quirigua fall between 9. 14. 13. 4. 17 and 9. 19. 0. 0. 0, which, according to Spinden's correlation corresponds to A. D. 465—550.[3] From what has been here adduced in the way of stylistic correspondence between the two bowls, on the one hand, and »The Turtle» of Quirigua, on the other, it follows that fig. 130 m a y date from the period just referred to.

But also figs. 127, 128, and 129 possess stylistic points of contact, above all with Maya ceramics. Although, contrary to what is the case with fig. 130, I am unable to adduce any striking points of agreement — the literature and the museum material

[1] Saville 1919; Villacorta 1927:350—351. [2] Maudslay 1889—1902: vol. 2, pl. 53 seq.
[3] Spinden 1924:110.

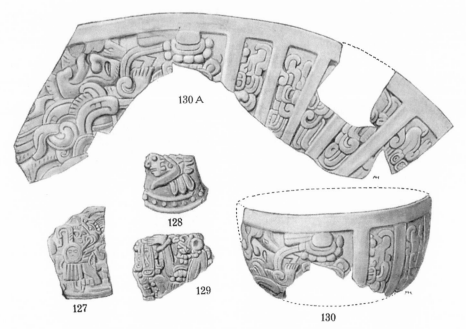

Figs. 127-130. Potsherds decorated with figures in relief, »Maya style». (1/2) 127:4028, 128:4029, 129:4017, 130:4309.

at my disposal being inadequate for such a thing — it must appear self-evident that these vessel-fragments cannot be indigenous to the Mexican plateau land.

Fig. 127 is a fragment of a cylindrical, or possibly slightly conical, vessel with a diameter of 15—20 cm., provided it originally was symmetrical. No part of the rim is left intact. It represents, as will be seen, a man in kneeling position and with his head turned backwards. In his right hand he holds, inter alia, a round shield ornamented with a face. Similar faces suggestive of the day sign, *ahau*, often recur as a decorative element in Maya representations of the human figure. In his left hand the figure carries an object which probably is meant for a spear-thrower, atlatl. Thus the figure would be left-handed. Unless it was purposely designed as left-handed, this circumstance may be explained by the figure perhaps having been made in a mould or applied by means of a stamp, and in that stage normally right-handed. In the cast, or impression, the case would be reversed. The figure is provided with a large head-dress, which inter alia, includes a plume, and from the centre of the ear-ornament issues an oblong object. Ear-plugs of this kind often occur in Maya figures. Below the knees and round his wrists he is wearing bands, possibly composed of feathers. To his stomach seems to be fastened a round plaque, which seen from the side is represented as semicircular, and on his breast is placed a strange-looking elongated plate with deeply notched ends.

Strebel depicts a vessel-cover of truncated cone shape, and with sides decorated with figures in high relief.[1] These figures are similarly assuming a kneeling posture, although more crouching, and notwithstanding their being weaponless they hold one arm raised as if for throwing. Some of them are similarly left-handed. Occupying the spaces between the figures are some circular, undecorated disks. Like the man in fig. 127, they are richly provided with ornaments. The frieze is in two places interrupted by Tlaloc faces. Of this object, which was found in a grave-mound at Ranchito de los Animas, Strebel, inter alia, says: »Es ist ohne Frage ein Meisterwerk in seiner Art und höchst interessant, wenn ich auch glauben möchte, dass es aus einer anderen Gegend stammt.»[2]

Fig. 129 shows a fragment of a vessel of more or less spherical shape. The decoration consists of a human figure, probably in a sitting posture, judging, inter alia, from its right foot with its upward-directed toes, which is seen in the left bottom corner. The face is shown in profile, and in his right hand the figure is holding an oblong object which possibly may be taken to represent a richly decorated satchel, although more probably some ceremonial implement. Similar elongated objects, »ceremonial bars», occur in the Maya stelae, e. g. in Copan, held in front of the breast by human figures.

As regards the last of these fragments, fig. 128, it is of extremely slight convexity, and the rounded edge may possibly be a demarcation line. The under side being very badly damaged, it is not possible to determine whether such is the case, or whether it is a strongly relieved decoration with rounded edge. It represents a human face seen in profile, framed in the wide-open mouth of a serpent. The details on the right, resembling feathers, appear to indicate a feather-serpent. The entire surface of the object shows traces of red paint. Impressed, round decorations are known from Maya ceramics.[3]

But the objects just referred to are not the only evidences of anciently existing intercourse between the Maya culture and Teotihuacan, or with places culturally connected with Teotihuacan.

At Tula, a town in the State of Hidalgo lying about 70 km., as the crow flies, northwest of Teotihuacan was long ago found a piece of shell decorated with incised figures. On one side is depicted a figure sitting with his legs crossed, and upper body and face turned in profile. Not only in its general character but also in the details, this figure closely corresponds with fig. 128. Starr says of the Tula figure that »the workmanship is more Mayan than Aztecan or Zapotecan».[4] On its opposite side are incised signs which closely resemble Maya hieroglyphics. Undoubtedly this object is of Mayan origin and reached Tula by the agency of commerce. How this place is culturally related to Teotihuacan has not yet been ascertained, but although at least part of the architectural remains date from a later period, it may be supposed that in earlier times strong ties connected these two places.

A jade plaque found at Teotihuacan is stylistically closely related both to the decorated

[1] Strebel 1885: pl. 5 and 14. [2] Strebel 1885:69. [3] Spinden 1915: fig. 72. [4] Starr 1900b: 109; Peñafiel 1900: pl. 80.

shell-piece from Tula and to fig. 127. Thus may be mentioned the similarity as regards head and ear ornaments, the arm and leg bands, the breast ornament, and the round object on the stomach. By the left arm there is an object resembling a shield, rectangular with rounded corners, which is decorated with a face very similar to, and possibly of the same import as, that on the shield in fig. 127. This jadeite object has been repeatedly depicted. The most exhaustive study made of it is probably that by Gann in his treatise »Maya jades». This expert on Mayan archaeology says: »This plaque . . . proves conclusively the existence of intercommunication between Teotihuacan, the Toltec Capital, and some Maya City of the Old Empire. The design is typically and unmistakeably Maya». He further proves certain points of agreement as to detail with Palenque and Quirigua, and concludes that »stylistically this plaque dates from between Katun 15 and Katun 18 of cycle 9».[1] According to Spinden's correlation this would correspond to A. D. 471—530.[2]

From what has been adduced above it would seem clearly proved that intercommunication existed between Teotihuacan and the Mayas of the so-called Old, or First, Empire. It is therefore not surprising that artifacts originating from the Central Mexican plateau have been recovered far south of the modern borders of that country.

Lothrop mentions among the ceramics found by him at Chuatinamit, on the shore of Lake Atitlan in Guatemala, »a sherd apparently from Puebla, Mexico».[3] In this connection, however, the following accounts are of greater importance.

Saville, for example, has published two earthenware objects from Guatemala, of a most surprising character[4]. The locality of the find is a very large site of ruins near the Guatemalan capital. Along with, inter alia, »a remarkable black-ware tripod vessel, with cover, of unquestioned Valley of Mexico Toltec type», Museum of the American Indian, Heye Foundation, New York, acquired two objects which, in regard to appearance, quite well might have been recovered at Teotihuacan. One of them is a »candelero», with two cavities, straight sides and decorated with indentations. Objects practically identical with these are preserved in the collections from Xolalpan.[5] The other is a circular clay plaque decorated with a figure not unlike a four-petalled flower with a circular centre. Plaques of this kind, so-called adornos, were, to some extent at least, used for decorating incense-burners of the type recovered at Azcapotzalco, and others with identically similar decoration have been found at Teotihuacan. This motive of decoration also occurs on clay vessels from the lastmentioned place, cf. fig. 22.

Seeing that Saville undoubtedly is one of the most experienced specialists on Mexican archaeology, the greatest weight must be attached to his pronouncement on the above-related finds and ancient intercommunication between Guatemala and Mexico. He concludes his treatise above referred to with the following words: »Finally, we again

[1] Gann 1925:277. [2] Spinden 1924:110. [3] Lothrop 1928:384. [4] Saville 1930:195 seq.

[5] Without stretching conclusions too far it may be mentioned that clay objects of candelero-shape have been found in Salvador (Weber 1922: fig. 38) and similar of stone in Costa Rica (Hartman 1901: pl. 68).

Figs. 131-135. Yellowish-red pottery. (1/9) 131: 5194a, 132: 5194, (1/3) 133: M, 134: 5194f, 135: 5194g.

emphasize the fact that the candelero and adorno artifacts originated, so far as our very meager knowledge of Middle American archaeology extends, in a style developed near Teotihuacan. The two little objects of native clay from Guatemala are so nearly identical with their Toltec or Teotihuacan prototypes from the Mexican highlands that the resemblance cannot be fortuitous; and furthermore, in this case they are not trade objects. Hence we may affirm the close relations which must have existed between these two widely separated centers of culture. In other instances we must assume that objects have been exchanged from both directions, having been brought by pilgrims who journeyed southward from Mexico, and by others who went northward from Salvador and Guatemala. In further support of this we need only call attention to the considerable numbers of vases of plumbate ware found at Teotihuacan and other places in central Mexico, which could have originated only in Salvador or in Guatemala. Moreover, the palmate sculptures found in the Ulua valley of Honduras would certainly seem to have been taken there from the State of Vera Cruz, Mexico.»

The yellowish-red pottery.

In the Xolalpan ruin, below the floors of the centrally situated rooms of the western file, Rooms XII and XIV, were recovered ceramics of types alien to Teotihuacan. Most conspicuous of these is the yellowish-red pottery which has already been referred to in connection with Grave 4. In this group are found vessels of highly varying form but of very uniform material. This is of exceedingly fine quality, homogeneous,

and very hard. The commonest type consists of bowls with a low, annular foot. A considerable number of fragments of the same kind of bowls as in Grave 4, figs. 43—46, were here discovered, and they occur — although more sparingly — also in other spots in the ruin below floors dating from later building-periods. These bowls are very constant as to form, generally provided with a very low annular foot, and often decorated with simple ornaments incised on the outer side, consisting of S-lines surrounded by indented dots. They are of great thinness, made possible by the excellent quality of the material. Thus in a bowl with a diameter of 15.8 cm., the material has only a thickness of 1.9 mm. These bowls are mostly very small, the largest of the intact ones only having a diameter of 25.9 cm.

Below the floor of Room XII, sherds were however recovered of three very large vessels of a slightly divergent type. The largest of these, which was almost complete, consisted of nearly 300 fragments, has been reconstructed and restored, fig. 132, and its diameter is no less than 68.7 cm. Another very large vessel is reproduced in fig. 131. It was not possible to restore it, but reconstruction shows that from rim to rim it measured ca. 68 cm. As will be seen, the decoration is very simple and only consisting of softly incised lines. This bowl, while complete — prior to its being smashed up — had sustained a crack through the rim and got mended. This had been done by the usual method, i. e., by holes being bored along both sides of the crack and then threaded with string, by the tight pulling of which the edges of the crack were brought close together, cf. Appendix 10. As its complete contrast there is the small vase, fig. 134. This was found intact, which is all the more remarkable as the material is exceedingly thin. In its thinnest parts it does not exceed 1.1 mm. Very strange are the two little holes that have been bored through the upper portion of the body of the vessel, diametrically opposite each other. The only explanation that occurs to me is that they were meant either for suspension cords or for fastening a cover, possibly of some perishable material.

The most interesting representatives of this group are the following two vessels, viz. figs. 135 and 133. The former is a representation of a recumbent, oblong fruit, in the upper side of which a large aperture has been cut out. With a view to enhancing the realistic effect, the edges of the aperture have been left untrimmed. On one of the sides of this naturalistic fruit has been placed a small, monkey-like figure, looking down into the vessel. This combination produces a droll effect, and removes the vessel from the ordinary run of ceramics consisting of utility vessels or vases decorated strictly according to tradition. In this case the artist has given rein to his fancy, and with a certain playfulness modelled this amusing little thing. There is an air of »art for art's sake» about it. The vessel's »mouth» is placed at one end, which is elongated in spout-form, and if the vessel was used for pulque-drinking, it may be that perhaps the figure is meant to represent the mental state in which the drinker might find himself. From a technical point of view the vessel is especially interesting inasmuch as it has been formed of two halves joined together. The well-fired and hard material

is very thin. The object is not complete, but enough of it has been recovered to make its reconstruction possible.

Quite close to this vessel were found fragments of an object which, when put together, formed a rectangular box and its cover, fig. 133. Unlike the foregoing, it was almost complete. The box is divided into two compartments by a partition wall, inserted after the completion of the tray. The walls must by then already have become fairly hard, and the partition was put into its place by being pressed down in grooves cut out in the walls of the box. The box was originally provided with four feet, one in each corner. The cover, which is about 0.5 cm. wider, and 1 cm. longer, than the tray, is ornamented with incised lines running along the edges, in addition to which the two long sides and one of the ends are decorated with plain, wavy, incised lines. The knob-shaped handle is provided with a slit in its upper part, and has rattlers in its interior.

All these vessels are made of a yellowish-red, hard, material which, as mentioned, is of a character alien to Teotihuacan. The Teotihuacan culture is, however, by no means limited to this locality. Traces of it are found over a wide region, extending from Azcapotzalco to Tula and Huauhchinango, in the state of Hidalgo, and to Chalchicomula, by the volcano of Orizaba. At San Rodrigo Aljojuca, Jalapazco, in the Chalchicomula district, objects have been recovered that, without arousing suspicion, might have formed part of a collection from Teotihuacan.[1]

In the Ethnographical Museum, Berlin, are on the other hand preserved objects from this region, which both as to material and general character closely approach to the yellowish-red ceramics. Seler depicts ceramics of this type from San Rodrigo Aljojuca[2] and from Huauhchinango.[3] It seems to me more than probable that these objects, which were recovered at Teotihuacan, originally belonged to the Chalchicomula district. Analysis of the material of a classical Teotihuacan vessel, compared with that of this type of yellowish-red pottery, have provided an answer to this question. Dr. G. Beskow has carried out such analyses of microscopical sections, and he has found that the material used in both cases have entirely different character, in such a degree that these two kinds of ceramic ware must be of different regions, cf. Appendix 12. In favour of intimate trading relations between Chalchicomula and Teotihuacan also speak the abovementioned Teotihuacan vessels found in the firstmentioned region.

Rectangular clay vessels are of rare occurrence, and of lidded boxes I only know two more examples. One was recovered at Teotihuacan, and is preserved in the local museum. It is provided with four conical feet, and has a handle of the same shape as that of a hand-bag. The material, too, is different, it being greyish-black. A photographic reproduction of this interesting vessel is found in Lehmann.[4] The other one originates from the Totonac area and belongs to Museo Nacional, Mexico. The archaeological exploration of Mexico can, of course, hardly be said to have been more than begun, and, in respect of the Teotihuacan culture, Tula and Chalchicomula must be considered as the most important objectives for future research work.

[1] Seler 1915: pl. 63. [2] Seler 1915:471 and pl. 53. [3] Seler 1915: fig. 145—147. [4] Lehmann 1933:66.

Figs. 136-140. Polished red ware. (1/3) 136: M, 137: 152, 138: 6713, 139: 6748, 140: 6714.

POLISHED RED WARE

In another place an account has been given of certain finds made between Xolalpan and Las Palmas, among which were recovered a good deal of pottery coated with red paint. Of these, a vase is reproduced in fig. 136. Circumstances attending the finding proved that this vessel, as well as all other vessels, and fragments, of polished red ware that were discovered on that occasion date from the Teotihuacan period.

At Xolalpan fragments of this class of pottery were recovered in many different places beneath the floors. All of them originate from bowls of the same shape as that reproduced in fig. 139, which to some extent has been restored, and was recovered under circumstances from which no definite conclusions can be drawn as to its age. Inside, as well as outside, it is coated with red paint. A small and almost flat saucer from Grave 3 also belongs to this group. Two almost complete vessels, which also have been restored, are of divergent form, figs. 138 and 140. It is noteworthy that decoration is absent, except in the case of the lastmentioned which is ornamented with incisions. While the latter two vessels undoubtedly date from the Teotihuacan culture, the large vessel, fig. 137, was discovered in the course of diggings in the maize field

of Las Palmas, and it is not impossible that it was manufactured during the Mazapan period. Its colour is somewhat lighter, and its material brownish-red. The remainder are manufactured of material of lighter colour, and the paint has been mixed with hematite in finely powdered form, appearing as minute plane mirrors with irregular edges. The red colour derives from iron oxide, as in all other cases where red occurs in such Teotihuacan pottery as was painted prior to firing.

Polished red ware is found through all the periods at Zacatenco and Ticoman,[1] although the vessels that are decorated by this method differ in form from the examples that are here presented. Among the finds of the third period recovered at Gualupita there are, on the other hand, bowls of polished red ware which also in form agree with those recovered in the site south of Xolalpan.[2] This class of decoration must have been very popular as it extends over such a considerable space of time as from and including the first period at Zacatenco, and through the Ticoman and Teotihuacan epochs on to the era of the Discovery. For even the Aztecs favoured a red and glossy paint, although their vessels of a corresponding type were decorated with patterns in black.

PLUMBATE WARE

Vaillant found plumbate ware at Las Palmas, but none within the »archaeological zone». For our part, we could discover no traces whatsoever of this class of pottery either below or above the floors at Xolalpan, and at Las Palmas only the necks of two vases. The colour is orange, and the form corresponds with similar portions of the figural vases that are characteristic of this type. From conditions relating to the find no date is determinable, but Vaillant's researches, as well as the fact that no discoveries were made underneath the floors of the ruin, tend to show that plumbate ware in all probability was unknown to the Teotihuacan culture.

A great deal has been written about this exceedingly interesting type of ceramics, and opinions vary considerably.[3] The vessels, which are of thin and hard material, are generally decorated with animal or human figures in relief, separately manufactured and affixed to the ready-formed vessel. The area of distribution extends from Tepic, via Central Mexico, to Yucatan, Guatemala, Salvador and further south to Chiriqui. Plumbate ware is easily distinguishable from every other kind of pottery, because its surface has a lustre resembling real pottery glaze, which however was unknown to American native potters, with the possible exception of the Pueblo tribes of New Mexico.[4] From this circumstance the inaccurate appellation of glazed ware has come into being.

[1] Vaillant 1930:42 seq.; 1931:284 seq. [2] Vaillant 1934:88 and fig. 27.

[3] E. g. Lumholtz 1904; Lehmann 1910; Seler 1915; Spinden 1915 and 1928 a; Saville 1916; Lothrop 1926; 1927 and 1933.

[4] A potsherd from New Mexico which I have had examined as to its chemical composition was found to have a glaze which in all probability has been produced by smelting caolin or meagre and feldspar-lacking clay together with oxides of lead, iron and manganese, or with sulphidic, respectively oxidic, ores of those metals.

The vessels are of different colours, which vary from blueish-grey to orange. It has been stated that the metallic lustre, or semi-vitrified surface, was achieved by using clay containing lead, and that variation in colour was the result of greater or less temperature and air supply in the firing process. Lothrop consulted an old woman potter at Suchitoto in Salvador, and she told him that her grandmother had been using clay from a special locality, and that this clay »when fired at one temperature it turned a greenish-gray colour, and when fired at another temperature it turned orange».[1] Lumholtz, however, caused a vessel he had recovered at Tepic to be analyzed, with the result that the surface layer and the mass of the material were found to be the same material. The former contained, however, an incomparably higher percentage of carbon.[2] In this case it would therefore appear that both lustre and colour tint resulted from some special firing method. This vessel differs, however, in many respects from the rest, and Seler mentions a vessel from Colima which resembles the »genuine» article, although a mere look at its form and decoration marks it down as »imitation». The lustre may most likely have resulted from the use of iron oxide, or graphite.[3] He mentions strangely enough that Franz Heger has found that the vessels from Salvador that are preserved in the Ethnographical Collections of Vienna are of a character similar to those of Lumholtz.[4]

Plumbate ware was doubtlessly a type of great popularity, and as merchandise it was spread far and wide. While Seler has suggested Vera Paz as the centre from which it was disseminated, the majority of students seem to be of the opinion that the locality where it was manufactured — provided only one such place existed, and that the Lumholtz type of vessels are imitations — was situated in Salvador. A fair number of this class of vessels have been recovered at Teotihuacan.[5] Strangely enough there are in this case two types, firstly the ordinary, and secondly representations of deities belonging to the Aztec pantheon and in Aztec style. As to the circumstances of their finding, nothing whatever is known.

Finds have been made, it is true, in a grave at Copan, but opinions seem however inclined to date it to a period following the abandonment of that city. The finds in question do not, moreover, include any Maya vessels.[6] Lothrop says, however: »Plumbate ware, as has been pointed out, is the most widely dispersed pottery now known in Mexico and Central America, while the period during which it was manufactured must extend back of the Spanish Conquest by at least 700 years».[7] The absence of plumbate ware in the Teotihuacan culture therefore points to a comparatively remote antiquity of that civilization.

[1] Lothrop 1927:205. [2] Lumholtz 1904: vol. 2, 260 (English edition: vol. 2, 295— 299). [3] Seler 1915:571.
[4] Seler 1915:583. [5] Batres 1906, Appendix: pl. 1—8. [6] Saville 1916:421. [7] Lothrop 1933:97.

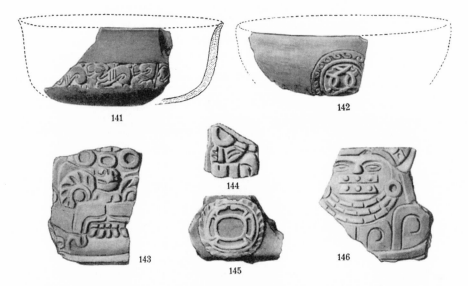

Figs. 141-146. Potsherds with impressed (figs. 141-142) and moulded ornaments. (2/5) 141:4079,
142:4441, 143:4293, 144:6090, 145:6095, 146:4226.

POTTERY WITH IMPRESSED ORNAMENTATION

This technique differs from that dealt with in the following chapter insomuch as here the walls of ready-formed vessels have been decorated with ornaments impressed by means of stamps. These implements were possibly carved in wood, but among the objects recovered are some plain stamps of clay suitable for this purpose. Bowls, and fragments of bowls, ornamented by this method have been published in large numbers from San Miguel Amantla, near Azcapotzalco.[1] The same technique was also in use in the Chalchicomula district for decorating vessels closely related to the Teotihuacan tripod vessels.[2] The Maya Indians, too, made use of this method of decoration.[3] Two examples of this decorative method, of comparatively sparse occurrence at Teotihuacan, are reproduced in figs. 141 and 142. Both of the here depicted fragments were recovered in surroundings that remove any doubt of their belonging to the Teotihuacan culture. The pattern in fig. 141 consists of S-shaped figures, which in part have been given a finishing touch after being impressed. The ornament seen in the second fragment shows close correspondence with the object placed between the two figures that are facing each other in the wall paintings in the house at Teopancaxco.[4] Seler explains it as a representation of the sun's disk.[5] A sherd with similar ornamentation, and of the same shape, is depicted from Azcapotzalco by Tozzer.[6]

[1] Boas 1911—1912: pl. 60 and 61. [2] Seler 1915: pl. 54. [3] Joyce 1926: pl. 26; Lundell 1934: pl. 9.
[4] Peñafiel 1900: pl. 82. [5] Seler 1915:415. [6] Tozzer 1921: fig. 8.

Seeing that the geographical distribution of stamps in America is very wide-spread, it is only to be supposed that ceramics decorated by means of implements of this description will be found over considerable areas. It is to be expected that the impression technique in a certain degree should accompany the moulding technique, as both processes involve »multiplication», although in slightly different spheres. On the Peruvian coast, where, besides Mexico, moulds were in ancient times extensively used, impressed ornaments were also largely employed.

This method of decoration still survives in Mexico. Ries depicts and describes richly decorated implements from San Antonio, at Cuernavaca, over which shallow bowls were formed, or they were depressed into the bowls.[1]

POTTERY WITH MOULDED ORNAMENTS

Of interest, not least from a technical point of view, is a kind of decoration technique occurring in pottery of the Teotihuacan culture, in which ornaments have been manufactured in moulds. Decoration in relief, modelled directly out of the walls of the vessels, is not to be found, the method of scraping away portions of the material in the tripod vessels serving, as we know, a different purpose. On the vessels in question are seen small faces, and other details, made in moulds and generally applied in the form of a border along the bottom edge, fig. 35. More seldom larger ornaments were made, either in moulds or by means of stamps, and these plaques, which were quite thin, were »stuck on» to the sides of the vessels which were ready formed but not yet dry. The same kind of clay was used both in the vessels and for the decorations. Figs. 143—146 shows examples of this kind of decoration. In fig. 143 is seen the head of a jaguar, and above it another, and smaller, head with large round eyes is discernible. On the lastmentioned fragment is represented a human figure, full-face, with ear ornaments, three necklaces, and a large ornament concealing the mouth. Both of these fragments originate from the ballast below the floor of Room VII. While fig. 144 is chiefly interesting on account of the difference between the thin layer containing the ornaments and the wall of the vessel coming out so conspicuously, fig. 145 claims importance for the reason that the identical ornament also appears on one of the tripod vessels with scraped decoration, fig. 22. The same ornament, suggestive of a four-petalled flower, also appears in head ornaments on certain clay heads as well as on clay plaques which presumably once were fixed on incense-burners of Azcapotzalco type, fig. 149. The material of these fragments is yellow, and most nearly approaches to the yellowish-red imported ware. From its probable country of origin, the District of Chalchicomula, there is preserved a fragment presenting close relationship, stylistically as well as technically.[2] Another sherd reproduced in the same figure represents,

[1] Ries 1932:467. [2] Seler 1915: fig. 148.

however, a butterfly motive, which shows close kinship to the well preserved and often reproduced urn, decorated in in-fresco technique, from Teotihuacan, which is in the possession of Museo Nacional de Mexico.[1] The same method of decoration has been used at Tepeaca and Matamoros Izúcar.[2] The same technical process is still used in Mexico. »Figures pressed in moulds at Cuernavaca are laid on the surface of jars in apliqué.»[3]

Hitherto far too little material has been published to make it possible with any degree of certainty to advance an opinion as to the distribution and origin of this technique.

POTTERY WITH IMPRESSED PATTERNS OF TEXTILE PLANT FIBRES

In different parts of America, vessels with a rounded bottom were occasionally built up on bowl-shaped underlays of basketwork. When flat-bottomed dishes or platters were shaped, this was in certain cases done on underlays of leaves or textiles. Of these materials impressions would then remain in the ware.[4]

Among the collections there is only one instance where impressions made by textiles are discernible, namely on a somewhat rounded sherd from Xolalpan. The fabric to which the impressed pattern is ascribable was in all probability manufactured of agave fibre, certainly not cotton, and twoshaft woven. The sherd was found below an intact floor, and consequently dates from the Teotihuacan culture. This vessel fragment is of great interest because it furnishes proof that in ancient times clothes were manufactured of maguey fibre.

Of another vessel dateable to the same period, and originally of cylindrical form, a fragment has been recovered. It is decorated with thin, slightly serpentine, lines. If a dried leaf of the species *Aloe arborensens* be placed on top of the sherd, the ramifications of the fibres and the pattern on the fragment appear practically congruent. The depth of the decoration moreover corresponds to the thickness of the fibres. Thus there is great probability that similar, or nearly related, fibre reticulations were used for pattern production.

A bowl with rounded bottom, straight walls and out-curving rim, fragments of which were recovered beneath one of the floors, has the whole of its firstmentioned part covered with impressions applied closely together. These impressions show a certain resemblance to arrow-points, and are in all probability produced by cactus spines. Spines of *Cereus* have a particular hollow at the base, close to their point of issue from the stem, and also a peculiar curve, and experiments have shown that exactly this kind of spines produce the same effect as the impressions on the fragments.

[1] Peñafiel 1900: pl. 22. [2] Beyer 1920:171. [3] Ries 1932:467. [4] Cf. Linné 1925:92 seq. and map 2. Peñafiel reproduces a sherd from Xochicalco with impressions of basketwork (1890: vol. 2, pl. 205).

EARTHENWARE ROASTING DISHES

Among the collections from Las Palmas and Xolalpan are found, respectively, 45 and 13 fragments of plates, or dishes, of clay. They are parts of roasting dishes of practically the same kind as are universally being used to this day. The under side is rough and uneven, while the upper side is plane and smooth, and in some cases finely polished and given a thin coating of red paint. The thickness of the dishes varies between 0.5 and 1.1 cm., the average being 0.8 cm. With few exceptions they are provided with a raised rim, curving outward, and with a concave under side. In some specimens the rim is low and straight upstanding. The roasting dishes appear fairly generally to have been provided with handles — probably two, and diametrically opposite — rather roughly finished and with a stunted look, cf. figure on map 2. From the fragments, which evidently derive from roughly circular plates, it appears that the latter in diameter varied between 13.6 and 67 cm., the mean being 39.6 cm. A remarkable circumstance is that none of these fragments were found beneath the floors in the house ruin. Therefrom is not to be concluded that flat roasting dishes were not in use in the days of the Teotihuacan culture, because at Xolalpan even other utilitarian pottery and other objects for practical purposes, e. g. grinding pans with accessory stone rollers — metates and manos — are absent, or only sparsely represented, among the artifacts that with absolute certainty can be dated to this period. This indicates that the culinary arrangements for the house-dwellers were relegated to some removed place. Although not directly in association with graves of the Mazapan culture, roasting dishes may nevertheless be considered to have formed part of the kitchen equipment of that period. Concerning the geographical distribution of roasting dishes, see Appendix 4.

INCENSE BURNERS

The Mexican codices contain numerous representations of persons engaged in burning incense. From information obtainable from early Spanish writers it is also apparent that the burning of incense played a very important part in ritual services, and even down to our own days it is practiced by remotely settled Maya Indians to burn incense in honour of their ancient gods in the deserted temples of the ruined cities. It is therefore not surprising that a very considerable number of whole or fragmentary incense burners of various types were recovered.

Of those of the plainest form, »ladles», there were at Xolalpan recovered two almost complete examples and 14 fragments, and at Las Palmas 22 fragments. They are always circular in shape, but they usually differ from an ordinary ladle by having a plane bottom and straight sides. The handle is cylindrical. Most of them are undecorated, but in some there is a red border — or several borders in red, yellow and blue — running along the inside of the rim. They all have perforations drilled through

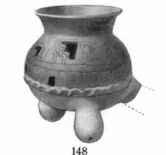

Fig. 147. Clay head representing the »Old God». (1/2) 6703.

147

Fig. 148. Incense burner. (1/3) M.

148

their walls, and in some cases also the centre of the bottom is perforated. Not much art of variety has been expended on their form, the material is coarse, and they convey the impression of having been used for »workaday» purposes only. Only two of the finds are with certainty dateable to the Teotihuacan culture. Exceedingly showy specimens have been recovered in the excavation at the head temple of Tenochtitlan, in the centre of the present capital of the country.[1] The area of geographical distribution is of very wide compass: from Michoacan towards the south to Yucatan and Guatemala, and thence down to Costa Rica. Even in Peru a similar type has been found. Merely this circumstance by itself points to great antiquity. This is confirmed by Vaillant having recovered objects designed for similar purposes not only »at all levels in Gualupita, but also in Middle Zacatenco, and at Ticoman».[2] Even in Maya ruined cities from the First Empire this »frying pan» type is found.[3]

A developed form of this type has a more or less spherical body with wide or narrow mouth, and is provided with three legs, one of which is placed higher up than the rest and prolonged into a handle. The feet are usually provided with rattle balls inside, and have openwork walls. A handsome example of this type is reproduced by Joyce from Cholula.[4] Incensarios of that type seem above all to have been used in Oaxaca, where as a rule they are narrow-mouthed. They are also known from other localities, e. g. Cerro Montoso.[5] Of this type there were at Las Palmas recovered fragments of five examples, at Xolalpan of eight, besides one almost complete specimen, fig. 148. This was found below the floor of Room XII. Fragments of yet another incense burner of the same type were found in its immediate vicinity, and below the floor of the room adjoining on the north side there were fragments of a third incense burner. One fragment was found underneath the floor belonging to the third building period of Room II. The remainder are »undateable», but it is probable that they belong to later times. Fig. 148 is well formed. The material is dark, in contrast to that of the rest, which are made of reddish-brown clay. The bulging portion of the walls is well polished, and the feet are provided with rattles. Its correspondence with similar vessels from Oaxaca is striking. Whether importation in this case has taken place,

[1] Batres 1902. [2] Vaillant 1934:95. [3] Lothrop 1933:97. [4] Joyce 1914: pl. 9. [5] Strebel 1885: pl. 9.

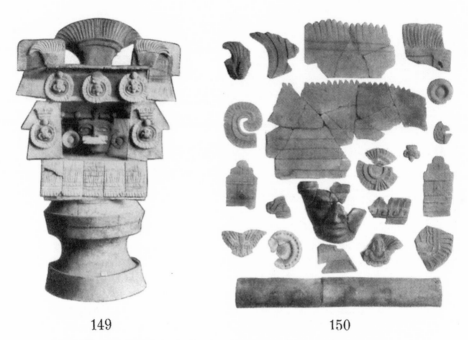

149 150

Fig. 149. Incense burner found at Azcapotzalco. Museo Nacional, Mexico.
Fig. 150. Fragments of incense burners found at the altar of the central court. (1/5) 6099.

only analysis of the clay would be likely to determine. The remainder of the vessels are in all probability of local manufacture.

In connection with the report on the altar in the central court-yard mention was made of the discovery of fragments of large earthenware incense burners, as well as portions of a large stone figure which was identified as Ueueteotl, the »Old God», of the Aztecs. A number of fragments of similar representations in miniature executed in earthenware, have been recovered from the Teotihuacan culture, fig. 147. It is not inconceivable that they, as well as the large stone figure, served as incensarios. Figural representations of a similar kind have been recovered underneath the lava belt at Copilco, and at Cuicuilco. As the »Old God» is frequently depicted in the Aztec codices, it is in this connection possible to trace the roots of the Aztec religion back to a very remote antiquity.[1]

The pottery fragments from the central altar consisted of portions of incense burners of a peculiar type, complete examples of which have so far only been recovered at Azcapotzalco. In fig. 150 are reproduced a number of the most important fragments from the altar, and in fig. 149, which reproduces a complete example from Azcapotzalco, is seen the complete structure. Fig. 150 shows at the bottom a cylindrical object,

[1] cf. Vaillant 1931:307—309.

112

Figs. 151-164. Incense burners, »candeleros». Fig. 164 found in Grave 2. (1/4) 151: 5884, 152: 4644a, 153: 6763, 154: 5718, 155: 4044, 156: 6402, 157: 3518, 158: 6766, 159: 6444, 160: 3519, 161: 4260, 162: 5573e, 163: 5779, 164: 5255.

and in the centre portions of a face. This is for the most part surrounded by decorative details of different character. A considerable number of fragments of similar incense burners were found in different parts of the ruin, in every case underneath floors or under circumstances that make them certainly dateable to the Teotihuacan culture. In the manufacture of the decorative details moulds have very largely been used. A certain proportion of the ornaments possess their direct analogies among the decorative patterns that are found on clay vessels ornamented with figures scraped out of the surface layer, and in the latter case they give the impression of being »translations» in relief.

»C a n d e l e r o s».

In figs. 151—164 are reproduced representatives of different types of clay objects characteristic of Teotihuacan, generally known by the appellation of »candeleros» — candlesticks. What purpose they actually served is unknown. It is possible that they were vessels for the burning of incense, although not infrequently their form is found not especially well adapted. Finds of this class that have been recovered by Mexican archaeologists have shown traces of some organic substance. When analyzed, this was found to be copal. Candeleros recovered at Ciudadela also contained traces of carbon. Even beeswax has been found present, but only in objects not directly recovered in archaeological excavations.[1] Seler also states that traces of copal were found,[2] and J. Eric Thompson writes: ...» wax appears to have been used for ceremonial purposes. Traces of beeswax have been found in some of those odd vessels typical of the Teotihuacan culture, which are generally known as candeleros».[3] Two specimens in our collection contain traces of some organic substance, which however are too insignificant to make analyses possible. Zelia Nuttall gives the following explanation of the use of these objects, which, although its historical foundation relates to Aztec

[1] Gamio 1922: Tomo I, vol. 1, 207. [2] Seler 1915:496. [3] J. E. Thompson 1930:105.

times, nevertheless appears probable: »During the sixth movable festival those who rendered homage to the god Quetzalcoatl sent to the temple what are described by Serna (an author from the middle of the 17th century) as »small salt-cellars» containing eight to ten drops or more of their own blood, absorbed by means of strips of paper which were subsequently burnt, with copal gum, on the altars of the temple».[1]

There are roughly speaking two types of candeleros, one-chambered and two-chambered. The former type, which is represented by 36 specimens — intact, or fragmentary — were mostly found in Graves 1—4. Its form is apparent from fig. 164, and the decoration always consists of large or small impressions, generally of circular shape. The two-chambered type varies very considerably as to form, and still more as to decoration. The collection contains 166 specimens, intact or represented by fragments. The most common kinds are those which are reproduced in figs. 151, 152, and 160, where also the largest and the smallest specimens are included. The surface, as will be seen, is worked up with heavy impressions. In certain cases, however, these are so faint, fig. 160, that the respective objects, as regards decoration, are on the border line to those entirely smooth-surfaced. The latter may also occasionally be decorated with incised lines, or with round or rectangular impressions, figs. 155—156. While all those referred to above have more or less convex sides, there are others with plane sides which are either straight, fig. 158, or in which the shorter sides are in two parts forming an angle with each other, fig. 157. Three of the fragments are ornamented with rudely formed faces, produced by a combination of modelling, sticking-on, and incision, fig. 159. While the one-chambered category with one exception are devoid of vent-holes, such are present in about one-half of the other kind.

Seeing that both one- and two-chambered candeleros were found in the graves it may with certainty be inferred that this type of object was in use during the Teotihuacan culture. While hitherto, at any rate, no candeleros have been recovered from earlier periods, it does not however appear improbable that they were in use during later periods. Thus at Las Palmas were recovered 48 examples, all of the two-chambered type. With only two exceptions the decoration was of the kind shown on figs. 151—152. Eight of them were discovered placed in a row next to a primitive wall, or part of a house foundation, which may well be supposed to have belonged to the Mazapan culture. None were however recovered in immediate association with artifacts from the period in question.

Of very great interest is the find of a candelero in Guatemala. An account of this has been given in the foregoing, p. 100.

BOWLS WITH INNER HANDLES

Of this quaint type of vessel were recovered one fairly complete specimen and fragments of a further ten. As will be apparent from figs. 165 and 166, in the former the handles are undecorated, which on the contrary is not the case with the second one.

[1] Nuttall 1904:13.

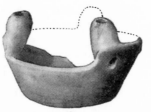
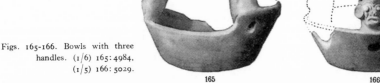

Figs. 165-166. Bowls with three
handles. (1/6) 165: 4984,
(1/5) 166: 5029.

165 166

In these, the handles are decorated with superimposed representations of faces, manufactured in moulds. The small and thin faces, hollowed at the back, that are referred to in the following, may possibly have served this purpose, cf. p. 123. Most of them are grotesque, like that in fig. 166. The majority were recovered below the floors of the house ruin. What purpose they may have served, is difficult to say. Brasiers of a type resembling the bowl in fig. 165 are known from different parts of the world. As in the case of this bowl, part of the rim is cut away so as to facilitate the placing of charcoal within the brasier, and the vessel, or roasting dish, rests on three projections on the inner side. In some of the specimens here dealt with, the handles are declining inwards to such a degree that they may have served this purpose. In other cases they are straight upstanding, and, as mentioned, decorated. Fragments of similar vessels, which also have been recovered at Azcapotzalco, are depicted by Seler also from San Andres Tuxtla in southern Vera Cruz.[1] Seler considers them to be covers of incense burners (Deckel von Räuchergefässen).[2] Tozzer no doubt expresses the general opinion when he calls this theory in question.[3] He adduces that Spinden »suggests that these vessels were intended to be suspended by ropes running through the holes in the handles». These holes are, however, exceedingly uneven, and therefore have not the appearance of having served such an important purpose. The placing of the handles is frequently arranged in such a way that the heavy vessel would be apt to break if suspended by cords attached by this method.

CLAY FIGURINES

In the course of our excavations a very large number of fragments of small clay figures were recovered. The chief value of figurines of this kind may be considered to lie in the fact that they frequently — when backed by stratigraphical digging — better than other artifacts serve as chronological guides, or epoch indices. In a considerably higher degree than, e. g., clay vessels they reflect what in our days might be called »the trend of fashion» during specific, brief periods of time. Our figurines, however, being largely devoid of these qualities — the finds from below the floors

[1] Seler 1915: fig. 133—135. [2] Seler 1915:496. [3] Tozzer 1921:50.

115

Figs. 167-169. Clay figurines. Fig. 168 R. shows the reverse of the head seen from below in oblique angle. (1/2) 167: 4825, 168: 4351, 169: 6105

167 168 169

of the ruin are, it must be admitted, unfortunately relatively few in number — cannot therefore lay claim to any especial importance, for which reason they will be more summarily dealt with.

At Las Palmas were recovered in all 277 heads of various types, 297 fragments of bodies belonging to figurines, and 173 of arms and legs. The Xolalpan finds amounted to 676 heads and 519 fragments of figures. In the former place only four complete, or very nearly intact, figurines were recovered, while the Xolalpan collection consists of 24 complete pieces.

Strangely enough, both at Las Palmas and Xolalpan heads of Early types were found. They did not by any means occur at any considerable depths, but, strangely enough, at all sorts of levels. Fig. 170, for example, was found underneaht a floor dating from the latest building period, while figs. 171 and 172 were embedded in a stratum carrying Mazapan artifacts.

A rather extensive group is that of 108 heads of somewhat flattish shape with eyes of the »slit-eye» type, and these symmetrical heads are often markedly prognathic. Stylistically, they are closely allied to certain of the Early types. They were obviously not manufactured in moulds. Vaillant lays it down that of all the types occurring in the Valley of Mexico, the group to which he has given the name of E II is most closely related to the Teotihuacan type.[1] A head of this type was recovered in the test-diggings out in the field. It was found in association with fragments both of Teotihuacan and Mazapan ceramics. The fact of archaic artifacts of this kind being found in this locality appears difficult of explanation. Either they must have been collected by the people of the Teotihuacan culture or the Mazapan period, or have formed part of adobe — sun-dried clay bricks — that since has disintegrated.

Heads with slit eyes, or with round disks in the place of eyes, were recovered both in the open field, fig. 173, above the floors in the ruin, fig. 174, and below the floors, figs. 175 and 176. A figurine of this type was found below the undermost floor of Room II, which dates from the second building period. Entirely identical figures are depicted by Vaillant from Santa Maria, Tlaltenango, near Cuernavaca.[2] He ascribes this type to the second Teotihuacan period, »which is associable with the first great building period».[3] Out of this type several groups appear — at any rate on purely typological grounds — to have been evolved. In point of numbers, there being 54

[1] Vaillant 1934: 54; 1931: 346-47. [2] Vaillant 1934: fig. 16. [3] Vaillant 1934: 54.

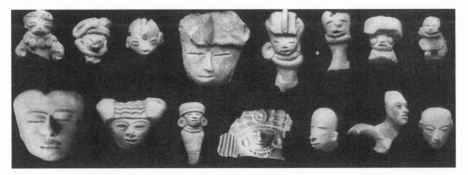

Figs. 170-177. Figurines. (1/3) 170:4551, 171:4548, 172:5914, 173:5889, 174:6789, 175:6632b, 176:5061, 177:6678.
Figs. 178-184. Figurines. (1/3) 178:4839, 179:3947, 180:5729, 181:5745, (1/2) 182:5887, (1/3) 183:5866, (1/2) 184:3953.

of them, the »heart-shaped», fig. 178, occupies the first place. Of this type examples were found in association with representatives of the abovementioned slit-eyed class. But this also refers to the more developed types, among which Vaillant dates the »portrait» type, figs. 182—184, to the third period, and also the most highly developed, of which he says that they are »rare at the actual site of Teotihuacan and are commonest at Azcapotzalco. This class may well represent a fourth period». It is possible to range together typological series showing the gradual evolution of different classes out of these heart-shaped heads. The doctrine of evolution, as applied to the products of human labour, may perhaps still claim adherents. Conclusions based on detached typological series is in most cases apt to prove an erroneous reconstruction of historical development. Whether this applies to the present case I am not prepared to say with certainty, but the clay heads and figurines that are reproduced in figs. 178—198 were found in association with the stylistically plainer types above referred to, as well as in the open field and above, and even below, the floors of the ruin. In the firstmentioned cases this is of little, if any, importance because, as already has been pointed out, the comparatively thin earth stratum has been displaced vertically as well as laterally, resulting in the artifacts therein contained having been confusedly intermingled. But the finds below the floors, a number of which are here reproduced, figs. 170, 175, 181, 184, 188, nevertheless belong to well-defined, brief epochs of time. In certain cases no doubt older figurines may for some reason or other have been preserved, but that this was done to any greater extent appears somewhat unlikely. That they might have come into being simultaneously within the space of a limited period is just as improbable as the supposition that development proceeded at such a rapid rate that for that reason they were found side by side. Perhaps the explanation is that the fillings below the floors partly consist of soil that had previously been intermixed with artifacts from some earlier epoch.

Vaillant, as has been mentioned, ascribes heads of the »portrait» type to the third

117

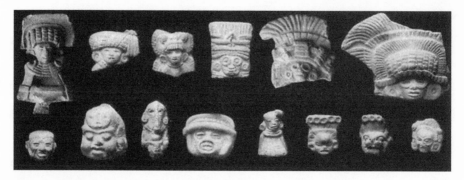

Figs. 185-190. Figurines. (1/3) 185: 4503, 186: 5524, 187: 4152, 188: 3638, 189: 5948, 190: 3640.
Figs. 191-198. Figurines. (2/5) 191: 2860, 192: 4077, 193: 5529, 194: 3854, 195: 5525,196: 3951, 197: 6435, 198: 4546.

period, during which Ciudadela and other later building complexes came into being. The elaborate heads, e. g. figs. 181, 186—187, 189—190, which are common at Azcapotzalco but rare in the Teotihuacan zone, he dates to the fourth and last period, during which the Teotihuacan inhabitants had begun to intermingle with the people of the Valley of Mexico, and their culture had already begun to break up. These heads are as a rule made in moulds. Neither was any of them found below any of the floors, excepting that reproduced in fig. 188. The »portrait» type comprises 101 numbers. They are often of amazingly skilful workmanship, frequently appearing in very beautiful types with »character» features, and produced by means of extreme simplicity. From a purely esthetic point of view they no doubt occupy a very high place in the ancient American world of art. Although individual peculiarities may be discernible — such as heads of flatter or more rounded shape, and a varying degree of primitiveness of workmanship — they do not so much convey an impression of being portraits but rather as aiming at some idealized beauty type. Of the most developed, two slightly different types are distinguishable, figs. 182—184. If not all, the majority of them must, at all events, have been manufactured in moulds since the marks left by the edge of the mould are occasionally observable. In many cases one is tempted to believe that certain figurines were made in the same mould, although as a rule having been worked over fairly thoroughly after the moulding. Typical features are found in the universal baldness of the crown of the head and the very badly shaped body. The limbs are thin and scrawney, and at best like those in fig. 30. It is also worthy of note that they are set in unconstrained, often lifelike, poses, and it is seldom that the law of formality seems to have been observed.

With regard to animal representations, during the Teotihuacan culture predominance was given to owls and jaguars, fig. 197, while later civilizations were more interested in dogs or doglike animals, fig. 169. The proportion in which animal representations occur amounts roughly to 10 %.

Herman Beyer has pointed out that a deity with a peculiar butterfly for a head ornament, and another which he denotes as the Fat God, were common to the Totonacs and Teotihuacan.[1] In our collections of earthenware 5 heads of this plump-cheeked figure with drooping eyelids appears, fig. 192, and, judging from vessel-fragments, three of the Teotihuacan tripods once had their bottom frieze decorated with faces of this kind. All of these are mould-made, and at the thin and flat back parts of the heads are attached, as mentioned, slightly convex plates. An adjoining head has on its back part something in the way of a hook, by means of which it may have been fastened, e. g., to some figural body, fig. 168. Also on small earthenware stamps this head is in many cases found. From his studies Beyer, among other things, draws the following conslusion: »The frequent occurrence of heads and figurines of the Fat God in the ancient remains of Teotihuacan and Atzcapotzalco, and the fact that his forehead is adorned with a typical symbol of that culture make it sure that he was a familiar deity of that people. He evidently had his assigned place in a pantheon of recognized deities.« The Fat God does not occur among the Aztec clay heads, but was known in Cholula.[2] Neither does it appear in Maya codices, or on the stelae. Beyer depicts however a clay head from Toniná, Chiapas and Joyce report finds from Lubaantun.[3]

It is probable that at least a proportion of the clay heads represent deities. Of these, apart from the Fat God, only Tlaloc, fig. 188, and the Old God — the fire god Ueue-teotl — figs. 147 and 191, are identifiable. These are the names by which they were known and worshipped by the Aztecs. Of the latter, 22 examples were recovered. Other heads, with rings about the eyes, are probably also connected with representations of Tlaloc. Similar heads are known from the Atlantic coast and intervening localities. A fairly numerous represented type has a mask before the face, with apertures for the eyes and mouth, fig. 194.

Only in two graves were found clay figurines, viz. in Grave 2 and in a child-grave from the Mazapan culture. These figurines have been described in the foregoing, and reproductions are seen in figs. 30 and 112. From Aztec times there are but few figurines, and of those which with certainty are referable to the Mazapan culture, only one type exists. It is one which, represented by two identical examples — made in the same mould — was included in the child-grave. It must, however, have been a very popular type, seeing that no less than 55 fragmentary figures of this class were recovered. Vaillant has pointed out that: — »in the 150 burials of the early cultures opened by us in the Valley of Mexico, figurines were never buried with the dead . . . In the bottom strata of Gualupita a number of burials were found . . . which had pots and figurines as funeral furniture«.[4]

[1] Beyer 1930: 82-84. [2] Clay head reproduced by Strebel; from among unpublished pictures in my private collection. [3] Joyce 1933: pl. 7. [4] Vaillant 1932: 488.

EAR-PLUGS

From Las Palmas and Xolalpan are preserved, respectively, 7 and 8 ear-plugs of clay. They consist of circular plaques that are entirely devoid of ornamentation, with the exception of one, in the centre of which a thin clay disk has been stuck on. All these objects, except the one just referred to, are quite symmetrical, with plane sides and the edge more or less grooved. The largest measures 4.2 cm. in diameter, while its thickness is only 1.3 cm. The thickest has a height of 2 cm., but its diameter is only 2.5, which coincides with the mean diameter. The average thickness is 1.4 cm. These objects, being of such Spartan simplicity, contrast very markedly with the remainder of the ceramics, as well as the stone objects of similar kind, which are on a high level throughout. This applies, however, more to the ceramic products of the Teotihuacan culture than to those of the Mazapan epoch. None of the ear-plugs of those which have been recovered can with certainty be referred to the firstmentioned culture. While as a rule they undoubtedly belong to a still later period, two of them were however recovered under circumstances indicating the possibility that they may date from the Teotihuacan culture. It is remarkable that objects of this class are of such rare occurrence, so crudely executed, and that only two examples, at the most, are referable to this culture. Fragments of ear-plugs made of stone bear however witness that this class of ornaments were actually in use, and on human heads modelled in clay they are almost always reproduced. Side by side with handsomely ornamented ear-plugs, Vaillant depicts, both from Zacatenco and Ticoman as well from Gualupita, some plain ones which present a high degree of conformity to those above referred to.[1]

CLAY-PELLETS

Of interest are a number of clay pellets that we recovered, viz. 22 at Las Palmas and 20 at Xolalpan. They vary a great deal both in size and in workmanship. Some are roughly made, carelessly shaped and unevenly smoothed down, while others are quite symmetrical and so well polished as to present, in cases, a burnished and glossy surface. In size they vary from a diameter of 8.5 mm. to 34 mm. On the whole they may however be divided into two size-groups, those which exceed 20 mm. in diameter and the rest, the majority, which are smaller. In the latter the diameter averages 13.4 mm. If those with a diameter of 22 mm. are counted in, the average diameter would be 14.7 mm. To the larger group the jump is considerable, those pellets having as a rule a diameter of about 30 mm. Those of very small size are few in number, and the majority of the pellets have a diameter of 14—16 mm.

What their employment may have been is unknown. Some of them — the very smallest — may possible have served as rattlers, either in hollow feet of earthenware vessels — having in that case probably been already baked when inserted — or inside

[1] Vaillant 1930: pl. 37 and 41; 1931: pl. 82 and 93; 1934: fig. 30.

hollow clay balls, or the like. Neatly polished specimens of this kind are contained in the collection. Rattle-feet generally belong to tripod ceramics of a later period, but exceptions are however met with. A fragment discovered below the earliest floor but one, in the Xolalpan ruin, is from a vessel which once was decorated with small, hollow projections containing pellets, fig. 20. The largest clay pellets and the smaller stone balls, whose dimensions are equal, may possibly have been employed as sling stones, or used in games, or even as toys. The clay pellets of the smaller group, on the other hand, would apparently have been well suited as projectiles for blowguns. Whether this weapon was known to the Teotihuacan civilization cannot with certainty be determined, although in a later era it was found among the Aztecs. The collection of Désiré Charnay in the Ethnographical Museum (Palais du Trocadéro) of Paris, contains, according to Lehmann, a potsherd of typical Teotihuacan style with a representation of a bird-hunter using a blowgun.[1] With the Aztecs it seems to have played an important part, as may be judged from Cortés' report to the Emperor Charles V in which he mentions that he received from Montezuma twelve beautifully decorated blowguns as a present. From circumstances attending their discovery it appears that only part of the pellets are with certainty attributable to the Teotihuacan culture. The remainder may belong to a later time, some of them probably to the Mazapan period.

In South America, whose blowguns I have studied very extensively (above all from material preserved in the Gothenburg Museum), the calibre varies from 9 to 12 mm., and in exceptional cases — then generally blowguns of bamboo — may reach 25 mm. These latter weapons were however designed for use with poisoned darts. Unfortunately I have only had the opportunity of examining two Central American blowguns, viz. one from Guatemala (G. M. 28. 5. 1.) and one from the Talamanca Indians (R. M. 1885. 11. 34). Their calibres were 13 and 14 mm., respectively. It is only by taking the measurements of a large number of Central American tubes, i. e. those meant for clay pellet missiles, that it would be possible to establish with any degree of certainty whether the smaller type of clay pellets might have been used as blowgun projectiles. As already mentioned they have a diameter of 13.4 mm. Regarding the distribution of American blowguns, see Appendix 5.

DISCS MADE FROM POTSHERDS

A considerable number of circular disks, manufactured — in nearly all cases without any doubt whatsoever — from potsherds were recovered from both sites, those from Las Palmas numbering 76, and from Xolalpan 69. In size they vary greatly. The largest and the smallest thus measure, respectively, 7.7 and 1.9 cm. in diameter, the average diameter being 4.2 cm. In thickness they also vary a great deal. Some are almost

[1] Lehmann 1933:73.

perfectly circular, while others are rather roughly formed. As regards their sides they do not appear to have been subjected to friction, but their edges, which are frequently well polished, preclude any general pronouncement being made on that point. Different kinds of potsherds have been made use of. Several pottery types belonging to the Teotihuacan culture are represented. While with absolute certainty fragments of tripod ceramics have in no case been used, there are many instances of the yellowish-red imported ware. These always appear in the form of small and thin disks. Mazapan bowls reveal their presence by the usual characteristic groups of wavy lines painted in the customary red colour. Of Aztec ceramics, fragments both of the light-coloured type with thin black lines ornamentation, and the red — with heavier, black decoration — have been put into use. While small disks of this kind thus with certainty were used in the Aztec era, only two were recovered beneath the floors of Xolalpan. Unfortunately, these were however not intact, by reason of which no conclusive evidence is available that they were in use in the time of the Teotihuacan culture. Three small stone disks, rounded and badly formed, no doubt also belong to this category of objects.

What their employment may have been is difficult to say. Objects of this kind, which besides may have been recovered in widely separated places in America, are usually labelled toys, or game counters, (»men«). If the latter alternative were correct these objects ought to be flat — which however is not the case — with sides differently coloured or otherwise distinguished. They may, perhaps, have served various purposes.

From the Pima Indians there is an exceedingly interesting account of the use of similar objects in guessing games.[1] Possibly they may be reported, unknown to me, from places nearer at hand, but the one just referred to appears sufficiently interesting to merit citation. In this case, as will be seen, the appearance of the object is of no importance whatever: »Any number of players may participate, but they are under two leaders who are selected by toss. Each draws up his men in line so that they face their opponents. A goal about 50 yards distant is marked out and the game begins. A small object, usually a circular piece of pottery, one of those so common about the ruins of the Southwest, is carried around behind the line by a leader and placed in the hands of one of his men. The opposite leader guesses which man holds the object. If he guesses wrong, the man at the end of the line in which the object is held who stands farthest from the goal runs and jumps over the upheld leg of the man at the opposite end of his own line. This moves the winning line the width of one man and the length of a jump toward the goal. If the first guess is correct, the object is passed to him and there is no jumping until a guess fails«.

[1] Russel 1908:177 seq.

CLAY-MOULDS

While no moulds, or their fragments, were recovered at Las Palmas, we have quite an imposing collection from Xolalpan, figs. 199—208. There are 24 of them, in all. The majority are intended for the manufacture of clay figures or heads of such figures, while 9 of them were used for the production of decorative details and stamps. With the exception of one fragmentary specimen designed for making large, square stamps, all the moulds of the latter category were employed for moulding, or, more correctly, pressing into shape, small circular stamps with designs in low relief. Drawing the line between stamps and moulds is in some cases hardly possible. In these moulds it is thus possible to manufacture stamps wherewith to decorate clay vessels, i. e. to provide them with impressed ornaments. But it may not be quite certain that this »impressed» decoration was not, instead, directly manufactured in moulds, because moulds do occur with a positive design. In four of the moulds decorative details for incense-burners of Azcapotzalco type have been made, cf. fig. 149. One of them would in all probability have been used for manufacturing small heads — of the type that Beyer has named »the Fat God»[1] — for ornamental friezes round the bottom edge in Teotihuacan tripod vessels.

Beneath the floor of Room XIV were found closely together two intact heads of clay, and a third one in fragments, all of which had been produced in the same mould. More remarkable than this, however, is that there were recovered fragments of no less than six heads, all deriving from the same mould. Minor irregularities, prevalent throughout, prove them to originate from one and the same mould, not merely from identically similar ones. Five of these fragments were recovered below the floors of Rooms XII and XXIII, and below the one that was discovered in the northwestern corner of the field, which as already mentioned, was not closely examined. The remainder was found in the maize field of Las Palmas. In Room XII was also recovered a fragment of the mould that in all probability is the one from which all those six heads originate. In both cases above referred to, only the face and the complex head ornament have been moulded, or, rather, fashioned in the mould by pressing, seeing that the objects are of very thin material, while the face is of a strongly convex form, with a bowl-shaped depression at the back. They were never quite finished, as is evident from the fact that the edges have not been ground even, nor have such roughnesses as protruded beyond the mould been cut away. Trimming operations of this kind would in most cases have been necessary, and ought to have been performed prior to the firing. These heads are more of the character of masks, as they do not appear ever to have been attached to any bodies. Possibly they may have been fired through some oversight, and thereupon rejected. If this was the case, an explanation is found as to why the former group of mouldings were discovered together, but against this supposition speaks the fact that those from the second mould had been dispersed, and found their resting places not only beneath various floors in Xolalpan, but also travelled as far as Las Palmas.

[1] Beyer 1930:82—84.

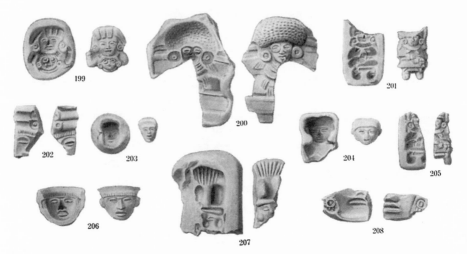

Figs. 199-208. Clay moulds and casts (to the right at the figures). (1/3) 199: 6787, 200: 4502, 201: 5414, 202: 5131, 203: 6737, 204: 3554, 205: 5414a, 206: 6800, 207: 5970, 208: 6683.

The remainder of the face-moulds are less remarkable. Some of them approach, in part, stylistically to the abovementioned thin and mask-like heads. One is complete, and in that were moulded the head and upper body part of figures of Teotihuacan style, of the kind that wear on the breast an ornament in the form of a large face. Likewise complete is a small, rather badly made mould, in which were manufactured heads that in some degree conform to the so-called portrait type.

As to the figure-moulds, there are fragments of three particularly massive ones which had been used for moulding flat and coarse figures, possibly of Aztec — but in any case not of Teotihuacan — type. Figures of the latter type were manufactured from moulds of various kinds, and in many respects remarkable. Among them is a type, of thin material, designed for the manufacture of figures seated on a broad stool, or throne-like structure, and wearing large head-dresses resembling turbans. These head ornaments, which are decorated with small depressions placed closely together, are found on Mayan stelae. Round their eyes the figures wore spectacle-like rings. Another mould, producing a face of typical Teotihuacan appearance, is evidently faultily constructed. It is incomplete, there being only the head, shoulder and breast parts remaining. It is faulty in construction inasmuch as it would be impossible to remove a figure from its inside, because the »inlet» is smaller than the figure contained.

The most interesting, by far, are no doubt two moulds in which have been moulded figures that were almost identically similar. One of them is almost complete, while only about one-half remains of the other. They were found in close proximity beneath the floor of Room XXXI. The divergencies, minor irregularities in the material of the moulds, are however sufficiently marked so as to make it possible to distinguish

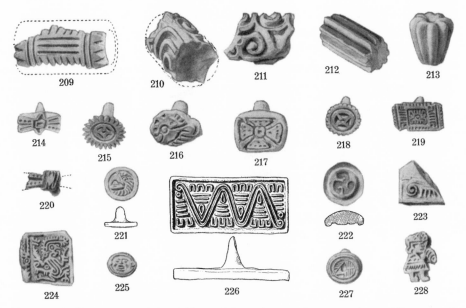

Figs. 209-228. Pattern stamps of clay. (1/2) 209: 5646, 210: 6121, 211: 6121, 212: 4069, 213: 6680, 214: 4106, 215: 5542, 216: 5185, 217: 5541a, 218: 975, 219: 4105, 220: 6739, 221: 3540, 222: 3552, 223: 5548, 224: 4456, 225: 3541, 226: 666, 227: 5543, 228: 5541.

figures made in the one from those made in the other. They show, however, that it was the practice to cast moulds over figures that from some reason or other were popular, and which it was desired to manifold.

As regards technique of ceramic moulding, and its distribution in America, see Appendix 6.

CLAY-STAMPS

While only two fragments — and possibly two complete specimens — of roller stamps were recovered, no less than 46 complete, and defective, plane stamps were found. Of the finds, 11 came from Las Palmas and the remainder from Xolalpan. Those which are most important are reproduced in figs. 209—228. In the upper row all the roller stamps are depicted. As will be seen, one of them is a hollow cylinder, while another, with an exceedingly vigorous and very deeply incised pattern, is solid. Whether the next object, with longitudinal grooves of V-shape, was used as a stamp may — contrary to what is the case with the preceding two — possibly be doubted. This may with still more reason be said of the cone-shaped object, likewise provided with longitudinal grooves. In this broader part a hole has been longitudinally bored, reaching about half-way into the object. Of the plane stamps the majority are round,

and most of them have patterns in low relief. As a feature common to them all may be mentioned their conical handle. This is in certain cases so diminutive that even Indian hands may have found it difficult to use. It is therefore not inconceivable that these projections once were fixed, e. g., in a wooden handle. With exception of figs. 209, 212, 219, and 225, these objects were recovered in surroundings precluding any definite conclusions as to their age, although some are with certainty dateable to the Aztec era. Fig. 223 was probably used for stamping-in ornaments on pottery.

Regarding the employment of stamps — for the decoration of ceramics, textiles, etc., as well as for stamping ornaments on the face and other parts of the body — the reader is referred to Ries' exhaustive monograph,[1] and, as to their geographical distribution, this is a subject the author has dealt with in an earlier work.[2]

SPINDLE-WHORLS

Our collection of spindle-whorls, complete or represented by fragments, amounts to 169 numbers, 62 of which originate from Las Palmas, and the remainder from Xolalpan. Only a very few were recovered under such conditions that they with certainty can be dated to the era of the Teotihuacan culture, as for example figs. 236 and 240. Others, again, are Aztec, see figs. 233 and 235. Although not a single spindle-whorl was found in direct association with Mazapan graves, there is however much reason to believe that a special type was in use during that period. These whorls are generally painted red, of large size and fairly flat, one side being plane and the other convex. The former is decorated with rude ornaments in a peculiar, glossy red paint, thickly laid on. Similar decoration is found on the Aztec spindle-whorl, fig. 235, as well as on whorls from the Huaxtec district[3] and Ranchito de las Animas in the Totonac district.[4] Similar whorls have also been recovered at Cholula, where Seler has found whorls originating from the Huaxtec district.[5]

The collection includes a large number of types, as is in some degree apparent from figs. 229– 243. There is considerable variation, not only as to form and size, but also in regard to material and decoration. Although the whorls are dateable to different periods and a variety of cultures, the divergences between the numerous types seems too wide to admit the possibility of their being exclusively of local manufacture. Positive evidence as to importation should here be obtainable, above all through studies of important museum collections. Spindle-whorls belonging to some definite epoch may, however, survive it and be adopted for use by later generations. In this way Otomí Indians of the mountain regions between Mexico and Toluca use spindle-whorls of ancient origin that they have collected and preserved.[6]

The spindle-whorls in our collection are on the whole of the following types: with

[1] Ries 1932:415 seq. [2] Linné 1929:38 seq. and maps 3 and 4. [3]Seler-Sachs 1916: pl. D—E. [4] Strebel 1885: pl. 12. [5] Seler 1904:183. [6] According to Mr. R. Weitlaner.

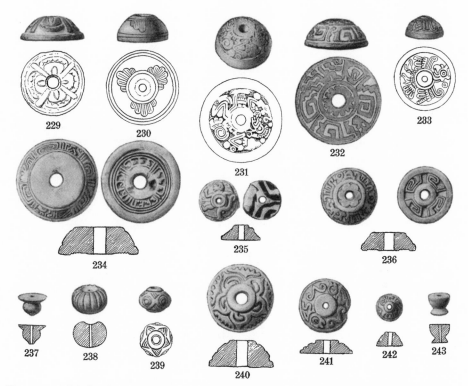

Figs. 229-243. Spindle whorls. (2/5) 229:2047, 230:4771, 231:4363, 232:4900, 233:4675, 234:2441, 235:6446, 236:4365, (1/2) 237:6538b, 238:6579, 239:6562, 240:5931, 241:4362, 242:3349, 243:6537.

a plane or slightly convex under side, and a rounded upper side, figs. 229—233, 240, and 242; of truncated cone shape with the edge and upper side — in certain cases also the under side — decorated, figs. 234 and 236; with plane under side and convex upper side, and painted decoration, cf. above; fairly flat whorls with one side slightly convex. These are all badly formed and lacking decoration. Further, there are whorls quite plane and undecorated, and others which are almost spherical with a cup-shaped depression on the upper side, the edge frequently grooved, and very narrow perforation for the spindle, fig. 238. The latter also applies to the small, conical, whorls, which are always well polished. A related type has slightly convex sides. In addition to these, there are some irregular types, such as figs. 237, 239 and 243.

Spindle-whorls resembling figs. 237 and 243 are known from Misantla,[1] Cerro Montoso and Cempoallan.[2] Others of more or less dark material and with fine incisions, like fig. 230, are known from Pupinalco[3] and Atotonilco el Grande (Hidalgo).[4] One somewhat resembling fig. 236 is reproduced by Peñafiel, from Texcoco.[5]

[1] Strebel 1889: pl. 8. [2] Strebel 1885: pl. 6 and 12. [3] Strebel 1889: pl. 8. [4] Peñafiel 1890: pl. 31. [5] Peñafiel 1890: pl. 34.

As will be mentioned below, spindle-whorls were to a considerable extent made in moulds. The majority of those here reproduced have been manufactured by that method. Beside the black paint mentioned above, the whorls are often painted red, and traces of red and blue paint go to show that they were occasionally also decorated after the firing. Their sizes vary considerably. Thus the largest whorl, fig. 234, weighs 77.2 grammes, and the smallest only 3.6 gr., fig. 242. The size, i. e. the weight, had of course relation both to the material and to the quality of the thread. Finer thread thus requires lighter spindle-whorls, and for the spinning of cotton lighter implements are similarly best suited. Heavy whorls are most suitable for the spinning of ixtli, the strong fibre obtainable from the maguey plant. Spun thread is not necessarily exclusively produced for the textile industry, but may also be used, e. g., in netweaving, as for example among the Huaves.[1]

MUSICAL INSTRUMENTS

The paucity of musical instruments possessed by the Indians in pre-Spanish times is striking. But, seeing that only objects of clay, bone, etc., have been able to escape destruction, archaeological collections are naturally unable to convey a proper appreciation of the instruments that originally were employed. Exceptions to this are however found in archaeological finds from the Peruvian coast and the Southwest, thanks to the dryness of the climate. From Seler's researches — even in this department precursory — it is however possible to obtain a fairly good picture of the musical instruments of ancient Mexico.[2]

In our collections are included two whistles, one complete scraping bone and two fragments, and also some fragments of earthenware flutes. The lastmentioned are too small to make possible any determination as to their type. It is probably that they derive from flutes of the ordinary Aztec model. The complete scraping bone was recovered in a dislocated grave at Las Palmas belonging to the Mazapan culture. Also the fragments are probably dateable to that period. Regarding the method of using this instrument, and their geographical distribution as well as that of related objects, see Appendix 8. The whistles were of bird-shape and are referable to the Teotihuacan culture, fig. 244. Their execution is not remarkable for any special precision, and they only produced a high and shrill note. They were blown from the prolonged rear end of the conical body. Thus there exists a certain degree of resemblance to our toy ocarinas of bird-shape. As in both cases the feet are absent, it is uncertain whether they were independent objects or had possibly been attached to some pottery lid. Many covers of Teotihuacan tripod vessels are provided with attached bird figures, figs. 28—29, but these are in no case whistles. If this had been the case with the »ocarinas» they would probably have been better shaped and carried traces of painted decoration.

[1] Starr 1899: pl. 112. [2] Seler 1904:695—703; 1916: 392—402.

244

Fig. 244. Earthenware whistle. (1/2) 6755.
Fig. 245. Rasping bone. (1/2) 371.

245

Other objects in the collections that might come under the heading of musical instruments are but few, and of no special importance. If one stretches a point, it may be possible to class hollow pottery feet with rattling clay pellets inside with this category of objects. There are comparatively few of these, and they belong to vessels both of Teotihuacan type and others of later times. Some of the smallest of the clay pellets that were recovered had possibly once had their place inside the feet of earthenware vessels, or the like. The very important part played by rattling contrivances of this kinds in ritual ceremonies is apparent from the cult performances connected with the worship of the god Xipe Totec.

9

PART VII

STONE OBJECTS

Numerically, objects of stone form a considerable part of the collections. The more important of them have been grouped together according to the purpose for which they were used.

On account of the total absence of metals most implements were made of stone, the tool equipage being supplemented with others made of bone, burnt clay, and wood. While the objects belonging to the firstmentioned groups are dealt with in another connection, hardly anything can be learnt of the last, which, at any rate so far as our archaeological sites are concerned, have perished without leaving a trace. Apart from the sparse finds that have been made, e. g., in La Ciudadela, the frescoes of Teopancaxco may yield a modicum of information as regards wooden implements. Thus there are two figures equipped with arrows that are provided with heads in the form of balls, proving them to be designed for bird-hunting, »bird arrows».[1] Arrows of this kind are fairly common in South America, and this culture element may be regarded as possessing very great antiquity.[2]

Tufa of several varieties being very abundant, it is only natural that this material was extensively worked up into architectural details, sculptures and utensils. In fig. 261 is reproduced one of the small mortars that were recovered, and in fig. 274 part of a fairly large grinding slab which originally had three or four legs. Fragments of metates and manos, i. e. tripod slabs and stone rollers which were used in grinding maize, were also recovered, but — unlike the foregoing, which date from the Teotihuacan culture — were only rarely found underneath the floors of the house ruin. Implements of this class being very ancient, their absence only proves that the inhabitants did not occupy themselves with preparation of food, a conclusion supported by the absence of utilitarian pottery. Strangely enough there was found underneath one of the floors the object seen in fig. 265, made of basalt and classifiable as a polishing tool (stone) used in potterymaking. To the Teotihuacan culture belong two problematic objects, figs. 278 and 280. The former is made of very dark-coloured basalt. Its plane side is exceedingly carefully ground, and so is its edge. It has a slightly convex surface. It may of course have been a polisher of some sort, but it is perhaps worthy of mentioning that if the surface be wetted, the object is capable of serving as

[1] Peñafiel 1900: pl. 81 and 87. [2] Nordenskiöld 1919:38 and map 3.

a relatively useful mirror. The second object is of the same form, but the material consists of greyish eruptive rock, and the surface was once coated with thin film of plaster.

An important implement, among other things in the manufacture of stone objects, is the hammer-stone. It is found in a variety of forms, from more or less oblong and rounded, to quite spherical. The latter were either held in the hand or fitted with a handle. The former kind is represented in figs. 271—272, the latter in fig. 282.

Sahagun gives a fairly comprehensive account of the working methods of the stone-cutter, in particular in the working up of rock of the harder kinds. »Die Steinschneider, die Künstler, schneiden den Bergkristall und den Amethyst und den Grünstein und den feinen Grünstein (Jadeit) mit Schmirgel... und sie schaben sie mit einem zugehauenen Kieselstein ... dann facettiert man sie mit Schmirgel und gibt ihnen Hochglanz mit Schmirgel. Und dann macht man sie fertig, glättet sie mit dem Bambus».[1] Of especial interest is the evidence thus given as to the employment of emery and bamboo.

Stone beads were evidently in very great favour as ornaments, seeing that no less than 116 of these objects were recovered, including 84 from Xolalpan. In size they vary from 0.6 cm. to 3.7 cm. in diameter, and in form from nearly flatness to a rough cylindricity. The perforations are always bored from both sides, and conical. The boring-through of small beads of a hard material must have presented considerable difficulties. It has been suggested that the Indians of pre-Spanish times were acquainted with the pump-drill, and with a tool of that description the perforating process would have been comparatively easy. Nordenskiöld has however, with proofs of apparent conclusiveness, been able to show that the pump-drill is to be counted among the culture elements that the Indians at an early stage adopted from the whites.[2] It would certainly appear as if in pre-Spanish times the bow-drill had been in use in the Southwest,[3] but it may be supposed that the stone-workers of ancient Mexico were restricted to making the drill — of wood, with or without a stone point, or of bamboo or a hollow bone — rotate between the palms of their hands.

Some of the beads are of serpentine, and 12 specimens, dating from the period of the Teotihuacan culture, are of jadeite and extremely well polished, and in every way carefully fashioned. In the Aztec era this desirable commodity was obtained in the form of tribute, while in earlier times either the raw material or the ready-made beads were acquired by means of commerce. As these beads are of far superior workmanship, the latter alternative seems the more probable one. Raw jadeite has hitherto only been found at Oaxaca, and Lehmann supposes that »das Bergland der Mixteca» supplied Mexico with this semi-precious stone.[4] As these are the very parts where the working of metals has made greater progress than elsewhere in Mexico, which among other things is evident from the finds made in latter years on Monte Alban, the presence of jadeite, in conjunction with the absence of metal, at Teotihuacan argues in favour

[1] Sahagun 1927:376—377. [2] Nordenskiöld 1930:102 and map 9. [3] Martin 1934:96. [4] Lehmann 1933:86; cf. also Saville 1922:28.

Figs. 246-256. Stone axes. Fig. 255 found in Grave 1. (2/5) 246: 2708, 247: 837, 248: 4058, 249: 5566, 250: 4059, 251: 4912, 252: 2607, 253: 4676, 254: 4742, 255: 4377, 256: 5765.

of the lastmentioned place being of considerable antiquity. Even as late as 1891 there had been no local discovery made of jadeite in its natural state in Mexico, a circumstance which was readily seized upon as an excuse for building up some most extravagant theories as to importation, inter alia from China.[1]

Of turquoise only some minor fragments were recovered, likewise dating from the era of the Teotihuacan culture. For further information as to the distribution, from the Mayas in the south to Pima in the north, of this gem material which in ancient Mexico enjoyed such widespread popularity, see Beals.[2]

Stone axes.

Stone axes formed a comparatively small proportion of the stone objects, and axes appear on the whole to be rather poorly represented in collections from Teotihuacan. Owing to the relatively great dearth of trees in the country, which probably prevailed also in pre-Spanish times, demand for this class of tool was restricted. In the New

[1] Cf. Meyer 1891. [2] Beals 1932: 110 and table 64.

World stone axes were to a large extent mainly used in clearing new ground of forest for cultivations.

In figs. 246—256 most of the finds are reproduced. The great variation as to types and material is remarkable. Of the objects mentioned, figs. 246—249, 252—255, are made of diabas, 250—251 of basalt, and ultimately 256 is manufactured of greenstone. This great variation may be due to the supply of suitable material having been scanty, and that not only the material but also the ready-made axes presumably were imported from places more or less distant. The axes of Teotihuacan may therefore quite well constitute a collection of samples of the types that were current in the central highland country. Many of them are exceedingly well made and beautifully polished, and in most cases the edges are still irreproachable.

A strange model is seen in fig. 246. It is symmetrical like all the rest excepting two, but the faces of the edge form an unusually wide angle. In section it is roundedly quadratic, and this axe was most likely shafted in the primitive way of being socketed in the thickened end of the handle. From pictures in different codices it appears that in Mexico this shafting method was of very great prevalence.

The collection includes, as will be seen, two adzes, figs. 250 and 254. As the case most frequently appears to be with this type, they are rather small and only weigh 32 and 65 grammes, respectively, while the remainder on an average weigh 150 gr. Like the axe just referred to, they are made of a very dark-coloured and hard kind of rock. In the codices also elbow-handled adzes are depicted. The blades were probably of copper, but whether bevel-edged or not is not apparent.[1] This need not necessarily have been the case, although a bevel-edged adze must have had a handle of the construction in question.[2] Without adducing, so far as I can find, anything in the way of even remotely convincing proofs, Foy has advanced the theory that axes of this class, at all events in South America, belong to the Malayo-Polynesian culture elements.[3] Similar adzes, the principal purpose of which was the hollowing out, or planing down, of wooden objects occur sporadically in various parts of America, extending from the Eskimos in the north to the Patagonians in the south. In Mexico they are of comparatively frequent occurrence. Judging from their distribution, it does not appear that the invention, or, more correctly speaking, modifications of the same, is attributable to any particular single place in the New World, and still less that it has been imported from the South Sea Islands.

Points and blades.

While these were very numerously represented among the obsidian objects recovered, there were only six that were made of stone. In all of them the tang is short, broadening

[1] Cf. also Saville's interesting chapter about »The Aztec carpenters and sculptors» (1925:10 seq.). [2] Linné 1929: 197 seq. [3] Foy 1910:151.

Figs. 257-266. Various stone objects. (2/5) 257: 2496, 258: 6256a, 259: 6608, 260: 4036, 261: 5574, 262: 4381, 263: 5674, 264: 5467, 265: 4066, 266: 4369.

downwards, and in form they differ from each other mainly in the length of the blade. As to workmanship, they are by no means on a level with the obsidian points. Of the points that were recovered, two typical examples are here reproduced, fig. 259 made of jasper, and fig. 263, the material of which consists of chalcedony. The two blades, figs. 258 and 264 are manufactured of, respectively, jasper and chalcedony. These points were presumably either for arrows or for light throwing-spears, and it is not inconceivable that also the smaller blade served some kind of projectile purpose. The larger blade, which is very thin, is more likely to have been used as a knife, or as the blade of a stabbing spear. Both in form and the method of their manufacture they are in agreement with the corresponding types of obsidian objects, and account of which will be given below.

Masonry implements and rubbing-stones.

A considerable proportion of the stone implements were undoubtedly used in the art of building. It is possible that the small, drop-shaped objects, fig. 276, was used as a plumb bob, although this is not so certain. Any supposition in this direction would have no other support than its resemblance to our own corresponding implement. Its construction would be well suited to the purpose, it is true, but the exquisiteness of its material — Mexican onyx — and the care expended on its shaping rather favour the assumption that it was used as an ornament.

The plane and smooth surfaces of walls and floors in Xolalpan arouse the admiration of modern building experts. Not least does this apply to the platforms with their

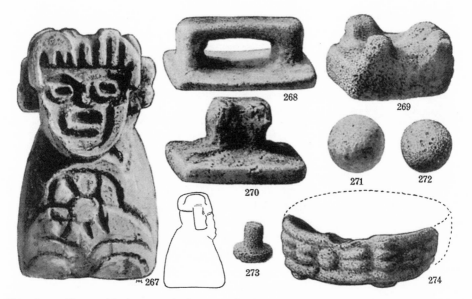

Figs. 267-274. Figure and implements made of stone or tuffa. (1/4) 267: 3442, (1/3) 268: 6415, 269: 5719, 270: 3900, 271: 4817, 272: 3899, 273: 4065, (1/4) 274: 4422.

more complex structure. And yet this building is utterly insignificant when compared with the gigantic architectural monuments of the ancient city. The masons of Teoti-huacan must have carried out their plastering by aid of implements of the kinds seen in figs. 268—270. It is probable that similar tools made of wood also were in use. Their correspondence with the tools that, e. g., European masons are using is obvious, and they belong to a class of implements that may be counted among those of universal occurrence which, with minor divergencies, have been, and to this day are being, used all over the world.

These stone implements have a plane surface, are of rectangular shape and usually made of more or less porous tufa. Some have a looped, »flatiron», handle, while in others the handle is solid, and more or less rectangular. In some the perimeter is circular, and the handle similarly shaped, fig. 273. One of the objects, probably belonging to this group, resembles a tripod miniature grinding slab, fig. 269. In many cases these objects are exceedingly worn down, and one of them has been in use for so long that nothing much beyond the handle remains. Thick layers of lime are still adhering to many of them. No less than 67 objects that are referable to this group were recovered, including 58 from Xolalpan.

In plastering angles e. g. between walls and floors, stone balls were probably used. This is all the more likely as the angles nearly always were somewhat rounded. Two typical stone balls are reproduced in figs. 271—272. The material consists of tufa of

varying hardness and in colour ranging from light grey to brownish-red. Their sizes vary very greatly, viz. from 2 cm. to 8.5 cm. Only the larger ones could have been used in the procedure just referred to. Stone balls, particularly those of more compact material, were presumably also used as mullers, in conjunction with grinding slabs or mortars. To this purpose, however, stones more pestle-like in form — of which intact examples as well as fragments were recovered — would have been better adapted.

Bark-beaters.

In the course of our excavation work at Las Palmas and Xolalpan altogether twelve bark-beaters of stone were found, including three at the former place, cf. the figures in map 5. Of these six are intact, while four are in fragments and the remaining one is a toy. There is further a small object which possibly also may have been a toy beater. It has roughly the same shape as the rest, and is provided with groove-like depression round the edges. It has one face plane, and on the other is a boss decorated with incisions. The proper beaters are all of about the same type, although varying in size and with individual divergences, and they are made of different materials, e. g. dolorite, porphyritic lava rock, and basalt. Their shape is the one which is typical of Mexico, namely rectangular with more or less rounded corners. Round the edges, either all of them or only three, there runs a deep and rounded groove. Two of the beaters are not fluted but in other respects entirely similar to the rest, although they are made of tufa which at least in one of them is softer and more porous. Both present a worn appearance, which shows that they have been used, and in the flat side of one there is a concavity which probably has served as a grinding pan, seeing that in minor depressions there remain traces of some red substance. These objects may possibly also have been used as burnishers, but both their shape and the groove running round the edges clearly indicate their character of bark-beaters. The papermaking tools depicted by Starr, and here referred to in the Appendix 7, are otherwise of similar shape, and ungrooved. In the Gothenburg Museum are preserved two ungrooved bark-beaters, one originating from the vicinity of Atotonilco Quimistlan, and the other from Yucatan. Of those with fluted faces, half the number are fluted on both sides. In their case the fluting is larger on one side than on the other. The beater with the finest fluting contains 28 grooves to 6.5 cm., while in the one with the largest fluting there are only 5 grooves to 5.7 cm. Small beaters may have a large fluting, while larger ones may be provided with a finer. The fluting is throughout very carefully made. The incisions are parallel and much of the same dimensions, the surface is very accurately plained down, and the edges of the flutings are fairly acute. In one beater it would appear as if the fluting either had been worn out or only begun and then rejected, followed by renewed fluting with very deeply cut furrows. The largest of the intact beaters weighs 480 gr., the smallest 280 gr., while the small toy, which is

slightly defective, weighs no more than 18 gr. The implement of tufa with a bowl-shaped depression above referred to, has a weight of 205 gr. A fragmentary one, of which only about one-half remains, appears from the wear it has seen to have been in use even after the mishap. It weighs only 145 gr. These beaters were undoubtedly at one time fitted with handles of a construction which is still being used in Celebes, whose stone beaters present exceedingly close resemblance to those of Central America, cf. the figure in map 5. As will be apparent from the illustration, the implement only needs grooving round two or three edges for fixing in the handle, although it may naturally be to advantage if all the edges are grooved. These grooves are worn to a perfect polish, which proves both that the beaters were actually fixed in a handle of the kind referred to, and that they have been very long time in use. The fluted surfaces do not show nearly so much wear as the edge-grooves, which only stands to reason in view of their function principally being that of a hammer.

Only two beaters were found below the floors in the Xolalpan house, namely under Rooms VII and XII, respectively. The remainder were found above the floors, except one which we discovered outside the ruin while test digging. No typological difference exists between the earlier and the latter, unless possibly the earlier ones were somewhat better made.

Sculptural representations.

The great stone masks that have been discovered at Teotihuacan in fairly considerable numbers, although unfortunately but sparsely reproduced, are justly renowned for their severe beauty. They undoubtedly must be counted among the elite of art productions achieved by the people of ancient America. In these we find a high degree of stylisation and simplification in conjunction with naturalism, and they frequently bear witness of a delicate faculty of observation as regards facial expression. Here, as practically everywhere — not only in Teotihuacan, but all through America — art was governed by rigid laws. Methodical standardization is universally prevalent. Vaillant characterizes pre-Columbian art in the following way: »The arts were created by nameless craftsmen to enrich their tribal ceremony, and were not expressions of the individual as they are to-day. Thus we see the Central American arts as a communal production», not the aesthetic reactions of a number of individual artists».[1] To this we possess to some extent a parallel in the religious art of our own culture, where not only motives but also stylistic features survive through periods of the most varying conceptions of art and ideals of beauty.

The masks are made of different kinds of rock, greenstone, basalt, jadeite, andesite, and others. The eyes were provided with inlays of mussel-shells or obsidian, and in certain cases probably mica. The lips are slightly parted, and the teeth are indicated by shaped pieces of shell. A feature they all seem to have in common is that in the

[1] Vaillant 1934a: 259.

flat, hinder surface a deep cutting has been made, with a planed-down bottom, roughly corresponding to the outline of the mask. On either side of this sunk surface a wall has been left, in the parts of which holes are drilled. We were fortunate enough to find a fragment of a little mask of this description, which however was large enough to make reconstruction possible, fig. 275. What purpose these masks served is difficult to say with absolute certainty. It is however possible that at least some of them were tied on to the outside of bundles containing dead persons, in the same way as was done in the case of the mummy bundles of ancient Peru, to which were attached face-masks of various material.

The remainder of the human representations in stone from Teotihuacan are, whether aesthetically or from any other point of view, of minor interest. In fig. 262 is reproduced a figurine made of greenstone, rather rich in feldspar. It is strongly stylised, and not very artistically formed. The association in which it was recovered definitely places it with the Teotihuacan culture. It must have been carved by a tyro or mere artizan, while the mask just referred to is the work of a real artist.

At the entrance leading down to a natural cave beneath a house dating from the Mazapan period, at Las Palmas, was recovered the rather uncouth and stylised figure which is reproduced in fig. 267. The material it is made of is tufa. The inferiority of its material — and the crudity of its execution — notwithstanding, it is meant to represent some sort of deity. Technically it is noteworthy inasmuch as the face is executed in, so to speak, negative relief. A still more rudely executed human representation, also referable to the Mazapan period, is reproduced in fig. 257. It is extremely summarily shaped of porous tufa, and its back surface may possibly have been used as a grinding bowl or mortar. As in the case of ceramic and architectural art, even in art the Mazapan period exhibits a gigantic step in a retrograde direction, and it strikes one as remarkable that the people of that period adopted so little of the classical Teotihuacan culture. It is difficult to imagine anything else than that this high civilization was abruptly and violently annihilated, for if it had fallen into decay by degrees, it is only reasonable to suppose that part of it would have been inherited by its successors.

Stone vessels.

In the art of working in stone, many of the high-culture peoples of ancient America, and even the more primitive tribes, had attained a high degree of perfection. While we are intent upon developing speedy and efficient methods for treating easily-worked material, those people would appear to have striven all they knew, and made it — as it were — a point of honour, to produce elaborately finished objects from the most difficult materials. As in many cases the results of their exertions are describable as articles-de-luxe, there is here occasion, even if the working of slaves for their mighty rulers be involved, to speak of art for art's sake.

The obsidian ear-plug mentioned in the following is in its way a marvel of skilled workmanship. But in museums are also found exquisite exponents of the Indian's ability in manufacturing vessels out of stone, in fact even of obsidian. The material varies, or at any rate the names it is known by. In Mexico and adjoining southern regions the material apparently most commonly in use was Tecali, or onyx marble, also called Mexican onyx or Tehuacan marble. This is a very beautiful material, often veined, and with colours softly shading off from white to yellow or greyish. From various localities vessels of this material are preserved, e. g., Ulua valley in Honduras,[1] the Island of Sacrificios,[2] Quimistlan,[3] Cholula,[4] Texcoco,[5] and Tepic[6] but above all they seem to have been in use in Oaxaca.[7] Of exquisite workmanship are the vessels that were recovered in the famous Tomb 7 on Monte Alban, which was opened in 1932.[8] The locality of the southernmost find appears to be Guanacaste in Costa Rica.[9]

Extremely interesting is a half-finished vessel, recovered near the town of Tlaxcala, which has been described in detail by Saville. Its outer wall has received its final shape, but the hollowing-out had only been begun. Saville, inter alia, writes: »The method employed was drilling, probably with a bow- or pump-drill, the shaft of which was a hollow o t l a t i, the common reed found generally in Mexico. A series of cores averaging 9 mm. in diameter were drilled around the inner edge, leaving a scalloped rim varying from 3.5 to 9.5 mm. in thickness, and an average diameter of the inner wall of the jar of 81 mm. These cores, thirteen in number, have been broken off with the exception of two, and at varying depths, 34 mm. being the greatest, while four of the cores were broken off at a depth of only 10 mm. The thickness of the walls of the hollow drill, as indicated by the spaces left, must have been about 2 mm. These outer cores being removed left a large inner scalloped core in the centre, about 42 mm. in diameter, and three cores were made across it with a smaller drill, they being but 7 mm. in diameter and 8 mm. in depth. Had the work been carried on, this would have left two walls which could have been easily broken off, leaving the first stage of the work complete, and ready for repeating the process below, until the whole mass had been hollowed out».[10]

That the material of which drills were made might vary is apparent from a plaque of onyx marble which was found near Chalco in the Valley of Mexico, and has been depicted and described by Holmes.[11] It had been pierced longitudinally, and the two, conical, drill holes had met about half-way. In one of the holes remained, broken off, the drill with which it probably was intended to enlarge the rather narrow middle section. The drill consisted of a hollow piece of bone, probably from the leg of a crane or other large bird. By microscopic examination of particles remaining in the drill hole it was found that the stone-cutting material consisted of sand of a degree of hardness surpassing that of the plaque.

[1] Gordon 1916:137—141; Lehmann mentions several finding places in this region (1910:738).

[2] Nuttall 1910:282 seq; Joyce 1916a: 33. [3] Strebel 1889: pl. 29. [4] Lehmann 1910:738. [5] Blake 1891:71.

[6] Lumholtz 1904: vol. 2, 258. [7] Seler-Sachs 1900:44; Saville 1900:105; Lehmann 1921:24. [8] Caso 1932:500; 1932a: 18, 22. [9] Lehmann 1921:24. [10] Saville 1900:106. [11] Holmes 1895—1897:304 seq.; 1919:351 seq.

From the instances given above, the stone-working methods in use in ancient Mexico will be apparent. Although relating to a period subsequent to that of the Teotihuacan culture, it may be presumed that similar methods were also then prevalent.

Fragments of vessels manufactured of onyx marble, or some similar material, were recovered beneath the floors of the Xolalpan ruin in Rooms VII, XV—XVII, XX and XXII. They consist of flat covers with a low, vertical and straight rim, and vessels of more or less spherical form, cf. figs. 260 and 266. The former originate from seven different objects, the latter from six. The covers were all alike in shape, but in size they had varied from ca. 6.8 to 13.6 cm. in diameter, the mean diameter being about 9 cm. Only one of them appears to have been decorated. In this, the upper side is ornamented with large, softly incised, circular lines, and along the rim runs a band of rectangular figures, each enclosing a broad, straight line. One of the vessel fragments is decorated with deeply incised grooves with clear-cut edges, placed closely together in a slightly oblique position (i. e., not quite perpendicular). The sherd reproduced in fig. 260 is the largest of the fragments, but formed part of a fairly small vase. The largest of the vases seems to have had a diameter at the mouth of about 15 cm. In form, the vessels appear to have been spherical. One of them — the material consists in this case of marble-banded crystalline limestone — was provided with a low but massive annular foot.

Of similar material there are in addition three fragments, although not of vessels. One of them is from a plaque whose thickness was at least 3.5 cm., one side of which is faintly convex and exceedingly fine-polished. The other two also derive from evenly ground and polished objects, more or less flat, the shape of which probably were elliptical and rounded, respectively.

The material of which these objects were manufactured was supposedly only found within a comparatively limited area. Even these simple fragments may on that account prove of no inconsiderable interest in their character of proofs of ancient trading connections.

Ear-plugs and problematic objects.

A beautiful example of the technically highly perfected art of the stone carver is seen in the object reproduced in fig. 283, although unfortunately it is only fragmentary. The material is probable jadeite. The shaping is most accurate, and the polish is beyond praise. It probably formed part of a so-called ear-plug of the type that — apart from several complete examples from Teotihuacan — is known from, e. g., Rio Frio,[1] the southern Cayo district,[2] Baking Pot,[3] Holmul,[4] Huehuetenango,[5] Monte Alban,[6] and Morelos.[7] The upright middle portion in an object made of jadeite, from Rio Frio, is fairly conical but pierced with two diametrically opposite holes. By the aid

[1] Gregory Mason 1928: fig. 19. [2] Thompson 1931: pl. 38. [3] Ricketson 1931: pl. 18. [4] Merwin-Vaillant 1932: pl. 33. [5] Villacorta 1927:160. [6] Caso 1932:495. [7] Museo Nacional, Mexico.

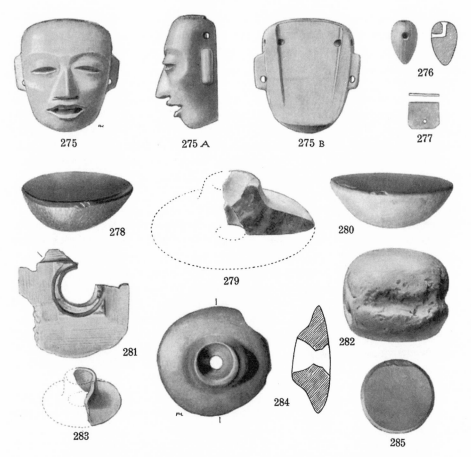

Figs. 275-285. Objects made of different kinds of stone and slate (fig. 285). (1/2) 275: 6740, 276: 6790, 277: 6113, 278: 5567, 279: 4055b, 280: 3978, 281: 6788, 282: 1199, 283: 4415, 284: 4050a, 285: 4100.

of, e. g., pieces of string threaded through these holes this ear-plug might have been kept in place. The corresponding portion of our ear-plug is however cylindrical, by reason of which it is better suited to its — presumed — purpose. An exceedingly plausible explanation of the employ of these — anything but practical — ear-plugs is advanced by Arreola.[1] According to his theory, they were only used ceremonially, namely in the ear-lobes of certain stone figures. A representation of Ueueteotl, the Old God, in conventional sitting posture and with a cylindrical bowl on his head, in some instances shown with — and in others without — ear-plugs fixed-in, would appear to lend colour to his theory. Attached to the object we are concerned with are

[1] Gamio 1922: Tomo 1, vol. 1, 216.

small »warts» of some foreign material — some of them being impossible to remove — which can hardly be explained otherwise than by the object having been subjected to the action of fire. If such was the case, it must have occurred before the object came to rest beneath the floor of Room VII, as no traces of carbon were discoverable there. A small fragment of a similar ear-plug was recovered at Las Palmas. Its diameter was unusually small, viz. 3 cm. at the outside.

In close proximity to the ear-plug found below the floor of Room VII, were recovered several fragments of unfinished ornaments of this class. Probably they had got broken in the process of manufacture, and the pieces thrown away. One of these fragments is shown in fig. 281. It is interesting because it shows how the work progressed. The perforation had first been made, then the under side was planed and given a preliminary polish. With the aid of a drill of larger calibre the cylindrical centre portion was then given its shape. For the removal of superfluous material, parallel and rather shallow grooves had been cut into it, closely together, so that the resulting thin partitions between them could be broken off or knocked away. These straight and narrow grooves had probably been made by means of a saw-blade of stone. These systems of grooves, four in number, the traces of which are easily noticeable, are approximately at right angles with each other. Strangely enough the edges have been shaped by the same method, and their subsequent grinding into round shape would presumably have been carried out only on completion of the shaping process, when nothing but the polishing remained to be done. The material is possibly an albite rock belonging to the magalite series of H. S. Washington.[1]

This method of sawing, or cutting, stone with stone was very frequently used. In the small figurine of stone, fig. 262, for example, superfluous material has been removed by sawing down, with subsequent breaking away, along the two longer edges. The two incisions never met, the snapping off of the waste pieces having been done just before. Of this procedure a small projecting ridge bears evidence.

Another object of interest, and of unknown purpose, is reproduced in fig. 284. Its material consists of some hard and almost black kind of rock, related to the magalite series of Washington. Its shape is not beyond reproach, either as to diameter or depth, but, although the craftsman has not taken overmuch pains to achieve symmetry, a great deal of labour has been expended on the polishing. That this ring-shaped object might have served as an ear ornament seems out of the question, and the perforation is much too small to allow of the supposition that it may have been of any practical use as a club, or mace, head. As will be seen from the section, perforation has been carried out by three stages. It is noteworthy that the walls of the drill-holes are much hollowed. This may probably have resulted from the drill having been of some soft material and of conical shape, and that, as the work progressed, its diameter was more and more reduced. This object is almost intact, but not far from it was recovered a fragment of a similar ring, fig. 279. In this, the material is a light-greyish,

[1] Washington 1922:325.

crystalline kind of rock, possibly an albite rock, belonging to the magalite series of Washington. It will be noticed that also in this case the drill-holes are cup-shaped. The work not completed, seeing that, although both perforations meet, a third drilling operation would have produced a fairly large and even hole. Both of these objects were recovered beneath the floor of Room XV, but another, almost identical, fragment made of saccharoidal albite, is included in the collection of artifacts originating from the altar of the Central Court. Similar objects, from the Ulua valley, are preserved in the Department of Middle American Research, the Tulane University of Louisiana, New Orleans.

OBJECTS OF OBSIDIAN

Even the casual visitor to Teotihuacan must be struck by the copious prevalence of potsherds, fragments of clay figures, and the like. But also splinters of obsidian, fragments of obsidian knives, etc. are constantly being found both in the ruined city and in the fields adjoining the archaeological zone. The reason for this state of things is to seek in the presence of local »obsidian mines», whereby anciently a rich supply of the raw material was ensured, and in the circumstance that this material is of exceeding suitability for the manufacture of weapons and implements.

Obsidian is a volcanic rock, a glassy lava — also known as »volcanic glass» — and occurs in the form of cooled lava streams alongside volcanoes. It is said to derive its name from a Roman named Obsius (in the early printed editions of Pliny erroneously called Obsidius) who discovered a similar rock in Ethiopia. Its chemical composition varies somewhat, but, like ordinary window glass, its main constituent is silica. In hardness it corresponds to No. 6 in Mohs' notation, thus being slightly below that of quartz (7).

It cuts ordinary glass of a hardness of No. 5.5, but can be scratched by steel of hardness 6.5. Its fracture is conchoidal, perfectly close, and with exceedingly sharp edges. In colour it varies somewhat, ranging from the black or blackish of the most common occurrence to greyish-black, brown or red. It is generally more or less translucent in thin fragments or edges. The more homogeneous varieties flake very easily, and in this respect obsidian surpasses all other kinds of rock. It is therefore not surprising that obsidian in ancient times was an article of trade that travelled far and wide. In a mound in Ohio have been recovered hundreds of obsidian objects, the raw material of which originates from an unknown locality probably situated in the Rocky Mountains, some 2000 km. distant.[1] In Teotihuacan, on the other hand, it was not necessary to import obsidian. Because there rich quarries are found only 20 km. east of the archaeological zone at Cerro Tepayo. Material from quarries situated in various localities has been carefully analyzed.[2] From the different analyses it is inter alia apparent that the proportion of silica ($Si O_2$) amounts to 70.60—70.80 %.

[1] Holmes 1919:107. [2] Gamio 1922: Tomo II, 48 seq.

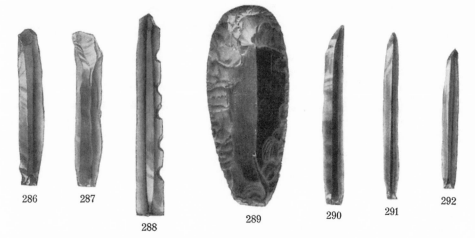

286 287

288

289 290 291 292

Figs. 286-292. Obsidian knives and scraper (fig. 289). (1/2) 286: 6395, 287: 6153, 288: 6622, 289: 4677, 290: 6245, 291: 6397, 292: 6251.

At this place many obsidian varieties have been found, and it is probable that anciently this rich store provided the inhabitants of vast tracts of the Valley of Mexico with this to them so necessary material.

Another exceedingly important obsidian mine, Sierra de las Navajas, is located northeast of the town of Pachuca, in the State of Hidalgo.[1] Quite a number of flake knives, cores, blades, spear-heads, arrow-points and scrapers, almost identical with those from Teotihuacan, have been recovered in exploration work on Sierra de las Navajas.

Flake knives.

Of the obsidian objects that were recovered, the largest proportion, by far, consists of thin-bladed knives. Their number — including large and small, intact or fragmentary — amounts to about 350. These knives are derived by fracture from faceted spool-shaped cores. Some fifty of the latter were recovered, most of them in fragments, while such as were found intact, figs. 325 and 327, are exhausted. Examples of knives of this kind are seen in figs. 286—288, 290—292. A peculiar type, and one of fairly rare occurrence, has a toothed edge suggestive of a saw — were presumably employed for some special purpose, possibly they were in fact saws.

These long knives, of fairly even breadth, and more or less pointed and slightly curved, have edges of razor-like sharpness. As is pointed out in an account from the early colonial period, cited below, they very easily lost their edge. The majority of

[1] Holmes 1919:214 seq.

the knives, which were found in bowls in graves dating from the Mazapan period, had never been used: even under the microscope their edges show up straight and even. It may be noted that even after very slight use the appearance of the edge is altered, as evidenced by practical experiments, in that minute splinters are flaked off. Then the blade has become blunt. The edges being so very delicate, it hardly seems probable that these knives had been subjected to any transport, but made locally. The great prevalence of cores indicates that such was, in fact, the case. Strangely enough, judging from the Xolalpan finds the people of the Teotihuacan culture appear to have availed themselves in less degree of these excellent knives than was the case during the Mazapan period. Their sparse occurrence below the floors of the ruin is probably more properly ascribable to the inhabitants not having to any considerable extent engaged themselves in any practical work. Other kinds of workaday objects, such as purely utilitarian ceramics for the preparation of food, are in the same way of rare occurrence. It should also be emphasized that flake knives occur in the earlier cultures in the Valley of Mexico.

An excellent description of the manufacture of flake knives is given by the Franciscan monk Juan de Torquemada, who in 1583 began work in the service of his order in Mexico. Although it may seem superfluous to cite his account, published among others by Wilson and Holmes, it is of such general interest to our knowledge of primitive, now extinct, technique that, if thereby further knowledge be spread — e. g. to non-Americanists — the space is used to good purpose. Torquemada says: »They had, and still have, workmen who make knives of a certain black stone . . . They are made and got out of the stone (if one can explain it) in this manner: One of these Indian workmen sits down upon the ground and takes a piece of this black stone . . . The piece they take is about 8 inches long, or rather more, and as thick as one's leg or rather less, and cylindrical. They have a stick as large as the shaft of a lance, and 3 cubits, or rather more, in length, and at the end of it they fasten firmly another piece of wood 8 inches long, to give more weight to this part, then pressing their naked feet together, they hold the stones as with a pair of pincers or the vise of a carpenter's bench. They take the stick (which is cut off smooth at the end) with both hands, and set it well home against the edge of the front of the stone, which also is cut smooth in that part; and then they press it against their breast, and with the force of the pressure there flies off a knife, with its point and edge on each side, as neatly as if one were to make them of a turnip with a sharp knife, or of iron in the fire. Then they sharpen it on a stone, using a hone to give it a very fine edge; and in a very short time these workmen will make more than 20 knives in the aforesaid manner. They come out of the same shape as our barbers' lancets, except that they have a rib up the middle, and have a slight graceful curve toward the point. They will cut and shave the hair the first time they are used, at the first cut nearly as well as a steel razor, but they lose their edge at the second cut; and so to finish shaving one's beard or hair, one after another has to be used; though indeed they are cheap, and spoiling them is of no

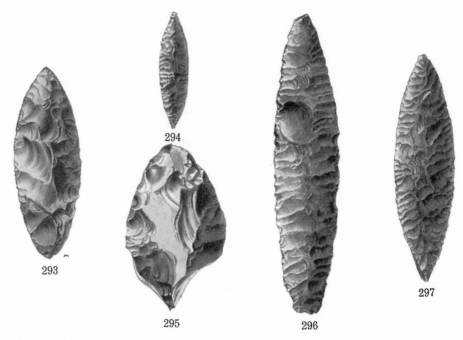

Figs. 293-297. Obsidian blades. Fig. 297 found in Grave 1. (1/2) 293:4057, 294:4402, 295:3446, 296:4055, 297:4401a.

consequence. Many Spaniards, both regular and secular clergy, have been shaved with them, especially in the beginning of the colonization of these realms, when there was no such abundance as now of the necessary instruments and people who gain their livelihood by practicing this occupation . . .».[1]

Leaf-shaped blades.

The finest of the obsidian objects are undoubtedly the large leaf-shaped blades of which three examples are shown in figs. 293—297, side by side with a blade of pitch-stone and a fragment of partly-worked material, of corresponding form and execution. At Las Palmas and Xolalpan, respectively, were found 5 and 11 objects, intact or fragmentary, of this description. Nearly all objects that originate from the latter locality were discovered below the floors of the ruin, and consequently date from the Teotihuacan culture. In size they vary considerably, the smallest being 5.6 cm. long, while the largest measures 20.1 cm. The form, however, is constant. They

[1] Not having Torquemada's work accessible, I am here giving Wilson's translation (1899:988).

146

are symmetrical, leaf-shaped or lanceolate, with both sides equal, and of acutely oval section, while both ends are pointed and the edges carefully chipped.

Obsidian blades of this type are found from northwestern California to Guatemala. The Californian ones are marvels of the flaking art, and attain fantastic measurements, even exceeding 80 cm. in length. As to form, they show extremely close correspondence to those of Teotihuacan.[1] The Californian ones were exclusively designed for ceremonial purposes, and it may not be impossible that such also was the case with those of Teotihuacan. If they had been entended for practical use they ought to have been shafted like those of the Hupa Indians,[2] or like the ceremonial knives of the Aztecs, with a handle in the form of a human figure decorated with mosaic inlay.[3] Against this speaks the fact of their being double-ended. As practical implements they naturally cannot be compared with flake knives.

Spear-heads and arrow-points.

Next to plain knives, points for arrows and spears constitute the numerically most important part of the manufactured obsidian objects. Bows and arrows must have been popular weapons, seeing that no less than 124 complete or fragmentary points were recovered. The line of demarcation between points for bow-shooting, throwing-spears, and stabbing-spears, is no doubt difficult of exact definition. Individual peculiarities must here have played a part, but an expert archer should however be able to decide the upward limit for arrow-points, i. e., the maximum weight and size. Their size probably varied within a fairly wide margin, owing to a hunter using a smaller point for a small animal, and a heavier for larger game. The weapons of ancient Mexico (excepting possible the Mayan) have not, to the best of my knowledge, been subjected to exhaustive study, but, e. g., from Beals' excellent work, »The comparative ethnology of northern Mexico before 1750», much valuable knowledge is obtainable. The central-Mexican bow was probably a single-stave. Beals says: »The sinew-backed bow was found on the northern border of the area, but in no case among tribes that might be considered typically north Mexican.» Of the arrow-construction all through Mexico he gives the following information: »The use of reed arrows with a foreshaft of hard wood was apparently general.»[4] Spears were thrown by aid of the spear-thrower, atlatl, and, as is proved by the finds from the Southwest, bows and arrows came into use at a comparatively late period.[5]

These single-stave bows were hardly adapted for projecting heavy arrows. While the smallest point, fig. 298, only weighs 0.26 grammes, the largest, fig. 309, scales at 58.1 gr. The average weight is about 10 gr. For points that probably were used in arrows, the mean weight is 6 grammes, and for the larger points that are provided

[1] Kroeber 1905: pl. 41; Holmes 1919: fig. 92. [2] Goddard 1903: pl. 3. [3] Saville 1922: pl. 38.
[4] Beals 1932:115. [5] Harrington 1933:89 seq.

with a broad tang, and therefore may be supposed to have been used as spear-heads, 20 gr. The larger specimens of the former category also have broad tangs, as apparent from the pictures, which means arrow shafts of a fairly large diameter. This provides a further standard of judging whether a certain point was that of an arrow, throwing-spear, or stabbing-spear. The width of the tang might probably have constituted the deciding factor in this respect. But a study of ethnographical material would naturally also give a good result.[1]

In figs. 298—312 are collected examples of the various types of points. All that are intact are provided with a tang. This is generally of even breadth, and rounded or pointed at the lower end. In some few, however, the tang widens in the lower part. The side edges are always more or less saw-toothed, although the teeth occasionally are so small as almost to be invisible to the naked eye. The side edges are straight, or, even more frequently, slightly convex. Bladebase barbs have been produced by making the base of the blade form right or acute angles with its longitudinal axis, and they are not infrequently lengthened so as to form lateral projections. Arrows of the former kind are supposedly more effective, as it is only with difficulty such a point can be pulled out of a wound, while points with lateral projections would cause more severe damage.

It appears to me remarkable that points of an earlier period, like those found by Vaillant at Ticoman, almost universally have a differently shaped tang. In these, the tang is broadest in its lower part, even with an outward curve, like in fig. 311. Although the finest specimens in our collection were found below the floors of the house at Xolalpan, there is no marked difference between them and those dating from later periods.

Many good descriptions have been published as regards the manufacture of obsidian points. For a very valuable one the material was supplied by one Ishi, the last of the Yahi tribe in California, and in the studies of primitive shooting with a bow that were carried out by his assistance, interesting data are also given as to the power of penetration possessed by obsidian points.[2]

»He began this work by taking one chunk of obsidian and throwing it against another; several small pieces were thus shattered off. One of these, approximately three inches long, two inches wide and half an inch thick, was selected as suitable for an arrow-head, or *haka*. Protecting the palm of his left hand by a piece of thick buckskin, Ishi placed a piece of obsidian flat upon it, holding it firmly with his fingers folded over it. In his right hand he held a short stick on the end of which was lashed a sharp piece of deer horn. Grasping the horn firmly while the longer extremity lay beneath

[1] Vaillant (1931:300—304) having made a thorough investigation of projectile points in his collections from Zacatenco and Ticoman mentions that Doctor A. V. Kidder gave 1.9 gr. as the maximum weights of arrow-heads from the Southwest while dart- or atlatl-heads ranged between 4.8 and 11.3 gr. On the other hand Vaillant has ascertained that of the projectile points from the two abovementioned places 33.7 % have a weight until 2 gr., 46.2 % between 2 and 5 gr., 12.5 % between 5 and 11.3 gr., and 7.5 % between 11.3 and 42.3 gr.

[2] Saxton Pope 1925:23—24 and 47—48; cf. also Nelson 1931:244—249.

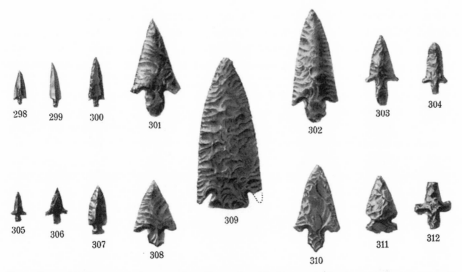

Figs. 298-312. Obsidian spear and arrow points. Fig. 309 found in Grave 1. (2/5) 298: 900, 299: 4193, 300: 4054, 301: 4491, 302: 4051, 303: 3646, 304: 4823,.305: 4903, 306: 4406, 307: 1030, 308: 3980, 309: 4401a, 310: 1465, 311: 832, 312: 6604.

his forearm, he pressed the point of the horn against the edge of the obsidian. Without jar or blow, a flake of glass flew off, as large as a fish scale. Repeating this process at various spots on the intended head, turning it from side to side, first reducing one face, then the other, he soon had a symmetrical point. In half an hour he could make the most graceful and perfectly proportioned arrow-head imaginable. The little notches fashioned to hold the sinew binding below the barbs he shaped with a smaller piece of bone, while the arrow-head was held on the ball of his thumb. When ready for use, these heads were set on the end of the shaft with heated resin and bound in place with sinew which encircled the end of the arrow and crossed diagonally through the barb notches with many recurrences. Such a point has better cutting qualities in animal tissue than has steel.

The question of the cutting qualities of the obsidian head as compared to those of the sharpened steel head, was answered in the following experiment: A box was so constructed that two opposite sides were formed by fresh deer skin tacked in place. The interior of the box was filled with bovine liver. This represented animal tissue, minus the bones. At a distance of ten yards I discharged an obsidian-pointed arrow and a steel-pointed arrow from a weak bow. The two missiles were alike in size, weight, and feathering, in fact, were made by Ishi, only one had the native head and the other its modern substitute. Upon repeated trials, the steel-headed arrow uniformly penetrated a distance of twenty-two inches from the front surface of the box, while the obsidian uniformly penetrated thirty inches, or eight inches farther, ap-

proximately 25 per cent better penetration. This advantage is undoubtedly due to the conchoidal edge of the flaked glass operating upon the same principle that fluted-edged bread and bandage knives cut better than ordinary knives. In the same way we discovered that steel broadheads sharpened by filing have a better meat-cutting edge than when ground on a stone.»

To this account may be added the following information kindly given me by the explorer, Count Eric von Rosen, at present one of the leading archers in Sweden:

»I know instances of American sportsmen, armed with a long bow, having killed elk, bear or lion by a single shot in the chest with a broad-bladed arrow, discharged at a distance of about 60 m. By experiments it has been shown that points of flint penetrate as deeply into flesh and bone as steel points, and moreover that the best-chipped points of obsidian or flint, on account of their finely toothed edges, in this respect are superior to steel points with straight, sharply ground, edges.»

Scrapers.

A good many scrapers, more or less carefully formed, and also of the type shown in fig. 289, were recovered. The latter are of oval perimeter and slightly curved. They are also provided with sharp and well chipped edges. In section, one side is plane, the other convex. In some cases these scrapers are not curved, and then in form approach to the large, flake-chipped knives, but while these are worked all over, the scrapers — which naturally also may be used as knives, the boundary line between knife and scraper being, as we know, vague — have only the edges flake-chipped. They may have served various purposes, among other things it has been asserted that they were used in the extraction of pulque (octli). When the maguey (metl) plant begins to rear its flowerstalk, the latter is cut off and the juice collects in the hollow thus produced. It is said that the scraper would be an implement well fitted for this operation, and that the modern tools are direct translations, into iron, of the original obsidian implements. The cultivation of agave for pulque production is of ancient date, and these very implements probably constitute a proof that pulque was made in Teotihuacan.[1]

Circular plaques.

In the course of test diggings that were carried out in the maize field outside the ruin complex was discovered a grave, or, more correctly, parts of a skeleton. The grave had been totally demolished on some earlier occasion, probably in the planting of an agave. The depth below the ground level was 60 cm. All that remained was fragments of a skull, a few vertebrae and ribs, and the bones of one arm. In the immediate neighbourhood of the skull were found two circular obsidian plaques, figs.

[1] Gamio 1922: Tomo I, vol. 1, 216 and pl. 120.

320—321. One of them is somewhat thicker than the other, but there can be no doubt as to an attempt having been made to give them as plane a finish as possible. Perfectly plane they could only have been made by a finishing process of grinding, which, however, had not been done. Judging by the position of the plaques, it does not to me appear altogether out of the question that they had been mounted in a mask made of some perishable material, which had been placed over the face of the dead. The case is unique among the graves that were examined, and, so far as I know, nothing of this kind has been observed at Teotihuacan. As no other artifacts were discovered in situ, it was impossible to determine to which culture this grave belonged, although most probably it was the Mazapan. Two similar plaques were however discovered below the floor of Room II, dating from the fourth building period, figs. 323—324. The remaining three cannot be dated.

Ear-plug and labret.

The obsidian object that from a technical point of view takes the first place is an ear-plug, unfortunately not complete, which has been reconstructed, fig. 322. The material is light-coloured, greyish-green, translucent obsidian. It was recovered close to the western wall of Room VIII. As here the floor had been demolished, probably in later times by the planting of maguey, it was impossible to determine whether it had originally belonged to the filling beneath the floor. If one may judge from its superficial position — it was found roughly on a level with the floor — that could hardly have been the case. No traces whatever, either of the missing portions or of other objects of a similar kind, could be discovered.

The object in question, and the lip-plug, fig. 319, are the only polished obsidian objects that have been found. While the manufacture of arrow- and spear-heads, and, above all, flake knives, only requires comparatively simple methods — although a highly specialized technique — this ear-plug is an example of a most highly developed technical skill, coupled with infinite patience.

The labret here depicted is of a fairly common type. Strebel reproduces an exactly identical lip-ornament from Cholula in a collection of archaeological drawings of which I am possessed. The labret under discussion was found in the southwestern corner of Room VI. As this portion of the house lay at a very shallow depth, very little remained of the walls and the floor, and it was therefore not possible to determine whether the object belonged to the Teotihuacan culture or not. It is probable that it dates from a later time. It is exceedingly well formed, and has as many others in the front a bowl-shaped depression. In this were fixed stones or other ornaments.

Both ear-plugs and labrets show great uniformity over a large area of the country. No doubt they are products of the workshops of skilful specialists, and it should be possible to trace them back to certain centres of manufacture.

In the manufacture of the ear-plugs it is likely that, to begin with, a suitable chunk

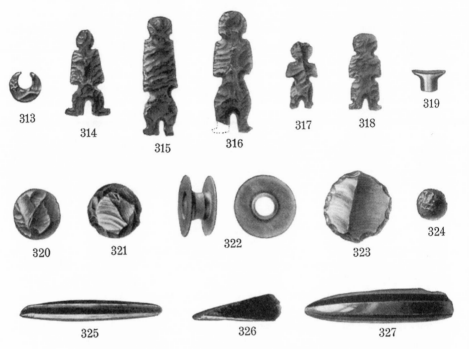

Figs. 313-327. Various obsidian objects. Figs. 315-317 found in Grave 1. (1/2) 313: 5213, 314: 6045a, 315: 4407, 316: 4408, 317: 4409, 318: 5568, 319: 6661, 320: 6255b, 321: 6255a, 322: 4492, 323: 6628, 324: 5972, 325: 6557, 326: 4410, 327: 3435.

of obsidian was obtained by being split off. The resulting flat piece was then carefully plane-ground on both sides, whereupon the groove was fashioned. The hole would then have been bored from both sides, probably with a hollow drilling tool, e. g. of bone. Held fast by a wooden stick wedged through the hole, the object would then be given the final grinding and polishing.

In view of the hard and brittle material it must be considered a feat of outstanding skill to grind and polish the sides almost exactly plane, and to pare them down to such thinness that they only measure $3/4$ mm.

An interesting experiment in the reconstruction of manufacturing of objects of this kind has been made by Orchard. He also depicts a similar ear-ornament which was recovered at Santiago de Tlatiluco in the Valley of Mexico.[1]

Eccentric obsidian objects.

From various localities at Xolalpan, including Grave 1, are derived the eccentric objects that are here reproduced, figs. 314—318. They represent, as will be seen,

[1] Orchard 1927:216—221.

small human figures, made from thin flat pieces of obsidian. Their proportions are not very naturalistic, the arms not distinct from the trunk of the body, the legs are short and the feet turned outwards. Notwithstanding some minor divergencies, they are all very much alike. What purpose they have served is difficult of determination. That they might have been toys is inconsistent with the fact that some of them were found in Grave 1, where the dead, judging from the skeletal remains, was an aged person.

The crescent-shaped object, fig. 313, might be included with this group. Possibly it served as an ornament of some sort. A pointed piece of obsidian, which unfortunately is not complete, is provided with lateral projections of such a size that it is almost cruciform, fig. 312. As it may confidently be presumed not to have been designed for any practical use, it may well be included under the heading »eccentric objects».

Of the very greatest importance appears to me the circumstance that similar objects have been found in a very far-removed region, namely British Honduras. Flints, and specimens made of obsidian, of eccentric forms have been discovered in eastern parts of the area occupied by the early Maya culture, the Old, or First, Empire.[1] The localities in question are Tikal, Benque Viejo, Lubaantun, Pusilhá, Piedras Negras,[2] and Quirigua. Some of the finds were made in graves and others below dated stelae.[3] Joyce reproduces a small figure from Honduras, in form almost identical with that from Teotihuacan, and circular plaques like those shown in figs. 320, 321, 323, 324 (Pusilhá), crescent-shaped objects resembling fig. 313 (Pusilhá, and Benque Viejo), and arrow-points of a type suggestive of fig. 312 (Rio Hondo).

SLATE AND MICA

While at Las Palmas only a few fragments of mica and some thin and irregularly shaped pieces of slate were recovered, quite a number of objects of these materials were collected at Xolalpan. It is not in any way a matter for surprise that nearly all of the mica objects were only recovered in a fragmentary state, seeing that this material is so very fragile. In many places, both superficially and in the ground of the ruin, as well as in test-diggings in the Xolalpan maize field, thin flakes of mica were recovered, some of which were circular, although the majority were of irregular shape. Nearly all of them, however, have at least one straight and clear-cut edge. This suggests their originally having been formed to some special purpose. Mica plates of this kind were recovered from various archaeological sites below the floors. In a vase in Grave 4 were found a number of small, rounded, and very thin plates, nine of them of about the same size and not quite circular, while the tenth was larger and of more regular shape. The small ones have a diameter

[1] Joyce 1932:XVII seq.; 1927:183. [2] Mason 1934:355. [3] Gann 1934:51.

of about 1.5 cm., the larger one 2.5 cm. What they have been used for is difficult to guess, but possibly pieces of mica were pasted on different objects by way of decoration. As regards Mexico I know of no authority for this theory, nor am I acquainted with any modern parallels. Holmes says, however, without mentioning any particular locality, that: »It is stated on very good authority that they were used also as mirrors, and this is doubtless true, since the thick sheets, or thin sheets properly backed, afforded good reflecting surfaces.»[1] The white coating of the walls at Xolalpan that consists of line is amply mixed with extremely fine-powdered mica.

Irregularly shaped pieces of slate were recovered both in the digging operations in the maize field and above and below the floors of the ruin. Some of them have partly worked edges, and show traces of red paint. In the filling underneath the floor of Room VI was recovered a circular piece of slate with a diameter of 5.5 cm., together with another which was slightly larger and somewhat damaged, fig. 285. In test-digging in the maize field was recovered a fragment of a slab of considerable size, whose shape originally had been rounded, although not circular. Among the objects recovered below the floor that was discovered in the northwestern corner of the field — an archaeological site that was never properly examined — there is a small circular plate with a diameter of 2.8 cm. All these circular plates are carefully formed, planed to exactness, and have a bevelled edge so that one surface is larger than the other. To what purpose they were employed is unknown.[2] In the rubble underneath the western platform was discovered part of a fairly thick slate object, one side of which is bevelled, and in which there are two perforations. This fragment may have formed part of a rectangular implement which by means of those holes was fastened to a handle, in which case it would have much resembled the primitive skin scrapers that are used not only by the Eskimos, but also — although of iron — in old-fashioned skin-dressing professionally carried on in Europe. This is, however, merely a piece of conjecture, without any pretension to correctness.

Seler mentions and reproduces pieces of slate of the same size and shape as the circular ones above referred to — likewise with a bevelled edge — that were recovered in excavations on the crest of the Pyramid of the Sun. Some of them are provided with two diametrically opposite perforations at the edge, in this respect also resembling those recovered at Chamá in Alta Vera Paz and at Chaculá in western Guatemala. Those from Chaculá served as covers for small vases containing offerings. The disks from the Pyramid of the Sun are coated with, or embedded in, copal, the hard resin that is largely used as incense. On the Sun Pyramid have also been recovered votive knives of slate, of lanceolate form. They are decorated with plain patterns consisting

[1] Holmes 1919:241.

[2] J. Eric Thompson has found a quite similar plate in the southern Cayo District. He mentions the plate as follows: »An object of interest from the cache was a circular disk of slate . . . with beveled edge. Similar disks of sandstone seem to have been highly prized by the Mayas, for they were used as centers for mosaic disks . . . Possibly the slate disk under discussion formed the center of a small feather mosaic disk set on wood, of which no trace now remains. The specimen has a diameter of 7.5 cm.» (1931:273).

of red lines, and it is probable that at least part of the Xolalpan fragments originate from this particular class of objects.[1]

These somewhat insignificant finds of mica and slate nevertheless give proof of both materials having been worked by the inhabitants of the site, and their occurrence beneath the ruin at Xolalpan shows that this took place even as early as the Teotihuacan period.

OBJECTS OF BONE

Among our finds bone objects play no prominent part, either qualitatively or quantitatively. In the main they consist of awls, bodkins, needles and similar implements, and their total number amounts to 45. The most important types are shown in figs. 328—336.

Those from Las Palmas are only three in number, viz. one bone with transverse, incised lines, and two fragments of similar objects. These have undoubtedly done service as scraping bones, or »Knochenrassel», a primitive musical instrument, a detailed description of which is found in Appendix 8. The complete bone, see figure on map 6, is of small size (18.2 cm. long), while the fragments originate from larger specimens. The milieu in which they were recovered is not with certainty indicative of the epoch to which they belong, but with great probability they may be ascribed to the Mazapan culture.

The main part of the bone objects were, as may be inferred, recovered at Xolalpan, and the majority discovered in different places beneath the floors. It naturally adds to the value of the collection that so large a proportion of them with certainty are referable to the Teotihuacan culture.

Below the undermost floor of Room II were discovered five implements, three of which are reproduced in figs. 330—332. They are thus contemporaneous with the earliest portions of the building complex. Three of them, notwithstanding their unpretentious appearance, probably were tools of importance, presumably pressure-chipping tools for the manufacture of points, blades, and the like, of obsidian. Similar implements for these purposes are depicted by Holmes.[2] They were probably attached to a wooden handle.

In one part, at least, of America there are to this day in use stone implements designed for practical purposes, viz. Tierra del Fuego. In his highly imposing work on the Selk'nam Indians, Gusinde reproduces implements entirely corresponding with fig. 330. He gives a description of the manufacture of arrow-points, in which both the method of employment and the great importance of the bone implement is very clearly demonstrated. Although relating to a far distant locality, Gusinde's description may yet offer a great deal of interest, partly because, as already has been mentioned,

[1] Seler 1915:431. [2] Holmes 1919: fig. 173 seq.

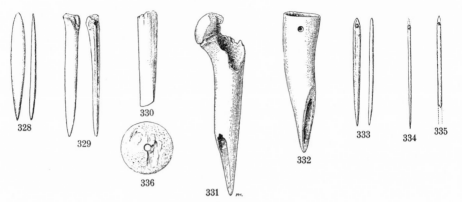

Figs. 328—336. Tools made of bone. (2/5) 328: 4387, 329: 4820, 330: 4819, 331: 6662, 332: 6688a, 333: 3579, 334: 3576, 335: 4383, 336: 4380.

the Selk'nam probably are the only people that in real earnest are manufacturing in such degree primitive implements, and also because in this case his observations in all probability are the last that have been made among Indians pursuing their primitive occupations. This is briefly what Gusinde writes: »With a stone hammer the material is given a preliminary shaping. For the finishing work then two bone staves are employed. These implements form an indispensable part of a man's equipment, and consist of the fibula of a guanaco, broken in two. The fracture surfaces are then ground smooth on sandstone. The longer piece is given a rounded point, while the point of the shorter and thinner one is made more acute and sharp-edged. The arrow-head-to-be is wrapped in a soft piece of leather and held by the worker in his left hand which he rests against his leg. In his right hand he holds the bone tool, and places it perpendicularly against the edge of the material. By pressure executed in a series of small jerks, at the same time with a slightly inward movement, small conchoidal splinters are flaked off. These are made smaller and smaller as the work approaches completion. He begins by working over the object with the bigger tool, and changes over to the smaller and sharper one for imparting the finished evenness».[1]

Figs. 331—332 shows two objects of essentially similar shape. In the former the head of the femur has been retained, and made to serve as a natural handle. In both cases the point has been formed by cutting the ends slantingly. Their employment is uncertain. A certain resemblance exists between the latter and the simple bone implement that is used in reaping maize, e. g., in Oaxaca, and with which the spathes enveloping the ears are cut open.[2] By long-continued use, of whatever kind this may have been, the implement has acquired patina and gloss. Among archaeological finds from the Paraná delta, Argentina, Lothrop reproduces a point closely resembling the one here being dealt with.[3] He is of opinion that it was used as a spear-head. It has

[1] Gusinde 1931:237.　[2] Seler-Sachs 1900:47.　[3] Lothrop 1932: fig. 44.

156

in fact a perforation at the base, so that it would have been possible to fix it on to a shaft. Points of that kind serve some practical purpose in stoneless regions, but hardly so at Teotihuacan. Similar implements with conical points have been fitted with a string through the aperture and used for carrying fish about.[1]

The main portion of the bone objects consists of awls and similar tools. They vary considerably in size, and also in finish, figs. 328—329. Some of the larger of the pointed objects may have been corn-husking pegs. Pointed bone objects of this class may also have been used as ritual implements. Not only on Mayan stelae but also in Mexican codices are reproduced scenes representing human beings carrying forth the blood that has been made to gush by this method.[2] Frequently it can as clearly as possible be seen that the instruments in these cases consisted of pointed bones with the femural knob left on. Possibly the so-called candeleros were used in these ceremonies.

What purpose the circular bone disk, fig. 336, once served is difficult of determination. It may have been some sort of ornament; it is however not inconceivable that it did duty as a spindle-whorl, although its weight — only four grammes — argues against such a supposition. It is exceedingly precarious to theorize and speculate on the use of objects that are more or less problematical. In this connection I think it should be mentioned that disks of similar size are used by the Itonama Indians of Bolivia in a game of patience.[3] The circumstance that in this case the disks were made of gourd shell is of no importance to the game. By this I by no means wish to say that the bone disks were used for a similar purpose, but only to show that the answer to the question as to the use of any given object not always is self-evident or ready to hand.

The needles, thirteen in number, of which the majority are broken, can only in some few cases have been used for actual sewing, e. g. figs. 334—335. Most of them are all too thick for ever having been of any use in textile work. For needles of that kind there is however employment. In the weaving of nets, e. g., carrying nets, thicker and stronger needles, as is known, are used.[4] That needles were recovered in such a relatively small number may be explained in two ways. For one thing, cloth, i. e. woven cloth, may not have been in general use. It is related from the era following the conquest that »the cotton they use for clothing is brought from the region of Panuco».[5] Then again: nature herself provided sewing-needles, »needles of agave leaf spines», with adhering thread. Needles of this description have been recovered in the Southwest, e. g., in the Canyon Creek ruin in Arizona.[6] In agave leaves the median fibres were combed out and twined, while the hard spine at the point of the leaf was retained and used as a needle. After completion of the work, the »needle» was cut off and thrown away. This combination of needle and thread ought above

[1] Nordenskiöld 1925:267 seq. [2] Nuttall 1904. [3] Nordenskiöld 1924:188.
[4] E. g., Blom 1926—1927: 350; Gabb 1876:511. From El Gran Chaco in South America, Nordenskiöld mentions: »Needles in the Chaco are used in the first place for making Caraguatá bags of different kinds ... One seldom sees the joining of two pieces of cloth among these Indians» (1919:195).
[5] Nuttall 1926:79. [6] Haury 1934:85.

all to appertain to regions where the fibre of the maguey plant plays a prominent part in textile industry. The geographical distribution of this invention should be well worth a closer study. That cloth woven from maguey fibre was anciently in use has been mentioned in another connection.

MOLLUSK MATERIAL FROM THE SITES

Both during the excavations at Las Palmas as well as in the maize field and the house ruin at Xolalpan, shells and mussels were met with. Although all the mollusk material was carefully gathered up, the resultant collection is only of slender proportions. Nevertheless the mollusks bear important witness as to trading intercourse between the mountain dwellers and the coastal population in ancient times.

The mollusk material has been determined by Dr. Nils Odhner of the State Museum of Natural History (Naturhistoriska Riksmuseet), Stockholm. The following species were represented:

LAS PALMAS

NAME	OCCURRENCE
Chama coralloides Reeve	Panama (the Pacific coast)
Fusus dupetithouarsi Kiener	W. coast of Central America to Acapulco
Spondylus pictorum Chemnitz (*crassisquama* Lamarck)	Mazatlan
Spondylus princeps Broderip	The coast of California
Arca grandis Broderip	From Panama to California

XOLALPAN

Pecten subnodosus Sowerby	Mexico, Baja California
Latirus ceratus Gray	From Panama to Mazatlan
Fasciolaria princeps Sowerby	From Panama to Mazatlan
Meleagrina margaritacea Lamarck	Panama, the Pacific coast
Melongena patula Brod. and Sow.	From Panama to Mazatlan
Turbinella scolymus Gmelin	Brazil and West India
Spondylus pictorum Chemnitz (*crassisquama* Lamarck)	Mazatlan
Spondylus princeps Broderip	The coast of California
Natica recluziana Desh.	California and Mexico

As will be seen, all of the mollusks originate — with one exception — from the Pacific Ocean. As for this sole exception, *Turbinella scolymus*, the habitat is only given as Brazil and the West Indies, one may suppose that its geographical distribution is not quite exactly known, as naturally no intercourse between Teotihuacan and the West Indies can very well have existed. As regards all the rest of the mollusks it is

however conclusively established that they are only found on the Pacific coast. Intercourse with Panama being altogether out of the question, it is to be expected that *Meleagrina margaritacea* and *Chama coralloides* will be reported also from the northern parts of the coast.

From the positions of the finds it is not possible to draw any comprehensive conclusions in the way of dating the trading connections above referred to. No specimens were found in the graves, and very few below the floors, that is to say from the era of the Teotihuacan culture. This much is however certain that the abovementioned specimens of *Turbinella scolymus* must have been brought to Teotihuacan at the time when only the western — the earliest — portions of the building were erected. The spot where the discovery was made was, it should be noted, situated below the western corner between Rooms XVII and XXIII, and several circumstances point to this corner having been part of the outer wall prior to the addition of the northern suite of rooms.

It is, however, with full evidence established that Teotihuacan carried on trading intercourse with the western coast, and, if one may judge from the mollusk material, this intercourse increased in volume after the specific era of the locality's greatness had passed away. It is remarkable, however, that hitherto no artifacts have been found in support of any trading relations of this kind. On the other hand there is much that lends colour to the existence of intercourse with the inhabitants of the Atlantic coast, and it is, e. g., directly stated in the period following immediately upon the conquest that cotton was imported from the Panuco region.[1] This was probably in continuation of pre-Spanish connections.

Unfortunately we have as yet only few possibilities of instituting comparisons with zoologically determined mollusk material from other archaeological sites in the mountain area. In his excavations carried out with extreme precision, Vaillant has however also discovered mollusks. His finds in this line at Zacatenco likewise originate from the Pacific coast.[2] Excepting for pearl oyster shell he has, however, both at the place just referred to and at Ticoman found species other than those which were discovered by me.[3]

To the ancient inhabitants of Teotihuacan sea mollusks evidently were of great interest.[4] This is, among other things, apparent from the fact that they made representations of these mollusks in clay. Part of these are perfectly naturalistic, while others are simplified and stylized. Even our collections include examples of the latter category. As models for these representations Pecten was generally employed. Large sea shells are depicted in the frescoes of Casa de los Frescos and carved out in relief on the Quetzalcoatl temple façade, fig. 5. On a number of clay vessels, too, there are conventionalized figures which may be referred to Pecten motives.[5]

[1] Nuttall 1926:79. [2] Vaillant 1930:50. [3] Vaillant 1931:312.

[4] A great deal of interesting information about shells used by the ancient Americans as symbols in art and religion has been brought together by Jackson (1917:46 seq.) from archaeological collections, statements in literature, drawings in Mexican picture-writings etc. His conclusions are most probably a little too far-fetched, to say the least of it.

[5] Gamio 1922: Tomo I, vol. 1, pl. 101.

COLOUR MATERIALS

Raw material for the painting of earthenware vessels, wall surfaces, etc., were discovered in different places beneath the floors. A number of small clay pots, usually cylindrical, had evidently served as containers or paintpots, seeing that thick layers of paint remain encrusted on their walls and bottoms. One of them was half-full of red paint. This was composed of iron oxide mixed with finely powdered hematite. While in Teotihuacan tripod vessels with scraped-out decoration the portions thus removed were filled with cinnabar — also used in in-fresco painting on clay vessels — all other red-coloured decoration appears to have been produced by means of iron oxide. Generally there are noticeable in the red paint, e. g. in the case of the polished red ware, minute particles which are black and shiny. Magnification shows them to consist of hematite crystals with reflecting surfaces and irregular edges. This mixture gives good effect, and was very greatly in vogue, even the red decoration of the house walls showing the presence of glossy grains of hematite. In white-coloured walls, coated with calcareous plaster, in the place of these black grains, a very effective substitute was found in fine-ground mica.

In the Mexican highland there was no difficulty as regards obtaining iron oxide. There were also available other iron compounds suitable for paint production. There was, for example, recovered a large lump of somewhat cylindrical shape and light-green colour. Its surface showed obvious traces of having been tampered with. This object was undoubtedly some green colour material, and, when required, a suitable quantity had been scraped off, the surface having first been moistened with water. It is a natural decomposition product of ferriferous tufa, and the colouring agent consists of celadonite (hydrosilicate of iron). As this colouring matter is not suitable for firing — moderate heating makes it brown-red, and a stronger heat red — it was made use of, inter alia, in wall-painting (Casa de los Frescos) and in in-fresco decoration of clay vessels.

In a small vase were contained a considerable number of small yellow lumps. They proved to be yellow ochre, also a natural substance, being a decomposition product of ferruginous tufa. As this yellow ochre in a natural way was diluted with clay, its colour was of a rather light shade of yellow.

White colouring material was recovered, partly in form of thick incrustations on the inner side of more solid potsherds — fragments of large paint containers — partly in the form of small round balls, and, in one instance, in the form of an elongated object of rounded section. While the former are composed of fairly pure lime, the latter are a mixture of lime and smooth-worn grains of crystals characteristic of tufa (such as hornblende and feldspar). These decomposed grains, worn to bluntness by the action of water in which they had travelled, testify to the lime having been mixed with sand.

In addition to these red, green, yellow, and white colours, the ancient potters of Teotihuacan also had cinnabar at their disposal. As has been mentioned, cinnabar

was used in in-fresco painting as well as for refilling the portions scraped away from the wall surfaces of tripod vessels, cf. frontispiece. Decoration by this method has to be done after the firing, as cinnabar volatizes in heating, and it is therefore very natural that such a strange and mystical substance would be well suited just for decorating ceramics of a ritual character. Apart from this, among all other colours red has in all times and among all peoples played an important part, above all in mortuary ceremonies.[1] The use of cinnabar as colour material is of still higher age in Central Mexico as Vaillant in Ticoman found a tiny bowl of quartzite which contained cinnabar. He adds: »The ceremonial use of cinnabar in these early times is quite significant in view of its use at Copan, Holmul, and other sites of high civilizations».[2]

The abovementioned colours, red, green, yellow, and white, which were used in Teotihuacan decorative art, in wall-paintings and on in-fresco decorated vessels, also possessed symbolic directional significance. Thus Sahagun relates that the Toltec king, Quetzalcoatl, had four places of worship. From this description it appears that red symbolized north, green, yellow and white standing for west, east and south, respectively.[3]

[1] Peabody 1927:207 seq. [2] Vaillant 1931:306. [3] Sahagun 1927:269.

PART VIII. APPENDICES

APPENDIX 1

NEGATIVE PAINTING

In Grave 1 below the floor of Room VII were found two clay vessels, almost identical in appearance, which were decorated by the so-called negative painting method. The presence in Teotihuacan of this decoration technique is interesting not least on account of the vessels being of a type especially characteristic of the locality, so that they may in all certainty be presumed to have been manufactured there, cf. fig. 23. The »genuine» Teotihuacan vessels of the tripod type are devoid of painted decoration with the exception of the abovementioned two, a heterogeneous vessel from Grave 3, fig. 39 and the »in fresco painted ceramics», fig. 36. The remainder of the vessels from Grave 1 are, besides, of classical Teotihuacan type. As is apparent from the picture, the decorative pattern is very simple: two borders composed of horizontal lines and between the borders there is a row of circles inscribed with round figures. Nowhere else among the ceramical material is this simple pattern found, but on the other hand it is a familiar motive in architectural decoration. »Casa de los Frescos» and »Los Subterráneos» thus have, inter alia, decorations consisting of green annular disks encircling red cores.[1]

As to my knowledge no detailed description of negative painting in America, its technique and distribution, has ever been published, it may be expedient here to adduce certain data and some viewpoints.

As early as 1888 Holmes brought forward his solution as to the technique of negative painting, arrived at by purely theoretical reasoning. In the main, his theories have proved correct.[2] The complete solver of this problem was C. V. Hartman. During his stay in Salvador in 1896—97 he pursued ethnographical studies in which he, inter alia, found that only in one single Indian village were calabash vessels manufactured to any considerable extent.[3] This was at Izalco, in the Aztec region. The calabash vessels were manufactured exclusively by women, and were decorated in the following way: the outer skin of the calabash was rubbed off, whereupon the surface was finely polished. The ornaments were then painted on with a small hair brush dipped in melted wax contained in a clay bowl set on red-hot embers. When the wax painting had dried, the whole surface was coated with black paint consisting of powdered charcoal and the pods of a certain tree, mixed with sugar. The calabash

[1] Gamio 1922: Tomo I, vol. 1, pl. 27—30. [2] Holmes 1888:113. [3] Hartman 1910:137 seq.; 1911:268.

was then again left to dry. After that it was dipped in boiling water. The wax then melted, and along with it came away the black paint that had covered the figures painted in wax. The pattern then showed up in the light colouring of the rind itself, against the black coating.

In the Ethnographical Museum's collections, in Stockholm, are also preserved calabashes from Guatemala decorated in this way, and a calabash originating from that republic and published by Stoll has evidently been decorated by the same method.[1]

As can be seen from map 1, negative painting of clay vessels is a technique which is common to Mexico, Central and South-America. In what place the invention was first made, or whether it originated independently in more than one place, or again whether in one or more places it developed out of one or more other technical methods, are questions still without an answer.

In a discussion in September, 1924, at Gothenburg Museum, Professor Max Uhle asserted his opinion that the method, together with a great many of other culture elements, had been imported to South America — Ecuador in particular — by culture waves that emanated from Central America. In a number of works he has subsequently vindicated his theories.[2] Uhle undoubtedly being the leading connoisseur of the archaeology of western South America — surely no one has through field work enriched science with so much material as he — the greatest importance must be attached to his opinion. Jijón y Caamaño agrees with Uhle as to the origin of the technique.[3]

Such an eminent scientist, and, inter alia, specialist on Central American archaeology, as S. K. Lothrop is on the other hand of a diametrically opposite opinion.[4] For he considers that the invention in question forms part of the contribution that the potters of northwestern South America made to the ceramic art of the New World. In this connection he points out how universally this decoration technique was applied within that area, but how poorly it was favoured in Central America in spite of its wide distribution. He further emphasizes that negative painting accompanies advanced metal technique, and that casting à cire perdue and the negative painting decoration method both work with wax.[5]

Unquestionably wax is an indispensable factor in the technical processes just referred to, but, according to Dixon and Nordenskiöld,[6] consideration should in this connection also be given to ikat and batik. As these two forms occur separately or together in the literature without detailed definitions, it should first of all be explained which is which.[7] In addition there is also a method that forms an intermediary between them, or, perhaps more correctly, a basis on which ikat and batik have been

[1] Stoll 1889: pl. 1, fig. 6. [2] Uhle 1925—1933. [3] Jijón y Caamaño 1930: 158. [4] Lothrop 1926: 410.

[5] To Mexican influence may possibly be ascribed certain negative patterns in the Southwest (including the Mimbres region) that present an appearance similar to that of negative painting although not produced by the latter technique but by the barring-out method (Carey 1931: 353 seq.).

[6] Dixon 1928: 201; Nordenskiöld 1931: 45.

[7] A description of the different methods is found in Meyer and Richter 1903: 24 seq.

developed, namely »pelangi» (its Javanese appellation) — false ikat — usually known as the »tie-and-dye» method.

Batik consists in painting a piece of cloth with wax in order thereby to protect the surfaces thus covered from absorbing dye when immersed in a dyeing bath. When the dyeing is completed, the fabric is dipped in hot water. By this means the wax becomes liquid and, because of its lower specific gravity, floats up to the surface. The procedure may then be repeated with other dyes and variegated wax-paintings. The batik method was never empolyed in ancient America but only introduced by Europeans.

In the tie-and-dye, or »pelangi», method certain portions of the one-coloured or undyed piece of cloth are gathered up into small puckers which are tightly wound round with thread so as to prevent the dye from penetrating into these protected bundles. The thread used in this procedure would either have beforehand been prepared so as to withstand the dye, or made from some material in itself imperv'ous to it. Upon subsequent removal of the windings the parts that were tied round appear in the form of irregular spots on the otherwise dyed cloth.

Ikat — from the Malay word »ikat, mengikat»: to knot, bind, tie round — implies a dyeing of the warp or woof threads, or both, designed in such a way that the dyed portions of the threads form patterns in the weaving. Once, or even several conse-cutive times, the threads are tied round and dipped in the dyeing bath. In the same way as in the tie-and-dye method, the portions tied round emerge undyed.

The tie-and-dye method may therefore typologically be considered a forerunner of ikat, but may also have formed an earlier stage of batik. Although I have no de-finite information of wax also having been employed in the tie-and-dye process — in the preparation of the threads — it is not altogether impossible that such may have been the case. The object aimed at in batik and in this method is identical, although the former is a more highly developed form, a decoration technique which in its way has attained perfection.

According to Meyer and Richter, ikat is known — or was in pre-Spanish times known — in Ecuador, Patagonia and Peru. To these, Loebèr adds Bolivia.[1]

While all Peruvian textiles of pre-Spanish times with barred-out patterns that I have studied are decorated by the tie-and-dye method,[2] Snethlage adduces some which are in ikat technique.[3] These originate from Pacasmayo and Pachacamac.

Hambruch also gives instances of ikat from modern Indians in Guatemala. Near Quezaltenango are two villages whose inhabitants largely occupy themselves with weaving, and for decoration employ ikat-dyeing in its true form. In this case the looms are of European type, and no reliable evidence of the ikat method actually having been employed in pre-Spanish times has been brought forward. Hambruch nevertheless opines that such was the case. From Mapuche in Chile the method is cited by Aichel, who however supplies no further details.[4]

[1] Loebèr 1926: 96. [2] Loebèr 1926: 96, mentions the same technique from Argentina, Bolivia and the Quichua.
[3] Snethlage 1931: 49 seq. [4] Hambruch 1929: 63—66.

No absolutely certain evidence — Snethlage's excepted — so far as my knowledge goes exists as to the employment in pre-Spanish times of the ikat method. Batik seems to have been a technique that was then unknown, while tie-and-dye played a certain part in the Southwest and on the Peruvian coast in the pre-Spanish era.

A Peruvian piece of weaving dating from the pre-Spanish era, which is preserved in the Linden-Museum, Stuttgart, though unfortunately with no locality stated, supplies an excellent illustration of the pelangi method.[1] The pattern consists of round-cornered rectangular figures with blurred edges, set closely together. Crawford depicts an interesting example of specific application of the technique from the Peruvian coast.[2] In this, a piece of cloth was made into a roll, tied round at even intervals, and then dyed. The result has come out as a striped piece of weaving. The specimen published by O'Neale and Kroeber is less typical but shows the technique quite plainly.[3] According to their table of Peruvian textile art, giving »frequencies of processes according to area and period», tie-dyeing is sparsely represented in various places but occurs both in the »Late and Inca Cultures, Middle Cultures and Early Cultures». Nordenskiöld's specimens from Indians of Calilegua, Argentina, and the Mataco Indians of El Gran Chaco, testify to the survival in those localities of culture elements at one time borrowed from the Peruvian high civilizations.

As regards Mexico, I have been unable to find any evidence of the tie-and-dye method having been employed there either in ancient or modern times. It is however possible that such was the case. Interesting to note is that the technique has been authenticated in the Southwest,[4] where four localities have so far been ascertained, viz. the Canyon Creek Ruin, the Nitsie Canyon, the Kayenta region, and Wupatki. The first and last mentioned localities have yielded tree-ring dates, whereby the latest years have been fixed at A. D. 1348 and 1197, respectively. The occurrence of the method in the Southwest is thus exactly dated.

Authenticated instances of the tie-and-dye technique having occurred in America in pre-Spanish times are only available from the Peruvian coast and the Southwest. In the former place it undoubtedly dates farther back. Of those who endeavour to correlate this method's American occurrence with its Asiatic — by here pointing to cultural influence — one may well ask for an explanation of the fact that the technique in question is absent in the regions that lie between. Laying down consequences involving cultural influence from Asia, on the basis of the occurrence of the tie-and-dye method in America, would therefore seem to be an argument which does not carry much weight. The process is simplicity itself — unlike that of batik — and is found, besides Indonesia and India, also in Africa.

If ikat can be proved to have been employed in the New World, then that technique has a distribution calculated to give very little encouragement to seekers of evidence

[1] Fischer 1933: pl. 7, fig. 6. [2] Crawford 1916: fig. 29. [3] O'Neale and Kroeber 1930: pl. 27, fig. a. [4] Haury 1934: 99 and pl. 61.

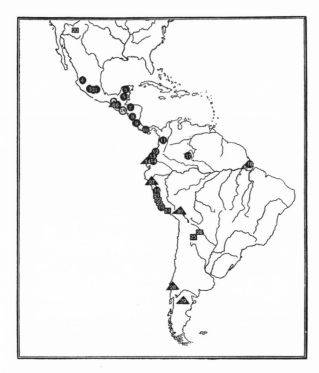

Map 1. Distribution of negative painting, tie-and-dye method, and ikat.

● Negative painting on pottery.

○ Negative painting on calabash vessels.

■ Tie-and-dye method.

▲ Ikat.

of culture waves from across the South Seas. Ikat, it should be noted, is known from southeastern Asia, eastern Asia, Indonesia, Persia, Turkestan, Afghanistan, and from Europe (the Balkan Peninsula and Mallorca).[1]

Negative painted ceramics appear to have been only little known in Peru. When consideration is given to the immense numbers of earthenware vessels that there have been recovered, and to those few which are negative-painted, it may rather be said that the latter kind is extremely rare. The tie-and-dye method was not either very common, although not actually rare. It is therefore not improbable that the potters received inspiration from the tie-and-dye method in textile art.

In northwestern South America negative painting seems to have occurred at a later date than in Central America. For this theory speak Vaillant's discoveries from Ticoman[2] and our find from the Teotihuacan period. The finds originating from Rio Negro and Lower Amazonas cannot, although the latter being archaeological ceramics, either be of great antiquity. The archaeology of these regions is still far too incompletely known to allow of any evidence being advanced in proof of cultural influence from any particular quarter.

[1] Hambruch 1929: 66; Meyer and Richter 1903: 31. [2] Vaillant 1931: 277 seq.

THE GEOGRAPHICAL DISTRIBUTION OF NEGATIVE PAINTING

Negative painting on pottery.

1	Teotihuacan	Fig. 23.
1	Santiago Ahuitzotla, Azcapotzalco	Tozzer 1921: 53.
1	Ticoman	Vaillant 1931: 290, 374—375.
2	Valle de Toluca	Spinden 1928: 184.
3	Michoacan	Spinden 1928: 184.
4	Totoate, Jalisco	Spinden 1928: 185.
5	Yucatan	Museo Arqueologico, Mérida.
5	Holmul	Merwin and Vaillant, 1932: 70.
6	Guatemala	Museum für Völkerkunde, Berlin.
7	Honduras	Museum für Völkerkunde, Berlin.
8	Nicaragua	Spinden 1928: 184.
9	Costa Rica	MacCurdy 1911: 106.
10	Chiriqui, Panama	MacCurdy 1911:103 seq.
11	Manizales, Colombia	Uhle 1889: pl. 2.
12	Tumaco District, Colombia	Lothrop 1926: 222.
13	Puruhá, Ecuador	Jijón y Caamaño 1922: 22 and pl. 16.
13	Esmeraldas	Uhle 1927: pl. 4.
13	Carchi	Uhle 1925: 15; 1928: 8; 1933: 20.
14	Riobamba	MacCurdy 1911: 106.
14	Cumbayá	Uhle 1926: 17.
15	Recuay	Yacovleff y Muelle 1932: 57.
16	Paracas	Yacovleff y Muelle 1932: 57.
17	Rio Uaupés	G. M. 28. 1.
18	Rebordello, Delta of Amazon river	G. M. 25. 14.

Negative painting on calabashes.

6	Guatemala	Hartman 1911: 269—270.
19	Izalco, Salvador	Hartman 1911: 269—270.
19	Sonsonate, Salvador	G. M. 27. 5.

Tie-dyeing.

20	The Southwest Region: Canyon Creek, Nitsie Canyon, Kayenta region, and Wupatki	Haury 1934: 99 and pl. 61.
21	Chancay	O'Neale and Kroeber 1930: The Basic Table.
22	Pachacamac	Nordenskiöld 1924: 221.
22	Lima	O'Neale and Kroeber 1930: The Basic Table.
23	Cañete	O'Neale and Kroeber 1930: The Basic Table.
24	Nazca	O'Neale and Kroeber 1930: The Basic Table.
25	Indians of Calilegua, Argentina	Nordenskiöld 1924: 220.
26	Mataco Indians	Nordenskiöld 1912: fig. 132; 1924: 220.

Ikat.

6	Quezaltenango, Guatemala	Hambruch 1929: 63.
14	Ecuador	Meyer and Richter 1903: 30.
27	Pacasmayo	Snethlage 1931: 49 seq.
28	Mapuche Indians, Chile	Hambruch 1929: 66.
29	Patagonien	Meyer and Richter 1903: 30.
30	Bolivia	Loèber 1926: 96.

APPENDIX 2

IN-FRESCO PAINTED AND SIMILAR WARE

Referring to a certain technique in pottery decoration, of comparatively sparse occurrence in Mexico, Spinden has coined the descriptive terms »pottery vessels with cloisonné or encaustic decoration». This class of ceramics, which is known from various parts of northwestern Mexico, he describes in the following way: »Examination shows that this pottery was first burned in the usual way so that it acquired a red or orange colour. Then the surface was covered with a layer of greenish or blackish pigment to the depth of perhaps a sixteenth of an inch. A large part of this surface layer was then carefully cut away with a sharp blade in such a way that the remaining portions outlined certain geometric and realistic figures. The sunken spaces, from which the material had just been removed, were then filled in flush with red, yellow, white, and green pigments. The designs on this class of pottery are thus mosaics in which the different colours are separated by narrow lines of a neutral tint.»[1]

»Encaustic» properly means the art of fixing colours by burning-in, which was a method of painting employed in classical antiquity and the earlier Middle Ages in Europe. The colours were mixed with wax, or, when laid on, coated with wax. They were then burnt-in by the application of hot irons. The characteristic feature of the cloisonné technique consists of the different fields of colours being separated from each other by a thin dividing line of metal. The outlines of the pattern were first drawn up, i. e. the thin metal bands were shaped and soldered on to the ground. Thereupon the intervening spaces were filled with paint, which was then melted by heat. The whole was then ground until the surface was perfectly even.

The nomenclature created by Spinden can therefore hardly be said to be altogether an apt one, and as regards Teotihuacan it is incorrect. But concerning ceramics from that place he also mentions a second method, namely that »the outside of the vessel was covered with a fine coating of plaster upon which the design was painted exactly as in fresco».[2] So far as I have been able to find, this is the only in-fresco method that has been in use in Teotihuacan, and the finds described in the foregoing under the head-line »Grave 3» belong to this class.

As the different colours are divided off from each other — they never shade off one into the other — by black painted lines, the in-fresco painted ware of Teotihuacan may be considered as a simplified form of the »cloisonné decoration» of the northwestern area. In this, the whole surface was spread over with the colour stuff dividing the differently coloured fields which were inlaid in the parts that were carved out of the dark-coloured coating. Which of these techniques is the original one is as yet difficult of determination. That they derive from a common origin seems more than probable.

[1] Spinden 1928: 183. [2] Spinden 1928: 178.

The method of decoration that was most common in Teotihuacan — the scraping away of certain portions of the surface layer so as to leave out the pattern intact — may well be considered as related to this cloisonné technique, especially as the parts that were scraped away were replaced by coats of cinnabar of a corresponding thickness. Neither this class of ceramics nor the one that was in-fresco decorated was fired after it had been decorated. This because the paint would not stand firing. It has been maintained that the cloisonné technique originally was employed for decorating calabashes, a practice still obtaining in Mexico and Central America, and subsequently applied to potterymaking. The question arises, however, whether it does not come more readily to hand to accept the scraping-out technique — so universally employed in Teotihuacan — as the natural forerunner of »cloisonné decoration». In favour of the former theory speaks, however, the circumstance that in Uruapan, in N. W. Michoacan, situated in a district where this decoration technique was especially popular, there is to this day produced by Tarascan Indians a kind of lacquer work in a technique which undoubtedly dates back to pre-Spanish times. It is described by Lumholtz as follows: »The vessel to be lacquered is first of all coated with a thick layer of some sort of clay. In this is incised the design which is cut out with a knife, and then the women fill in the portions that have been cut away with different colours . . . Thereupon the varnish is laid on, and the object is polished by means of assiduous rubbing with cotton. Through this the lacquer becomes so hard that it is able to withstand the action of water for quite a long time.'» It frequently appears that it is the men that draw the pattern designs, while the women carry out the remainder of the work. The latter may perhaps constitute a relic of the past, and perhaps the Teotihuacan vessels were manufactured by women — American potterymaking originally lay in the hands of the women, the inventors of the ceramic art — while men, the »scribes», perhaps — executed the incisions, which often present an appearance of hieroglyphic symbols.

The use of this ornamentation technique probably covers a very considerable space of time, and, with two exceptions — Pueblo Bonito and Guanacaste — its occurrence seems restricted to Mexico and the peninsula of Yucatan, cf. the table. It would seem of little practical use to distinguish, on the data that are available, between cloisonné and in fresco, as descriptions in many cases are rather vague. Both in the cenotes of Chichén Itzá and at Pusilhá and Holmul finds have been made that probably in a very high degree vary as to age. In the Teotihuacan culture the so-called glazed pottery is absent, but at Tepic Lumholtz recovered a vase of turkey form with its surface »glazed», and in addition ornamented with gold foil and in-fresco decoration.[2]

Of very great importance are Joyce's finds of in-fresco painted ware from Pusilhá. He points out the remarkable fact that »certain fragments, few in number, show the remains of a thick turqouise-blue slip . . . characteristic of Mexican Toltec ware». These ceramics were only found in the lower strata of the site. Joyce remarks, how-

[1] Lumholtz 1904: vol. 2, 380; cf. also Molina Enriquez 1925: 115 seq. [2] Lumholtz 1904: vol. 2, 259.

ever, that these artifacts, belonging to the in-fresco painted ware category, »ante-dates the Toltec period by centuries».[1] The wording of Joyce's remark is due to his being a subscriber to the theory that what intercommunication the Toltecs — the bearers of the Teotihuacan culture — had with the Mayas only dates back to the »Toltec period of the New Empire». In another place in the present treatise I have pointed out the existence of other pottery finds indicative of direct or indirect inter-communication between the people of the Teotihuacan culture and the Mayas of the Old, or First, Empire.

From these facts I do not, however, wish to draw any forced conclusions. For just as little as one swallow makes a summer, does the circumstance that a culture element happens to be represented in two different localities prove cultural inter-communication. There exist, however, still other points of correspondence between Teotihuacan and the Maya culture — problems to which I shall recur in the Conclusions.

Very remarkable is the isolated find of Pueblo Bonito, especially in view of the immense mass of material from those parts that have been examined. One might feel inclined to take up a sceptical position against the evidence brought forward, were it not that it has been accepted by Kidder.[2] In the case in question the decoration has been applied on stone, which may possibly be a fragment of a stone vessel.

Two vessels belonging to the Ethnographical Museum of Berlin, are decorated by the in fresco method, that is to say in the same way as the vessels of Grave 3 at Xolalpan, here described.[3] As regards form, they are of pure Teotihuacan type, and the motive — priests engaged in ritual performance — is most intimately connected with the frescoes of Teopancaxco. They are very superior exponents of their type, but what lends them their greatest value is that they were recovered at San Rodrigo Aljojuca, Jalapazco, in the District of Chalchicomula. The Berlin Museum's col-lections of pottery of yellowish-red clay, originating from the locality just referred to, are undoubtedly connected with the group of yellowish-red pottery dealt with in the foregoing. From this it is evident that lively intercommunication existed be-tween those two localities, and circumstances attending the archaeological discoveries at Xolalpan show that the in-fresco painted ware and the yellowish-red of the Chal-chicomula type are contemporaries.

In-fresco painted ware of a simplified form, i. e. nothing beyond painting done on a ground especially prepared for the purpose, has been recovered by Walter Lehmann in the province of Guanacaste, Costa Rica,[4] and to this class no doubt also belong the finds from, inter alia, Cholula, Atlapexco and Ranchito de las Animas, here listed in the table.

That so comparatively few vessels of this class have been recovered may partly be owing to both design and ground having perished on account of the imperfectness of the method of decoration. As already pointed out, no firing was done after the

[1] Joyce 1929: 444. [2] Kidder 1924: 129. [3] Seler 1915: 520 and pl. 63. [4] Lehmann 1913: 85.

vessels had received their decoration. At Xolalpan were thus recovered a number of sherds showing faint traces of white paint, and in a few cases it was possible to observe some scanty remains of painting on this film of white paint which had served as a ground. Only on one vessel was a more extensive decoration found.

Seler has pointed out the interesting circumstance that a similar method of decoration was employed in the production of part of the Mexican picture-writings, namely those which are written on deerskin.[1] The fact of their originating just from the Atlantic coast region conveys a valuable hint which may possible provide a clue in the search for supplementary evidence as to the geographical distribution of the technique in question. As to the origin of the in-fresco technique doctors may disagree — probably without much result. The Teotihuacan potters did not excel as regards painted decoration. With iron oxide was achieved a red decoration which could be fired, but for other strong and vivid colours they were dependent on in-fresco painting and cinnabar.

It may be that — from the point of view of the history of ceramic art generally — in-fresco painted pottery may be regarded merely as a stage in the development towards a technically superior class of ceramics, viz. the polychrome, in which were used colours that would stand firing. To this, however, the Teotihuacan potters never attained.

THE GEOGRAPHICAL DISTRIBUTION OF IN-FRESCO PAINTED AND SIMILAR WARE

[1] Seler 1915: 520.

APPENDIX 3

XIPE TOTEC

Since the great clay figure representing Xipe Totec must be counted among the most important gains of the Xolalpan excavations, besides being beyond comparison the most pretentious of the stray finds, it seems only fitting that some space be here allotted for recapitulating what we know about this deity, his worship and his origin. It is characteristic of the Mexican gods that their spheres of activity were not rigidly defined. Thus Xipe was in the first place the harvest god, but he was besides the god of skin and eye diseases as well as being the war god. He was further the lord of the 14th week of tonalamatl — the ritual year consisting of 20 weeks of 13 days each — and lastly he was the goldsmiths' special patron. As he occupied one of the most prominent places in the Aztec pantheon, we are in possession of not a few records of him noted down by different early Spanish writers. Pictorial representations of Xipe frequently occur in the codices and are moreover archaeologically found in fairly large numbers in various parts of Mexico and even beyond its borders. Even modern authors have devoted study to him, and divergent theories have been advanced among other things as regards the conceptions that pertained to this cult.[1] In this, as in so many other cases, the researches of Eduard Seler occupy the place of honour, and are no doubt unsurpassed as to commentaries on the original texts, the codices and the writings of the earliest Spanish authors.

Our earliest source of information is probably that supplied by the Franciscan monk Toribio de Motolinía, who as early as 1524 arrived in Mexico and in 1541 completed his work »Historia de los Indios de la Nueva España». He gives however only a rather cursory description of the sacrifices at which human victims were flayed, and their skins worn as dancing dresses.[2] Our far and away most important source of information as regards the time immediately following the Conquest we have from a fellow member of his order, Bernardino de Sahagun, who sailed for Mexico five years later than he. In his efforts at saving from oblivion the historical knowledge of the Indians, their traditions and religious beliefs, he was centuries ahead of his period. Therefore it is not surprising that those works of his did not meet with encouragement, but were misunderstood and opposed.

A lengthy account of Xipe Totec is given by Sahagun in libro primero, cap. 18, of his historical work, »Historia general de las cosas de Nueva España», published by Bustamente.[3] The latter's publication is however based upon the manuscript found in Biblioteca Laurentiana at Florence, which may practically be accepted as

[1] Beside Seler, who incomparably more than anyone else has extended our knowledge in this department, mention should also be made of Andres 1928; Bancroft 1875—76; Beyer 1919; Joyce 1914; Loewenthal 1922; Saville 1929, and Thompson 1933. [2] Motolinía 1914: 39. [3] Sahagun 1890—96: vol. 1, 57.

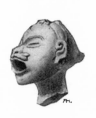

Fig. 337. Clay head from figure representing Xipe Totec. Goajimalpa. (3/5) 6886.
Fig. 338. Clay vessel from Oaxaca. (1/2) R. M. 23. 8. 864.

337 **338**

a summarized abstract of the two that are in the possession of Biblioteca del Palacio and Academia de la Historia, respectively, in Madrid. The Florence manuscript also contains a translation made by Sahagun at a later date. This translation is however by no means literal, being only in broad outline interpretative of the main contents. Seler has however carried out the translation of certain portions of the Madrid manuscripts in parallel Aztec and German text.

In the section dealing with the gods, the following information about Xipe is found: —

»Unser Herr, der Geschundene»,
der Herr des Küstenlandes,
der im besonderen der Gott der Zapoteken war.
Als sein Amt galt,
als sein besonderes Werk,
als das ihm besonders Zukommende,
dass er den Leuten anwarf, anhexte,
ihnen gab,
die Pustelkrankheit (Beulenkrankheit),
eiternde Wunden,
Krätze,
Augenkrankheit,
die Krötenkrankheit der Augen,
die Hühnerkrankheit der Augen,
die Spiegelkrankheit der Augen.
Wenn auf einen von uns Männern eine dieser Krankheiten gefallen ist,
gelobte er vor ihm (Dem Gotte),
dass er seine (des Gottes) Haut anziehen werde,
dass er sie anziehen wolle,
wenn sein Fest gefeiert werde,
das man »Menschenschinden« nennt.
Sie laufen, sie verfolgen,
in grosser Zahl erscheinen sie am Platz.
Alle tragen sie die Haut,
triefend von Fett, rieselnd von Blut,
über und über besudelt,
dass ihnen Folgenden darüber erschrecken.

[1] Sahagun 1927: 19—20.

Man hörte auf,
an dem sogenannten Totecco (Tempel Xipes).
Aber die Abbilder Xipes
gehen überall in die Häuser hinein,
es wird gebettet,
man setzt sich auf Kissen von Zapoteblättern,
macht ihnen eine Halskette von Maiskolben
und Schultergirlanden von Blumen,
bekränzt sie mit Blumen
und gibt ihnen Wein zu trinken.
Und wenn eine Frau an der Pustelkrankheit oder
an einer Augenkrankheit leidet, spricht sie:
»Ich werde Xipe Opfer bringen am Feste des
Menschenschindens.» —
Sein Putz:
er hat im Gesicht die Wachtelbemalung,
die Lippen sperren, mittels Kautschuk,
seine Yopikrone hat er aufgesetzt, mit den sperren-
den Bändern (deren Enden auseinandergehen),
die Menschenhaut hat er angezogen, die Haut
des Gefangegen,
er trägt eine Perücke aus lockeren Federn und
einen goldenen Ohrpflock,
er trägt das Röckchen aus Zapoteblättern,
er trägt Schellen;
sein Schild ist rot, mit Kreisen versehen,
den Rasselstab hält er in der Hand.[1]

173

The second in the order of annual festivals, Tlacaxipeualiztli, »the flaying of men», was devoted to Xipe. Of this, Sahagun gives a very comprehensive account.[1] From the abovementioned translation by Seler the following particulars of the sanguinary occasion are excerpted as follows: —

Das zweite (Fest) heisst »Menschenschinden».
Die in dieser Zeit getötet wurden,
die Gefangenen und die Sklaven,
denen zog man die Haut ab.
Und in dieser Zeit gingen die Xipeme umher,
die als Kleidung angezogen hatten
die Häute der Geschundenen.

Das Fest fand statt
am 26. Februar.

Und die Haut, die man ihnen abgezogen hatte,
zogen sich gewisse Leute an
und tanzten darin zwanzig Tage;
in dieser Zeit wurden die Häute heraus
 (auf die Strasse) gebracht,
das heisst,
alles Volk kam heraus,
kam zu schauen.
Und am dritten Tage

stellte man sich auf das Gras.
Jedesmal, wenn sie zum erstenmal angezogen hatten
die Menschenhaut,
nannte man das »auf dem Grase».
Denn es wurde Gras zerzupft,
worauf man die Xipeme stellte,
Auch nannte man es »mit der Rassel säen».

alle mit der Rassel,
während die Fürsten und die Gemeinen tanzten;
und auf dem Markt,
wenn sie von allen Leuten Gaben einsammelten,
hatten alle ihre Rasseln,
während sie tanzten.
Am zwanzigsten Tage
taten alle nichts anderes als singen
in den verschiedenen im Innern gelegenen Teilen
 der Stadt,
alle dabei Beteiligten,
jeder mit besonderem Putz.

Xipe's character of being the god of vegetation is clearly evident in the following where it is stated that the flesh of the victims was eaten: —

Und er lädt seine Vervandten,
versammelt sie zum Verzehren des Menschen,
in seinem Hause, er der den Gefangenen gemacht hat.
Dort kocht man für sie,
jedem in einer besonderen Saucenschlüssel,

das Gericht aus gekochten Maiskörnern
und setzt es ihnen vor;
es heisst »Menschenmaiskörnern».
Darin befindet sich für jeden ein Stückchen
von dem Fleisch des Gefangenen.

In his work on the eighteen annual feasts of the Mexicans (»Die achtzehn Jahresfeste der Mexikaner») Seler has made an exceedingly exhaustive, thorough and interesting study of Xipe and of everything connected with the rites pertaining to his worship. On the basis of the accounts supplied by such early chroniclers as Sahagun, Duran and others he also gives detailed description of the procedure observed in those gory ceremonies.[2]

It may well be surprising that the festival mentioned above began on February 26th and lasted up the March 18th.[3] The rainy season only begins in the latter half of May, and the rites that were performed in honour of Xipe are unmistakeably of

[1] Sahagun 1927: 61—76. [2] Seler 1899: 76—100 and 1904—09: 167—180.

[3] Duran makes the festival of the flaying of men take place on March 20, but whether by that means that it began on that date is not clear from the excerpt, the only one from this important author I have at my disposal (Saville 1929).

a rain-magic character, and included the preparation of the ground i. e. the earth spirit, for the new cultivation year. Consequently the festival ought to fall near the beginning of the rains. The Spaniards, who followed the Julian calendar, were about ten days behind, according to our chronology. The heavy dislocation of European chronology was only corrected in 1582, when the Gregorian calendar was introduced. Hence we are able to advance the conclusion of the Xipe festival to March 28, a date which still falls short of making connection with the rainy season. The Aztecs employed no leap-year, and with them the year of 365 days successively retrograded. Thus Seler has shown that from the Conquest until the year 1559 the Mexican year had retrograded 10 days, a period corresponding to the omitted leap-years.[1] In different localities the population had different ideas as to the exact date on which the year began, as is related by Sahagun. This was probably due to correlations having been attempted, and different results having been arrived at. If the Xipe festival actually fell on March 28, at the time when Sahagun made his investigations, and if the Mexican calendar had by then been in use, let us say, about 200 years, the occasion had originally taken place at a date immediately before the beginning of the rainy season. In the reports, frequently referred to in the foregoing, that in 1580 were despatched to Philip II and the »Council of the Indies» regarding conditions in certain portions of the Valley of Mexico is found a long and interesting description of Tlacaxipeualiztli. There it is stated that this festival was held in the month of March, and that it lasted for 20 days, towards the end of which period the sacrificial rites were performed. This corresponds well enough with what has been said in the foregoing.

Thanks to Sahagun's enthusiasm and untiring student's zeal there have been preserved a number of Aztec religious hymns. In his manuscript in Biblioteca del Palacio at Madrid is found a collection of twenty songs to different gods. He has entitled them »de los cantares que deziã a hõrra de los dioses en los templos y fuera dellos». However objective may have been the point of view of Sahagun when he was collaborating with his Indian informants, it must of course be self-evident that nowhere else have their conceptions of their various gods been rendered in as pure and original form as in these directly written down songs. They constitute an echo from that ensanguined temple service that was brought to a still more blood-stained end by the Spaniards who, in their introduction of the religion of charity and mercy, did not eschew, but rather sought occasion for, the most brutal deeds of violence.

On the basis of the abovementioned manuscript, and supplementing his information from corresponding passages appearing in that which is found in Biblioteca Laurenziana at Florence, Seler has accomplished a translation of these songs. To this translation he has appended precise explanations.[2] The text is often archaic and so obscure that Sahagun's informants themselves have added commentaries in Aztec. Hymn 15 is devoted to Xipe Totec. With the said commentaries inserted in their respective places it runs as follows: —

[1] Seler 1893, Erläuterungen: 20. [2] Seler 1904: 959—1107.

1. Du Nachttrinker, warum lässt du dich bitten (verstellst du dich)?
 Ziehe deine Verkleidung an,
 das goldene Gewand, ziehe es an!

 Du Nachttrinker, du Xipe Totec (unser Herr der Geschundene)!
 warum lässt du dich bitten (verstellst du dich)?
 (warum) bist du zornig, verbirgst dich?
 d. h. warum regnet es nicht?
 Ziehe das goldene Gewand an!
 d. h. es möge regnen, es möge das Wasser (der Regen) kommen!

2. Mein Gott, dein Edelsteinwasser . . . kam herab.
 Zu Quetzal (geworden) ist die hohe Zypresse.
 Zur Quetzal(schlange hat sich gewandelt) die Feuerschlange,
 es verliess mich (die Feuerschlange, die Hungersnoth).

 O mein Gott, herabgekommen ist dein Wasser (dein Regen), gekommen ist dein Wasser (dein Regen)
 d. h. schon hat es sich in Quetzal gewandelt,
 schon ist es grün geworden, schon ist der Sommer da,
 d. h. die Hungersnoth hat uns verlassen.

3. Es mag sein, dass ich dahingehe, dahingehe, um zu Grunde zu gehen,
 ich die junge Maispflanze.
 Gleich einem grünen Edelstein ist mein Herz
 (der junge Kolben, den ich in meinem Innern berge),
 Aber Gold werde ich dort noch (an ihm) sehen,
 ich werde befriedigt sein,
 wenn zuerst es reif geworden ist,
 (wenn ich sagen kann)
 der Kriegshäuptling ist geboren.

4. Mein Gott, ein Stück lass im Ueberflusse vorhanden sein die Maispflanze,
 es schaut nach deinem Berge, zu dir hin, dein Verehrer.
 Ich werde befriedigt sein,
 wenn zuerst etwas reif geworden sein wird
 (wenn ich sagen kann), der Kriegshäuptling ist geboren.

 Mein Gott, einiges bei der Feldarbeit wird reif,
 von seinen Lebensmitteln.
 Und was zuerst reif wird bei der Feldarbeit,
 bringt alle Welt dir zuerst dar.
 Und wenn alles reif geworden ist,
 bringt alle Welt wieder dir deine Lebensmittel dar.[1]

To the translation Seler has added valuable and partly much-needed explanations. The peculiar appellation »Nachttrinker» — night-drinker — he has given in translation, but does not explain that it means one that drinks pulque in the night. Libations were also included among the rites. By this, however, Xipe has been ranked with the pulque gods, who also were vegetation deities. Spence has interpreted »night-drinker» in a far-fetched way. He says: »Xipe was also the 'night-drinker', the vampire-being who sucked the blood of penitents during the hours of slumber.»[2] »Das goldene Gewand» is either an allusion to the painting yellow of the victim's

[1] Seler 1904: 1071—73. [2] Spence: 60.

skin, or merely a poetical paraphrase of the new vegetation. In stanza 1 the deity is invited to garb himself in the skin of the sacrificed victim, and from the commentary it appears that this act was supposed to bring on the rainy season. In the following stanzas these hopes have been fulfilled. »Die Feuerschlange» represent the ground which is parched by the incessant sun of the dry season, or a period of drought, the famine that has changed itself into »Quetzalfeuerschlange», and again into green vegetation, green like the feathers of the Quetzal bird. In the codices the Plumed Serpent, Quetzalcoatl, is pictured together with Xipe. »Das Herz der jungen Maizpflanze», the heart of the young maize plant, is the ear, still enveloped in its spathes, which, when the plant is still young, is green in colour, »einen grünen Edelstein». But it is going to ripen, to turn yellow, »aber Gold werde ich dort noch (an ihm) sehen». Stanza 3 means, at length: So long as the maize is still growing, the farmer is uneasy lest some disaster happen to it. It is only when the corn is ripe that he feels reassured. »Der Kriegshäuptling ist geboren»: that the War Lord has been born is another way of saying that the maize has ripened. The ears that have ripened earliest of all are presented to the god, and the offerings are continued at the harvest festival. From the contents of this hymn Xipe's importance as the god of fecundity is quite evident. Also the circumstance that the god and the man are talking alternatively bears the stamp of antiquity. In the hymn there is nothing that necessarily refers to human sacrifice. It has been maintained that the blood sacrifices belong to a comparative late period of Mexican history. Is it possible that this song is a relic from the worship of an earlier and more elementary pantheon?

Xipe Totec was the Earth Spirit, the harvest god, the lord of sowing and reaping. Seler says: »Xipe ist vielleicht Xiuh-a, der Herr des Türkises, des Grases, des Jahres.» The earth spirit must be recruited with fresh power to fit him for his ensuing labour. That the skins flayed off from human bodies should only be looked upon as symbolizing the earth in its particular manner donning a fresh garb is an explanation which does not appear to me as carrying much weight. No doubt the Indians possessed stronger reasons for their sacrifices to Xipe. No more than we are able to comprehend the idea of eternity and infinity, no more is primitive man able to conceive the idea of a god that perpetually infuses into the maize seed the power of germinating, growing up, bearing ears, ripening, and supplying daily bread to the husbandman. If the harvest god were to get weary, mankind would perish, and consequently he must repeatedly be instilled with fresh power. That the living force of man is concentrated to his blood, hair or skin, is a belief of almost universal range. Sacrificing a human being, and offering to Xipe, through his representatives, his skin therefore is equivalent to bestowing renewed power on the god. When regarded from this point of view the sacrifices become logical: »it is better that one man die for the people than suffering the whole people to perish».

The deputies of the god, those who have dressed themselves in the skins, provide for the continuity of his activity. This is inferable, among other things, from the fact

that when they appeared dressed in their grisly dresses they were given »ocholli», maize cobs, that for the year past had been kept stored in the roof-trees of the huts. These maize cobs, tied together in bundles, constituted the seed-corn.

Thompson explains the sacrificial rites in the Xipe worship as being built upon analogies: »it does not seem improbable in view of our knowledge of other symbolic sacrifices that the flaying of the victim represented the husking of the corn. This did not take place when the crop was gathered, for the ears were stored with their coverings of leaves in special granaries until required. This theory that Xipe was the patron of the husked maize is borne out by the fact that the heads of victims to be sacrificed to him were first shaved, symbolizing the removal of the beard of the corn when it is husked.»[1] As to this explanation of his the objection may be raised that it is too simple, that it is, so to speak, too palpable.

Among the rites performed in honour of Xipe there was one of quite a different character, although nevertheless connected with his functions as the lord of vegetation. On the second day of the feast — on the first were performed the mass sacrifices and the skin-flaying thereto pertaining — captives were tied to a large stone, resembling a millstone, and given wooden swords with which they had to fight champions armed with swords inlaid with obsidian splinters — sacrificio gladiatorio. When vanquished, the captive was roped fast, arms and legs spread out, to a ladder-like frame, and then made a target for throwing-spears.[2]

It is expressly stated that through the agency of the blood poured upon it the earth became fertilized. A similar form of power transmission occurred among the Incas. Karsten makes use of an exceedingly apposite expression when, on the subject of the Incas' sprinkling the fields with human blood in order to ensure a rich harvest, he calls this proceeding »magical fertilization».[3]

In Anales de Quauhtitlan we find particularly interesting information as to the significance of this sacrifice.[4] In the year »eight rabbits» (A. D. 1064 in our chronology) there appeared in Tollan a great many omens of evil portent. Then there arrived the female demons that were known as the ixcuinanme of the country of the Huaxtecs, whence they brought captives with them. They told their captives that they were taking them to Tollan for the purpose of using them at that place in fertilization of the soil. Further they said that never before had men been sacrificed by being shot to death with arrows. This constituted the inauguration of this kind of sacrifice. Possibly sexual analogies also are implied in this rite.

As it was in the rites of the Xipe cult that warriors fought while tied to a stone ring, »sacrificio gladiatorio», before being eventually sacrificed, it follows that Xipe was also the god of war. Seler has in addition pointed out that Xipe probably was a Moon God.[5] Certain figures found in the codices, as also sacrificio gladiatorio, would seem

[1] J. E. Thompson 1933: 145. [2] Arrow sacrifice also occurred at Tlascala, Huechotzingo as well as among the Huaxtecs and Kakchiquel (Beals 1932: table 130). [3] Karsten 1923: 153. [4] Seler 1900: 93; 1904—09: 172.
[5] Seler 1908: 317.

to point to this. At a later period he would then have merged into a vegetation deity and become Xipe Totec.

It is undoubtedly extremely hazardous to determine with any degree of certainty what conceptions were connected with the various deities of the Aztecs. These were adopted from different peoples and during different eras, and intertwined into one another's sphere of activity in a peculiar manner. Things that to us are logical were by no means necessarily so to the Indians. In very many respects we reason differently. Even the most painstaking and broadminded among the earliest Spanish authors must occasionally have been confronted with insurmountable obstacles when it came to understanding the significance of rites and ceremonies, and disentangling the respective importance and spheres of the different members of the motley, bizarre, and to them (the Spaniards) so alien-spirited circle of deities.

This ritual act of flaying the skins off men sacrificed to the Lord of Agriculture also contains an obvious analogy to the preparation of the fields for the sowing. In pre-Spanish times there was no occasion for removing the maize stalks in the reaping of the crop as the stalks were only useful as fodder for domestic animals, and such were only imported by the Europeans. In parts where more suitable fodder is available in sufficient quantities it is even to-day practiced to let the stalks remain on the fields through the winter. Already before the sowing is due, a great deal of weeds is likely to have come up, in warmer districts even profusely. This covering of weeds has to be removed, i. e. the old skin of the earth must be flayed off. At harvest time the ground is similarly stripped of its covering, and at the festivals that were then celebrated in honour of Teteoinnan, the earth-goddess, it was also customary to flay the victims.

An object of great interest is the rattle staff, chicauaztli, which forms part of Xipe's equipment. He is, however, not the only bearer of this emblem, for it also pertains to several deities connected with the fields, the hills and the waters. To this day rattle staffs are employed by the medicine-men of the Cuna Indians of Panama, and may reasonably be looked upon as a magical instrument of exceeding antiquity. The rattling sound — the upper, and thicker, end of the staff being hollow and containing loose objects, e. g. pellets, which rattle when the staff is shaken — is possibly meant to imitate the sound of a shower of rain when the drops patter against the ground. That rain might be induced to fall through making this imitative noise is an easily conceivable idea. Sahagun describes this instrument in the following words: »Tiene un cetro con ambas manos, á manera del cáliz de adormidera, donde tiene su semilla con un casquillo de saeta encima empinado.»[1] The appellation »chicauaztli» is thus interpreted by Seler: »ist eine Instrumentalform und bedeutet womit etwas kräftig gemacht wird».[2]

In Sahagun's particularized description of Tlacaxipeualiztli, the festival of the flaying of men, there is a detail of great interest although it may appear of no special importance. Before the killing of the victim he was given pulque to drink, and he then

[1] Sahagun 1890—96: vol. 1, 58.　[2] Seler 1904: 467.

179

employed a sucking tube. When he had been sacrificed and his heart had been torn out, a tube was inserted into his chest and through this tube his blood was sucked up.

In the collections from Xolalpan are found a number of fragments of thin clay tubes. These may quite well have been employed as sucking tubes. Birket-Smith has carried out an interesting enquiry as to the geographical distribution of this instrument.[1] It can be traced in a westerly direction as far as the Scandinavian Lapps. It occurs in Central Asia, and isolated, original instances are found in the countries east of the Baltic Sea. In Africa it occurs sporadically, inter alia among primitive Bushmen. It also forms part of the scanty equipment of the aborigines of Australia. From having once been a practical instrument for everyday use, its employment has been reduced to magical and ceremonial offices. This applies to North and Central America, with exception made for the Eskimos. Among the Fuegians it also serves a practical end. Birket-Smith has also shown that out of the drinking or sucking tube the tobacco pipe is likely to have been evolved. From its geographical distribution it is evident that the drinking tube is a very ancient culture element. Like many others it has in the main lost its practical application, but survived itself by the preserving agency of religion.

In the manuscript of Biblioteca del Palacio at Madrid, by the side of the picture of the god there is, beside the name, written »anavatl itec», which means the lord of the coastland.[2] Juxtaposition of Zapotec with a person of the coastlands is common in Aztec writings. Seler also says: ». . . the red god Xipe, whose original home was near Yopi, in the deep ravines of the Pacific slope . . .»[3] In another passage Seler adduces that Xipe was »der Gott der Yopi, der rothen Leuten, der Tlapaneca».[4] The Yopi was a people akin to, or even possibly of the same race as, the Zapotecs, a section that through invasion by the Mixtecs had been separated from their kinsmen. They occupied the coastland as immediate neighbours of the Couixco who possessed, inter alia, Chilapan, Tepequacuilco and Tlachmalacac in Guerrero. The domain of the Yopi, Yopitzinco, extended as far south as Acapulco.[5] Lehmann has established that the Tlapaneca-Yopi are linguistically related to the Maribios on the Pacific coast of Nicaragua.[6] Spinden, on the other hand, says that »the people of Yopico, specially given to the worship of Xipe, originated in Nicaragua».[7] This assertion does not, however, appear to have been conclusively proved. That the Xipe cult was practiced in Nicaragua will be found mentioned below, but it appears more probable that it was introduced from the north.

The temple at Tenochtitlan, dedicated to Xipe, was significantly enough known

[1] Birket-Smith 1929: 29—39.　[2] Sahagun 1922: pl. 8; Seler 1890: 151.　[3] Seler 1904 a: 132.　[4] Seler 1904: 464.

[5] Curiously enough, in Bustamente's edition of Sahagun, Xipe's place of origin is given as Zapotlán in Jalisco: »Este dios era honrado de aquellos que vivian á la orilla de la mar, y su orígin en Zapotlán, pueblo de Xalisco» (Sahagun 1890—96: vol. 1, 57). This is all the more remarkable as the manuscript made use of by Bustamente is later by 30 years, and in certain passages corrected by Sahagun himself. Zapotlán was however situated in the country of the Tarascos, whose area of distribution extends down to the Guerrero State.

[6] Lehmann 1920: vol. 2, 910 seq.　[7] Spinden 1928: 232.

as Yopico, or Yopico teocalli. Xipe's crown, or pointed cap, which had to be made from, or adorned with, the feathers of the spoonbill goose (Platalea ajaja L.), was called Yopitzontli.

According to Bauer-Thoma, bloody animal sacrifices occur in our days throughout Sierra de Oaxaca.[1] They are above all performed at the time of the sowing. Thus the Mixe kill turkeys and sprinkle the blood on the fields in order to obtain a good harvest. In the old days it may be supposed that human blood, so much more effective from a magic point of view, was employed. If Oaxaca was the country of Xipe's origin it may hardly be put down to mere accident that this »magic fertilization» with blood is tenaciously surviving in these parts.

Against Sahagun's statement that Xipe was the god of the Zapotecs Seler points out: »Eine Beobachtung drängt sich nun bei der Betrachtung dieser eigentlichen Alterthümer des Zapotekenlandes auf. Die Typen sind sehr konstante und sehr eigenartige ... Von dem vielgestaltigen Olymp der Bilderschriften ... insbesondere ... Xipe's ... ist unter den eigentlichen zapotekischen Alterthümern nichts anzutreffen. Man fühlt sich deshalb zu der Annahme gedrängt ... die kosmogonischen Darstellungen, sowie der vielgestaltige Olymp ... nicht eigentlich volksthümlich waren, im Zapotekenlande nicht ihre Wurzeln hatten, sondern eine übernommene Kultur darstellen, einer in vorgeschichtlicher Zeit erfolgten Einwirkung der Nahua-Stämme ihren Ursprung verdankten.»[2] In earlier — and, by the way, very sparsely occurring — records of the Zapotecs there is no mention whatever of Xipe. Of the Yopi we have no historical record at all. Seler however adduces an explanation of these mutually antagonistic statements: In Anales de Cuauhtitlan it is recorded that at the time when the Cuauhtitlan dynasty was founded groups of Chichimecs separated from their tribesmen and settled in various parts.[3] Among their new homes Yopitzinco and Acolhuacan are mentioned. The latter is here identical with Texcoco which prided itself upon being of Chichimec origin.[4] Through these migrations certain cultures, e. g. that of Totonacs, were in some degree »Mexicanized».

Although Chichimecs by race, or at any rate strongly intermingled with them, the people of Yopitzinco were among those counted as enemies of the Aztecs. Lively intercourse was, however, from early times established between them. It is therefore possible that it was only by means of the Chichimecs that Xipe came to the Yopi country. As in that region, however, he was given especially ardent worship, he came to be looked upon as a local god.

Seler himself remarks that this explanation is constructional, and he thinks it instead more likely, or even quite probable, that the mere character of the deity in question compelled the Aztecs to ascribe to him a southern origin. The south to them was »Amilpan xochitlalpan», the country of the well-watered fields and the flowers, and

[1] Bauer-Thoma 1916: 93 seq. [2] Seler 1895: 39. [3] Seler 1899: 82.
[4] From Texcoco originates a large clay figure much resembling ours from Xolalpan, a basalt figure in seated posture, and two particularly fine masks of stone (Saville 1929).

181

through this conception Xipe Totec, the harvest god, also became the god of the south-dwelling Zapotecs and Yopis.

The worship of Xipe was spread through large parts of Mexico. He occupied a prominent place in the circle of the Aztec gods. In war, their kings and commanders in chief assumed his dress and attributes. According to Codex Vaticanus A., in 1501 Montezuma I appeared in a dress of that kind in his capacity of being the vanquisher of Toluca.[1] Of this dress it is besides stated by Tezozomoc that it had previously belonged to Montezuma's predecessor, Axayacatl (1469—1482).[2]

Through the instigation of the Spanish priests all accessible images of the ancient gods were destroyed immediately upon the Conquest. Very few of them have therefore been preserved down to our times.

Representations of Xipe, easily identifiable through his grisly garb, have however been discovered in, inter alia — and apart from many places in the Valley of Mexico, and frequently in the Codices — Cholula,[3] Monte Alban,[4] Mitla (among the figures in the fresco-decorated palace),[5] Teotitlan del Camino,[6] Coxcatlan, Puebla,[7] Castillo de Teayo near Tuxpan in Vera Cruz,[8] Cerro Montoso, east of Jalapa in the same state,[9] Jalapa,[10] Michoacan,[11] and Tehuantepec.[12] The fact of Xipe not appearing among the Maya gods is hardly to be wondered at. A certain deity depicted in the Maya codices, and marked down as »F», the god of War and human sacrifices, has however been connected with him. »This is a deity closely related to the death-god A, resembling the Aztec Xipe.»[13] From the Quiché we have however indications of the Xipe cult not being unknown to them.[14] Maler reproduces incised drawings made upon the stucco-covered walls in temples and palaces of Tikal, and among them is found a figure suggestive of Xipe, as well as of a man tied to a sort of frame, while a throwing spear is being hurled at him.[15] But to conclude from this that the Xipe cult obtained in Tikal seems to me somewhat rash. The Aztecs, it may besides be noted, carried the Xipe cult beyond the borders of Mexico. Thus we learn from Spinden: »We have seen that the Otomi also were connected with wearing the skin of flayed victims. In the calendars of Guatemalan tribes the month of Xipe begins the year and this god of the flayed was well-known in Salvador.»[16] Henning sees in a stone figure found at Tazumal, Chalchuapa, in Salvador, a Xipe representation, and cites folklore indicating that the memory of that deity still lives in these parts.[17] Modern dancing masks in Guatemala[18] and Salvador[19] bear witness thereof. Even as far south as Nicaragua the spread of Xipe worship extended. Acting probably under influence from the Nicarao, the Maribio practiced a cult which — although possibly misunderstood in parts — was

[1] Codex Vaticanus A: 128. [2] Tezozomoc 1878: 611. [3] Verneau 1913: pl. 8. [4] Caso 1932: 504; 1932 a: fig. 44; Reh 1934: 151. [5] Seler 1895: 43.

[6] According to Herrera 1720—1736: Dec. 3, lib. 3, cap 15, p. 102, and a figure in the Ethnographical Museum of Berlin. From various sources we learn that Xipe received especially active worship in Teotitlan.

[7] Beyer 1919: fig. 7. [8] Seler 1908: 430. [9] Strebel 1904: pl. 31. [10] Danzel 1923: pl. 43. [11] Thord-Gray 1923: fig. 39. [12] Joyce 1927: 153. [13] Schellhas 1904: 25. [14] Seler 1899: 84. [15] Maler 1911: fig. 10. [16] Spinden 1925: 545. [17] Henning 1918: 10 seq. [18] Termer 1930: fig. 20. [19] Lothrop 1925: fig. 5b.

connected with the classical Xipe ceremonies of Mexico. A detailed description of this is given by Oviedo.[1] It is in very high degree remarkable that one of the rites that were connected with the Xipe cult possessed a near counterpart among the Pawnee Indians of Nebraska. These Indians on certain occasions sacrificed a girl tied to a frame by shooting at her with arrows.[2]

As already has been pointed out, our Xipe figure holds in his hand a typical Oaxaca vessel, fig. 338, and other ceramic finds bear witness of the intercourse that was carried on between Teotihuacan and those regions. Among the Aztecs Xipe is said to have been looked upon as the special god of the goldsmiths. This has been explained by connecting the removed skin of his victims with one of the most important tasks of that guild, namely the manufacture of goldleaf and the covering of objects with sheet-gold. As however the greater part of the Aztecs' gold was obtained from Oaxaca, and as the deity possibly had been imported from that place, it would appear near at hand to suppose that he would be appointed patron of the goldsmiths. No analogies between the flayed-off skins and the over-laying with gold need therefore be resorted to. The goldsmiths probably formed a clan of their own, a union of families of common origin. That even these craftsmen might have been imported from regions where the metal in question had long been worked is a possibility that can hardly be altogether excluded. In the great treasure hoard that in 1932 was recovered from Tomb 7 in Monte Alban was also found an exquisite golden mask of the deity in question. The treasure referred to was however, according to Alfonso Caso, of Mixtec origin.[3]

The statement mentioned in the foregoing that the kind of Xipe sacrifice at which the victim is made the target of arrows was practiced at Tula in the year 1074 is exceedingly interesting. Whether in this case Tula is identical with Teotihuacan or no, is a matter of minor importance. That the Xipe cult appeared at a relatively late date in the Valley of Mexico and neighbouring mountain regions seems to admit of no doubt. Apart from our large figure, which belongs to the Mazapan culture and consequently is of a later date than the classical culture of Teotihuacan, there are representations of the god on clay vessels. These however form part of the metallic-lustred, plumbate ware which undoubtedly is of a relatively late period.[4]

As regards many of the problems that are connected with Xipe, we find — as so frequently is the case in Mexican archaeological and historical researches — statement contra statement, theory contra theory. Obviously, when there are two statements contradicting each other, one of them must of necessity be false, or they may both be false while a third one is correct. What science needs is not theories or subjective speculations, but first and foremost material, fresh material. Mexican archaeological research is, in spite of everything, only just at its beginning, and it is to be expected, and hoped for, that to archaeologists and historians of the future it may be given to travel along paths laid down along surer lines than is the case in our days.

[1] Oviedo 1851—55: vol. 4, 100. [2] Linton: 1922; Dengler: fig. 77. [3] Caso 1932: 512.
[4] Merwin-Vaillant 1932: 80.

APPENDIX 4

THE GEOGRAPHICAL DISTRIBUTION OF EARTHENWARE ROASTING DISHES

As has been mentioned in the foregoing, the bearers of the Mazapan culture used shallow roasting dishes of burnt clay. These dishes were of the same type as those which are still being used in our days, and a visitor to a market place, e. g., in the modern town of San Juan Teotihuacan, will find ample evidence that clay dishes of this description, »tortilla-plates», compete very succesfully with iron plates designed for the same purpose. The roasting dish anciently was, and continues to be, an absolutely indispensable constituent of the simple equipment of the Indian kitchen apparatus. Roasting dishes, in the Aztec language known as comalli, are used for roasting thin cakes of crushed and boiled maize. Cakes of this kind, tortillas (in Aztec, tlaxcalli), substitute bread and still form an exceedingly important staple dish on the Mexican's bill of fare.

So far as I have been able to ascertain, nowhere on the literature is there any mention of roasting plates, or their fragments, having been recovered among artifacts of the earlier cultures in the Valley of Mexico. Vaillant has found tortilla-plates in the uppermost stratum at Gualupita (Gualupita III). He states that »a new shape, the tortilla-plate offers a link with the Aztec and pre-Aztec ceramic groups of Central Mexico». Gualupita III is contemporaneous with the last period of the Teotihuacan culture and the Mazapan civilization.[1] This means that tortillas were unknown to those earlier cultures. Whether this change in the menu took place already in the era of the Teotihuacan culture cannot, as has been mentioned, with certainty be established on the basis of our finds. No positive evidence that roasting dishes were used during the epoch in question was obtained by us.

The Indians of the forest regions on the Atlantic side of Central America do not use roasting dishes. They bake maize, however, in a more primitive way. Of the Bribri Indians it is thus reported: »The paste (of corn) . . . is made into cakes, rolled into plantain leaves, and baked in the ashes»,[2] and a similar procedure was practiced by their northern neighbours.[3] It is thus possible to bake maize without the aid of »roasting plates».

Any attempt at drawing up a sketch map showing the geographical distribution of roasting dishes in Mexico would, for the present, probably be foredoomed to failure. Purely ethnographical works are few in number, and objects of a more trivial character attract as a rule very little interest. In her excellent study of the Mexican (Indian) cuisine, Mrs. Seler-Sachs makes the categorical statement that roasting plates are found in every Indian hut.[4] Her data being as a rule collected from central

[1] Vaillant 1934: 90—91, 121, 127. [2] Skinner 1920: 94. [3] Conzemius 1932: 90; Sapper 1904: 18.
[4] Seler-Sachs 1909: 380.

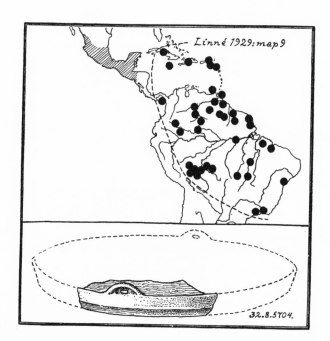

Map 2. Distribution of earthenware
roasting dishes.

and southern Mexico, the distribution in question may be taken to cover those areas, as well as the Yucatan peninsula, Guatemala and Salvador, map 2. The northern limit appears to be vague, and the same applies to the southern. In his magnificent monograph on the pottery of Costa Rica and Nicaragua, Lothrop depicts no objects of this class, but merely makes the brief statement that »plates are rare».[1] Whether roasting plates are thereby referred to, is however not clear.

In South America similar dishes are found, which are used for roasting maize or baking maize bread, for roasting manioc meal or for baking manioc bread. As is apparent from the map, they belong to the group of objects of east-Andean distribution. The manner in which this type of implement came into being is perhaps not so easily determined. In the Pueblo region of the Southwest a similar purpose is being served by stone plates. As eastern South America largely consists of regions extremely deficient in stone, such local conditions may perhaps have necessitated a »translation» of stone plates into earthenware. When in practice the new type proved superior to the old, it is not improbable that the latter fell into disuse. Plates of stone are, however, still being used in certain parts, e. g., by the Taulipang and Palicur, as well as by Indians of British Guiana.[2] Whether in Mexico development has proceeded on the same lines is hard to say. In South America the roasting dish does not appear to possess any great antiquity, and the same seems to apply to Mexico.[3]

[1] Lothrop 1926: 111. [2] Nordenskiöld 1924: map 18. [3] Linné 1929: 159 .

The distribution areas do not appear to be connected, although no certainty is possible on that point, owing to the superficial character of the knowledge that science possesses of a great deal of the archaeology of America. The locality where this important invention was made does not seem possible of determination. Not whether the invention originated in one place, or in several, independently.

APPENDIX 5

THE GEOGRAPHICAL DISTRIBUTION OF THE BLOWGUN IN AMERICA

In connection with the description of the clay pellets recovered in the excavations it was suggested that they had possibly been intended for blowgun projectiles. Evidence of that weapon actually having been in use during the period of the Teotihuacan culture is not likely to be forthcoming. Part of the pellets date from that period while others belong to a later era. According to Lehmann[1], a potsherd — a fragment of a typical Teotihuacan vessel — decorated with a figure of a bird hunter with blowgun is preserved in the Ethnographical Museum (Palais du Trocadéro) of Paris. Both at Zacatenco[2] and Ticoman[3], north of the Mexican capital, Vaillant found pellets of stone and of clay. All of them with the exception of three from the latter place are however too large for having been possible as blowgun ammunition. From the blowgun's geographical distribution in America, as also from historical data, it is apparent that it was of fairly widespread occurrence in Mexico in ancient times, at all events in the Aztec era, and that it was there probably always used with clay pellets.

A great deal has already been written about the blowgun and its distribution. The earliest study of a more detailed character is that made by Friederici.[4] Nordenskiöld has made especial study of the South American blowguns, and thereby not only supplemented, but also corrected, the data of the foregoing[5]. P. W. Schmidt classes this weapon with »Die frei-vaterrechtlichen Kulturkreise (polynesische und indonesische Kultur) in Südamerika»,[6] and even Dixon, who devotes considerable space to the blowgun in his interesting work »The Building of Cultures», looks upon it as an Asiatic culture element.[7] The sketch map here given, map 3, is mainly founded on the authors just referred to, but also supplemented from Central American material. The latter is of special interest in connection with Teotihuacan, because in Central America blowgun ammunition still remains, as it most probably also formerly was, clay pellets.

[1] Lehmann 1933: 73. [2] Vaillant 1930: pl. 39. [3] Vaillant 1931: pl. 81. [4] Friederici 1911: 71 seq.
[5] Nordenskiöld 1924: 59 seq. and map 7. [6] P. W. Schmidt 1913: 1096. [7] Dixon 1928: 121 seq.

The blowgun occurs, and formerly occurred, both in North America and in Central and South America. Its construction varies, and it has developed on different lines, within these regions, as will be apparent below.

In the Aztec religious hymns recorded by Sahagun, mention is made in the fourteenth hymn of blowguns as weapons for bird-shooting.[1] This points to the weapon in question having then long been in use among the Aztecs, for one thing because it had found a place in the world of their religious conceptions, and for another because, according to Seler, the hymns present exceedingly archaic features from a purely linguistic point of view. Without, unfortunately, naming his source Bancroft supplies the extremely important information that the blowgun was the weapon of the Chichimecs, and that it subsequently came into general use.[2] Friederici mentions, on the authority of earlier writers, that the chiefs in various districts of Zacatecas used this weapon in hunting small game.[3]

In Aztec times the blowgun appears to have played a certain part as a weapon. In Alonso de Santa Cruz' map in the library of the University of Uppsala, Sweden, a man armed with a blowgun is seen in action.[4] In his second report to the Emperor Charles V, Cortés relates how Montezuma has made him a present of twelve blowguns and a bag for pellets: »Tambien me dió una docena de cerbatanas, de las con que él tiraba, que tampoco no sabré décir á V. A. su perfeccion, porque eran todas pintadas de muy excelentes pinturas y perfectos matices, en que habia figuradas muchas maneras de avecicas y animales y árboles y flores y otras diversas cosas, y tenian los brocales y punteria tan grandes como un geme de oro, y en el medio otro tanto muy labrado. Dióme para con ellas un carniel de red de oro para los bodoques, . . .»[5]. Bernal Díaz del Castillo also mentions this present from Montezuma, but gives the number of blowguns as three. He writes that Montezuma particularly emphasized that the presents were to be handed to Cortés' overlord, and to nobody else. The blowguns were especially beautiful, set with precious stones and pearls, and inlaid with figures in feather mosaic and mother-of-pearl representing small birds. Of the very greatest interest is that not only did pellet-bags go with the blowguns but also »pellet moulds»: ». . . tres çerbatanas, Con sus esqueros . . . pues las tres çerbatanas Con sus bodoqueras, los engastos que tenian de pedrerias e perlas y las pinturas de pluma y de pajaritos llenos de aljofar . . .»[6]. Oviedo's description strikes a similarly laudatory key, and he, too, gives the number as twelve: »Tambien dió Monteçuma á Cortés una doçena de çerbatanas de las con quél tiraba, muy hermosas, porque eran todas pintadas de muy exçelentes pinturas é perfettos matiçes, en que avia figuradas muchas é diferençiadas maneras de aveçicas é animales é árboles é flores é otras diverssas cosas é fantasias.»[7] But the blowguns, like the rest of Montezuma's presents on that occasion, never reached their destination. The ship that was to carry the gift to Spain being instead captured by the French pirate Florin.[8]

[1] Seler 1904: 1060, 1068. [2] Bancroft 1875—76: vol. 2, 411. [3] Friederici 1911: 71. [4] Dahlgren 1889. [5] Cortés 1866: 101. [6] Díaz del Castillo 1904: vol. 1, 340, 341. [7] Oviedo 1851—55: vol. 3, 299. [8] Friederici 1911: 71.

All the way from central Mexico to the Isthmus of Panama clay pellets were anciently used for projectiles in blowgun-shooting. Thus the scope of their employment was very limited, being mainly confined to the shooting of small birds. From modern times I have been unable to find any data concerning Central Mexico but, judging from certain vague statements, the use of blowgun and pellets would appear to survive to this day in certain places as a toy. Vaillant however mentions that »Professor M. H. Saville and Mr. Miguel Mendizabal have both reported the use of clay balls in blowguns in Oaxaca.»[1]

Among the Mayas, blowguns are still in use. Sapper mentions them from the Kekchis, and supplies the information that the ammunition, pellets of clay, are parched on roasting-dishes over a fire in order to »temper» them.[2] The pellets are kept in special closely-woven bags. To each bag is attached a bone of fowl or turkey, open at one end. These bones served to calibrate the pellets correctly and to give them a fine rounded shape. Among the Quiché the blowgun was in use, and, judging from the very frequent mention of this weapon that is found in Popul Wuh, its use must have been universal. In many places it is even stated that every man carried his blowgun across his shoulder. The projectiles consisted of clay pellets. The principal employment of these appear, according to Popul Wuh, to have been for bird-shooting, as there are several passages in which it is stated that they were used, or had been used, for shooting birds.[3]

In Yucatan the blowgun was in use during the 16th century, as stated by J. E. Thompson, who cites authority, and still survives as a toy.[4] Also in that region it was used for bird-shooting in ancient times. In the folklore of San Antonio, southern British Honduras, the blowgun, according to Thompson's notes, plays an important part.[5] Dieseldorff has noted down tales among Indians living at Coban who were descendants of the Cocomes, once the ruling family of Mayapan, who subsequently were expelled from that place. In one of these tales, which in almost identical form is cited by Thompson from Honduras, the blowgun is referred to as a weapon for bird-shooting.[6] The only existing detailed description of the blowguns of the Mayas seems to have been written by Thompson: »The blowgun used by the Kekchis and Mayas of the Toledo District ranges from four and a half to six and a half feet in length. The wood from which it is constructed is known as komoltše. A section of wood is chosen and placed under water in the river. It is left there till the soft inner core rots away. A dab of chicle gum serves as a sight. The missile is a small pellet of baked clay, which is placed in the blowgun by means of a piece of hollowed bone. Sometimes hard seeds are employed instead of the clay pellets. The blowgun is useless for shooting anything except birds.»[7]

The blowguns of Central America all appear to bear mutual resemblance, although, e. g., lack of suitable material may compel the evolution of forms such as that among

[1] Vaillant 1934: 98. [2] Sapper 1903: 53. [3] Pohorilles 1913: 11 seq. [4] J. E. Thompson 1930: 88.
[5] J. E. Thompson 1930: 120—128. [6] Dieseldorff 1926: 5. [7] J. E. Thompson 1930: 88.

the Cunas, whose blowguns are composed of several tubes of slightly varying diameters, joined together so as to attain the correct length. Among all the rest of the tribes the blowguns are in one piece, generally about 2 metres in length, and of comparatively large calibre. Also in Central America blowguns are exclusively used for shooting small birds. The hunter's equipment always includes a bag, often divided into two compartments, one for keeping the pellets and the other containing clay for making fresh ammunition. From the bag are suspended two pieces of bone. One of these serves as a »ramrod», while the other, which is cut obliquely, is employed in the shaping of the »bullets».[1] Both of these bones are from a monkey. The »ramrod», the bigger of the two, is on occasion used in the removal of a pellet that has stuck fast. It is dropped down the tube, and by its weight is made to knock out the jammed projectile.[2] In Central America the pellets frequently do not appear to have either been baked, or »tempered» over fire. The Cunas of Panama are the southernmost Central American tribe to employ clay pellets with blowguns. With them, in these days the weapon mostly occurs as a toy. Among their neighbours, the Chocó Indians, blowguns on the other hand play an important part. Here the blowgun is of a South American type, and they make use of an exceedingly powerful cardiac poison, obtained from a tree called pakurú-neará, which became known to science through Nordenskiöld's expedition in 1927.[3]

It is remarkable that the Colorados of Ecuador shoot with clay pellets, while the Chocó and the Cayapa,[4] two tribes settled between them and the Cunas, employ poison-smeared darts. From the Peruvian coast no instances of blowguns are known, neither have these weapons, nor any darts, been discovered in graves. A piece of painted cloth originating from Pachacamac and preserved at the Ethnographical Museum of Berlin, beyond any kind of doubt represents a man using a blowgun. For various reasons the ammunition may be supposed to have consisted of clay pellets. Blowguns with clay-pellet ammunition thus occur — or have earlier occurred — from Mexico to Peru. Both the Chocó and the Cayapa have in all probability only in later times either themselves penetrated down to the Pacific coast, or obtained from the east the highly developed blowgun shooting poisoned arrows. Although the piece of textile from Pachacamac dates from the pre-Inca period it must, judging by everything, belong to some later coastland civilization.

To the South American blowgun east of the Andes, Nordenskiöld has devoted particularly thorough study both as regards its »anatomy» and its distribution. It occurs in the western portion of the Amazonas draining system and on Rio Orinoco and its tributaries. In these regions the blowguns have reached an exceedingly high development and constitute magnificent proofs of the inventive power and manual skill of the forest Indians. Certain details of construction, modifications and improvements are only met with within this region and therefore must have originated

[1] Bovallius 1885: 195 and fig. 15; R. M. 1885. II. 34—38. [2] Gabb 1876: 516.
[3] Santesson 1931. [4] Barrett 1925: 111 seq.

here. Of their kind, these weapons may be said to have attained the highest perfection. The principal cause and incentive of that high development is to be found in the improved ammunition, that is to say, the poisoned dart. The terrible poison known as curare — which is obtained from certain Strychnos species — is of speedy action, and it is only hereby that the weapon gains real importance as a hunting weapon. It is only from one place, Rio Jurua, it is reported (in 1775) that the Indians occasionally employed clay pellets instead of darts. This probably happened on occasions when for some reason poison was not available. Nordenskiöld has shown that the knowledge of curare was considerably less distributed among the Indians of the 16th century than it is in our days, and that consequently the rapid advance of the blowgun through the forest communities is a post-Columbian feature.[1] It is natural that its distribution will be ruled by the presence of suitable material for the manufacture of tubes and poison, but this limitation does not by itself explain the absence of the blowgun in eastern South America and the West Indies. For even beyond territories that are rich in the requisite raw material the blowgun may occur because there is evidence to show that a lively trading intercourse spanning wide areas once existed.[2] The absence of the blowgun also on the upper reaches of Rio Xingú is another indication of its spreading in a relatively late period. Those Indians had at the time when first visited (by Karl von den Steinen in 1884) an archaic civilization, only in a slight degree influenced by later Indian cultures.

In North America the blowgun plays an unimportant part, and such has probably always been the case. It is made of cane (in the South) or wood, e. g. elder stalks (the northern Iroquois). The blowguns may be as long as from 2.5 to 3 m. »The darts used in both types of blowgun were made usually of strips of cane ranging from 10 to 20 inches long, steamed and twisted into a screw-like form to prevent warping. These were permanently feathered, or rather tufted, with thistle-down or similar material tied on spirally, in which respect North American blowgun darts differ from those of South America, in which region the tufting material (usually cotton) that serves as a »gas-check» is wrapped about the dart just before placing it in the tube.»[3] On account of the inferior striking effect of the darts, the blowgun is only used for shooting small game, chiefly birds. Strangely enough there is employed in the southeastern woodland area of U. S. A., apart from a tube of cane — which is the rule — a blowgun construction similar to the one that is most widespread in South America. The tube is composed of two longitudinal halves which are fitted together subsequently to a groove corresponding to one-half of the bore having been cut out of each.[4] It is probable that this method of manufacture, which implies advanced tools, has come into use only after connection with the whites had been entered into. Their resemblance to the European cowherd trumpets is besides striking. These long wooden trumpets are, like the blowguns, constructed by joining together two halves which are wound with bast (or bark). These »lurs» were formerly used in all parts of Europe.

[1] Nordenskiöld 1924: 52 seq. [2] Nordenskiöld 1930: 135. [3] Hodge 1922: 73. [4] Hodge 1922: 72.

An improved form of a superior kind is known from the Chitimacha. They tied to-gether from 5 to 11 tubes of equal length and calibre in the way it is done in the pan-pipes. By means of this they could open quick-fire, and this soundless and smokeless weapon must be considered a good type of a primitive multi-barrelled breechloader.[1]

The question of the origin of the American blowgun has occupied many students of culture. Besides the New World there are blowguns in southeastern Asia. As has already been mentioned, P. W. Schmidt has classed the weapon with »Die frei-vaterrechtlichen Kulturkreise (polynesische und indonesische Kultur) in Südamerika». Dixon says that when coca-chewing, plank canoes, tie-dyeing, terraced irrigation, pan-pipes and blowguns are »all traits wide-spread in the western Pacific and south-eastern Asia, how can you deny that their occurrence is due to diffusion, or believe for a moment that so many similar and parallel inventions could take place? The challenge is a formidable one. Is there anything that can be said in reply?»[2]

For reply I only wish to quote a passage in Nordenskiöld's last work. Surely no one can deny that this study of his is the most exact and critical that so far has been made of the problem whether cultural influence in America emanated from southeastern Asia. It is here viewed from American ground and without any preconceived opinions. Nordenskiöld says: »These (culture elements) we may call 'Oceanian', although this certainly does not imply any proof that they have been imported into America from Oceania».[3] Among these about 50 culture elements he also includes the blow-gun. It should also be emphasized that in Indonesia the blowgun only occurs in a restricted area and that there it cannot compete either in frequency or technical de-velopment with its American counterpart.

The American blowguns are found in three separate geographical areas of distrib-ution. As will be appa ent from the foregoing, there are considerable divergencies both as to the construction of the tubes and the ammunition and as regards material. In Mexico, Central America and down to Peru we find plainly made, short blowguns, and projectiles of clay. The weapon is of great age, at any rate within and south of this area. In the western and northern portions of the South American forest region: highly developed tubes and poisoned darts; increased distribution in post-Columbian times. In North America there is a limited distribution area in the east. The pro-jectiles here consist of poisonless darts.

For my part I am not at all convinced that the blowgun was introduced into America from southeastern Asia, nor that it was only once invented in the New World. Maybe we can accept as a fact that a connection existed between Peru and Central America, although it is far from possible to prove that Thompson is correct when he says that »in all probability the blowgun was introduced into the Maya area from South Ame-rica».[4] That this distribution area is nowadays isolated does not prove it to have been so in the past.

Whether the blowgun reached the east-Andean forest Indians from the coastland

[1] Friederici 1911: 71. [2] Dixon 1928: 206 seq. [3] Nordenskiöld 1931: 16. [4] J. E. Thompson 1930: 88.

in the west, or whether it spread in an opposite direction, or whether it originated independently, are alternatives that appear impossible of being proved. Sayce does not consider the first alternative as being altogether out of question, but he adds: »But the distance of the blow gun from the west coast does increase the possibility of its independent origin».[1]

How then, when all is said and done, is the occurrence of the blowgun in eastern North America to be explained? From the West Indies, which might have served as stepping stones, we have no evidence of it, and thus there would only remain the possibility of its having spread from Mexico. But apart from the circumstance that the North American blowgun-users employ darts — and these darts being of a peculiar construction — they have in the manufacture of the tube greatly surpassed the Mexican makers in the matter of technique.

Tubes there are that serve other purposes, e. g. the drinking tube, which is a very ancient culture element. Medicine-men employ tubes of very considerable dimensions, e. g. in magical treatment of the sick.[2] Among the Hopi in the Southwest, where the blowgun as a weapon has never occurred, tubes are used in certain ceremonies to blow feathers to the cardinal points. It therefore appears possible to me that the blowgun may have been independently invented and developed in different parts of America.

As Nordenskiöld has shown, the Indians were inventors of no mean order, and not less than 54 Indian culture elements — partly of fundamental importance — were thus unknown in the Old World.[3] It is therefore a perfectly obvious thing that the Indians quite well may have made inventions that earlier, or even later, independently came into being in other parts of the world.

[1] Sayce 1933: 264. [2] Nordenskiöld 1928: fig. 47. [3] Nordenskiöld 1930: 23 seq.

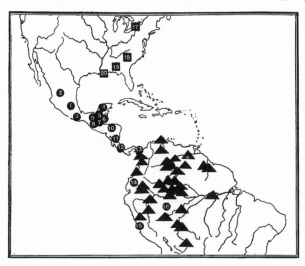

Map 3. Distribution of blowguns.

● Blowguns with clay-pellet ammunition.

■ Blowguns with unpoisoned arrows.

▲ » » poisoned arrows; Nordenskiöld 1924: map 7.

APPENDIX 6

POTTERY-MOULDING TECHNIQUE

In the foregoing an account has been given of the recovered earthenware moulds in which figures, etc., were moulded. So far as I know, no synoptical account with any pretension to completeness has ever been published on the use and distribution of these objects in America. The subject is an interesting one, and deserving of exhaustive study, but here I shall restrict myself to a few observations and the bringing forward of some material.[1] For the purpose of a closer study it should be possible to add very considerably to the latter.

By the expression »pottery-moulding technique» is meant the use of moulds for the manufacture of pottery, clay figures and other ceramics. This technique, which must be looked upon as an incipient stage of industrialisation, was known both in Mexico and Central and South America, cf. map 4. The moulds would appear always to have been made of clay, but — dependent on their different purposes — varied exceedingly as to size.

[1] Cf. Linné 1925: 81 seq.

From the Peruvian coast there are moulds for the manufacture of vessels of various types, and figures. These were moulded in two halves, subsequently joined together. The front part was made in one mould and the back part in another. Even smaller figures always appear, in this case, to have been made hollow. In Piura, Jijón y Caamaño, according to information kindly supplied me by Professor Max Uhle, has recovered moulds for very large vessels. From Pacasmayo, Chancay and Pisco there are moulds for clay vessels as well as for facial urns and figurines preserved in The Ethnographical Museum of Berlin. A collection of moulds from Chancay, which is preserved in Linden-Museum, Stuttgart, numbers about 150 objects and also includes specimens of respect-inspiring proportions. Some of them were intended for the manufacture of plain vessels. But also from Santiago de Tuxtla, in Mexico, there is a mould for making clay figures of considerable dimensions.

On the Peruvian coast, moulds that were intended for the manufacture of vessels in the shape of various fruits were moulded directly on the fruit it was meant to reproduce. In a study of cultivated plants recovered in pre-Spanish graves, Safford has recovered this interesting procedure, by which it may be possible to explain — at least theoretically — the origin of moulds.[1]

The moulds that are most commonly occurring are however those used for making heads and figurines, but in use were also moulds for the manufacture of minor details of decoration, spindle-whorls, stamps, feet for clay vessels, etc. The latter is the case with the majority of the Mexican moulds while those from Central America and the coastland of Ecuador only appear designed for moulding heads and smaller figurines. The sole find from Tiahuanaco consists of a very small mould for making heads. Moulds for spindle-whorls have been recovered, inter alia, from Cerro de Culebras (Misantla) and Colhuacan. In the spindle-whorl the bottom side is often undecorated, and, after having been approximately formed, the whorl was pressed into the mould. It was thereupon given the necessary trimming, and a hole bored for the spindle. As will be seen in figs. 234 and 236 there are spindle-whorls in which the plane bottom side is decorated. This has occasionally been done either with a second mould or with a stamp. From Colhuacan, the Ethnographical Museum of Berlin possesses a very interesting and richly varied collection of moulds. They are designed for the making of stamps, tall, conical and decorated legs of clay vessels, and spindle-whorls.

A large proportion of the spindle-whorls, both from Las Palmas and Xolalpan, have been manufactured by means of moulds. Part of them were standardized, both as regards form and decoration. A specimen identical with fig. 233 was recovered at Colhuacan (Mrs. Helga Larsen's collection, Mexico D. F.) and another is published by Beyer.[2] Among illustrations made by Strebel — not published, and in my possession — is the reproduction of yet another similar spindle-whorl from Coatlichan, near Texcoco. The whorls just referred to naturally need not have been

[1] Safford 1917: 14—18. [2] Beyer 1920: pl. 14.

manufactured in the same locality. It would be interesting, in a case like this, to carry out analyses in the same way as Beskow has done with ceramics.[1] Neither does it necessarily follow that two identically similar moulds that have been recovered at different places derive from the same place of origin, because, e. g., one of them may have been moulded over an object made in the other mould, or both may have been manufactured by aid of some object that was moulded in a third mould. The manufacturing of a mould is no doubt somewhat more difficult than the using of it, and it is not impossible that in ancient Mexico the same conditions were found as to this day prevail in China. In that country moulds are sold in the market places, for the manufacture of toys, in particular.

Moulds are still being used by the modern inhabitants of Teotihuacan for the manufacture of heads and decorative details on clay vessels especially made for sale to tourists. That such objects are of quite modern date even the veriest tyro would doubtlessly be able to verify. On earlier occasions, at any rate, there have at different places both in Mexico and Peru been produced »antiquities» in moulds especially made for the purpose. Frequently these sham articles are exceedingly clumsy, while in cases they may be very plausible indeed. When manufactured of the same clay as genuine archaeological finds, and fired by the same, or a similar, method, the science of mineralogy, whose microscopical analyses generally speaking are decisive, will stand outwitted.

The technique of pottery-moulding had attained a high degree of perfection both on the Peruvian coast and in Mexico. Whether it had grown up on a common foundation, or independently originated and been perfected in both places, appears impossible of determination, at any rate up to the present. The latter alternative appears however to carry the greater probability. It is not likely that cultural interchange between the two regions had taken place to any appreciable degree. Neither does any continuity exist as regards the distribution of the moulding technique, because the finds of the Ecuadorean coast, which are intimately connected with southern Central America, date from a late period, and most certainly cannot have influenced the highly developed ceramic art of the coastland in the south.

It would be of the greatest importance if in the one or the other of these regions greater antiquity could be established, but this seems hardly possible on the basis of the material hitherto available. According to what Dr. S. K. Lothrop has kindly told me, moulds »do not appear in Central America until the end of the Maya Old Empire. They seem to be very much more ancient in Peru.» This statement does not, however, quite agree with Tozzer's finds at Nakum, which is a town belonging to »the great period of the Old Empire». Even the Lubaantun finds indicate great age. Joyce says: »The very close correspondence of the art, as shown in the mould-made pottery, with that of the Early Empire sites of Copan, Quiriguá and Palenque, suggests that the site of Lubaantun flourished in the Early Empire.»[2] Further on

[1] Beskow 1929. [2] Joyce 1926: 230.

he also says: »In addition to the mould-made figurines, which can certainly be dated as belonging to old Empire times.»[1]

The intensive and multifarious application of pottery-moulding technique in Mexico also seems to speak in favour of its being very ancient in that region. In variety of application more restricted, although quantitatively by no means less employed, was the method of pottery-moulding in Peru, and from a purely technical point of view the mould-made pottery of the Peruvian coast may well be regarded as unsurpassed. The safest thing therefore seems to be, before further finds are made — above all such as are definitely dated — to leave open the question whether Mexicans or Peruvians could claim the credit of first having employed moulds in the technique of potterymaking. That the invention in question was independently made in both these regions appears, as already mentioned, most probable.

[1] Joyce, Cooper Clark, and Thompson 1927: 312.

Table to map 4.

THE GEOGRAPHICAL DISTRIBUTION OF CLAY MOULDS

1	Teotihuacan	Fig. 199—208.
2	Azcapotzalco	Nationalmuseet, Den etnografiske samling, Köpenhamn.
2	Colhuacan	Museum für Völkerkunde, Berlin.
3	Cholula	Seler 1890 a: 117; Musée d'Ethnographie, Paris.
3	Tepeaca	Beyer 1920: 171.
3	Matamoros Izúcar	Beyer 1920: 171.
4	Mixtecs	G. M. 23. 6. 311.
5	Zapotecs	Seler 1890 a: 140.
6	Rio Panuco	Staub 1921: 55.
7	Posa Larga	Ellen S. Spinden 1933: 268.
7	Espinal, Rio de Tecolutla	Ellen S. Spinden 1933: 268.
7	Cerro de Culebras, Misantla	Strebel 1889: pl. 8.
7	Cerro del Cojolite	Strebel 1889: pl. 29.
7	Atotonilco Quimistlan	Strebel 1889: pl. 32.
7	Cerro Montoso	Museum für Völkerkunde, Berlin.
7	Pilón de Azúcar	Museum für Völkerkunde, Berlin.
8	Papaloapam Basin, Vera Cruz	Weyerstall 1932: 45.
8	Santiago de Tuxtla	Krickeberg 1925: fig. 44.
9	Jaina	Museo Arqueologico, Mérida.
10	Labna	Edward H. Thompson 1897: pl. 11.
11	Corozal, Santa Rita	Gann 1900: 689.
12	Lubaantun	Gann 1925 a: 149; Joyce 1926: pl. 26; 1927: 98;
13	Coban	Seler 1908: 608.
13	Chuitinamit, Lake Atitlan	Lothrop 1933: 97.
14	Rio Salinas	Spinden 1913: pl. 17.
14	Nakum	Tozzer 1913: 190.
15	Northwestern Honduras	Lehmann 1910 a: 127.
15	Copan	Tulane University, New Orleans.
16	San Salvador	Lothrop 1927: fig. 23.
17	Nicaragua	Lothrop 1926: fig. 282.

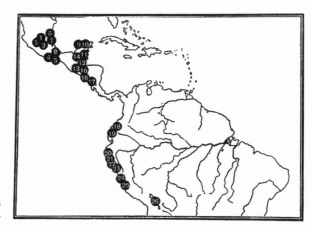

Map 4. Distribution
of clay moulds.

APPENDIX 7

BARK-BEATERS AND PAPER MANUFACTURE

Although it has been stated by Walter Hough that »the beating stones are among the commonest of Mexican antiquities»,[1] there were recovered, as has been mentioned, at Las Palmas and Xolalpan no more than a total of eleven bark-beaters of stone, six of which were intact and four fragmentary, and in addition one, or possibly two, toys of this shape.

León depicts, in association with ordinary fluted bark-beaters (besides one which is patterned), some stone implements of flatiron shape.[2] These were supposed to

[1] Hough 1899: 789. [2] León 1924: 103 and figs. 3—5.

have served as »burnishers» with which the pounded fibres were »ironed» for smoothing out uneven portions of the paper sheet in the making: »Finalmente, con otra piedra hecha ad hoc se frota la superficie de las fibras para uniformar el grosor de la hoja de papel.» A figure, previously published by Starr, representing a woman using a beater of ordinary type on pieces of bast or fibre spread out on a flat board, is reproduced by León. He has however modified the implement into a flatiron-like »burnisher». Nowhere in literature outside of León's treatise is any mention to be found of such a kind of smoothing stones. Only Hernandez, whose description of paper manufacture is cited in the following, mentions anything about burnishing or smoothing. The statement just referred to therefore does not appear to me as supplying sufficient ground for classing as implements for paper manufacture the flatiron-like implements that were recovered by us. Some of these objects are moreover on their sides heavily incrustated with lime. They are besides so much worn down that they must have been used for some different purpose, e. g. for smoothing plastered walls and floors.

Already in connection with the account of the finding of the bark-beaters it was mentioned that they had undoubtedly been fastened to a handle of the type shown in map 5 (this implement originates from Celebes). It is true that Starr depicts an Otomí woman beating bark paper, who, judging from the picture is holding the stone directly in her hand without using a handle.[1] The wear in the edge-groove of archaeologically recovered bark-beaters proves that they were not used that way in ancient times. He also depicts two modern beaters and remarks that they are too small for a European hand but of a size suitable for the hand of an Indian woman. Of an ancient bark-beater he, however, remarks that »the corners are notch-grooved for finger-holds, or for passage of lashings for a handle».[2]

In comparing modern with ancient beaters, Starr makes the following reflection: »These old beaters — larger and better made than the modern — suggest a question: Is it not probable that the old industry was *man's* work? Conservative woman has clung to it, and with tools, in size better adapted to her handling and quality showing the lessened importance of her art, still beats out the paper now used only in religious or superstitious ways».[3] It is of course far from improbable that anciently the manufacture of paper was men's work, but the lesser dimensions of the modern tools can hardly be cited in proof, seeing that in pre-Spanish times beaters were undoubtedly fitted with handles.

The resemblance — or rather points of agreement — existing between American and Oceanian beaters is so exceedingly marked that it has been advanced as a piece of evidence of cultural exchange between these so widely separated regions.[4]

[1] Starr 1900: 303. [2] Starr 1900: 307. [3] Starr 1900: 308.

[4] Nordenskiöld 1930: 14: »From the bark of certain trees the Indians manufacture bast cloth, but as similar manufacture is also known from Oceania, it cannot definitely be asserted that in this case the Indians have made an entirely independent discovery. Similarity between the implements used within and outside America in the preparation of bark cloth even speaks against such a supposition.»

American bark-beaters are mainly of two types, viz. stone beaters of the kind described above, where a special handle is required, and wooden mallets with a multi-grooved striking face. To these may be added a few irregular forms: beaters that are grooved on one side and on the other decorated with a head in relief,[1] and similar implements among the Indians of the northwestern coast of North America. These latter categories are unimportant in this connection.

As seen in map 5, the above two types cover entirely different areas of distribution. The wooden beaters (mallets) belong to the Amazon forest region and are besides found among the forest-dwelling Indians of the Atlantic coast districts of Central America. Culturally, however, these Indians are most nearly connected with South America. In the remainder of Central America and in Mexico stone beaters are almost exclusively met with. As in the present connection we are only concerned — except for the Otomí Indians, to be referred to below, and the Lacandones — with archaeological finds, it is however not altogether impossible that even in the regions just mentioned the use of wooden beaters in ancient times obtained to a not inconsiderable extent. In Celebes both stone and wooden beaters occur side by side.[2] While in South America bark-beaters were exclusively used in the manufacture of bark-cloth (the respective distribution areas coincide, as is apparent from Nordenskiöld 1924: maps 28 and 30), their Mexican counterparts were predominantly used as tools for manufacturing bast paper.

Very valuable studies and researches regarding the original paper manufacture among Mexican Indians in ancient and modern times have been carried out by Valentini,[3] Starr,[4] and Schwede.[5] In his exceedingly interesting study of the paper contained in Maya codices, Schwede has compiled a tableau of the earliest recordings of ancient Mexican paper and paper manufacture, a collocation which however might be capable of amplification. The earliest mention of Indian »books» is found in Martyr who, among other things, relates that they were manufactured out of the bast of certain trees. Francisco Hernandez, Motolinía and López de Gómara, as also later authors like Boturini and Lorenzana, state that the paper of the Mexicans was made of agave (maguey) leaves. As late as 1580, paper from maguey was still being manufactured at Colhuacan, near the Mexican capital, and large-scale fabrication was carried on in the years 1570—75 at Tepoztlan, according to Hernandez.[6] León gives a fairly extensive list of plants and trees, the fibre, bast or bark of which were used in the manufacture of paper.[7]

As will be seen from Schwede's investigations, account of which is given below, the paper of the codices appears as a rule to have been made exclusively from the bast of plants of the genus Ficus. This is no doubt because from this material can be produced paper of far better quality than is possible from agave fibre. In a subsequent era, in which those early authors collected their data, less importance was attached

[1] Seler-Sachs 1916: pl. 28.　[2] Adriani en Kruyt 1901.　[3] 1881.　[4] 1900.　[5] 1912 and 1916.　[6] León 1924: 102.
[7] León 1924: 101.

to quality, suitable Ficus material probably being difficult to obtain while agave was both easily accessible and abundant.

Hernandez also gives a detailed description of papermaking from the bast of »Amaquahuitl seu arbor papyri». Of this, Schwede supplies the following translation: »Danach wurden dickere Äste von den Bäumen geschnitten und über Nacht zum Erweichen in fliessendes Wasser gelegt. Am folgenden Tage wurde die Rinde abgelöst und nach dem Abschälen der Aussenrinde durch Schlagen mit einem flachen, durch einige Furchen gestreiften Steine ausgebreitet. Die auf solche Weise erhaltene (Faser-) Substanz wurde in Streifen geschnitten, welche, mit einem anderen noch flacheren Steine aufs neue geschlagen, sich leicht miteinander verbanden. Dann wurden sie geglättet und endlich zu Papierblättern geformt.»[1] This tree, »Amaquahuitl», elsewhere in the same work called »Amatl», appears from the description to have been a species of Ficus.

By his extremely exact and genuinely scientific analyses Schwede has established that the Maya codices have for their material bast of one or more Ficus species, and this also applies to the Aztec and other Mexican codices with the exception of one (No. 9 of Humboldt's Aztec picture-writings in the Berlin library) which is made from agave fibre.

In his microscopic examinations of Mexican paper — other than the Maya codices, that is — Schwede further found that »Diese Zerstörungserscheinungen lassen auf die Anwendung eines mechanischen Verfahrens bei der Isolierung der Fasern schliessen».[2] This mechanical process he considers to be identical with that described by Hernandez.

Thus everything seems to favour the supposition that the stone beaters that have been archaeologically recovered in Mexico were used in papermaking. The original manufacturing method has however survived down to our time.

Quite in accordance with this, in his excellent work on Mexican ethnography Starr gives the following description of papermaking among the Otomí Indians: »The art of beating paper from bark survives in many of these Otomí towns. San Gregorio (District Tenango, Hidalgo), Xalapa (District Zacualtipan, Hidalgo), San Pablito (Mun.° Pahuatlan, Puebla), and Ixtololoya (Mun.° Pantepec, Puebla) are towns where the art flourisheds. At San Pablito two kinds of bark are used: *moral* gives a whitish, *xalama* a purplish paper. The bark is best gathered when full of sap, but is kept after drying. A board is used for a foundation on which to beat. A stone approximately rectangular and generally with the corners grooved for convenient grasping is used for a beater. The bark is carefully washed in lyewater, taken from maize that has been prepared for *tortillas;* it is then washed in fresh water and finally boiled until it shreds readily into slender strips. These are arranged upon the board — first a boundary line for the future sheet of paper is laid out and then strips are laid near together lengthwise within this outline. They are then beaten

[1] Schwede 1912: 8. [2] Schwede 1916: 39.

200

with the stone until the spread fibres are felted together. The sheets are dried in the air, folded, and done up in packages of a dozen, which sell for three *centavos*. The work is done by women and usually in the houses with a certain degree of secrecy. The sound of the tapping of stones is, at certain times, to be heard through the whole village. . . . There is a large demand for this paper. It is not used, either for wrapping or for writing, but only for *brujeria* and ceremonies.»[1] Among the Lacandones paper is only manufactured for ceremonial uses. Thus we learn from Tozzer that »strips of bark pounded out thin over a log by means of a grooved stick are a frequent offering to the gods».[2] The Mayas, however, formerly manufactured also clothing out of bast-cloth, an art which has survived in certain places almost to our own days.[3] In this they undoubtedly made use of the stone beaters that have been discovered within their area. As has already been pointed out, it is not impossible that wooden beaters were also employed. The Lacandonean variety is besides exactly similar to the South American. In »Documentos inéditos del archivo de los Indios» Friederici has found it stated the clothes of the Mayan priests were made of bark-cloth.[4]

According to the Spanish chroniclers, paper was consumed on a very large scale in ancient Mexico. The Aztec tribute rolls include immense quantities of this article to be delivered by the subject tribes to their Aztec rulers. Paper was used not only for writing on, but was in increasing degree applied to ritual customs, offerings, decoration of images of gods and temples, etc. In Sahagun — that inexhaustible source of knowledge as regards ancient Mexico — detailed account is given of the employment of paper for dresses of deities and in the religious ceremonies.[5] He refers to the considerable trade that was carried on in paper, its different colours, qualities, etc.[6] It is remarkable that this peculiar application of paper has survived to our times among the Otomí, from whom Starr gives valuable accounts of ceremonies where paper is used.[7] As the employment of paper for making books presupposes a highly developed civilization, and as, so far as we know, only very few of the peoples were thus qualified, it may be presumed that far from all stone beaters recovered in Mexico were used in book-paper manufacture. As to whether the use of paper in ritual observances is an ancient custom does not seem possible of determination. There is much that points to this not having been the case. The book, as such, is a magical object — the Cuna Indians, for example, burn leaves out of bibles and use the ashes for medicine — and it then comes natural to suppose that the material of which books are made, the substance which so to speak stores up the magic, is put to ceremonial use. It has been supposed that the art of papermaking was spread by the Toltecs, but no evidence is available in support of this theory.

The bark-beaters originating from the mountain regions may therefore at least in

[1] Starr 1901: 81—82. [2] Tozzer 1907: 129. [3] J. E. Thompson 1930: 98. [4] Friederici 1906: 303.
[5] e. g. Sahagun 1927: 33 seq. »Tracht und Attribute der Gottheiten.»
[6] Sahagun 1890—96: vol. 3, 279. [7] Starr 1901: 82—83.

part be presumed to have been employed in the manufacture of paper. On account of the altitude Ficus species supposedly played a less prominent part, the raw material probably being taken from maguey. In Zelia Nuttall's »Official reports on the towns of Tequizistlan, Tepechpan, Acolman, and San Juan Teotihuacan ... in 1580» there is frequent mention of clothes made of »agave fibre». Whether by this refers to clothes woven from agave fibre or whether the fibre was treated in the same way as the South American bark-cloth, that is to say converted into some sort of paper-cloth, cannot however be determined. That the agave fibre was spun is however not quite certain, as it is stated, e. g., that the people of Tepechpan supplied their chieftain with clothes of cotton and »clothes for wearing worked with rabbits' wool».[1] Like the Teotihuacan people they possibly obtained their cotton from »the region of Panuco».[2] The spindle-whorls that have been archaeologically discovered are of exceedingly varying size. While the smaller ones are well suited for spinning cotton, the large and heavy ones would be equal to spinning such a comparatively intractable material as agave fibre. A pottery fragment recovered at Xolalpan exhibited distinct impressions from some textile material, which on good grounds may be supposed to have been vegetable fibre, cf. p. 109. Sahagun also makes mention of maguey thread.[3] Hernandez however suggests that paper, or bark-cloth, to some extent was also used for making clothes.

The rectangular or oval bark-beater of stone may possibly have developed from club-shaped beaters of the same material. Such beaters are known, inter alia, from Oaxaca, Vera Cruz regions, Quirigua, Nicoya and the Cauca valley in Colombia.[4] The beater fitted with a flexible handle not only marks the final stage of a course of evolution, but also constitutes a tool which is perfect of its kind. Without metals and the aid of machinery no further development in this sphere is thinkable. This is probably the reason why beaters from different periods and localities are all practically of the same type; whether they are rounded or more or less rectangular in shape being an unessential matter.

[1] Nuttall 1926: E. g. p. 64. (Acolman) »To their native lords they had formerly paid, as tribute, a load of coarse agave-fibre cloths, twenty in a load, and another load of thin agave-fibre cloths; a load of women's shoulder capes of thin agave-fibre; a load of petticoats of the same» ...
[2] Nuttall 1926: 79. [3] Sahagun 1890—96: vol. 3, 274. [4] Lothrop 1926: 99.

Table to map 5.

THE GEOGRAPHICAL DISTRIBUTION OF BARK-BEATERS

1	Teotihuacan	E. g. figs. on map 5.
1	Tenochtitlan	Batres 1902: 24.
1	Coatlichan, Texcoco	G. M. 23. 6. 109—110.
2	San Gregorio, Dist. Tenango, Hidalgo	Starr 1901: 81.
2	Xalapa, Dist. Zacualtipan, Hidalgo	Starr 1901: 81.
3	San Pablito, Municipio Pahuatlan, Puebla	Starr 1901: 81.
3	Ixtololoya, Municipio Pantepec, Puebla	Starr 1901: 81.
4	Huaxtec-territory	Staub 1921: 45; 1925: 16; Seler-Sachs 1916: pl. 28.

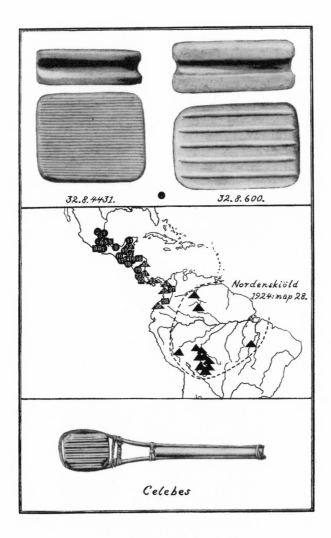

32.8.4431. 32.8.600.

Nordenskiöld
1924: map 28.

Celebes

Map. 5. Distribution of bark-beaters.

▲ Wooden beaters (mallets).

● Stone beaters.

■ Club-shaped beaters of stone.

APPENDIX 8

RASPING BONES

In the foregoing it has been pointed out that a bone, recovered at Las Palmas, with transversely arranged, incised notches at one time did service as a kind of primitive musical instrument, known as a »rasping bone», fig. 245. That it actually may have served as a musical instrument is beyond doubt evident from Seler's studies of objects of this description.[1] There have been advanced different theories, more or less fantastic as to the employment of archaeologically discovered bones that fre-

[1] Seler 1904: 672—694; 1916: 392—402.

quently were human — usually thigh bones — provided with transverse incisions, but after Seler's investigation all further speculations appear purposeless. This because Seler bases his argumentation both on museum exhibits and citations from the literature. Thus there are quite elegant instruments of this kind, beautifully ornamented and provided with a mussel-shell attached by a chain. The cavity of the bones has usually been opened, either at one end or through fissures made in the incisions. The mussel-shell was used as a »plectrum» for stroking the notches to and fro along the bone. The latter, being hollow, then served to give resonance to the rattling sound that resulted. Francisco López de Gómara relates that the instruments in Montezuma's orchestra consisted of flutes, mussels, b o n e s and kettledrums. In Tezozomoc's »Crónica mexicana» this instrument and its appurtenant mussel-shell are mentioned and named. This bone-rattle instrument was not however included among the dance-music instruments but was only used on special occasions, among other things memorial festivals given in honour of warriors fallen in war. Tezozomoc relates that at these ceremonies it was usual to play on similar instruments »of deers' antlers, but hollow and incised with notches across which a mussel-shell was stroked, whereby was produced a mournful and plaintive tone».[1]

What in European collections probably is the earliest known Mexican specimen of this instrument is preserved in the Ethnographical Museum (Museo preistorico ed etnografico »Luigi Pigorini»), Rome. It is made from a left-side femur and is handsomely decorated with mosaic inlay covering the condyle. A hole bored through the lower end of the bone affords a fastening for a copper chain (of modern origin) and to this is attached a fragment of mussel-shell of the genus Oliva.[2] This clearly shows this instrument's character of a rattle-instrument.

Batres[3] depicts a »rasping bone» provided with incisions, stated to originate from Teotihuacan. Judging from the style of the incisions it must, however, be attributed to the Aztec era.

Beyer has pointed out that in a Mexican picture-writing — the picture-writing in the late Court Library at Vienna, Codex Vindobonensis, leaf 24 — there is found a representation of an instrument of the kind in question being played on.[4] The god Quetzalcoatl holds with his right hand the instrument which is resting horizontally on a skull, while with his left he draws a bone — probably the shoulder blade of a deer — along its surface which is scored with incisions. The instrument seems to have been made of some kind of bone. In this case the skull serves for a sounding-board, thus constituting an analogy to the earthenware vessels, gourds, etc., that in the north are employed for the same purpose. According to Seler,[5] the picture-writing just referred to is attributable to tribes of the Atlantic coast region.

Very interesting is a clay figure from Iztlan, Tepic, published by Lumholtz. This figure, which is executed in typical Tarascan style, holds in its left hand, and supported by its left knee, an object which without the slightest doubt is a musical instrument

[1] Tezozomoc 1878: 301, 561. [2] Saville 1922: pl. 40. [3] Batres 1906: fig. 24. [4] Beyer 1916. [5] Seler 1908: 461.

of the kind under review. From a neighbouring locality he depicts similar figures, one of which is playing on a sort of drum consisting of a tortoise's carapace.

As to the purpose served by these archaeologically recovered bones which are provided with incisions there can thus be no doubt whatever. The specimen discovered at Las Palmas is not very large, it is true, and the incisions are shallow, but two fragments from a different spot within the same locality formed parts of bones of larger size and more deeply incised.

The rasping bone may well be said to be an extremely primitive instrument.[1] In those which were in use among the Aztecs, the primitive character was disguised, among other things by beautiful carvings, the import of which, according to Seler, is intimately connected with their employment in the service of the cult. The here appended sketch map showing the geographical distribution of this musical instrument does not profess to be complete. But it suffices to show that we have before us a case of a culture element that Mexico and western North America possessed in common.[2] While among the Huichol Indians the instrument is made of bone — not human bone like among the most highly developed Mexican tribes but of deer's bone — elsewhere in the north it is made of wood. The only archaeological finds from southwestern U. S. A. known to me are likewise made of bone, viz. those from Hawikuh and the Swarts Ruin in Mimbres Valley. Among the Hopi the »stroker» is made of bone, and, like the instrument already referred to as preserved in Rome, fastened to the saw-or rasp-like wooden stick. As a rule, however, a smooth stick is used for stroking the notched wooden body of the instrument. For a sounding-board occasionally is used, e. g., an upturned basket or a gourd shell, corresponding, as we see, to the skull in the picture-writing above referred to. The instruments are always used in ceremonies, for accompanying medicine songs, at dances conveying hunting magic, rain ceremonies, etc. Regarding their employment among the Pima Indians, Russel writes: »So important are these instruments in Pima rain ceremonies that they are usually spoken of as rain sticks.»[3]

[1] That similar instruments also were known in Europe in prehistoric times does not seem improbable in the light of archaeological finds made at La Madelaine, Laugerie Haute, and in Pyrenean caves. Capitan 1907: pl. 4.
[2] There are a few statements in the literature that certain Indians in South America use notched rattles of bamboo. Certainly they have got these instruments from the negroes, because such rattles also were and still are in use in Africa. Lindblom 1924: 68.
[3] Russel 1908: 167.

Table to map 6.

THE GEOGRAPHICAL DISTRIBUTION OF RASPING BONES AND SCRAPING STICKS

Rasping bones.

1 Teotihuacan	R. M. 32. 8. 371; fig. 245.	
2 Tenochtitlan	Batres 1902: 48.	
2 Tlatelolco	Starr 1900 a: 102.	
2 Anacuco, Chalco	Starr 1900 a: 102.	
2 Xicco, Chalco	Starr 1900 a: 102.	

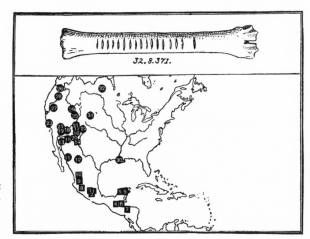

Map 6. Distribution of rasping
bones and scraping sticks.

■ Rasping bones.

● Scraping sticks.

Scraping sticks.

APPENDIX 9

ENTIRE ABSENCE OF METAL OBJECTS

No metal objects whatever were discovered during our excavations. Neither have, to the best of my knowledge, any finds of that kind ever been made at Teotihuacan with the exception of some small copper bells attributable to the Aztec era.[1]

This is especially remarkable seeing that in its heyday Teotihuacan probably was the most important locality in central Mexico. Whether it was a centre for religious pilgrimage, as is stated to have been the case with Chichén Itzá, is perhaps hardly possible of determination. Certain ceramic finds as well as objects of jadeite have furnished ample evidence of far-flung trading connections. The same may be said of the mollusk material which plainly shows these connections to have extended from coast to coast. By this it should of course not be understood that trade was carried on in a direct manner, the objects being instead likely to have passed through many hands before finally arriving here. From the time of the conquest, however, it is recorded that the cotton of which the inhabitants of Teotihuacan partly manufactured their clothes was obtained from the region of Panuco.[2] If objects of gold or other metals had been found in any of the districts connected by trade with Teotihuacan it seems entirely out of the question that such objects would not have been discovered in some grave or other.

The bearers of the Mazapan culture were, as among other things the Xipe figure shows, influenced by the inhabitants of Oaxaca, the gold country par préférence. Grave 1 contained — apart from ceramics of especially fine quality — a stone axe, a spear-head, a knife, and three figurines, all these objects made of obsidian, presumably to be counted as personal belongings of the interred. The equipment of the Mazapan graves on the contrary was, so to speak, standardized. As a rule the funeral furniture only consisted of earthenware vessels and obsidian knives. At that time gold may possibly have been about, but without finding its way into graves. Spinden, however, while on the subject of the Zapotecs, emphasizes that »beautiful examples of gold work found in this region must be given a late date».[3]

This absence of metal ware is all the more remarkable as the Aztecs were abundantly provided with gold. When Cortés and his men risked life and limb in Mexico, it was by no means for the sole purpose of exploring unknown regions, but in the acquisition of wealth for themselves and the King of Spain. A great deal of gold was given to them by Montezuma, but quite naturally they were exceedingly keen on knowing whence the Aztecs themselves obtained the desirable metal. Thus Bernal Díaz del Castillo relates that Cortés pressed Montezuma with questioning on that point. The latter eventually disclosed that they got their gold from three different

[1] Gamio 1922: Tomo I, vol. 1, 361. [2] Nuttall 1926: 79. [3] Spinden 1928: 160.

places. The greater part of it they generally obtained from a province called Za-catula, situate 10—12 days' journeys from Tenochtitlan. At the time it was also brought to him from another province, named Tustepeque, in the neighbourhood of which there were other rich mines in a country whose inhabitants, who were not his subjects, were known as Chinantecas and Zapotecas.[1] In his second report to the Emperor Charles, Cortés gives a detailed account of his inquiries for the gold mines of the Indians. These appear to have been for the most part situated in Oaxaca.[2]

As regards the Mayas, on the other hand, in the era known as the First, or Old, Empire metals were exceedingly rarely used, if indeed they possessed any metals at all. Joyce acquired for the British Museum a golden bell stated to have been brought back by Frederick de Waldeck, from Palenque. The latter visited that place in 1832, »and for two years was engaged in making drawings and investigations at this site». Joyce however makes the reserve of saying that, if the family tradition is correct (the object in question is the property of the family), »it is the first piece of gold discovered at a Maya Old Empire site».[3] Lundell saw at Yaxha (east of L. Petén) a copper axe that had been found in a ruin. He remarks: »if this tool dates from the time of the Old Empire period, it is a find of the greatest importance, no metal ever having been previously reported from a definite Old Empire site in the southern Maya area».[4] Spinden categorically states that metal-working was unknown »in the Maya area at the time of the First Empire» . . . »The ruin of Las Quebradas, belonging to the same age as Quirigua» — according to Spinden's correlation A. D. 465-550 — »is situated upon the richest placer mine in Guatemala. Although most of this site has been excavated, and many pieces of pottery and jade recovered, not one specimen of worked metal has come to light . . . From these facts we may conclude that the metal age in Central America and Mexico began between 600 and 1100 A. D.»[5]

Mason did not find any objects of metal at Piedras Negras.[6] Further, Tozzer states: »The Maya area is singularly lacking in metal objects. Early and vague reports tell of a gold bell found at Palenque and another at Tikal. There are no gold or other metal objects represented in the Maya bas-reliefs. A few metal trade objects have been reported from the highlands of Guatemala and on a key off the British Honduras coast. Otherwise metal has never been found in actual excavations».[7]

Metallurgy appears to be of considerably greater antiquity in South America than in Mexico, and it is very probable that in this department Mexico was influenced from the south. At any rate the arts of working bronze and silver are considered to be, by some archaeologists, of Peruvian origin. There they have been developed, and thence subsequently spread to Mexico.[8]

It would probably not be advisable to conclude, solely from the absence of gold and other metals at Teotihuacan, that both the classical Teotihuacan culture and the Mazapan culture are of very great antiquity. Rather, it seems, should that circum-

[1] Díaz del Castillo 1904: vol. 1, p. 333. [2] Cortés 1866: 92 [3] Joyce 1924: 46. [4] Lundell 1934: 185.
[5] Spinden 1928 a: 74 seq. [6] Mason 1934: 355. [7] Tozzer 1934: 12. [8] Rivet and Arsandaux 1921; 1923.

stance be accepted as indicating that in Mexico the art of working gold and other metals belongs to a later period of the cultural development. Of the same opinion was Nordenskiöld as seen from the following: »As bronze presumably only in Incaic times became known on the coast of Peru, it must also in Mexico have become known at a very late period. This points to communication having existed between Peru and Mexico shortly before the discovery of America.»[1]

APPENDIX 10

MENDING POTTERY BY THE »CRACK-LACING« METHOD

A certain proportion of the large number of pottery fragments preserved in our collections is provided with holes that have been bored through the clay material after baking. These holes are always found near at least one of the edges of the fragments. In many cases it is evident that the holes were made in close proximity to the mouths of the original vessels. This is a matter of course, for so far as my experience goes all such holes were bored for mending cracks by the method described below. Beside the fragments drilled with holes of this kind, one of the largest vessels of the collection, a huge bowl measuring 68.7 cm. in diameter, fig. 132, has once been mended — in two places, by the way. An incomplete vessel of about the same size and appearance has also been mended.

When a vessel had received a crack at the rim it was occasionally mended by boring holes along both sides of the crack. A piece of string was threaded through the holes and the crack was drawn together in a way similar to the lacing up of a boot. After the two edges had been brought into close contact the crack would sometimes further be closed up with some suitable substance, e. g. beeswax or resin, which was also used to fill up the craters of the holes. To make this process easier, the holes are occasionally monoconical with the larger aperture on the outer side.

In earlier works I have given detailed description of the technique and geographical distribution of this mending method.[2] With the data that since then have become available, this distribution would in brief be as follows:

In South America the method was much in vogue on the Peruvian coast and the northern part of the Chilean coastland, in northwestern Argentina, in the delta land of Rio Paraná, as also in Ecuador, and in the Santa Marta district and the western coast of Colombia. From Central America the only instances known to me are from Costa Rica, Nicaragua and Guatemala, and in Mexico only from Yucatan, Ticoman, and Teotihuacan. In North America the method is only sporadically occurring, e .g.

[1] Nordenskiöld 1931: 59. [2] Linné 1925: 156 and 1929: 206.

in the Southwest in Louisiana, and in various districts of eastern U. S. as far as the Canadian border. Strangely enough, it is also employed by the Eskimos.

In a similar way even calabashes are, and formerly were, mended. Nordenskiöld[1] gives account of its distribution in South America. It is restricted to the coastland of Peru, to the Chaco district — culturally influenced from the mountain regions — and to isolated instances on Rio Xingú and among the Ijca Indians of Santa Marta, in Colombia.

The questions whether this method originated from a single source, which perhaps may be doubted, and whether it was primarily employed for mending calabashes or for mending earthenware vessels, are, for the present at all events, apparently not capable of being determined. It is probable that its distribution was considerably more widespread than is apparent from a map based on the above-cited data. For the most part both ethnographical and archaeological collections preserved in museums and material which has been published, generally, as far as ceramics are concerned, consist of or deal with objects that are more beautiful or showy than potsherds. It is nevertheless true that pottery fragments frequently are the better source of information as regards technical methods, and it is above all from the fragments that we shall be able to add to our knowledge of the distribution of the crack-lacing method.

APPENDIX 11

EXAMINATIONS OF WALL FRAGMENTS FROM THE HOUSE RUIN AT XOLALPAN

At the Central Testing Station (Statens provningsanstalt) have been examined certain wall fragments from the house ruin at Xolalpan. One of these fragments originated from the eastern platform of the central court (No. 1), another from Room II (No. 2), and a third, and smaller, from a wall-pier below Room II, constructed during the third building period (No. 3).

Professor P. J. Holmquist, leading specialist on mineralogical and petrographical analyses, reports as follows: —

»The samples submitted consisted of two large, flat fragments (Nos. 1 and 2) and a smaller one of similar shape (No. 3). The flat surfaces carried a white coating some millimetres in thickness. On one of the larger fragments the surface of the white coating had been coloured in a reddish tint. A similar colouring substance had been applied over the smooth surface of the smaller fragment direct, without any intervening stratum.

[1] Nordenskiöld 1919: 228 and map 44.

The results of the microscopical (and microchemical) examinations carried out are the following: —

The main mass in the two larger fragments consists of a variety of volcanic tuff, most nearly classifiable as basaltic, or augite andesitic, tuff. It is accordingly an agglomerate (volcanic conglomerate) of small lava particles, mostly in the form of dark-coloured fragments of pumice stone and crystals of augite, hornblende, varieties of basic feldspar, olivine, iron ochre, with traces of carbonates. In addition there is a general prevalence of glassy lava particles, frequently in the form of ruptured filaments of brown or pale-coloured lava glass. It seems that in building operations blocks of fairly loose tuff were used. It is possible that the blocks were planed on one surface and then coated with a paste of lime and powdered with pumice stone. This pumice stone is of a composition different to that of the beforementioned tuff, probably being of a trachyte character like the pumice stone used by modern house painters. It is a throughout glassy substance, abounding in air bubbles formed by trachyte, gaseous, lava when cooling. Evidently such trachyte pumice stone has been crushed and then mixed with lime, whereupon the resulting mass was plastered on the planed blocks of the dark-coloured tuff.

Hence one of the larger test samples exhibits a surface coating of white or light colour (No. 2). In the other, the surface itself has been painted red (No. 1). That is to say, the coating has been given a red colour, effected by the use of red iron ochre (hematite, ferric oxide).[1] The presence of the ferric oxide pigment, and of lime, has been microchemically demonstrated. As regards the lime it should be noted that this substance appears in a very finely crystalline form, which makes it probable that it was applied as caustic lime, i. e. after having been burnt. No other binding agent appears to have been used.

In the case of the smallest test sample (No. 3), conditions appear in some degree different. It is of a reddish-grey consistence, of clay character, but hard. Microscopic examination however proves that even here the material is of tuff origin, and not very dissimilar to that of the two foregoing samples. But it is rich in ferric oxide and decomposition products (carbonates, however, excepted), by reason of which it appears to derive from tuff decomposed by efflorescing, possibly originating from the surface layer of some tuff stratification, while the dark-coloured tuff (of the larger samples) have been broken from the deeper strata of the quarry. The small, glittering grains which are visible in the surfaces of the smaller test sample consist of minute pumice stone particles of the same kind as those which are present in the coating of the larger samples.»

[1] A stone plate originating from the altar of the central court-yard has also been painted red. The thin red coating in this case consists of cinnabar.

APPENDIX 12

MICROSCOPIC INVESTIGATIONS OF
CERAMICS

Dr. Gunnar Beskow of The Geological Survey of Sweden has microscopically examined four thin sections of pottery fragments, below referred to as I, I$_A$, II and III. They originate from the following vessels: I and I$_A$, from the yellowish-red bowls, figs. 43 and 44, from Grave 4; II, from a tripod vessel of usually light-coloured, yellowish-red material, whose ornaments present a certain Totonac character, a fragment of which is reproduced in fig. 117; and, lastly, III, which is a fragment of a typical Teotihuacan tripod vessel, fig. 21, from Grave 1.

With the detailed mineralogical description left out, the preliminary results of Dr. Beskow's examination are as follows: —

»Nos. I and I$_A$ are of such close agreement as to be almost identical, and are therefore here dealt with as one entity. The other two, however, differ considerably from each other and from the former.

Nos. I and I$_A$ are composed of isotropic (not birefringent) clay mass and relatively coarse sand. A characteristic trait is that the sand grains show a very high degree of weathering. Among the smaller particles grains of carbonate (probably calcite) are comparatively numerous.

No. II differs from I and I$_A$ in that the clay mass is distinctly birefringent. The sand is on the whole of a considerably finer grain. The proportion of carbonates is very high, especially in the smaller-sized grains.

No. III is above all characterized by its comparatively fine-grained sand being remarkably well preserved (not weathered). This applies in a particularly noteworthy degree to the coloured minerals. For another thing, there are no calcareous particles present. The clay mass itself is isotropic (not birefringent).

The composition and especially the unweathered condition of the mineral particles in No. III indicates that — when, as in the present case, it is a question of pottery derived from tropical regions not touched by the late quaternary glaciation — the material with certainty is referable to some very late volcanic formation. The locality where the find was made being, according to information, noted for recent volcanism, what has been adduced above lends support to the supposition that the pottery here dealt with is of local origin.

As regards the other samples (I and II) it can only with full certainty be said that here have been used materials entirely different from that of No. III. If the recent volcanic formations in the Teotihuacan neighbourhood are of relatively great expanse and depth, it is moreover practically certain that these samples originate from a lo-

cality, or localities, outside the volcanic region referred to. In any case it is improbable that they originate from the same locality as No. III. With regard especially to the differences between the clay mass in Nos. I and II, respectively, it also may with practical certainty be concluded that these were manufactured of clay taken from different pits which were probable not very adjacent.»

Stockholm, July 8th, 1934.

(sgd) GUNNAR BESKOW, Ph. D.,

The Geological Survey of Sweden.

SUMMARY AND CONCLUSIONS

The results of our excavation work at Teotihuacan may be summarized as follows:—
Having located, excavated and examined a building complex at Xolalpan
dating from the period of the Teotihuacan culture, that is to say from the
local era of greatness. As the building work in question was presumably at least partly
of a profane character, our knowledge is thereby increased as regards the planning
and construction of the dwelling houses of that period for a certain more highly placed
class of people. Whether these were priests, warriors or chiefs is difficult to say,
although the first alternative seems of greater probability.

The movable finds belong to the Teotihuacan culture, from the Aztec era, and from
a certain intervening period, the so-called Mazapan culture.

Considerable numbers of artifacts were recovered below the floors of the building,
in consequence of which these objects were contemporaneous with, or possibly older
than, the respective portions of the ruin. Among the finds, the most important were
seven graves dating from the time of the builders of the house. Of the grave fur-
niture, as well as of the loose finds contained in the fillings of the floors, the main part
is no doubt of local manufacture. A certain proportion, however, may be put down
as imported goods.

The finds dating from the Aztec era were of no particular importance either as regards
quantity or quality. Artifacts of the Mazapan culture, on the other hand, were num-
erously represented. Their character and their position in relation to the ruin
reveal as clearly as possible not only that here the Teotihuacan culture came to an
abrupt end (i. e. at this place), but also that the new occupants were unacquainted
with the ruin. Judging from the artifacts, points of contact between the two civil-
izations must have been exceedingly slight. It appears probable that a certain in-
terval of time lies between the abandonment of the house and its being taken in oc-
cupation by the bearers of the Mazapan culture. This is remarkable inter alia in
view of the fact that earlier stratigraphical examinations of other sections of Teoti-
huacan — within the archaeological zone, as well as south and west of it — have
established that the Teotihuacan culture continued into the Aztec era.[1]

[1] Gamio 1922: Tomo I, vol. 1, 266. »La cultura azteca existió en la región al mismo tiempo que la teotihuacana,
aunque en menor proporción.»

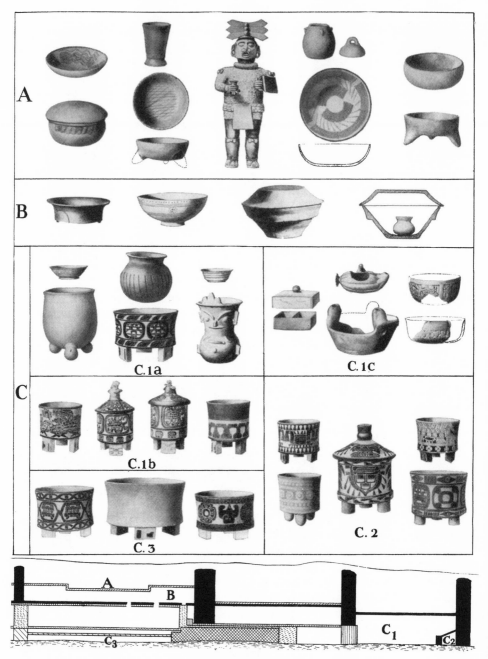

Fig. 339. Diagram showing types of ceramics recovered in different parts of the ruin. Below, section of the earliest portion of the building, with approximate localities of finds. The differently shaded tiers represent the various building periods.

As has been mentioned, the ruin in question belongs to the Teotihuacan culture and dates from a relatively late period of the history of the locality. Its palpable correspondence with the style of the later building works on Camino de los Muertos, La Ciudadela, and other places, points to this. The ruin when excavated proved the result of a series of extensions and superstructural building works.

Below the rooms at the highest level (Nos. I and II on the plan, fig. 9), there were thus discernible remains of five consecutive building periods, the floors of the rooms just referred to representing the sixth period. Thereto may be added certain later structural modifications of the sections connected with the central court-yard.

One of the graves discovered below a floor in the ruin was directly built-in with one of the outer walls. In many cases the grave furniture gives an excellent representation of the ceramic art of the Teotihuacan culture. The relative ages of the graves are determinable with a considerable degree of certainty, while the latest three of them contain grave furniture of slightly divergent character in that the tripod vessels that are typical of the other graves are here absent.

In fig. 339, the bottom part, is shown a section of the ruin, the sector line running north-south through Rooms II, III and VII in the eastern margin of the quadratic vertical section of the firstmentioned floor. This line cuts through Grave 1, and the grave is indicated at the bottom right. The different building periods are denoted by different systems of hatching.

Above this ruin section will be found representatives of the ceramics recovered in different portions of the ruin. They are collected in groups A, B, and C_1—C_3. The corresponding figures on the plan — excepting C_2 — only denote their approximate vertical position. C_3 illustrates some of the earliest artifacts, C_2 the most important of the contents of Grave 1, and C_1 representative furniture of Graves 4 and 2, together with a few stray finds roughly dating from the same period, denoted as C_{1a}, C_{1b} and C_{1c}. Under B are grouped some of the finds from Graves 6 and 7.

Quite near the ground surface were found artifacts from Aztec times. Not being from any point of view remarkable, they have not been included in this summarizing picture. Between the surface and the floors of the ruin both graves and stray finds from the Mazapan culture were discovered. A number of objects characteristic of this culture are grouped under A. All of the objects — with exception of the Xipe Totec figure which considerations of space made it necessary to reduce — are reproduced so as to appear in true size relation.

From the finds — whether those of the Teotihuacan or Mazapan cultures — it is not possible to obtain any comprehensive culture picture, as is only natural in the kind of climate that prevails in these regions. As regards the culture of the housebuilders, there is a great dearth of purely utilitarian objects, a circumstance no doubt due to the inhabitants not having had to fend for themselves in the matter of the necessaries of life.

The typical Mazapan ceramics vary, as regards form, within narrow limits, while

the painted decoration, consisting of wave-lines, volute and straight lines, shows infinite variation. The same may, on the whole, be said of the Teotihuacan ceramics. The dominating find from the Mazapan era consists of the figure representing Xipe Totec. It bears evidence that this culture was, directly or indirectly, influenced from Oaxaca. While clay vessels belonging to the Mazapan culture, of kinds deviating from the ordinary type, as a rule are rather coarse and in most cases manufactured from the same kind of clay as the »zonal fossils», there appears during the era of the Teotihuacan culture certain pottery of entirely alien character. A numerically very small group would seem to indicate far-distant commercial connections, but these importation goods have evidently not influenced the local ceramic art. Another, and more numerous, group was, judging from microscopic analyses, imported from the Chalchicomula district, and this pottery appears in certain cases to have inspired to imitations, generally rather clumsily executed. In this direction it appears that a suitable field offers itself for further investigations of the Teotihuacan culture with regard to the lively interchange of objects that existed between the two localities just referred to. Great importance also attaches to the fact that artifacts were there recovered, which it is possible to connect with certain others from the Early Cultures in the Valley of Mexico.

Extremely remarkable, too, are such vessel-fragments of Maya stamp as may possibly indicate intercourse — of an indirect kind — with the Mayas of the First Empire. Of interest are also other points of correspondence with the Maya culture of that epoch: obsidian figures of extremely specialized type, as well as other objects of this class belonging to the group denoted as »eccentric objects», jadeite objects of Maya type, the Fat God, in-fresco painting, the use of cinnabar, and the absence of metal objects.

On the basis of the detached finds that are here grouped according to the character of the objects, some interesting deductions have been made. The size of the clay pellets seem to indicate that blowguns with pellet ammunition were in use already during the Teotihuacan culture. The same applies to paper, or clothing, of bark. Earthenware moulds played a very important part in the manufacture of clay figurines, spindle-whorls, stamps, decorative details on clay vessels, etc. The collections further include representative examples of the clay vessel types belonging to the Teotihuacan culture, while the stone and obsidian objects and implements, both of that era and the Mazapan culture, are well represented. The paint material employed has in many cases been possible of determination. Neither the colour range nor the material varies to any considerable extent, and no interest appears to have been given to mixing and toning different colours.

The geographical distribution of the Teotihuacan culture has not yet been established. In a map drawn up by Noguera, seven districts are shown where artifacts of Teotihuacan type have been found. Of these localities, the farthest north lies in Queretaro, the farthest south in Oaxaca, and the farthest east in the Chalchicomula

district.[1] Whether future field work is going to enlarge these restricted areas and merge them into one, remains to be seen. It is moreover by no means certain that this culture successively grew out from a single, defined locality, e. g. Teotihuacan. It is of course not impossible that this civilization, which has been named after the so far best known locality, from reasons still unknown may have been compelled to change ground, for example by its bearers having migrated or been expelled. By active intercommunication — not least of a commercial nature — colonization, and the like, it stands to reason that a district may absorb foreign culture elements to such a degree that thereby the archaeological material is dominated. On the other hand, the wide distribution area explains to some extent the presence of the »imported ware» at Teotihuacan.

Clay vessels of the type characteristic of Teotihuacan — the cylindrical tripod vessels — are however found outside the above defined districts. Such vessels of more or less corresponding type are, it may be noted, known from Lubaantun in British Honduras,[2] and from Guatemala.[3] But to speak of »Toltec influence» in Chichén Itzá, and in doing so to identify those hypothetic Toltecs with the bearers of the Teotihuacan culture, cannot be right and proper. Whoever those invaders of northern Yucatan may have been, who grafted a fresh branch on to the ancient tree of the Maya culture, they had nothing to do with the Teotihuacan people. Thus there exist no points of connection between these places as regards ceramics, architecture or stone sculpture.

In the foregoing, proofs have with more or less certainty been adduced that the Teotihuacan culture was enriched by influences attributable to commerce. Indian trading intercourse in pre-Spanish times would well repay a closer study. Instances are recorded of this sort of connections over immense areas. A striking illustration in point is found in the fact that fowls existed in the Inca kingdom at the time of the Spaniards' arrival there. The Indians of the Brazilian coast had obtained fowls from the whites shortly after the year 1500, and this novel and popular bird had, as an object of barter, been carried right across the continent in considerably shorter time than it had taken the Spaniards to reach the Inca realm. Thus it is not surprising that, as has been mentioned, objects of foreign origin were found at Teotihuacan, or that others belonging to that culture occur outside its specific area. In this way mollusks had been brought there from the Pacific coast, while certain features point to intercommunication with the inhabitants of the Atlantic coast, although in the latter case the reason may be to seek in some common link of connection between the two groups of people. Jadeite, crude or worked into beads, had been imported from Oaxaca, and from that place was also, as already mentioned, acquired the cult of the god Xipe Totec, although not before the epoch of the Mazapan culture. Material for making axes, and other rock species, such as tecali, had also been imported, as possibly also cinnabar.

[1] Noguera 1932: »Mapa de México que indica la distribución de cerámicas arqueológicas.»
[2] Joyce, Cooper Clark, and Thompson 1927: 311. »In shape these vessels resemble certain Toltec vases».
[3] Gamio 1926—1927: 210; Termer 1931: fig. 27.

On the other hand it would seem as if certain elements of comparatively great age had, so to speak, leavened through many fairly equally developed cultures over wider regions. Among these may be counted, apart from maize cultivation and implements connected therewith, negative painting, moulds for the manufacture of figures and the like, bark-beaters, stamps, vessels with annular foot and tripod vessels, covers for clay vessels, quipus and blowguns. Their relative age is, among other things, apparent from the fact that they occur both in South and Central America. There are other elements of less antiquity, in certain cases at all events indicated by their more restricted area of distribution. Of these, the roasting dish is an example. The art of working metals is indisputably older in South America than in Mexico. The scraping bone not having penetrated farther south may possibly be ascribable to similar reasons. Of comparatively restricted geographical distribution are both plumbate ware and in-fresco painting, although not by any means describable as elements of late origin.

In Part I reference is made to the exceedingly divergent opinions as to the age of the Teotihuacan culture. Thus Walter Lehmann holds that the city went into decay towards the end of the 6th century, A. D. At a later date, however, its culture experienced a period of renaissance which lasted until the end of the 12th century. Whether Teotihuacan was sacked by barbarians, or whether it was abandoned because of famine caused by some extremely protracted dry season, remains an open question. Vaillant, for his part, places this cultural epoch farther on in time, and believes it to have been of considerably shorter duration. Thus he maintains that the Teotihuacan culture was played out by the end of A. D. 1000 or 1100. I readily admit being incapable as yet to take up a definite position with reference to these so widely divergent opinions, having, among other things, far too few literary sources available. The absence of plumbate ware and metal objects, the occurrence of Maya-influenced artifacts closely related to the First Empire, as also in some degree the circumstance that the bearers of the Mazapan culture possessed no appreciable knowledge of the Xolalpan ruin, however make me incline to the belief that the collapse of the city possibly may be dateable more in accordance with Lehmann's theory.

There are good reasons for objecting to the procedure, when studying culture elements and their geographical distribution, of employing the map method for demonstrating, on a broader basis — by »horizontal stratification» — the movements and interconnection of cultures. As far too little has yet been done in the way of field work, too wide a margin is left for subjective opinions. Historical sequence is moreover easily lost sight of. It is nevertheless an excellent way of obtaining a clear survey of extensive material. If not productive of positive results, the method in question may inspire an opposition by which research may profit. Perhaps the most important part of it is to provide, not only the reader but also the author, with stimulating study by the side of dry descriptions of material, a study that may act as the oxygen needed to maintain the flame of thought.

WORKS CONSULTED

ADRIANI, N. en KRUYT, ALB. C.
1901. Geklopte boomschors als kleedingstof op Midden-Celebes (Internationales Archiv für Ethnographie, Band 14). Leiden 1901.

ANDRES, FRIEDRICH.
1928. Buphonia-Opfer und Opfer im Kulte des Xipe-Totec (Festschrift P. W. Schmidt). Wien 1928.

BARRETT, S. A.
1925. The Cayapa Indians of Ecuador (Indian Notes and Monographs, no. 40, vols. 1—2). New York 1925.

BASLER, ADOLPHE and BRUMMER, ERNEST.
1928. L'art précolombien. Paris 1928.

BASTIAN, A.
1878—1888. Die Culturländer des alten America (vols. 1—3). Berlin 1878—1888.

BANCROFT, HUBERT HOWE.
1875—1876. The native races of the Pacific States of North America (vols. 1—5). London 1875—1876.

BATRES, LEOPOLDO.
1889. Teotihuacán ó la ciudad sagrada de los Toltecas. México 1889.
1902. Exploraciones arqueológicas en la Calle de las Escalerillas. México 1902.
1902 a. Explorations of Mount Alban, Oaxaca, Mexico. Mexico 1902.
1903. Visita a los monumentos arqueológicos de »La Quemada», Zacatecas (Inspección y conservación de monumentos arqueológicos de la República Mexicana). México 1903.
1906. Teotihuacan. Mexico 1906.
1906 a. Teotihuacán ó la ciudad sagrada de los Tolteca. Mexico 1906.
1908. Exploraciones y consolidacion de los monumentos arqueológicos de Teotihuacan. Mexico 1908.
1908 a. Civilización prehistórica de las Riberas del Papaloapam y Costa de Sotavento, Estado de Veracruz. Mexico 1908.

BEALS, RALPH.
1932. The comparative ethnology of northern Mexico before 1750 (Ibero-Americana: 2) Berkeley 1932.
1933. Ethnology of the Nisenan (University of California Publications in American Archaeology and Ethnology, vol. 31). Berkeley 1933.

BEYER, HERMANN.
1916. Una representacion autentica del uso del O m i c h i c a h u a z t l i (Memorias y Revista de la Sociadad Científica »Antonio Alzate», tomo 34). Mexico 1916.
1917. Sobre amtigüedades del pedregal de San Angel (Memorias de la Sociedad Científica »Antonio Alzate», tomo 37, núm. 1). Mexico 1917.
1919. Guerrero o dios? Nota arqueologica acerca de una estatua mexicana del Museo de Historia Natural de Nueva York (El Mexico Antiguo, tomo 1, núm. 4). Mexico 1919.
1920. Una pequeña colección de antiqüedades mexicanas (El Mexico Antiguo, tomo 1, núm. 6). Mexico 1920.
1930. A deity common to Teotihuacan and Totonac cultures (Proceedings of the 23d International Congress of Americanists, New York 1928). New York 1930.

BAUER-THOMA, WILHELM.
1916. Unter den Zapoteken und Mixes des Staates Oaxaca der Republik Mexico (Baessler-Archiv, Band 5). Leipzig und Berlin 1916.

BESKOW, GUNNAR.
1929. Microscopic investigations of certain ceramic from the Pearl Islands and the Gulf of Urabá (Darien in the past by S. Linné. Appendix II). Göteborg 1929.

BEUCHAT, H.
1912. Manuel d'Archéologie Américaine. Paris 1912.

BIRKET-SMITH, KAJ.
 1929. Drinking tube and tobacco pipe in North America (Ethnologische Studien). Leipzig 1929.
BLAKE, W. W.
 1891. The antiquities of Mexico. New York 1891.
BLOM, FRANS.
 1926—1927. Tribes and temples. A record of the expedition to Middle America conducted by the Tulane University of Louisiana in 1925 (vols. 1—2). New Orleans 1926—1927.
BOAS, FRANZ.
 1911—1912. Álbum de colecciones arqueológicas (Publicaciones de la Escuela Internacional de Arqueología y Etnología Americanas). Mexico 1911—1912.
BOVALLIUS, CARL.
 1885. En resa i Talamanca-indianernas land (Ymer, årg. 5). Stockholm 1885.
 1886. Nicaraguan antiquities. Stockholm 1886.
 1887. Resa i Central-Amerika 1881—1883. Upsala 1887.
BRANSFORD, J. F.
 1881. Archaeological researches in Nicaragua (Smithsonian contributions to knowledge, 383, vol. 25). Washington 1881.
BRINTON, DANIEL G.
 1890. Essays of an Americanist. Philadelphia 1890.
BRÜHL, GUSTAV.
 1875—1887. Die Culturvölker Alt-Amerika's. New York, Cincinnati, St. Louis 1875—1887.
CAPITAN, L.
 1907. Décades Américaines. Paris 1907.
CAREY, HENRY A.
 1931. An analysis of the northwestern Chihuahua culture (American Anthropologist, new series, vol. 33, 1931).
CASO, ALFONSO.
 1928. Las estelas Zapotecas (Publicaciones de la Secretaría de Educación Pública. Monografias del Museo Nacional de Arqueología, Historia y Etnografía). Mexico 1928.
 1932. Monte Albán, richest archeological find in America (The National Geographic Magazine, vol. 62, no. 4). Washington 1932.
 1932 a. Las exploraciones en Monte Alban (Instituto Panamericano de Geografía e Historia, publ. no. 7). Mexico 1932.
CHARNAY, DÉSIRÉ.
 1885. Les anciennes villes du Nouveau Monde. Paris 1885.

CODEX VATICANUS A.
 Codex Vaticanus A (Cod. Vatic. 3788). Rome 1900.
CONZEMIUS, EDUARD.
 1927—1928. Los Indios Payas de Honduras (Journal de la Société des Américanistes de Paris, nouvelle série, tomes 19—20). Paris 1927—1928.
 1928. On the aborigenes of the Bay Islands, Honduras (Proceedings of the 22nd Congress of Americanists, Roma 1926, vol. 2). Roma 1928.
 1932. Ethnographical survey of the Miskito and Sumu Indians of Honduras and Nicaragua (Bulletin 106 of the Bureau of American Ethnology). Washington 1932.
CORNER, WILLIAM.
 1899. Mitla: An archaeological study of the ancient ruins and remains in that Pueblo (Journal of the Anthropological Institute, vol. 29). London 1899.
CORTÉS, HERNAN.
 1866. Cartas y relaciones de Hernan Cortés al Emperador Carlos V (edited by Pascual de Gayangos). Paris 1866.
COSGROVE, H. S. and C. B.
 1932. The Swarts ruin. A typical Mimbres site in southwestern New Mexico (Papers of the Peabody Museum of American Archaeology and Ethnology, Harvard University, vol. 15, no. 1). Cambridge 1932.
CRAWFORD, M. D. C.
 1916. Peruvian fabrics (Anthropological Papers of the American Museum of Natural History, vol. 12, part 4). New York 1916.
DAHLGREN, E. W.
 1889. Något om det forna och nuvarande Mexico (Ymer, årg. 9). Stockholm 1889.
DANZEL, TH. D.
 1923. Mexiko (vol. 2). Hagen i. W. und Darmstadt 1923.
DE GEER, EBBA HULDT.
 1931. Geokronologi och biokronologi (Ymer, årg. 51). Stockholm 1931.
DENGLER, HERMANN.
 Indianer. Stuttgart.
DENSMORE, FRANCES.
 1927. Handbook of the collection of musical instruments in the United States National Museum (Bulletin 136 of the United States National Museum, Smithsonian Institution). Washington 1927.
 1929. Papago music (Bulletin 90 of the Bureau of American Ethnology). Washington 1929.

1932. Yuman and Yaqui music (Bulletin 110 of the Bureau of American Ethnology). Washington 1932.

DÍAZ DEL CASTILLO, BERNAL.
1904. Historia verdadera de la Conquista de la Nueva España (edited by Genaro García, vols. 1—2). México 1904.

DIESELDORFF, E. P.
1926. Kunst und Religion der Mayavölker im alten und heutigen Mittelamerika. Berlin 1926.

DIXON, ROLAND B.
1928. The building of cultures. New York, London 1928.

DORSEY, GEORGE A.
1905. The Cheyenne (Field Columbian Museum, Anthropological series, vol. 9). Chicago 1905.

ERIKSSON, J. V.
1919. Montezumas Mexico (Ymer, årg. 39). Stockholm 1919.

FEWKES, JESSE WALTER.
1907. Certain antiquities of eastern Mexico (25th Annual Report of the Bureau of American Ethnology). Washington 1907.

FISCHER, H.
1881. Bericht über eine Anzahl Steinsculpturen aus Costarica (Abhandlungen des Naturwissenschaftlichen Vereins zu Bremen, Band 7). Bremen 1881.

FISCHER, HEINRICH.
1933. Die altperuanischen Sammlungen des Museums für Länder- und Völkerkunde, Linden-Museum, Stuttgart (Festschrift und 50. Jahresbericht 1931—32 des Württ. Vereins für Handelsgeographie). Stuttgart 1933.

FOY, W.
1910. Führer durch das Rautenstrauch-Joest-Museum der Stadt Cöln. Cöln 1910.

FRIEDERICI, GEORG.
1906. Die Ethnographie in den »Documentos inéditos del archivo de Indias» (Globus, Band 90). Braunschweig 1906.
1911. Die geographische Verbreitung des Blasrohrs in Amerika (Petermanns Geographischen Mitteilungen 1911).

GABB, WM. M.
1876. On the Indian tribes and languages of Costa Rica (Proceedings of the American Philosophical Society, vol. 14). Philadelphia 1876.

GAMIO, MANUEL.
1910. Los monumentos arqueologicos de las immediacciones de Chalchuites (Anales del Museo Nacional de Arqueología y Etnologia, tomo 2). México 1910.

1913. Arqueología de Atzcapotzalco, D. F., Mexico (Proceedings of the 18th International Congress of Americanists, London 1912). London 1913.
1920. Las excavaciones del pedregal de San Angel y la cultura arcaica del Valle de Mexico (American Anthropologist, new series, vol. 22, 1920).
1921. Álbum de colecciones arqueológicas, texto (Publicaciones de la Escuela Internacional de Arqueología y Etnología Americanas). México 1921.
1922. La población del Valle de Teotihuácan (vols. 1—3). Mexico 1922.
1922 a. The population of the Valley of Teotihuacan. Introduction, synthesis and conclusions of the work. Mexico 1922.
1926—1927. Cultural evolution in Guatemala and its geographic and historic handicaps (Art and Archaeology, vol. 22, no. 6, vol. 23, nos. 1—3). Washington 1926—1927.
1929. Las excavaciones del pedregal de San Angel y la cultura arcaica del Valle de Mexico (Publicaciones de la Secretaria de Educacion Publica, tomo 22, núm. 2). Mexico 1929.

GANN, THOMAS.
1900. Mounds in northern Honduras (19th Annual Report of the Bureau of American Ethnology, part 2). Washington 1900.
1918. The Maya Indians of the southern Yucatan and northern British Honduras (Bulletin 64 of the Bureau of American Ethnology). Washington 1918.
1924. In an unknown land. London 1924.
1925. Maya jades (Proceedings of the 21st. International Congress of Americanists, Göteborg 1924). Göteborg 1925.
1925 a. Mystery cities. London 1925.
1934. Changes in the Maya censor, from the earliest to the latest times (Proceedings of the 24th International Congress of Americanists, Hamburg 1930). Hamburg 1934.

GODDARD, P. E.
1903. Life and culture of the Hupa (University of California Publications in American Archaeology and Ethnology, vol. 1). Berkeley 1903.

GÓMARA, FRANCISCO LÓPEZ DE.
1922. Historia general de las Indias (vols. 1—2). Madrid 1922.

GORDON, G. B.
1896. Prehistoric ruins of Copan, Honduras. A preliminary report of the explorations by the Museum, 1891—1895 (Memoirs

of the Peabody Museum of American Archaeology and Ethnology, Harvard University, vol. 1, no. 1). Cambridge 1896.

1898. Researches in the Uloa Valley, Honduras Report on explorations by the Museum, 1896—1897 (Memoirs of the Peabody Museum of American Archaeology and Ethnology, Harvard University, vol. 1, no. 4). Cambridge 1898.

1916. A contribution to the archaeology of Middle America (Holmes Anniversary volume). Washington 1916.

GRUNING, E. L.
1930. Report of the British Museum expedition to British Honduras, 1930 (Journal of the Royal Anthropological Institute, vol. 60). London 1930.

GUSINDE, MARTIN.
1931. Die Feuerland-Indianer. Band 1. Die Selk'nam (Anthropos-Bibliotek, Expeditions-Serie I). Mödling bei Wien 1931.

HAMBRUCH, P.
1929. Ikatgewebe in Guatemala (Tagungsbericht der 50. deutschen Anthropologischen Gesellschaft, 1928). Hamburg 1929.

HAMY, E. T.
1897. Galerie américaine du Musée d'Ethnographie du Trocadéro (vols. 1—2). Paris 1897.

HANDBOOK.
1912. Handbok of American Indians north of Mexico (Bulletin 30 of the Bureau of American Ethnology, vols. 1—2, edited by Frederick Webb Hodge). Washington 1912.

HARRINGTON, M. R.
1922. Cherokee and earlier remains on upper Tennessee River (Indian Notes and Monographs). New York 1922.

1933. Gypsum Cave, Nevada (Southwest Museum Papers, no. 8). Los Angeles 1933.

HARTMAN, C. V.
1901. Archaeological researches in Costa Rica (The Royal Ethnographical Museum in Stockholm). Stockholm 1901.

1902. Etnografiska undersökningar öfver aztekerna i Salvador (Ymer, årg. 21). Stockholm 1902.

1903. Arkeologiska undersökningar på Costa Ricas ostkust (Ymer, årg. 22). Stockholm 1903.

1907. Archeological researches on the Pacific coast of Costa Rica (Memoirs of the Carnegie Museum, vol. 3, no. 1). Pittsburg 1907.

1910. Le calebassier de l'Amérique tropicale (Crescentia). Étude d'Ethnobotanique (Journal de la Société des Américanistes de Paris, nouvelle série, tome 7). Paris 1910.

1911. Kalebassträdet i tropiska Amerika (K. Svenska Vetenskapsakademiens årsbok för år 1911). Uppsala 1911.

HAURY, EMIL W.
1934. The Canyon Creek ruin and the cliff dwellings of the Sierra Ancha (Medallion Papers, no. 14). Lancaster 1934.

HAWLEY, E. H.
1898. Distribution of the notched rattle (American Anthropologist, vol. 11, 1898).

HÉBERT, J.
1902. Quelques mots sur la technique des céramistes Péruviens (Journal de la Société des Américanistes de Paris, première série, tome 4). Paris 1902.

HENNING, PAUL.
1918. El Xipe del Tazumal de Chalchuapa, Departamento de Santa Ana, Rep. de El Salvador (Disertaciones cientificas de autores alemanes en Mexico, 4, La Arqueologia Mexicana). Mexico 1918.

HERRERA, ANTONIO DE.
1720—1736. Historia general de los hechos de los Castellanos en las islas y tierra firme del Mar Oceano (vols. 1—4). Madrid 1720—1736.

HODGE, F. W.
1920. Hawikuh bonework (Indian Notes and Monographs, vol. 3, no. 3). New York 1920.

1922. Guide to the museum (Indian Notes and Monographs. Museum of the American Indian, Heye Foundation). New York 1922.

HOLMES, WILLIAM H.
1888. Ancient art of the province of Chiriqui, Colombia (6th Annual Report of the Bureau of American Ethnology). Washington 1888.

1895—1897. Archeological studies among the ancient cities of Mexico (Field Columbian Museum. Anthropological series, vol. 1, no. 1; vols. 1—2). Chicago 1895—1897.

1903. Aboriginal pottery of the eastern United States (20th Annual Report of the Bureau of American Ethnology). Washington 1903.

1919. Handbook of aboriginal American antiquities (Bulletin 60 of the Bureau of American Ethnology). Washington 1919.

HOUGH, WALTER.
1899. Material of the Mexican codices (American Anthropologist, new series, vol. 1, 1899).
1912. Censers and incense of Mexico and Central America (Proceedings of the United States National Museum, vol. 42). Washington 1912.
1928. The lead glaze decorated pottery of the Pueblo region (American Anthropologist, new series, vol. 30, 1928).

HRDLIČKA, ALEŠ.
1899. Description of an ancient anomalous skeleton (Bulletin of the American Museum of Natural History, vol. 12). New York 1899.
1903. The region of the ancient »Chichimecs», with notes on the Tepecanos and the ruin of La Quemada, Mexico (American Anthropologist, new series, vol. 5, 1903).

JACKSON, J. WILFRID.
1917. Shells as evidence of the migration of Early culture (Publications of the University of Manchester, no. 112, Ethnological series, no. 2). Manchester 1917.

JIJÓN Y CAAMAÑO, J.
1922—1923. Puruha (Boletín de la Academia Nacional de Historia, vols. 3—6). Quito 1922—1923.
1930. Una gran marea cultural en el n. o. de Sud América (Journal de la Société des Américanistes de Paris, nouvelle série, tome 22). Paris 1930.

JOYCE, THOMAS A.
1914. Mexican archaeology. London 1914.
1916. Central American and West Indian archaeology. London 1916.
1916 a. Note on a fine Tecalli vase of ancient Mexican manufacture (Man, vol. 16). London 1916.
1924. An example of cast gold-work, discovered at Palenque by de Waldeck, now in the British Museum (Proceedings of the 21st International Congress of Americanists, first part, The Hague 1924). The Hague 1924.
1926. Report of the investigations at Lubaantun, British Honduras, in 1926 (Journal of the Royal Anthropological Institute, vol. 56). London 1926.
1927. Maya and Mexican art. London 1927.
1928. Report on the British Museum expedition to British Honduras, 1928 (Journal of the Royal Anthropological Institute, vol. 58). London 1928.
1929. Report of the British Museum expedition to British Honduras, 1929 (Journal of the Royal Anthropological Institute, vol. 59). London 1929.
1932. The »eccentric flints» of Central America (Journal of the Royal Anthropological Institute, vol. 62). London 1932.
1933. The pottery whistle-figurines of Lubaantun (Journal of the Royal Anthropological Institute, vol. 63). London 1933.

JOYCE, T.A., COOPER CLARK, J., and THOMPSON, J.E.
1927. Report on the British Museum expedition to British Honduras, 1927 (Journal of the Royal Anthropological Institute, vol. 57). London 1927.

KARSTEN, RAFAEL.
1923. Naturfolkens religion (Natur och Kultur, no. 27). Stockholm 1923.

KELLY, ISABEL T.
1932. Ethnography of the Surprise Valley Paiute (University of California Publications in American Archaeology and Ethnology, vol. 31). Berkeley 1932.

KIDDER, A. V. and GUERNSEY, S. J.
1919. Archeological explorations in northeastern Arizona (Bulletin 65 of the Bureau of American Ethnology). Washington 1919.

KIDDER, ALFRED VINCENT.
1924. An introduction to the study of southwestern archaeology. New Haven 1924.

KRICKEBERG, WALTER.
1922. Amerika (Illustrierte Völkerkunde, edited by Georg Buschan. Second edition, vol. 1). Stuttgart 1922.
1918—1925. Die Totonaken (Baessler-Archiv, Band 7, and 9). Berlin 1918—1922, 1925.
1928. Mexikanisch-peruanische Parallelen (Festschrift P. W. Schmidt). Wien 1928.

KROEBER, A. L.
1905. The obsidian blades of California (American Anthropologist, new series, vol. 7, 1905).
1925. Archaic culture horizons in the Valley of Mexico (University of California Publications in American Archaeology and Ethnology, vol. 17). Berkeley 1925.
1925 a. Handbook of the Indians of California (Bulletin 78 of the Bureau of American Ethnology). Washington 1925.

LANDA, DIEGO DE.
1928—1929. Relation des choses de Yucatan (Relacion de las cosas de Yucatan, vols. 1—2). Paris 1928—1929.

LANDENBERGER, E.
1922. Durch Zentral-Amerika. Stuttgart-Cannstatt 1922.

LEHMANN, WALTER.
1909. Methods and results in Mexican research (Originally published in the Archiv für Anthropologie, vol. 6, 1907). Paris 1909.
1910. Ergebnisse einer Forschungsreise in Mittelamerika und México 1907—1909 (Zeitschrift für Ethnologie, Band 42). Berlin 1910.
1910 a. Berichte des K. Ethnographischen Museums in München, 1909. Herausgegeben von L. Scherman (Sonderabdruck aus dem Münchner Jahrbuch der bildenden Kunst). München 1910.
1913. Die Archäologie Costa Ricas (Festschrift zum 44. Anthropologen-Kongress). Nürnberg 1913.
1916. Ein kostbares Räuchergefäss aus Guatemala (Zeitschrift für Ethnologie, Band. 48). Berlin 1916.
1920. Zentral-Amerika. Teil 1. Die Sprachen Zentral-Amerikas in ihren Beziehungen zueinander sowie zu Süd-Amerika und Mexiko, vols. 1—2). Berlin 1920.
1921. Altmexikanische Kunstgeschichte. Ein Entwurf in Umrissen (Orbis Pictus, Band 8). Berlin 1921.
1922. Ein Tolteken-Klagesang (Festschrift Eduard Seler). Stuttgart 1922.
1924. Kunstgeschichte des alten Peru. Berlin 1924.
1931. Ausstellung altamerikanischer Kunst. Berlin 1931.
1933. Aus den Pyramidenstädten in Alt-Mexiko. Berlin 1933.
LEÓN, N.
1924. La industria indigena del papel en México, en los tiempos precolombinos y actuales (Boletin del Museo Nacional de Arqueología, Historia y Etnografía, t. 2). Mexico 1924.
LINDBLOM, GERHARD.
1924. Afrikanische Relikte und indianische Entlehnungen in der Kultur der Buschneger Surinams (Göteborgs Kungl. Vetenskaps- och Vitterhets-Samhälles Handlingar. Fjärde följden. 28: 1). Göteborg 1924.
LINNÉ, S.
1925. The technique of South American ceramics (Göteborgs Kungl. Vetenskaps- och Vitterhets-Samhälles Handlingar. Fjärde följden. Band 29. N:o 5). Göteborg 1925.
1929. Darien in the past (Göteborgs Kungl. Vetenskaps- och Vitterhets-Samhälles Handlingar. Femte följden. Ser. A. Band 1, N:o 3). Göteborg 1929.

LINTON, RALPH.
1922. The sacrifice to the Morning Star by the Skidi Pawnee (Field Museum of Natural History. Department of Anthropology. Leaflet, number 6). Chicago 1922.
LOEBÈR JUN., J. A.
1926. Das Batiken. Eine blüte indonesischen Kunstlebens. Oldenburg 1926.
LOEWENTHAL, JOHN.
1922. Das altmexikanische Ritual tlacacàliliztli und seine Parallelen in den Vegetationskulten der Alten Welt (Mitteilungen der Anthropologischen Gesellschaft in Wien, Band 52). Wien 1922.
LOTHROP, S. K.
1925. The Museum Central American expedition, 1924. (Indian Notes, vol. 2, no. 1). New York 1925.
1926. Pottery of Costa Rica and Nicaragua (Contributions from the Museum of the American Indian, Heye Foundation, vol. 8; vols. 1—2). New York 1926.
1926 a. Nicoyan incense burner (Indian Notes, vol. 3, no. 2). New York 1926.
1927. Pottery types and their sequence in El Salvador (Indian Notes and Monographs, vol. 1, no. 4). New York 1927.
1928. Santiago Atitlan, Guatemala (Indian Notes, vol. 5, no. 4). New York 1928.
1932. Indians of the Paraná delta, Argentina (Annals of the New York Academy of Sciences, vol. 33). New York 1932.
1933. Atitlan. An archaeological study of ancient remains on the borders of Lake Atitlan, Guatemala (Carnegie Institution of Washington. Publication no. 444). Washington 1933.
LOVÉN, SVEN.
1924. Über die Wurzeln der Tainischen Kultur. Göteborg 1924.
LOWIE, ROBERT H.
1909. The northern Shoshone (Anthropological papers of the American Museum of Natural History, vol. 2, part 2). New York 1909.
1915. Dances and societies of the Plains Shoshone (Anthropological Papers of the American Museum of Natural History, vol. 11, part 10). New York 1915.
LUMHOLTZ, CARL and HRDLIČKA, ALEŠ.
1898. Marked human bones from a prehistoric Tarasco Indian burial place in the State of Michoacan, Mexico (Bulletin of the American Museum of Natural History, vol. 10). New York 1898.

LUMHOLTZ, CARL.
1900. Symbolism of the Huichol Indians (Memoirs of the American Museum of Natural History, vol. 3). New York 1900.
1904. Bland Mexikos indianer (vols. 1—2). Stockholm 1904.
LUNDELL, C. L.
1934. Ruins of Popol and other archaeological discoveries in the Department of Peten, Guatemala (Contributions to American Archaeology, no. 8. Publication no. 436 of Carnegie Institution of Washington). Washington 1934.
MACCURDY, GEORGE GRANT.
1911. A study of Chiriquian antiquities (Memoirs of the Connecticut Academy of Arts and Sciences, vol. 3). New Haven 1911.
MALER, TEOBERT.
1911. Explorations in the Department of Peten, Guatemala. Tikal (Memoirs of the Peabody Museum of American Archaeology and Ethnology, Harward University, vol. 5, nos. 1 and 2). Cambridge 1911.
MARQUINA, IGNACIO.
1928. Estudio arquitectonico comparativo de los monumentos arquelogicos de Mexico (Secretaría de Educación Pública). Mexico 1928.
MARTIN, PAUL S.
1934. The bow-drill in North America (American Anthropologist, new series. vol. 36, 1934).
MASON, GREGORY.
1928. Pottery and other artifacts from caves in British Honduras and Guatemala (Indian Notes and Monographs, no. 47). New York 1928.
MASON, J. ALDEN.
1912. The ethnology of the Salinan Indians (University of California Publications in American Archaeology and Ethnology, vol. 10). Berkeley 1912.
1934. Esculturas Mayas rescatadas de la Selva (Boletín de la Unión Panamericana, mayo 1934). Washington 1934.
MAUDSLEY, A. P.
1889—1902. Archaeology (Biologia Centrali-Americana, 4 vols.). London 1889—1902.
MERWIN, RAYMOND E. and VAILLANT, GEORGE C.
1932. The ruins of Holmul, Guatemala (Memoirs of the Peabody Museum of American Archaeology and Ethnology, Harvard University, vol. 3, no. 2). Cambridge 1932.

MEYER, A. B.
1891. Neue Beiträge zur Kenntnis des Nephrit und Jadeït (Abhandlungen und Berichte des Königlichen Zoologischen und Anthropologisch-Ethnographischen Museums zu Dresden. Band 3. No. 1). Dresden 1891.
MEYER, A. B. and RICHTER, O.
1903. Webgerät aus dem ostindischen Archipele mit besonderer Rücksicht auf Gorontalo in Nord Celebes (Abhandlungen und Berichte des Königlichen Zoologischen und Anthropologisch-Ethnographischen Museums zu Dresden, Band 10. Etnographische Miszellen 2). Berlin 1903.
MOLINA ENRIQUEZ, RENATO.
1925. Las lacas de México (Ethnos, tercera época, tomo 1, núm. 5). Mexico 1925.
MORLEY, S. G.
1915. An introduction to the study of the Maya hieroglyphs (Bulletin 57 of the Bureau of American Ethnology). Washington 1915.
MOTOLINÍA, FR. TORIBIO DE BENAVENTE.
1914. Historia de los indios de la Nueva España. Barcelona 1914.
MÜLLER, J. G.
1847. Der mexikanische Nationalgott Huitzilopochtli. Basel 1847.
O'NEALE, LILA M. and KROEBER, A. L.
1930. Textile periods in Ancient Peru (University of California Publications in American Archaeology and Ethnology, vol. 28). Berkeley 1930.
NELSON, NELS C.
1931. Flint working by Ishi (Source Book in Anthropology by A. L. Kroeber and T. T. Waterman). New York 1931.
1933. The antiquity of man in America in the light of archaeology (The American Aborigines, their Origin and Antiquity). Victoria 1933.
NOGUERA, EDUARDO.
1930. Ruinas arqueologicas del norte de Mexico. Casas Grandes (Chihuahua), La Quemada, Chalchihuites (Zacatecas) (Publicaciones de la Secretaría de Educación Pública). Mexico 1930.
1930 a. Algunas características de la cerámica de México (Journal de la Société des Américanistes de Paris, nouvelle série, tome 22). Paris 1930.
1932 Extensiones cronologico-culturales y geograficas de las ceramicas de Mexico. Mexico 1932.

NORDENSKIÖLD, ERLAND.
1910. Indianlif. Stockholm 1910.
1912. De sydamerikanska indianernas kultur-
historia. Stockholm 1912.
1913. Urnengräber und Mounds im boli-
vianischen Flachlande (Baessler-Archiv,
Band 3). Leipzig und Berlin 1913.
1919. An ethno-geographical analysis of the
material culture of two Indian tribes
in the Gran Chaco (Comparative ethno-
graphical studies, vol. 1). Göteborg 1919.
1920. The changes in the material culture of
two Indian tribes under the influence
of new surroundings (Comparative
ethnographical studies, vol. 2). Göte-
borg 1920.
1921. The copper and bronze ages in South
America (Comparative ethnographical
studies, vol. 4). Göteborg 1921.
1922. Deductions suggested by the geographic-
al distribution of some post-Columbian
words used by the Indians of S. America
(Comparative ethnographical studies,
vol. 5). Göteborg 1922.
1924. The ethnography of South America seen
from Mojos in Bolivia (Comparative
ethnographical studies, vol. 3). Göteborg
1924.
1925. Au sujet de quelques pointes, dites de
harpons, provenant du delta du Paraná
(Journal de la Société des Américanistes
de Paris, nouvelle série, tome 17).
Paris 1925.
1928. Indianerna på Panamanäset. Stockholm
1928.
1929. The American Indian as an inventor
(Journal of the Royal Anthropological
Institute, vol. 59). London 1929.
1930. Modifications in Indian culture through
inventions and loans (Comparative ethno-
graphical studies, vol. 8). Göteborg 1930.
1931. Origin of the Indian civilizations in
South America (Comparative ethno-
graphical studies, vol. 9). Göteborg 1931.
NUTTALL, ZELIA.
1904. A penitential rite of the ancient Mexi-
cans (Archaeological and Ethnological
Papers of the Peabody Museum. Har-
vard University, vol. 1, no. 7). Cam-
bridge 1904.
1910. The Island of Sacrificios (American
Anthropologist, new series, vol. 12,
1910).
1926. Official reports ... to His Majesty,
Philip II, and the Council of the Indies,
in 1580 (translated by Zelia Nuttall).
Cambridge 1926.

1926 a. The Aztecs and their predecessors in the
Valley of Mexico (Proceedings of the
American Philosophical Society, vol. 65,
no. 4.). Philadelphia 1926.
1930. Documentary evidence concerning wild
maize in Mexico (Journal of Heredity,
vol. 21, no. 5). Washington 1930.
OVIEDO Y VALDÉS, GONZALO FERNANDEZ DE.
1851—1855. Historia general y natural de las
Indias. Madrid 1851—1855.
ORCHARD, WILLIAM C.
1927. Obsidian ear-ornaments (Indian Notes,
vol. 4, no. 3). New York 1927.
PAUER, PAUL SILICIO.
1927. La población indígena de Yalalag,
Oaxaca (Anthropos, tom. 22). St.
Gabriel-Mödling bei Wien 1927.
PEABODY, CH.
1927. Red paint (Journal de la Société des
Américanistes de Paris, nouvelle série,
tome 19). Paris 1927.
PEÑAFIEL, ANTONIO.
1890. Monumentos del arte Mexicano antiguo
(vols. 1—3). Berlin 1890.
1900. Teotihuacán. Historical and archaeolo-
gical study. México 1900.
PENCK, ALBRECHT.
1930. Wann kamen die Indianer nach Nord-
Amerika? (Proceedings of the 23d
International Congress of America-
nists, New York 1928). New York 1930.
PEPPER, GEORGE H.
1920. Pueblo Bonito (Anthropological Papers
of the American Museum of Natural
History, vol. 27). New York 1920.
PLANCARTE Y NAVARRETE, FRANCISCO.
1911. Tamoanchan. El estado de Morelos y
el principio de la civilizacion en Mexico.
Mexico 1911.
POHORILLES, NOAH E.
1913. Das Popol Wuh (Mythologische Biblio-
tek 6, 1). Leipzig 1913.
POPE, SAXTON.
1925. Hunting with the bow and arrow. Lon-
don and New York 1925.
RADIN, PAUL.
1920. The sources and authenticity of the
history of the ancient Mexicans (Uni-
versity of California Publications in
American Archaeology and Ethnology,
vol. 17, no. 1). Berkeley 1920.
REH, EMMA.
1934. Tomb discoveries at Monte Alban
(El Palacio, vol. 36, nos. 19—20).
Santa Fe 1934.

228

RIBEIRO DE SAMPAIO, FRANCISCO XAVIER.
1825. Diario da Viagem no anno de 1774 e
1775. Lisboa 1825.
RICKARDS, CONSTANTINE GEORGE.
1910. The Ruins of Mexico. London 1910.
RICKETSON JR., OLIVER.
1931. Excavations at Baking Pot, British
Honduras (Contributions to American
Archaeology, vol. 1, no. 1. Publication
no. 403 of Carnegie Institution of
Washington). Washington 1931.
RIES, MAURICE.
1932. Stamping: a mass-production printing
method 2000 years old (Middle American
Papers. The Tulane University of Loui-
siana. Middle American Research Series.
Publication no. 4). New Orleans 1932.
RIVET, PAUL.
1905. Les indiens Colorados (Journal de la
Société des Américanistes de Paris,
nouvelle série, tome 2). Paris 1905.
RIVET, P. and ARSANDAUX, H.
1921. Contribution à l'étude de la métallurgie
mexicaine (Journal de la Société des
Américanistes de Paris, nouvelle série,
tome 13). Paris 1921.
1923. Nouvelle note sur la métallurgie mexi-
caine (L'Anthropologie, tome 33). Paris
1923.
ROSEN, ERIC VON.
1919. En förgången värld. Stockholm 1919.
RUSSEL, FRANK.
1908. The Pima Indians (26th Annual Report
of the Bureau of American Ethnology).
Washington 1908.
RÖCK, FRIEDRICH.
1929. Kunstgewerbe von Mexiko, Mittel-
Amerika und Westindien (Geschichte
des Kunstgewerbes aller Zeiten und
Völker. Herausgegeben von H. Th.
Bossert, Band 2). Berlin 1929.
SAFFORD, WILLIAM E.
1917. Food-plants and textiles of ancient
America (Proceedings of the 19th
International Congress of Americanists,
Washington 1915). Washington 1917.
SAHAGUN, FRAY BERNARDINO DE.
1890—1896. Historia general de las cosas de
Nueva España (edited and translated
by Carlos Maria de Bustamante, 2nd
edition; vols. 1—4). México 1890—1896.
1922. Historia de las cosas de Nueva España
(Portfolio of illustrations from two
Sahagun manuscripts copied under
direction of F. del Paso y Troncoso
and issued by the Mexican Govern-
ment). Firenze 1922.

1927. Einige Kapitel aus dem Geschichtswerk
des Fray Bernardino de Sahagun aus
dem Aztekischen übersetzt von Eduard
Seler. Stuttgart 1927.
SANTESSON, C. G.
1931. An arrow poison with cardiac effect from
the New World (Comparative ethno-
graphical studies, edited by Erland
Nordenskiöld, vol. 9). Göteborg 1931.
SAPPER, KARL.
1897. Das nördliche Mittel-Amerika nebst
einem Ausflug nach dem Hochland von
Anahuac. Braunschweig 1897.
1899. Die Payas in Honduras (Globus, Band
75). Braunschweig 1899.
1902. Mittelamerikanische Reisen und Stu-
dien. Braunschweig 1902.
1903. Mittelamerikanische Waffen im moder-
nen Gebrauche (Globus, Band 83).
Braunschweig 1903.
1904. Der gegenwärtige Stand der ethnogra-
phischen Kenntnis von Mittelamerika
(Archiv für Anthropologie, Neue Folge,
Band 3). Braunschweig 1904.
1934. Geographie der Altindianischen Land-
wirtschaft (Petermanns Geographischen
Mitteilungen 1934)·
SAYCE, R. U.
1933. Primitive arts and crafts. Cambridge
1933.
SAVILLE, MARSHALL H.
1897. An ancient figure of terra cotta from the
Valley of Mexico (Bulletin of the Ameri-
can Museum of Natural History, vol. 9,
article 17). New York 1897.
1899. Explorations of Zapotecan tombs in
southern Mexico (American Anthropo-
logist, new series, vol. 1, 1899).
1900. An onyx jar from Mexico, in process of
manufacture (Bulletin of the American
Museum of Natural History, vol. 13,
article 11). New York 1900.
1907—1910. The antiquities of Manabi, Ecua-
dor, vols. 1—2. New York 1907—1910.
1916. The glazed ware of Central America,
with special reference to a whistling
jar from Honduras (Holmes Anniver-
sary Volume). Washington 1916.
1919. A sculptured vase from Guatemala
(Museum of the American Indian, Heye
Foundation, Leaflet no. 1). New York
1919.
1920. The goldsmith's art in ancient Mexico
(Indian Notes and Monographs). New
York 1920.

1922. Turquois mosaic art in ancient Mexico (Contributions from the Museum of the American Indian, Heye Foundation, vol. 6). New York 1922.

1925. The wood-carver's art in ancient Mexico (Contributions from the Museum of the American Indian, Heye Foundation, vol. 9). New York 1925.

1929. The Aztecan god Xipe Totec (Indian Notes, vol. 6, no. 2). New York 1929.

1930. Toltec or Teotihuacan types of artifacts in Guatemala (Indian Notes, vol. 7, no. 2). New York 1930.

SCHELLHAS, P.

1890. Vergleichende Studien auf dem Felde der Maya-Alterthümer (Internationales Archiv für Ethnographie. Band 3). Berlin 1890.

1904. Representation of deities of the Maya manuscripts (Papers of the Peabody Museum of American Archaeology and Ethnology, Harvard University, vol. 4, no. 1). Cambridge 1904.

1926. Der Ursprung der Mayahandschriften (Zeitschrift für Ethnologie, Band 58). Berlin 1926.

SCHMIDT, MAX.

1910. Über altperuanische Gewebe mit szenenhaften Darstellungen (Baessler-Archiv, Band 1). Leipzig und Berlin 1910.

1929. Kunst und Kultur von Peru. Berlin 1929.

SCHMIDT, P. Kulturkreise und Kulturschichten in

1913. Südamerika (Zeitschrift für Ethnologie, Band 45). Berlin 1913.

SCHWEDE, RUDOLF.

1912. Über das Papier der Maya-Codices und einiger altmexikanischer Bilderhandschriften. Dresden 1912.

1916. Ein weiterer Beitrag zur Geschichte des altamerikanischen Papiers (Jahresbericht der Vereinigung für angewandte Botanik, Jahrg. 13, 1915). Berlin 1916.

SELER, EDUARD.

1890. Ein Kapitel aus den in aztekischer Sprache geschriebenen ungedruckten Materialien zu dem Geschichtswerk des P. Sahagun (Veröffentlichungen aus dem Königlichen Museum für Völkerkunde, Band 1). Berlin 1890.

1890 a. Résultats archéologiques de son dernier voyage en Mexique (Proceedings of the 7th International Congress of Americanists, Berlin 1888). Berlin 1890.

1893. Die mexikanischen Bilderschriften Alexander von Humboldt's in der Königlichen Bibliothek zu Berlin. Berlin 1893.

1895. Wandmalereien von Mitla. Berlin 1985.

1895 a. Alterthümer aus Guatemala (Veröffentlichungen aus dem Königlichen Museum für Völkerkunde, Band 4). Berlin 1895.

1899. Die achtzehn Jahresfeste der Mexikaner (Veröffentlichungen aus dem Königlichen Museum für Völkerkunde, Band 6). Berlin 1899.

1900. Das Tonalamatl der Aubin'schen Sammlung. Berlin 1900.

1901. Die alten Ansiedelungen von Chaculá im Distrikte Nenton des Departements Huehuetenango der Republik Guatemala. Berlin 1901.

1901 a. Die Ausgrabungen am Orte des Haupttempels in Mexico (Mitteilungen der Anthropologischen Gesellschaft in Wien, Band 31). Wien 1901.

1901 b. Codex Fejérváry-Mayer. Berlin 1901.

1902. Gesammelte Abhandlungen zur amerikanischen Sprach- und Alterthumskunde (Erster Band). Berlin 1902.

1904. Gesammelte Abhandlungen zur amerikanischen Sprach- und Alterthumskunde (Zweiter Band). Berlin 1904.

1904 a. Mexican picture writings of Alexander von Humboldt (Bulletin 28 of the Bureau of American Ethnology). Washington 1904.

1904 b. Deities and religious conceptions of the Zapotecs (Bulletin 28 of the Bureau of American Ethnology). Washington 1904.

1904 c. Antiquities of Guatemala (Bulletin 28 of the Bureau of American Ethnology). Washington 1904.

1904—1909. Codex Borgia (vols. 1—3). Berlin 1904—1909.

1908. Gesammelte Abhandlungen zur amerikanischen Sprach- und Alterthumskunde (Dritter Band). Berlin 1908.

1912. Archäologische Reise in Süd und Mittel-Amerika (Zeitschrift für Ethnologie, Band 44). Berlin 1912.

1915. Die Teotiuacan-Kultur des Hochlands von México (Gesammelte Abhandlungen, Band 5). Berlin 1915.

1916. Eine altmexikanische Knochenrassel (Zeitschrift für Ethnologie, Band 48). Berlin 1916.

1923. Gesammelte Abhandlungen zur amerikanischen Sprach- und Alterthumskunde (Vierter Band). Berlin 1923.

SELER-SACHS, CAECILIE.

1900. Auf alten Wegen in Mexiko und Guatemala. Reiseerinnerungen und Eindrücke aus den Jahren 1895—1897. Berlin 1900.

1909. Mexikanische Küche (Zeitschrift des Vereins für Volkskunde in Berlin, 19. Jahrg.). Berlin 1909.
1916. Die Huaxteca-Sammlung des Königlichen Museums für Völkerkunde zu Berlin (Baessler-Archiv, Band 5). Leipzig und Berlin 1916.
1919. Frauenleben im Reiche der Azteken. Berlin 1919.
1922. Altertümer des Kanton Tuxtla im Staate Veracruz (Festschrift Eduard Seler). Stuttgart 1922.

SKINNER, ALANSON.
1920. Notes on the Bribri of Costa Rica (Indian Notes and Monographs, vol. 6, no. 3). New York 1920.

SNETHLAGE, HEINRICH.
1931. Ein figürliches Ikat-Gewebe aus Peru (Der Weltkreis, Jahrg. 2, Heft 3—4) Berlin 1931.

SOLIS, ANTONIO DE.
1704. Historia de la Conquista de Mexico. Madrid 1704.

SPENCE, LEWIS.
The magic and mysteries of Mexico. London.

SPIER, LESLIE.
1928. Havasupai ethnography (Anthropological Papers of the American Museum of Natural History, vol. 29). New York 1928.
1930. Klamath ethnography (University of California Publications in American Archaeology and Ethnology, vol. 30). Berkeley 1930.
1933. Yuman tribes of the Gila river. Chicago 1933.

SPIER, LESLIE and SAPIR, EDWARD.
1930. Wishram ethnology (University of Washington Publications in Anthropology, vol. 3, no. 3). Washington 1930.

SPINDEN, ELLEN S.
1933. The place of Tajin in Totonac archaeology. (American Anthropologist, new series, vol. 35, 1933).

SPINDEN, HERBERT J.
1911. An ancient sepulcher at Placeres del Oro, State of Guerrero (American Anthropologist, new series, vol. 13, 1911).
1913. A study of Maya art (Memoirs of the Peabody Museum of American Archaeology and Ethnology, Harvard University, vol. 6). Cambridge 1913.
1915. Notes on the archeology of Salvador. (American Anthropologist, new series, vol. 17, 1915).

1916. Portraiture in Central American art (Holmes Anniversary Volume). Washington 1916.
1924. The reduction of Mayan dates (Papers of the Peabody Museum of American Archaeology and Ethnology, Harvard University, vol. 6, no. 4). Cambridge 1924.
1925. The Chorotegan culture area (Proceedings of the 21st International Congress of Americanists, Göteborg 1924). Göteborg 1925.
1928. Ancient civilizations of Mexico and Central America (Handbook series, no. 3, American Museum of Natural History). New York 1928.
1928 a. The prosaic versus the romantic school in Anthropology. Culture, the diffusion controversy (by G. Elliot Smith, Bronislaw Malinowski, Herbert J. Spinden, A. Goldenweiser). London 1928.
1931. The origin and distribution of agriculture in America (Source Book in Anthropology edited by A. L. Kroeber and T. T. Waterman). New York 1931.

STARR, FREDERICK.
1899. Indians of southern Mexico. Chicago 1899.
1900. Mexican paper (The American and Antiquarian and Oriental Journal, vol. 22, no. 5). Chicago 1900.
1900 a. Notched bones from Mexico (Proceedings of the Davenport Academy of Natural Sciences, vol. 7). Davenport 1900.
1900 b. A shell inscription from Tula, Mexico (Proceedings of the Davenport Academy of Natural Sciences, vol. 7). Davenport 1900.
1901. Notes upon the ethnography of southern Mexico. Expeditions 1898—1900 (Proceedings of the Davenport Academy of Natural Sciences, vol. 8). Davenport 1901.
1902. Notes upon the ethnography of southern Mexico. Expedition of 1901 (Proceedings of the Davenport Academy of Natural Sciences, vol. 9). Davenport 1902.

STAUB, WALTHER.
1921. Neue Funde und Ausgrabungen in der Huaxteca, Ost-Mexiko (Jahresbericht über die Ethnographische Sammlung in Bern 1920). Bern 1921.
1921 a. Pre-Hispanic mortuary pottery, sherd deposits and other antiquities of the Huasteca (El Mexico Antiguo, tomo 1, no. 7). Mexico 1921.

1926. Ueber die Altersfolge der vorspanischen Kulturen in der Huaxteca, Nordost-Mexiko (Jahrbuch des Bernischen Historischen Museums in Bern 1925). Bern 1926.

1926 a. Le nord-est du Mexique et les Indiens de la Huaxtèque (Journal de la Société des Américanistes de Paris, nouvelle série, t. 18). Paris 1926.

STEVENSON, MATILDA COXE.

1904. The Zuñi Indians (23d Annual Report of the Bureau of American Ethnology). Washington 1904.

STEWARD, JULIAN H.

1933. Ethnography of the Owens Valley Paiute (University of California Publications in American Archaeology and Ethnology, vol. 33). Berkeley 1933.

STOLL, OTTO.

1889. Die Ethnologie der Indianerstämme von Guatemala (Internationales Archiv für Ethnographie, Band I). Leiden 1889.

STREBEL, HERMANN.

1885—1889. Alt-Mexiko. Archäologische Beiträge zur Kulturgeschichte seiner Bewohner (vols. 1—2). Hamburg und Leipzig 1885—1889.

1899. Über Tierornamente auf Thongefässen aus Alt-Mexico (Veröffentlichungen aus dem Königlichen Museum für Völkerkunde, Band 6). Berlin 1899.

1904. Ueber Ornamente auf Ton-Gefässer aus Alt-Mexiko. Hamburg und Leipzig 1904.

SWANTON, JOHN R.

1931. Source material for the social and ceremonial life of the Choctaw Indians (Bulletin 103 of the Bureau of the American Ethnology). Washington 1931.

TERMER, FRANZ.

1930. Zur Ethnologie und Ethnographie des nördlichen Mittelamerika (Ibero-Amerikanisches Archiv, Jahrg. 4, Heft 3). Berlin und Bonn 1930.

1930 a. Archäologische Studien und Beobachtungen in Guatemala in den Jahren 1925 —1929 (Tagungsberichte der Gesellschaft für Völkerkunde). Leipzig 1930.

1931. Zur Archäologie von Guatemala (Baessler-Archiv, Band 14). Berlin 1931.

TEZOZOMOC, HERNANDO ALVARADO.

1878. Cronica mexicana. Mexico 1878.

THOMPSON, EDWARD H.

1897. The chultunes of Labná, Yucatan (Memoirs of the Peabody Museum of American Archaeology and Ethnology, Harvard University, vol. 1, no. 3). Cambridge 1897.

1897 a. Cave of Loltun, Yucatan (Memoirs of the Peabody Museum of American Archaeology and Ethnology, Harvard University, vol. 1, no. 2). Cambridge 1897.

1904. Archaeological researches in Yucatan (Memoirs of the Peabody Museum of American Archaeology and Ethnology, Harvard University, vol 3, no. 1). Cambridge 1904.

THOMPSON, J. ERIC.

1930. Ethnology of the Mayas of southern and central British Honduras (Field Museum of Natural History, Anthropological series, vol. 17, no. 2). Chicago 1930.

1931. Archaeological investigations in the southern Cayo district, British Honduras (Field Museum of Natural History, Anthropological series, vol. 17, no. 3). Chicago 1931.

1933. Mexico before Cortez. New York and London 1933.

THORD-GRAY, I.

1923. Från Mexicos forntid. Stockholm 1923.

TOZZER, ALFRED M.

1907. A comparative study of the Mayas and the Lacandones (Archaeological Institute of America). New York 1907.

1913. A preliminary study of the prehistoric ruins of Nakum, Guatemala (Memoirs of the Peabody Museum of American Archaeology and Ethnology, Harvard University, vol. 5, no. 3). Cambridge 1913.

1921. Excavation of a site at Santiago Ahuitzotla, D. F. Mexico (Bulletin 74 of the Bureau of American Ethnology). Washington 1921.

1927. Time and American archaeology (Natural History, vol. 27). New York 1927.

1934. Maya research (Maya Research, vol. 1, no. 1). New York 1934.

UHLE, MAX.

1888. Ausgewälte Stücke des K. Museums für Völkerkunde zur Archäologie Amerikas (Veröffentlichungen aus dem Königlichen Museum für Völkerkunde). Berlin 1888.

1889. Kultur und Industrie südamerikanischer Völker (Erster Band). Berlin 1889.

1922. Influencias Mayas en el Alto Ecuador (Boletín de la Academia Nacional de Historia, vol. 4, núms. 10 y 11). Quito 1922.

1925. Cronologia y relaciones de las antiguas civilizaciones Panameñas (Edición espe-

cial del estudio publicado en los nos. 24, 25 y 26 del Boletín de la Academia Nacional de Historia). Quito 1925.

1926. Excavaciones arqueologicas en la region de Cumbaya (Anales de la Universidad Central, tomo 37, no. 257). Quito 1926.

1926 a. Los elementos constitutivos de las civilizaciones Andinas (Anales de la Universidad central, tomo 36, no. 255). Quito 1926.

1927. Estudios Esmeraldeños (Anales de la Universidad Central, tomo 39, no. 262). Quito 1927.

1927 a. Las antiguas civilizaciones Esmeraldeñas (Anales de la Universidad Central, tomo 38, no. 259). Quito 1927.

1928. Las ruinas de Cuasmal (Anales de la Universidad Central, tomo 40, no. 264.). Quito 1928.

1931. Las antiguas civilizaciones de Manta (Boletín de la Academia Nacional de Historia, vol. 12, núms. 33—35). Quito 1931.

1933. Estudio sobre las civilizaciones del Carchi e Imbabura. Quito 1933.

URIBE ANGEL, MANUEL.
1885. Geografia general y compendio historico del estado de Antioquia en Colombia. Paris 1885.

VAILLANT, GEORGE C.
1930. Excavations at Zacatenco (Anthropological Papers of the American Museum of Natural History, vol. 32, part 1). New York 1930.

1930 a. Notes on the Middle Cultures of Middle America (Proceedings of the 23d International Congress of Americanists, New York 1928). New York 1930.

1931. Excavations at Ticoman (Anthropological Papers of the American Museum of Natural History, vol. 32, part 2). New York 1931.

1931 a. Las antiguas culturas del Valle de Mexico (Quetzalcoatl, tomo 1, año 3, num. 5). Mexico 1931.

1932. Stratigraphical research in Central Mexico (Proceedings of the National Academy of Sciences, vol. 18). Washington 1932.

1932 a. Some resemblances in the ceramics of Central and North America (Medallion Papers, no. 12). Gila Pueblo-Globe, Arizona 1932.

1932 b. (See Merwin and Vaillant). 1932.

1933. Hidden history (Natural History, vol. 33). New York 1933.

1934. The sculpture of pre-Columbian Central America (Natural History, vol. 34). New York 1934.

VAILLANT, SUZANNAH B. and GEORGE C.
1934. Excavations at Gualupita (Anthropological Papers of the American Museum of Natural History, vol. 35, part 1). New York 1934.

VALENTINI, J. J.
1881. Mexican paper. Worcester 1881.

VERNEAU, R.
1913. Une nouvelle collection archéologique du Mexique (Journal de la Société des Américanistes de Paris, nouvelle série, tome 10). Paris 1913.

VILLACORTA, J. ANTONIO y CARLOS A.
1927. Arqueologia Guatemalteca. Guatemala 1927.

WASHINGTON, HENRY S.
1922. The jades of Middle America (Proceedings of the National Academy of Sciences, vol. 8). Philadelphia 1922.

WAUCHOPE, ROBERT.
1934. House mounds of Uaxactun, Guatemala (Contributions to American Archaeology, no. 7. Publication no. 436 of Carnegie Institution of Washington). Washington 1934.

WEBER, FRIEDRICH.
1911. Beiträge zur Charakteristik der älteren Geschichtsschreiber über Spanisch-Amerika. Leipzig 1911.

1922. Zur Archäologie Salvadors (Festschrift Eduard Seler). Stuttgart 1922.

WEYERSTALL, ALBERT.
1932. Some observations on Indian mounds, idols and pottery in the Lower Papaloapam Basin, State of Vera Cruz, Mexico (Middle American Papers. Publication no. 4. The Tulane University of Louisiana). New Orleans 1932.

WHITE, ROBERT BLAKE.
1883. Notes on the central provinces of Colombia (Proceedings of the Royal Geographical Society, vol. 5). London 1883.

WILSON, THOMAS.
1898. Prehistoric art (Annual Report of the Board of Regents of the Smithsonian Institution 1896). Washington 1898.

1899. Arrowpoints, spearheads, and knives of prehistoric times (Report of the U. S. National Museum for 1897). Washington 1899.

YACOVLEFF, E. y MUELLE J. C.
1932. Una exploracion en Cerro Colorado (Revista del Museo Nacional, no. 2). Lima 1932.

233

I N D E X

Agave, textiles manufactured by agave fibres, 109.
Age, of American Indians, 14 seq.; of the Teotihuacan culture, 21—22, 220; of the ruin at Xolalpan, 45, 47, 217; of the Mazapan culture, 21; of moulds, 195; of in-fresco painted ware, 170; of plumbate ware, 106.
Agriculture, origin and spread, 18—19.
Alonso de Santa Cruz, earliest map of the Mexico valley, 22.
Anthropological material, see skeletal remains.
Anthropomorphic vessels, 64, 67, 69.
Arrow-points, obsidian, 147; stone, 133.
Atlantean figures, clay, 49, 111—112.
Awls, bone, 155 seq.
Axes, stone, 132; found in grave, 58.
Azcapotzalco, 48, 107, 117, 119.
Aztecs, 17, 119, 122, 128, 205, 208, 215; finds of the Aztec culture, 87, 217; Xipe Totec, 172 seq.

Bark-beaters, 136, 197, 220.
Basket Maker period, 20.
Batik, 163 seq.
Beads, stone, 131.
Bering Strait, means of Asiatic migration, 14.
Bird, as decorative motiv on clay vessels, 62; as whistle, 128.
Blades, obsidian, 146; stone, 133; found in grave, 58.
Blow-gun, 121,185,218, 220.
Blue colour, 83; see colour materials.
Bodkins, bone, 155.
Bone, bodkins, 155; corn-husking pegs, 157; discs, 157; implements of, 155; needles, 157; rasping bones, 128, 155, 204, 220.
Burial customs, see graves; secondary, 73.

Calabashes, mending by the »crack-lacing» method, 211; negative painting on, 162.
Camino de los muertos, the Road of the Dead, 31, 47; Candeleros, 113; found in graves, 59, 62, 67, 68. from Guatemala 100, 114.
Casa de los frescos, 34.
Chalchicomula, District in the state of Puebla, ceramic imported from, 54, 67, 95, 103, 170, 218.

Cinnabar, used in decoration of tripod vessels, 52, 91, 160, 212, 218, 219.
Ciudadela, 27—30, 113.
Clay, discs, 121; ear-plugs, 120; figurines, 115; figurines found in graves, 119; flutes, 128; incense burners, 110, 113; incense ladles, 110; moulds, 123, 193, 218, 220; pellets, 120, 185, 218; spindle-whorls, 126, 194; stamps, 119, 125, 194, 220; whistles, 128.
Cloisonné decoration, 168.
Codices, manufactured of bast, 199; of deerskin, 171.
Colour materials, 160, 212, 218; see cinnabar.
Copal, 113.
Copilco, archaeological site in the Mexico valley, 19, 112.
Copper bells, see metals.
Corn-husking pegs, 157.
Cremation, 63.

Deformation of skulls, 71.
Discs, bone, 157; made from potsherds, 121; slate, 154; stone, 122.

Ear-plugs, clay, 120; obsidian, 151; stone, 140.

Fat God, 119, 218.
Flutes, clay, 128.
Folsom, archaeological site in New Mexico, 16.

Glazed ware, 105.
Gods, Diosa del Agua, 34; the Fat God, 119, 218; the Old God, Ueueteotl, 49, 112, 119, 141; Tlaloc, 53, 57, 58, 61, 67, 92, 119; Quetzalcoatl, 30; Xipe Totec, 82, 83, 172, 218, 219.
Graves, below the floors at Xolalpan, 54—74; child graves, 72—74; from the Mazapan culture, 80—83; relative age of the Xolalpan graves, 217.
Gypsum Cave, archaeological site in Nevada, 16.

Hieroglyphs, symbolic on Teotihuacan vessels, 56 seq., 61.